ENCOUNTERS IN THE VIRTUAL
FEMINIST MUSEUM

In an innovative and experimental format, Griselda Pollock provides another new impetus in our ways of thinking and writing about the visual arts.

Neither cybernetic nor etherised, the virtual feminist museum is a poetic laboratory breaking the museum's rigid rules to create encounters with and between images by and about women as they engaged with and were defined by modernity. Tracking the complex relays between femininity, modernity and representation by means of a sequence of virtual exhibitions, this book reframes art in the twentieth century 'with women in mind'. Initially exploring how modernist women engaged creatively with the legacies of Western art's prime representation of femininity – the nude female body – the book also contemplates the traumatic rupture scorched into the culture of the West by the Holocaust. What can be the function of art after the atrocity inflicted on bodies by Nazi terror and mass murder? What can feminist theory and aesthetic practice contribute to the debates about art after Auschwitz?

In our era of liquid modernity with its dizzyingly accelerating pace of change, how can art making, working with media such as painting and drawing, call upon us to take time, and reclaim the meaning of time – times of making, times of viewing, times of thinking?

Calling upon both the Freudian museum and Aby Warburg's *Memory Atlas* as resources for feminist cultural analysis, this book is another major contribution to contemporary art history and cultural studies.

Griselda Pollock is Professor of Social and Critical Histories of Art and Director of the Centre for Cultural Analysis, Theory and History at the University of Leeds. A world-renowned scholar of international, postcolonial feminist studies in the visual arts, she is best known for her theoretical and methodological innovation, combined with deeply engaged readings of historical and contemporary art, film and cultural theory.

ENCOUNTERS IN THE VIRTUAL FEMINIST MUSEUM

Time, space and the archive

Griselda Pollock

LONDON AND NEW YORK

First published 2007
by Routledge
2 Park Square, Milton Park, Abingdon, Oxon OX14 4RN

Simultaneously published in the USA and Canada
by Routledge
270 Madison Avenue, New York, NY 10016

Routledge is an imprint of the Taylor & Francis Group, an informa business

© 2007 Griselda Pollock

Typeset in Baskerville by
RefineCatch Limited, Bungay, Suffolk
Printed and bound in Great Britain by
MPG Books Ltd, Bodmin

British Library Cataloguing in Publication Data
A catalogue record for this book is available from the British Library

Library of Congress Cataloging in Publication Data
A catalog record for this book has been requested

ISBN10: 0–415–41373–7 (hbk)
ISBN10: 0–415–41374–5 (pbk)

ISBN13: 978–0–415–41373–2 (hbk)
ISBN13: 978–0–415–41374–9 (pbk)

CONTENTS

CONTENTS

ILLUSTRATIONS

We are indebted to the people and archives below for permission to reproduce images. Every effort has been made to trace copyright-holders and any omissions brought to our attention will be remedied in future editions.

Additional Copyright

Concerning the quotation taken from *Eurydice*, p. 185, by H.D. (Hilda Doolittle) from *Collected Poems 1912–1944*. © The Estate of Hilda Doolittle. Reprinted by kind permission of New Directions Publishing Corporation, New York, and Carcenet Press, Manchester.

ACKNOWLEDGEMENTS

This book has been conceived, researched and written with the support of the Arts and Humanities Research Council and the Getty Research Institute, to both of which organisations I am deeply grateful for their support. The AHRC funded a five-year centre to research the intersections of fine art, histories of art and cultural studies under the rubric of the Centre for Cultural Analysis, Theory and History. Conjugating theory, history and practice, inflecting this trio with questions of Jewish, feminist and postcolonial difference, the project was at heart transdisciplinary. It aimed to reconsider with feminist and postcolonial lenses the legacies of Aby Warburg's thought and work on the image and cultural memory, the topic of a recent and belated renaissance of critical interest in the anglophone as well as international art historical and cultural studies communities. 'The Grace of Time' was researched under the rubric of a Visiting Fellowship at the Getty Research Institute on the theme of the arts and the humanities in context.

In writing this book I have been part of a larger project in the feminist studies in the visual arts at the University of Leeds and now world-wide. I am grateful to the following for their support and creative vision as part of this adventure of feminist analysis of creativity. Jane Calow, Adriana Cerne, Elsa Hsiang-chun Chen, Young-Paik Chun, Vanessa Corby, Joanne Heath, Anna Johnson, Katrin Kvimaa, Miranda Mason, Nancy Proctor, Alison Rowley, Ji-Young Shin, Jennifer Tennant Jackson, Judith Tucker, Elizabeth Watkins, Suzanne Wilks, and many others. I am also grateful to the many artists who have engaged my curiosity and taught me much in the prolonged contact with their work, notably Bracha Ettinger and Christine Taylor Patten. I take full responsibility for all that I say about their work.

I dedicate this book with gratitude to those who made the Feminist Studies in the Visual Arts Project a stimulating and endlessly pleasurable project, and who sustained me in the promise that feminist studies are a continuous, an ever-enlarging and shared project. I am also grateful to my editors Natalie Foster and Charlotte Wood for their enthusiasm and care for the concept and realisation of this exhibitionary project.

I must also thank my children, tiny when first I ventured into this all-encompassing domain of feminism and the visual arts, teenagers as this book matured, now grown into admirable and vital adults, still amused by the maternal academic's obsessions and constant distraction. The pleasure of a life spent in shared adventures in knowledge means that there can be no adequate acknowledgement for the tolerance and patience, the recognition and support that comes from a true companion in life and thought. For this I thank Antony Bryant with a full heart.

Griselda Pollock
Leeds, 2007

Part I

THE AFTERLIFE OF IMAGES
Framing fathers

Responding to an encounter in a museum with postcards of a famous neoclassical statue of *The Three Graces*, this opening section proposes a feminist mode of reading against the grain of art history's classificatory systems in order to explore what Kristeva called 'women's time' in relation to the image and the archive: the latter reconceptualised through two contemporaries at the turn of the twentieth century who researched the 'psychology of the image': Freud through psychoanalysis, Warburg through what remained his 'nameless science'.

Exhibited items in Room 1

1.1a Antonio Canova, *The Three Graces*, marble, 1819, 173 × 97.2 × 75cm, Edinburgh, National Gallery of Scotland, and London, Victoria and Albert Museum. Photographs courtesy of V&A Images/Victoria and Albert Museum, London.

1.1b Antonio Canova, *The Three Graces*, marble, 1819, 173 × 97.2 × 75cm, Edinburgh, National Gallery of Scotland, and London, Victoria and Albert Museum. Four views sold as postcards, Edinburgh, National Gallery of Scotland Museum Shop.

1.2 *Portrait of Antonio Canova*, etching and engraving by W.H. Worthington after F. X. Fabre, 1824–8, from *The Works of Antonio Canova in Sculpture and Modelling, Engraved in Outline by Henry Moses* (London, 1876), Edinburgh, National Library of Scotland. Reproduced courtesy of the Trustees of the National Library of Scotland (NLS Shelfmark: Cn.1).

1.3 Maurice Janoux, *André Malraux with illustrations for* Le Musée Imaginaire, 1950. © MAURICE JARNOUX/PARIS MATCH/SCOOP. Courtesy Hachette Filipacchi Associés.

1.4 Aby Warburg, *Mnemosyne Atlas*, pl. 46, *Ninfa*, London: Warburg Institute.

1.5 (a and b) William Henry Fox Talbot, *The Three Graces of Antonio Canova*, *c.* 1840–1, positive and negative calotype on paper. Bradford, National Media Museum Photograph. Courtesy of Science & Society Picture Library.

1.6 Copy of Praxiteles, *Cnidian Venus*, marble, 215cm high, Rome, Museo Pio-Clementino, Vatican City. Photograph courtesy Scala Images, Florence.

1.7 Antonio Canova, *Venere Italica*, 1811. 172cm. Florence: Palazzo Pitti. Photograph courtesy Scala Images, Florence and Ministero per i Beni e le Attivitá Culturali © 2000.

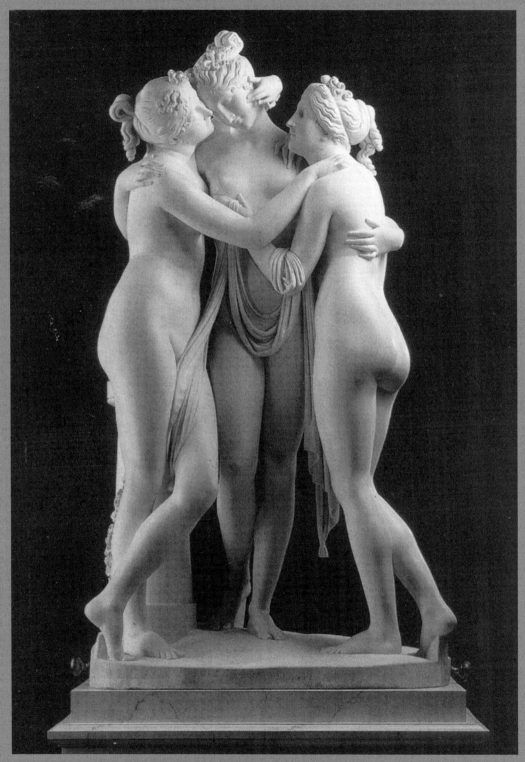

1.1a

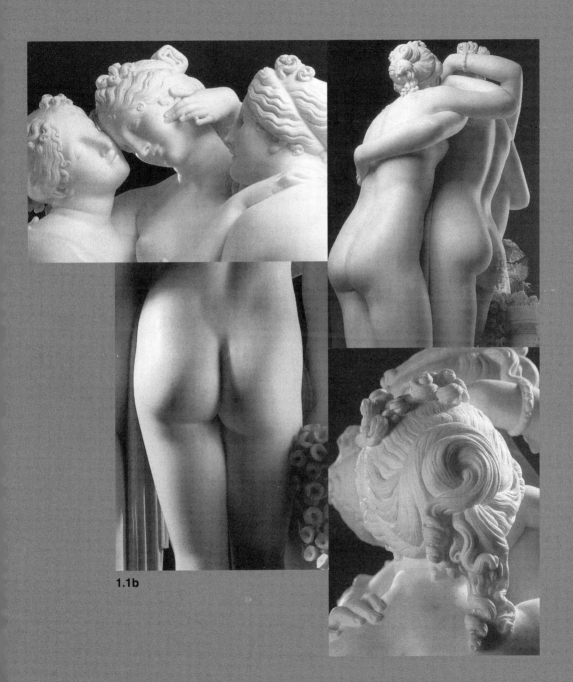

1.1b

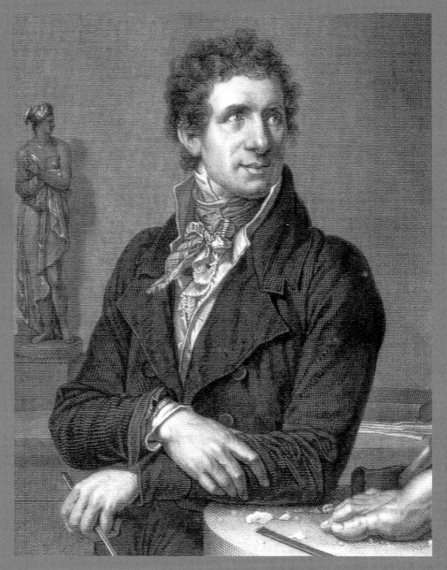

1.2

1.3

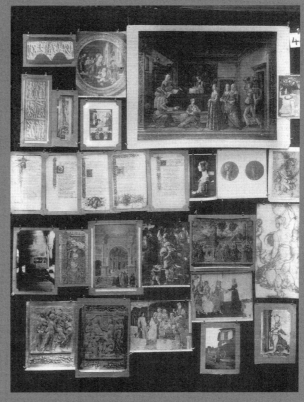

1.4

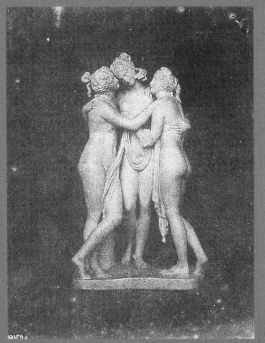
1.5a

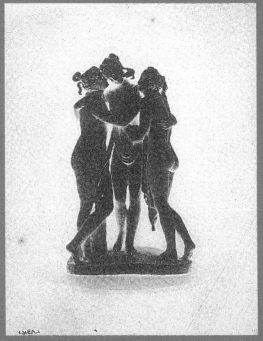
1.5b

1.6

1.7

1

WHAT THE GRACES MADE ME DO. . . . TIME, SPACE AND THE ARCHIVE

Questions of feminist method

To re-read as a woman is at least to imagine the lady's place; to imagine when reading the place of the woman's body; to read reminded that her identity is remembered in stories of the body.[1]

<div align="right">Nancy Miller</div>

Re-vision – the act of looking back, of seeing with fresh eyes, of entering an old text from a new critical direction – is for women far more than a chapter in cultural history; it is an act of survival.[2]

<div align="right">Adrienne Rich</div>

Prologue

I was in Edinburgh one day to see the Titians. I visited the National Gallery of Scotland. Wandering in the museum shop, I came across a suite of postcards of a recently acquired sculpture (1.1a and b). I knew then they would need serious feminist analysis. Now is their moment.

A bunch of attractively photographed images of bits of sculpted female bodies might appear to be a slight pretext on which to trespass into well-researched periods of neoclassical sculpture and formidably serious art historical terrains such as the work of Italian neoclassicist Antonio Canova (1.2). Substantive publications by Alex Potts and Malcolm Baker on the subject of viewing and interpreting neoclassical sculpture have only made my presumption clearer to me.[3] My point of access is not, however, art historical interpretation of the work of the sculptor Antonio Canova itself, but the vision of the work I encountered in the museum shop on the postcards. It thus concerns the encounter with sculpture mediated by photographic reproduction within the extended museum setting that leaks beyond the confines of the gallery and academic art history into that imaginary space I am calling the virtual feminist museum. Here many representations and images jostle in an expanded archive across time and space, prompting other resonances and opening out unexpected pathways through an archive of the image in time and space.

I aim here to explore what, in 1988, I called 'feminist interventions in art's histories' by means of a concept: *the virtual feminist museum*. This is not a cybernetic museum on the internet, a feminist virtual museum. Yet it cannot be realised. Virtual is used here first as an ironic term. It signals a museum that could never be actual. The dominant social and economic power relations that govern the museum make feminist analysis impossible. What

corporation would sponsor a feminist intervention which challenges the assumptions of class, race and gender that underpin the current social system despite gestures of inclusiveness and minor corrections to its histories of discrimination? The museum in contemporary society is increasingly bonded into the circuits of capital between entertainment, tourism, heritage, commercial sponsorship and investment. Men make money from and pay money for women; money does not, however, come to feminists precisely because feminism, as Luce Irigarary has argued, occurs when commodities (women in the phallocentric system) refuse those circuits and create a sociality and politics among themselves.[4] Feminist, therefore, stands for more than cosmetic correction by adding a few women to our half-empty museums, necessary as that remains tactically. It is the critical interrogation of the system some call patriarchy and others phallocentrism. As such, *feminist* itself marks the virtual as a perpetual becoming of what is not yet actual. It is a *poïesis* of the future, not a simple programme of corrective demands.

Thus the virtual feminist museum is not a version of the imaginary museum – *le musée imaginaire* – that French writer André Malraux proposed in 1954 as the result of photographic reproduction which removed works of art from their original contexts and enabled them to be assembled in orders and relations defined by superimposed art historical logics of style, iconography, artist and nation (1.3).[5] What makes critical feminist studies in the visual arts different starts with the various possibilities we claim for tracking relations among artworks outside of the museal categories of nation, style, period, movement, master, *oeuvre*, so that artworks can speak of something more than either the abstract principles of form and style or the individualism of the creative author. The point is so simple. Yet a world of difference lies in breaking down the categories without losing at any point the capacity to analyse what artworks do and say, and what shapes the saying at either social or personal levels.

If we approach artworks as propositions, as representations and as texts, that is as sites for the production of meanings and of affects by means of their visual and plastic operations between each other and for viewer/readers, they cease to be mere objects to be classified by aesthetic evaluation or idealised authorship. Artworks ask to be read as cultural *practices* negotiating meanings shaped by both history and the unconscious.[6] They ask to be allowed to change the culture into which they intervene by being considered as creative: *poïetic* and transformative. Bracha Ettinger has argued that artists put ideas into culture like 'trojan horses from the margins of their consciousness that transgress the limits of the current Symbolic'. Much art history concerns placing the work in its historical context. I am interested in what the artwork might be introducing into the world through its specificity as both a semiotic and an aesthetic practice. Ettinger continues:

> It is quite possible that many work-products carry subjective traces of their creators, but the specificity of works of art is that their materiality cannot be detached from ideas, perceptions, emotions, consciousness, cultural meaning etc., and that being interpreted and reinterpreted is their cultural destiny.[7]

This does not mean translating visual images into linguistic propositions. As Mieke Bal has extensively argued the hitherto rigid division between word and image, the former cognitively serious, the latter spontaneously visible, has been critically displaced.[8] There is indeed a rhetoric to the image, as the key figure in extending semiotics to visual art and culture, Roland Barthes, revealed in his analyses of photography and advertising.[9] Such a

rhetoric – that is the capacity to create a figurative level of meaning, connotation, beyond literal denotation – is an effect, in the visual arts, of the specific conjunction of space, form, colour, materiality and the capacity to solicit from the viewer a work of multi-levelled decipherment across these materialising processes of both thought and affect in a unique conjunction which I will call the aesthetic.

The virtual feminist museum (VFM) aims, therefore, to create a feminist space of encounter based on the innovations of matrixial theory proposed by Bracha Ettinger.[10] The VFM is not, like the modernist museum, about mastery, classification, definition. It is about argued responses, grounded speculations, exploratory relations, that tell us new things about femininity, modernity and representation. Daringly breaking all the museal and art historical rules about what can be put together with what (photographs with paintings, sculptures with films, posters with texts), the VFM is a research laboratory. It counters the narratives of heroic, nationalist and formalist art history to discover other meanings by daring to plot networks and transformative interactions between the images differently assembled in conversations framed by feminist analysis and theory.

By creating a virtual exhibition where we can track the movement of questions about sexuality, sexual difference and the representation of the body, I want to ask questions of the *unknown* history of women at moments of cultural radicalism and cultural trauma across the twentieth century. I want to look back with difference, to make a sexual difference to the stories of art by situating this questioning in a larger work on memory, on time, space and the archive that will summon other theorists and art historians to my aid, who in effect are shown to have already had the idea of a virtual museum – although not exactly a feminist one.

Where can we find the space for critical re-vision? My virtual museum is not actual. It is a potentiality for a counter-museum that uses the most interesting aspect of the museum: the *encounter* between and with artworks arranged according to a scheme that is not identical with their making (historicism). Hence the possibility of using the form of the exhibition – even in a book – as an opportunity to encounter artworks assembled by a *feminist* rather than phallocentric logic. The survey museums of the world produce a narrative of the history of art organised by nations, schools, periods, styles and masters. The virtual feminist museum is an open laboratory rather than a story. It is not aiming to be definitive, offering an alternative canon. It offers a series of situated readings, owned but offered to the reader as a means of sharing an excitement about the study of the visual arts that I find dampened by the heavy hand of official art historical story-telling.

The virtual feminist museum dares to draw upon two unconventional, transdisciplinary spaces for its inspiration for putting together images and histories in different ways. One model is the consulting room of Sigmund Freud at 19 Berggasse, Vienna (explored in Room 3) which puzzles about why the space in which Freud listened for the unconscious discourse of his analysands was so filled with images, so cluttered by sculptured antiquities from world cultures that interrogated the analyst and scholar while they stood as silent ciphers of ancient cultural memories of death and sex.[11] The other model is drawn from Freud's contemporary, the German-Jewish art historian Aby Warburg, who created what he called a *Mnemosyne* or Memory Atlas in the 1920s to trace the persistence of images of intense feeling from pagan times to modernity (1.4). Defying the aestheticising art history of his own moment, which he felt was closing down the discipline's frontiers prematurely, Warburg argued that art should not be defined as and confined to a developing narrative of changing styles. Instead Warburg read images as forms – *formulae* – for deep feelings – *pathos* – and

recurring cultural memory of those emotions that most deeply agitate human subjects (explored here in Room 1). Both late nineteenth-century culturally marginalised scholars (because of their Jewishness), in their different ways, offer us now theoretical resources and models for feminist counter-moves against the phallocentric and nationalist heroic narratives that still shape the discipline of art history and constitute its political unconscious. The transdisciplinary bridging of Jewish and feminist studies, marking both the complex relations between ethnic-cultural and sexual difference, will play repeatedly through this text, reminding us that no social subject is nakedly gendered or classed or raced. We are texts, textures, weavings of multiple positionalities and identifications that constitute our mobile placement on the double axes of generations and geographies.[12] Both Freud and Warburg treat the image as a mediation between human history and human subjectivity, between politics and emotion, and both depended on assembling and encountering as methods of discovering what we do not yet know about ourselves and human socio-psychological processes around memory, persistence, repetition, return. So, instead of writing history as a forward-moving story, they researched the dynamic of culture as a dialectic of time, space and the archive.

The concept of the archive has itself undergone several transformations in recent years, notably in the hands of Michel Foucault and Jacques Derrida. The archive initially functions for the historian as a kind of inert depository in which by means of documents the past is stored. By reading the assembled documents the historian hopes to reconstruct the past from these fragments. This leads to what has been called a fetishism of the archive as if the fragment and remnant can in some way stand in for the missing past, just as the fetish in Freudian terms stands in for and disavows the absence of the maternal phallus. Such a view has been challenged. The archive is selective not comprehensive. It is pre-selected in ways that reflect what each culture considered worth storing and remembering, skewing the historical record and indeed historical writing towards the privileged, the powerful, the political, military and religious. Vast areas of social life and huge numbers of people hardly exist, according to the archive. The archive is overdetermined by facts of class, race, gender sexuality and above all power.

The archive is also a concept that has profound implications for our self-understanding as it relates to memory and memorial activities, to a consciousness of a past, what we could call a perpetual haunting by others whom we exorcise by our attempted mastery through writing them as history. We thus come to be curious, desirous of knowing, like little children wanting to know the secrets of adult bodies and desires. We are spies, voyeurs, subject to fantasies and identifications, idealisations and misrecognitions.

Thus we have been taught that we must read the archives, taking Freud as a monitor, a reminder always of our desires and fantasies that are at work in any work of anamnesis. At the same time, beyond what we can monitor in ourselves is the unconscious, always at work, itself an inaccessible but active archive, both highly personalised because of each individual's singular and historical trajectory through the processes of formation as a subject and culturally structural as the insertion of the laws of culture and language into the heart of each subject, like an imported internal skeleton that provides the structure on which hangs the fleshly skin of our singular subjectivities.

Archives matter. What is included shapes forever what we think we were and hence what we might become. The absence of women's histories in world archives has defined a vision of the human on the pattern of a privileged masculinity. Humanity's self-definition requires a challenge to that vision. The museum as concept is an archive concept that participates

actively in presenting these distorting mirrors for our identification. Not only have we had to struggle and still struggle on to ensure equity in the representation of all women as well as all men in our cultural archives, but now our very struggle is being written out of history, brushed off as a passing irritant.

My combination of the virtual – meaning both what is not real and what is a potentiality not yet realised, hence a becoming futurity – and the museological intervenes in the current political reaction that is trying to silence women again, to position feminism as something from the past, finished, unnecessary, unfashionable. Adrienne Rich's powerful statement that feminist work on the missing past of women's creativity is an 'act of survival' resonates very differently in this present moment of revision. In the early twenty-first century, feminist concerns that Rich declared with such hope and force thirty years ago are being increasingly marginalised in cultural politics and displaced in cultural theory and practice which loudly proclaims that we are in a post-feminist era. So my initial project to create a virtual feminist museum because museum sponsors would never help a feminist scholar to realise an overtly 'feminist' project, even in the 1990s, now becomes even less possible. The virtuality is now attached to the *feminist* dimension of the imagined museum.

Psychoanalytically, however, we can take some comfort. Negation and repression always indicate that something is really at stake.[13] Both work hard against the anxiety generated by that which they need to deny or silence: the continuing challenge to think about sexual difference, its social arrangements and imaginary meanings. Thus the very urgency with which feminist questions about femininity and representation are being pushed off the agenda of contemporary cultural theory and practice, erased by this all too premature declaration that such concerns are no longer necessary or relevant, underscores the potency of what feminism poses to still so adamantly phallocentric cultures. What is also at stake is sexuality, or rather desire as the motor force of life and creativity. We can take heart, however, for what seems to cause resistance, annihilating as it feels personally to feminist women who are rejected as irrelevant dinosaurs of a past age, indicates, in fact, some seriously unfinished business. So virtual either because of official resistance or as a result of false and premature post-feminist dismissal, the questions I wish to address by the following encounters in the virtual feminist museum hold open if not scandal, certainly interest. What kind of interest?

In one of her earliest interventions from which stems feminist thought in and on art history, in 1973, American art historian Linda Nochlin asked how can women know themselves in a country – art – where they have no language, if there are no representations – or spaces of representation in which we can read for what I called in 1996 'inscriptions in, of and from the feminine?'[14] In the moment of formal and semiotic innovation we call modern Western art, women artists from all parts of the world attempted to produce a representational repertoire that corresponded with their desire to find themselves in and through art in new, differenced terms. But do our museums allow us to know this story, to travel in this country? Why is it that only women art historians seek to create an expanded art history placing both men and women artists of all cultures in view?

So why would I want to reintroduce the idea of the museum as a feminist tactic? In fact, what I am really proposing is the feminist appropriation of the concept of the museum's speciality: the exhibition as *encounter* that opens up new critical relations among artworks, and between viewers and artworks, that points to repressed narratives in the histories of art, and continues what I called, in 1999, the feminist project of *differencing the canon*. So let me welcome you to a virtual museum where a series of virtual encounters are plotted in image

and text, not for touristic consumption or aestheticising enjoyment. The purpose is, as Adrienne Rich suggests above, a rereading which is also a remembering – a word that in English involves not only recalling from oblivion, but also reassembling as an act – for a feminist future.

The virtual museum into which these postcards inserted themselves is, however, *different* and *differencing*: hence *feminist*. The encounters imagined for this work will follow a *differencing* logic, a logic concerning both the formations of, and the potentialities for dissidence within, sexual difference.

I first used this neologism in *Differencing the Canon* in 1999.[15] It is a feminist-Anglicisation of Derrida's key concept of *différance* which almost works in French, but not at all in English. The [French] ear cannot hear but the eye can read the difference between *différence* meaning distinction and *différance* meaning deferral. The effect is to allow both, mutually unsettling meanings to inhabit a similar phoneme in a way that destabilises the impulse to make things clearly distinct, fixed in their corners, and which reveals a constant deferral of meaning along a chain of signifiers that are not secured with reference to anything external to their own semiotic productivity. Deconstruction asks us to become acutely aware of what we want to say but what, in effect, language says despite or across such volition. We are bound to be part of this game, since language, or signifying, is our major business as human beings. Yet we are self-deluding all the time because we think of language or signs as mere instruments for meanings generated within us or within things. Language foils us because the only way we can think and speak is in relation to its systems of signifiers. But language is also the scene of the unconscious. We think we know what we are saying and say what we mean and want. But language/the unconscious is always saying more or less and different. The phrase 'the difference of the sexes', for instance, aspires to a description and hence an affirmation of the existence of two distinct categories, two sexes, who are unlike each other yet are both a sex. The phrase 'sexual difference' contests that ideology by acknowledging that there is no such thing as either a sex or its unqualified difference, which is in effect its essence. Instead we are caught up perpetually in the linguistic, psychological, cultural or social work of active differentiation that, by being that kind of *work*, never achieves its goal and is always undone by a fundamental instability. Any differentiation depends upon the relations between the temporarily distinguished terms. Thus to produce the momentary effect of difference (distinction) there is always deferral between the terms which can only produce difference in a kind of negative relation (as opposed to an essential and ontological being of each category independent of the other). This interdependence of masculine and feminine undoes the kind of gap, difference, to which we might linguistically aspire to get things straight and clear, and installs what appears to be the opposite, a constantly deferring co-emergence and interdependence.

Feminist work is not, therefore, about believing in or asserting the fact of difference, which would be to suggest that men and women are in and of themselves distinct entities, securely separable and with internally defined identities that might produce different aesthetic habits or meanings. Feminist work explores *différance*, that is the making and unmaking of relational, provisional, necessary but unstable meanings around something deeply central to human self-consciousness and desire, hence around subjectivity but also central to social, economic and cultural organisation. Feminist work critically engages with the processes of gendering, engendering and differentiating in relation to an axis of meaning, power and sociality: sex-gender.

A feminist museum thus is not a depository of knowable items exhibiting something

'feminist': an attitude, position or essence characteristic of the illusory unity: woman. It is not a collecting point for things by 'women'. It is a working practice, a critical and theoretical laboratory, intervening in and negotiating the conditions of the production and, of course, the failure of sexual difference as a crucial axis of meaning, power, subjectivity and change as it is mediated through aesthetic practices and our encounters with representation and work on visual images and art-making (not the same thing at all). Thus the feminist museum is *virtual*. It is not a cybernetic facsimile on the web or a fantasy virtual reality visited by means of technological prostheses. It is virtual in the philosophical sense of being like something that it is not in actuality. It is about potentialities (and possibilities) to which we aspire but which can be conceptually projected as a means of causing actual changes in the way we think and understand ourselves.

The actual sculpture *The Three Graces* by Antonio Canova can be encountered in a real museum, either in London at the Victoria and Albert Museum or in Edinburgh at the National Gallery of Scotland between which two museums the sculpture is shared. But we also encounter this work in other mediated, represented forms, such as my postcards, as a result of which a memory of a virtual image lodges in my imagination and becomes part of a portable image-bank with which I encounter other images.

Sculpture, like the rest of the visual arts, architecture and material culture, became a different kind of object as a result of the development of methods of mechanical reproduction. Initially print culture offered engravings and etchings which detached the object from its auratic actuality in time and space and enabled people distant from the actual object to know its appearance in this form and to make it part of their mental collections. Remade as an image, artworks began to travel with a new kind of identity. With the invention of photography in 1839 and its slow technological advance over the rest of the nineteenth century, this potentiality for dissemination was enhanced and further changed towards the simulacrum-image we now encounter in colour postcards and coffee-table books. Art history as a discipline is, therefore, deeply dependent on and co-emergent with reproductive technology, notably photography, since every art history book or lecture in one way or other performs a kind of museal collecting of art as image, assembling a range of works actually dispersed or even destroyed into a single virtual site/sight.[16] Ulrich Keller has drawn our attention to the shift from the sparsely illustrated and largely ekphrastic modes of writing about art, exemplified by J. J. Winckelmann in the eighteenth century, usually considered to be the founding moment of art history proper, to the emergence, in the nineteenth century, of engraved picture atlases produced to accompany the first survey texts such as Franz Kugler's *Handbuch der Kunstgeschichte – Handbook of the History of Art* (1842) – for which three volumes of plates only appeared in 1851. Kellner quotes H. Merz from the preface to this *Denkmäler der Kunst zur Übersicht ihres Entwicklungs-Ganges* (Monuments of Art for a Survey of its Developmental Pathways) who stated: 'only the atlas permits art history to make its victorious entry into the schools and lecture halls.'[17] Saturated as our culture now is with gorgeously illustrated art history books, it is hard for us to imagine the prevailing paucity and poverty of illustrations – almost all black and white engravings or etched sketches. Before the development of half-tone photography and the use of the lantern slide at the end of the nineteenth century, art remained tied very much to its place; books served to prepare the visitors for encounters rather than to provide them with vicarious or virtual access through lush colour imagery or brilliant and alluring transparencies projected at many degrees of magnification on walls of lecture halls.

The intimacy of photography and art history goes even deeper into the territory of the

museum. The picture atlas of the nineteenth century and now our slide collections or databases of jpegs are extensions of the museum which, in collecting exemplary objects and images from around the world into one instructional 'universal survey', radically transformed that which we encounter in real or virtual museums such as the slide library or art history book.

This is there to see in the much-reproduced photograph of André Malraux preparing his study of *le musée imaginaire*, standing amidst his large-scale photographs, laid out in serried ranks, each the same size, rendering uniform the multifarious diversity of medium, scale, materiality, size, form, purpose, location of the things, places, details captured in photographic democracy before his assimilating gaze (1.3). In the formulation of his idealist aesthetics that would be published as a three-volume psychology of art (1947–50) under the title *Les Voix de Silence* (1935 and 1951) André Malraux coined the phrase 'le musée imaginaire' – a museum of the mind or imagination, some think poorly translated as the 'museum without walls'.[18] It is now a truism that the creation of technologies of photographic reproduction transformed not only our relations to art by making its images travel through time and space, but in effect they created 'art' in general as that unreal, unlocated abstract universality. For Malraux, the museum of the imagination is the modern historical situation of art. What was once a ritual object, a building, an altarpiece, a special liturgical book, is now assimilated to being historically located and stylistically classified examples of ART. Art is both the product of the creation of the first public survey museums that provided the actual housing for these levelling-out collections and of their virtual expansion through photographic reproduction that, by manipulations of scale, angle and uniformity of surface, creates new objects entirely for a proximate lens-based visual appropriation, where, in effect, viewing twins consumption and voyeurism. The 'cultured' are no longer required to be travellers; in a particular kind of scholarly or collecting intimacy, we bring art home. Hence the dissemination of our generic knowledge of things as 'art' is structurally dependent on technologically expanded modern musealisation itself which always implied a certain virtualisation: a creation of an archive transcending time and space.[19]

From the beginnings of photography, sculpture in particular offered itself to early experimenters in the field (1.5). Sculpture was still and thus responded well to the long exposures necessary for early photography. It was also amenable to the limited tonal scales of early photography because it was so often white.[20] Sculpture, so often portraits and statues, remained interesting as a visual object for the new practice since, as a three-dimensional object, light fell upon it and could be manipulated by the photographer to create images that were always more than mere records. Dramas of light could already raise the image from document to its own kind of aesthetic interpretation of and through an act of looking. The intimacy between photography and sculpture at the intersection of art historical documentation and transmission on the one hand, and visual interpretation through framing, lighting and cropping has been highlighted by Mary Bergstein, who rightly insists that:

> Photographs of sculptures are representations of representations: charged with the nuances of the photographer's choice as well as cultural formation and reception, photographs of sculptures define their own realities which are dense and self-referential.[21]

The usual tension between seeing the actual object in the flesh and with our own eyes and

the suggestion that reproductions are a kind of second best – a deeply instilled tenet of art historical training – marks the deeper paradox already embedded in the history of looking at art in modern culture: without the museum collection and its dissemination into a virtual museum of reproduction, there might neither be the category of art nor the possibility of a history for that categorical catch-all. Yet, the very curation of objects of such diversity into the comparable unity, art, invites an interpretative framing either in the actual museum display and layout or through the manner of its photography. Art – as a category – is already a product of museal work – which demands of us, who can only encounter it thus, a critical self-reflexivity that does not imagine any escape, but proposes instead to make it visible, contested, a matter of argument.

The manner of the museum's collection and thus the deep structures of the representations of the representations are historically and ideologically inflected in ways which the virtual feminist museum aims to expose and interrupt and reconfigure for other kinds of readings that actively intervene in bigger questions of what it is to do art historical work.

I have argued elsewhere that the predominant forms of modern art history are curatorial in their underlying logic.[22] Museum categories of classification and conservation dictated to academic art history the way objects are put together in groups or classes, and are compared or contrasted. Typically these operate by medium (in this case sculpture), artist (for instance, Canova and his contemporaries), date (here early nineteenth century), period (formally neoclassical), nationality (Italian), style (neoclassical naturalism), genre (the female nude). These are the major categories in which art history thinks, establishing them as being the major job of the art historian. They determine the conditions of documentation and conservation (which department will hold the works or their records and how much space or light they need for exhibition). Such considerations, in effect, dictate categories of understanding and thus exclude other kinds of possible relations or connections. The curatorial model is translated from, and back into, the formats of academic art history books which themselves dictate the organisation of courses of art historical study so that we come to know and experience 'art' by means of this deep, curatorial logic of nation, period, medium, artist, genre that makes other kinds of linkages and connections invisible or aberrant: not art history. Art history makes art intelligible by means of classifying practices by named artists, historical time periods, medium, styles, and national schools creating narratives to account for either development, change, difference and to establish a canon of knowledge.

Knowledge is always a system that enlightens us by producing understanding of relations and histories otherwise not visible in a chaotic jumble of objects. But that system is not neutral or self-evident. It is generated within social and cultural determinations, interests, competences, and as I have argued elsewhere, desires.[23] Knowledge has intimate relations to power, constituting what Gayatri Spivak will call 'epistemic violence' in the manner in which hegemonic groups construct representations of the world which are projected on to their others as the required means of self-recognition.[24] Thus both feminist and postcolonial as well as other minorities have specifically challenged not merely the absences of dominant knowledge systems, but their very structures, protocols and normalisations.

The feminist cartoonist Jackie Fleming created a wonderful series of small paintings as a response in 1977 to her engagement with fledgling feminist work on visual imagery. Her 'heroine', a rather bushy and unkempt but lively young woman, rises one morning and dons her usual gear – jeans and sweatshirt. As she passes an advertising hoarding, a cosmetically fashioned beauty monumentally dwarfs her. She returns home and a second foray sees her

17

now smeared with make-up. An advertisement for stylish clothes also sends her scuttling back to redesign herself with high heels and a tight-fitting dress. Now 'properly' presenting her feminine self, our heroine visits an art gallery – another place to learn herself through representations made to her. Yet here, she becomes perplexed. The dress code is not consistent with what she has just assimilated about putting on and making up. Ladies in the art gallery appear . . . naked. Thus, well trained in adapting to what culture teaches her about being a woman, our heroine disrobes in front of a *Venus of Urbino* and adopts the appropriate lounging pose tickling her pubis. The final two images show her pink, frank and ungainly nudity framed by the legs and large boots of two Mr Plods who carry off the now nakedly transgressing woman.[25]

The museum is a historically, ideologically and discursive centre for production and dissemination of both cultural knowledge and knowledge of the visual arts as a part of that larger if ever inconsistent script about subjectivities, genders, classes, ethnicities, sexualities, abilities. How it orders its contents is not the same as the effect of what Tony Bennett called 'the exhibitionary complex'.[26]

It is here that a feminist intervention seeks to elaborate other visualities and rhetorics – not of curatorially ordered, and pedagogic display, but of encounter which owes more to Aby Warburg than to Heinrich Wölfflin's favoured method developed using twin projection of 'compare and contrast' which has structured both the modern museum and art history lecture. History is, of course, not simply chronology and certainly not pure developmental sequence. We have increasingly come to recognise that there are other temporalities at play than those that pass as linear and progressive time.[27] These are shaped by both the vagaries of memory and amnesia as much as by the politics of the archive, the official memory banks of culture that simultaneously represent a past and shape a present. For Aby Warburg, the key question for his 'nameless science' beyond what he dismissed as aestheticising, formalist art history was not about logical developments and sequences, but about the illogic of persistence: *Nachleben*, the afterlife of the image. In making use of newly developed possibilities of photographic reproduction of artworks held far apart in space and traversing extended historical times and transcultural dispersion, during the 1920s Aby Warburg created his own pictorial atlas that was to demonstrate his other conception of what the history of art might be. He called his collection of image-histories a *Mnemosyne* Atlas and placed his whole library under the same name: *Mnemosyne*, the mother of all the muses. His unfinished and never fully documented atlas was a huge illustrated memory compendium comprising more than seventy large hessian sheets on which Warburg hooked ensembles of photographic images drawn from different periods and media, from major cultural sites and daily newspapers and cartoons (1.4). These juxtapositions betrayed to sight and understanding a deeper, pictorial unconscious, a memory formation of deep emotions that were held in recurring patterns, gestures and forms in images that survived across the differences of time and space to register in difference as well as continuity themes of urgent significance to human thought and imagination. The history of the affectively charged, meaning-bearing image thus became the basis for a visual history of the mind, conceived beyond the divisions into which academic institutions divided it; philosophy, psychology, medicine, aesthetics, linguistics and so forth. The image for Warburg was not merely a visual representation; it was a thinking-feeling formula that shared in the conflicts that form distinctively human consciousness. Persistence and survival were revealed in unexpected recurrences of theme as well as actual manner of representation which Warburg named a *pathosformel* – a formula of feeling – an emotion signifier – which participated in his sense of art history as the search

for a historical psychology of the image. Giorgio Agamben defines the pathos formula thus: 'an indissoluble intertwining of an emotional charge and an iconographical formula in which it is impossible to distinguish between form and content'.[28] Warburg turned his face against both what he dismissed as contemporary, aestheticising, formalist art history that dreamed only of plotting out a logical sequence of autonomously changing forms and styles that would allow us to tell a story of artistic developments or a history of the succession of great artists. But he was also to point in a radically new direction for the ways in which we could study images and histories. Agamben declares:

> What is unique and significant about Warburg's method as a scholar is not so much that he adopts a new way of writing art history as that he always directs his research toward the overcoming of the borders of art history. It is as if Warburg were interested in this discipline solely to place within it the seed that would cause it to explode. The 'good God' who, according to that famous phrase, 'hides in the details' was for Warburg not the guardian spirit of art history but the dark demon of an unnamed science whose contours we are only today beginning to glimpse.[29]

Certainly, any art historian has to understand the fundamental grammars of pictorial arts: form. Forms are how artists think as well as realise their projects. But the limitation of art to form is like a study of linguistics without semantics. We cannot speak without grammars. Yet we speak because there is something to say, something being thought or felt which realises itself only in being signified which is deeply dependent on the signifier. Against aestheticising and formalist art history that plotted out the history of style such as that represented by Wölfflin, Warburg set forth what later became iconography: the proposition that art is always about something and works with a source-book of themes, poses, typologies and habits in order to speak through visuality of gesture and iconicity. But this kind of lexical iconography was not only what Warburg had in mind. Iconography since Warburg has become too inert and formulaic. Warburg was, according to Agamben, seeking to track 'an intermediary domain between consciousness and primitive reactions'. This domain is a kind of *Zwischenraum* – an interval – 'at the centre of the human'. In a note for his famous lecture on the serpent ritual of 1923, Warburg wrote:

> All mankind is eternally and at all times schizophrenic. Ontogenetically, however, we may perhaps describe one type of response to memory images as prior and primitive, though it continues on the sidelines. At the later stage the memory no longer arouses an immediate and purposeful reflex movement – be it that of a combatitive or religious character – but the memory images are now consciously stored in pictures and signs. Between these two stages we can find a treatment of the impression that may be described as the symbolic mode of thought.[30]

What Warburg would name 'iconology of the interval' was not a matter of opposing semantics to linguistics. It was to grasp the simultaneity of apparent opposites – thought mediated by the symbol and emotion invested in a kind of gestural vocabulary of the image that opened up a gap, *Denkraum*, a space of reflection – between the polarities of human life – rationality and irrationality, passionate surrender and distanced contemplation, a will to understand and master self and world, and a susceptibility to powerful emotions that could even dispossess one of one's reason in the intensity of affect. Warburg did not see or seek

19

balance, but struggled to understand the constant dynamic working in image-culture that acted upon and was in turn transformed by the enlivened encounter between artists, images and cultures across history made possible by not only survival but propelled transmission and active reception of this image-memory store. Art as a particular kind of pictorial practice, running alongside music, dance, design, poetry and philosophy, shared in this larger enterprise and gave to culture the image of the place where embodiment is also psychic inscription.

In his gloss on his master Warburg's creation of a new method that he would disseminate in the United States, Erwin Panofsky posits three levels of meaning in the image. A 'natural or primary subject' is pre-iconographic description. We see a picture of a woman and a child. The second level is that of iconographic analysis in which we recognise 'a conventional subject . . . the world of *stories, images* and of *allegories*'. We interpret them as part of a Christian story about Mary and Jesus, Madonna and Christ-child. But there is a third level, the iconological, 'the intrinsic meaning or content, constitutive of *symbolic values*'. This the humanist scholar Panofsky finally placed in the genius of the individual artist, the vision of a creative individual. Agambem points out the difference between what Panofsky proposed as the final meaning of this third level and Warburg, for whom, however,

> the significance of images lay in the fact that, being strictly speaking neither conscious nor unconscious, they constituted the ideal terrain for a unitary approach to culture, one capable of overcoming the opposition between *history*, as the study of 'conscious expressions' and *anthropology*, as the study of 'unconscious conditions,' which Lévi-Strauss identified twenty years later as the central problem in the relations between these two disciplines.[31]

Warburg opened the space for thinking about a history of images that was at once a psychology of human expression encoded in the pathos formulae of a figurative, gestural language of painted and sculpted images, and a study of transmission and transformation by means of the symbolic image. The iconology of the interval resists reducing art to purely formal exercises but it also opposes reducing its meanings to illustration of preconceived stories and subjects (iconography). The interval – the aesthetically produced space of thought or reflection – touches on the human conceived as a psychological but also symbolic entity, thinking and feeling, creating and producing both meaning and affects. Warburg was personally resistant to Freudian psychoanalysis, preferring aspects of Jungian thought on the collective unconscious. It is significant, however, that a model of conjugating history, psychoanalysis and anthropology was adumbrated, even in its fragmentary and never synthesised way by the work of Warburg and his circle in ways that several feminist art historians have already pointed out are propitious for a feminist project, a project that can also only articulate its themes by means of a dialectical and self-situating practice of reading images that connect conscious expressions (artists working in time and place with historically specific materials and conditions) and unconscious conditions (structural, persistent, formative, non-linear and even atemporal, linked with the other space and time of the unconscious).[32]

The chance encounter with a banal series of postcards in which photographic reproduction of a sculpture not only offered me close-ups of details of a complex three-dimensional work, but focused my attention on the co-existent memory work of the sculpture and its formal rethinking of a threesome, a group of female nude bodies, and a series of deeply

rooted thought-feelings encoded in a classical, pagan concept of Three Graces, opens on to a feminist-inflected 'iconology of the interval' that is the virtual feminist museum.

Thus in terms set by established disciplinary categories of art historical knowledge, I am not going to add much to the study of Antonio Canova, to neoclassical or even eighteenth-century sculpture as part of the way art history works as a historical discipline to tell us what happened, when and how, and with what effects. The conjunction of feminist thought and transdisciplinary cultural analysis does not aim to displace the results of the traditional art historical modes of study of the art of the past; rather the purpose is to supplement (both in the Derridian and the Matrixial senses) and to shift the focalisation so that our engagements with the visual field, which is a shared terrain diversely approached, may become complex and vivid in the act of constant, and situated, rereadings.[33] 'Feminist' becomes a term of provocation and inspiration to such rereadings. It does not offer an alternative interpretation of the archive. Rather it functions as a kind of movement within it, tracking across a series of images a sense of something deeper and recurrent, important for human existence yet marked by difference and division.

The postcards I bought concerned that paradox encountered by Jackie Fleming's *alter ego*: the naked lady in the sphere of art – the gallery. So naturalised that we hardly realise its oddity, the classically invented female nude is synonymous with and has become *the* sign of art in Western culture. When I first began tentatively to think feminist difference inside art history, one of my targets was 'images of women'. One of the key categories was the female nude – the obligatory undress with which I was confronted at the entry to every museum and in art history classes where it was improper to ask questions about why none of these women seem able to keep their clothes on during any major event. The arch-enemy, or rather the first object of critical feminist analysis in the Women's Art History Collective, to which I belonged then, was a book by Kenneth Clark, *The Nude: A Study of Ideal Art*, first published in 1956. Clark had just created a major TV series entitled *Civilisation*, in critical response to which John Berger had replied with his *Ways of Seeing*.[34] The former offered the standard art historical survey translated back into the grand tour by television, the latter, drawing on Walter Benjamin's notion of the disappearance of the aura of the artwork as a result of mechanical reproduction, created televisually and then in book form something more akin to Warburg's *Mnemosyne Atlas*, although I did not recognise this at the time, nor the possible links between Benjamin and Warburg.[35] Berger showed how certain themes and images traversed divisions of high and low art, popular culture and the esoteric art gallery. Fronted by a pictorial essay that now looks like a sheet from the Warburg atlas, Berger opened his chapter on the nude with his remark that 'the social presence of a woman is of a different kind from that of a man' and the now notorious statement:

> men *act* and women *appear*. Men look at women. Women watch themselves being looked at. This determines not only most relations between men and women but also the relation of women to themselves. The surveyor of woman in herself is male: the surveyed female. Thus she turns herself into an object – and most particularly an object of vision: a sight.[36]

Early feminist analysis sided with Berger's social reading of the image over Clark's unself-critical and connoisseurial art history. Nothing in my formalist art history education enabled me, however, to recognise the Warburgian character of Clark's book on the nude. In fact, as a young art historian in Rome, Kenneth Clark attended a lecture by Aby Warburg

that made a deep impression upon him. In retrospect, Clark declared that his book on the nude was his deepest homage to that encounter.[37] This leaves me perplexed. One moment of feminist studies railed against all sorts of suppositions embedded in Clark's confidently gendered and classed address to images of the human body, male and female, in Western art since antiquity. A later moment, inspired by the work of Sigrid Schade and Margaret Iverson, who have long advocated the relevance for feminist studies in the visual arts of the anti-formalist model of Aby Warburg's iconology, finds me returning with new interest and appreciation of the still extremely sexist and complacent Clark. Clark's book is Warburgian in identifying an approach to art that is neither iconographic nor stylistic but considers the ways in which artistic languages have emerged to register emotions and forces such as pathos, ecstasy and energy: these primarily concern a contradiction: sculpture or paint/line must find a formula that, while being still/static, represents both physical movement and psychological transformation. An invisible force or emotion or energy animates the body or its accoutrements and this must be represented without either change (narrative sequence) or movement. Our initial feminist analysis of Clark's text revealed a dissymmetry in his illustrations so that pathos and energy were primarily figured by masculine bodies: the former in the Crucifixion above all, the latter through figures such as Hercules. Ecstasy (the complete abandonment of reason to a possessed and even frenzied movement) was the sole chapter in which the feminine nude predominated – except for the chapters that formed the opening pair – establishing sexual difference from the start: Apollo and Venus. Venus, however, was herself divided. Clark states:

> Plato in his *Symposium* makes one of the guests assert that there are two Venuses, whom he calls Celestial and Vulgar . . .; and because it symbolised a deep-seated human feeling, this passing allusion was never forgotten. It became the axiom of medieval and renaissance philosophy. It is the justification of the female nude. Since the earliest times the obsessive, unreasonable nature of physical desire has sought relief in images, and to give these images a form by which Venus may cease to be vulgar and become celestial has been one of the recurring aims of European art.[38]

For Clark, the idealising classical nude thus manages the chaos of masculine heterosexual desire, both feeding it visually and elevating or sublimating sexual response into aesthetic contemplation.

The representation of Aphrodite in a naked state is, the art historians agree, a relatively late development in classical Greek art, the first example being a statue made by Praxiteles for the Island of Cnidos between 360 and 330 BCE. The original work is last recorded perishing in a fire in Constantinople in 476 CE. Thus it is only known to us in various and varying copies that do not agree on two crucial elements: the position of the goddess' head or her right hand.

Unknown before, and even shocking in its own culture, the female nude probably derives from a different tradition that is vital and extended in surrounding cultures of Asia Minor for centuries before the first Greek nude goddess was executed. From what was this very late sculptural form derived and what transformation was effected by the Greek sculptors in their refashioning of several sources that involved both ritual traditions associated with the Mother-Goddess and erotic figurations of specific social figures such as the dancer or prostitute or beloved?

The first form – we shall need this digression in order to situate the form with which

Canova worked in his *The Three Graces* – as what we now know as in the Latin as *Venus Pudica*: *pudenda* being the Latin term for the Greek *aidoia* – derived from *aidos* to which the Roman philosopher Lucian (120–200 CE), writing in Greek, refers in one of the only two extant witness descriptions of Praxiteles' sculpture. Usually translated as 'modesty', *aidos* can mean reverence, awe, respect or shame. *Pudica* picks up on the last, suggesting shame in the exposure of the genital region – a need to cover it that might also involve awe before it.

For many analysts, the goddess of Praxiteles is represented with a gesture that marks her body with shame or anxiety. Still as sculpture is, this work, none the less, contains a narrative to which a gesture indicating both movement and moment gives us the index (1.6). Why would this goddess in Greek culture be unclothed? The narrative premise of the sculpture is that she is bathing, unseen and in private. It is not a public act. The narrative, however, also proposes that she is disturbed and thus either clutches the towel to her in an attempt to hide her nakedness from the imaginary intruding eyes, or she tries to cover herself with her own hands, paradoxically drawing the eye's attention precisely to that which she tries to hide – a gesture that already imposes upon the figure the ideologically constructed idea of shame at sexual exposure to an invading gaze. The classic female nude from the Greek tradition is thus thought to stage an act of visual violation and to write the female body as shamed both by exposure and by being made into the object of voyeuristic curiosity. In its *pathos-formula*, the sculpture-type registers shrinking fear and anxious vulnerability as a response to a violation of the goddess' privacy and sanctity.

Others contest this interpretation. The pretext of taking a bath ensures her innocence. Aphrodite was mythologically associated with bathing, given her watery origins from the sea itself, and given the religious significance attributed to water and especially all forms of ritual washing.[39] Her gesture is not one of violated shame but of proud reference to the site of her awesome sanctity as the Goddess of Love. This latter point is also important, since it survives in many, notably African, traditions, where the body of a mature woman is sacred, and hence is powerful, even dangerously so, shameful, in its nakedness. Exposure can be and has been used for political threat.[40] Thus covering is not always associated with shame; it can involve respect for the power of the body in its sexuality and creativity from which men might need to be protected.

Zainab Bahrani contrasts the potential anxiety of Aphrodite's covering/shielding/pointing gesture with the confident touching of breasts or showing of sex typical of earlier Near-Eastern models from which the idea of the Greek naked female figure may have derived. Bahrani demonstrates that there is a long tradition of representing Ishtar in Near-Eastern art and literature with a frank acknowledgement of sexuality.[41] She identifies four types of female nudes in Near-Eastern visual arts: the mother, the seductress, the sexual partner and the entertainer. All representations do not hesitate to register the specific sexual anatomy of women, breasts and vulvas, including a variety of sculptural techniques for marking the hairy pubic triangle. Self-confident sexual desirability dominates the image-making, rather than fertility, and certainly there is no attribution of shame or hiding the body parts that both pleasure the female subject and the presumed viewer/partner. Neither Near-Eastern nor Greek carvings of the female body, however, appear to be produced by women or for women; they both represent the female body for a presumed heterosexual masculine subject either looking with pleasurable desire and respect or ambivalently and sadistically breaking in to peer at the vulnerably naked goddess. The pose and the form that has come down to us from Praxiteles' model, however, inscribes on to an older, inherited and transformed tradition from the Near East, a singular, cultural abhorrence at the female genitals and

hence female sexuality, and its ambivalence towards that which can incite desire due to a unique feature of the Greek sculpture – the sealed mound with no vulva and no pubic hair. These anatomically as well as psychologically strange negations might even suggest, although I have no evidence, the residue in Greek culture of a practice of infibulation, so extreme and otherwise unprecedented or explained is the erasure of the signs of the open, creative and responsive female sexual body in the Greek Venus amidst such a wealth of examples and long-lived traditions stretching back thousands of years in that region in which the point of making images of the female body was to mark its generative and sexual places. The Aphrodite of the Greeks bears the marks of both visual violence and psychic ambivalence in the physical deformations of her represented body – denied a vulva and yet required to point to its absent place by a gesture of both shame and advertisement and in the two still-contested gestures of hand and head – the gestures being as pathos formulae the register of emotions and affects. Many of the copies of the seven types of Aphrodite that have survived the classical period were found in Italy, and became part of the patrimony of post-classical artistic training. In 1803 Antonio Canova was commissioned to make a copy of the Medici Aphrodite, in which the goddess uses one hand to try to cover her breasts while the other shields her 'aidos'. In 1811 Canova created *Venere Italica*, which, as an interpretative translation, brings back into view the narrative of disturbance: the very young goddess clutches a drapery to her body – ineffectually – and her head is sharply turned as if in response to an intruder (1.7).

Tracing a genealogical history of the formative *Venus Pudica*, derived from Praxitiles' lost original, the *Cnidian Venus*, Nanette Salomon has argued that the masculinist and heterosexual presumption of the master narrative of Western art history has been built precisely on creating lines of continuity that traverse ages and periods, masters and styles, circling back ever to rediscover this 'perfected'/mutilated body of woman as the object that enables privileged men to speak with each other and only of themselves.[42] The classical female nude, once introduced into Western culture in its singularly problematic form of exposed and vulnerable nakedness, becomes a 'timeless body' in the sense of an ideal form traversing historical time as a fundamental proof text of form as beauty. As both Lynda Nead and Elisabeth Bronfen have variously argued, the female nude functions as the image that contains and attempts to fetishise, thus still and veil, a masculine fear of unbound productivity and uncontained sexuality as well as dread of the passing of time, decay and inevitable mortality that are all signified by association with the transitory beauty of a particular fixed vision of the youthful female form.[43]

As a means of furthering our contemplation of sexual difference and time, I want to explore the image – not the single standing figure of the *Venus Pudica* – but a group of three female nudes that I encountered in Edinburgh. One final Warburgian point needs to be made. The Graces – *Charites* in Greek – which we will explore in more detail in the next room, were often the attendants of Venus in the revival of antiquity in quattrocento Italian art, nowhere more beautifully so than in Botticelli's melancholic lament for a dead beauty, Simonetta Vespucci, in a painting known now as *Primavera* which Warburg would have preferred to title *The Realm of Venus*. Warburg interpreted Botticelli's painting as performing the work of mourning for those who loved and lost Simonetta Vespucci, whose features appear on the foreground figure of Spring. As an allegory of the Realm of Venus, the painting includes a somewhat mournful and restrained Venus, flanked, however, by the *dancing*, dressed but ungirt Graces as figures of movement and change in the foreground paralleling the figure of Spring. Warburg concludes:

It may be – and this is offered by way of hypothesis – that to Lorenzo and his friends, the image of personified Spring, the companion to Venus, and who recalls the earth to life, the consolatory personification of renewal, represented the memory of 'la bella Simonetta.'[44]

Warburg allows us to begin to understand the emotional impetus and even potential purpose of the image in relation to a profound grief over the death of a young woman. Love, death and renewal needed to find forms in pictorial representation. Enriched by the intellectual culture of an actively revived poetic tradition drawing on the *semes* of classical poetry that used images of motion to signify emotion, Botticelli's painting invites a reading that is not esoteric and intellectualising, but is concerned with how the archive of pathos formulae in word and image recovered from pagan antiquity could be reanimated – given an afterlife – by the need felt by emergent modern culture to find forms for emotion and affect, and was recharged with emotional energy as it confronted the immediate and unbearable passions of death and loss, desire and mourning. Note that here the Graces are of necessity clothed since it is the motion of their accessories and draperies that visually charges the image with an emotion-thought at the threshold of death, mourning, love and renewal. Conscious purposes met unconscious structures via the transmission of and through the details of this image cluster.

It is, therefore, in the spirit of a feminist differencing of both that archive and that of Warburg's attempt through his *Mnemosyne Atlas*, itself a work of and on pictorial memory, that I propose to create my own canvases of virtual encounter in order to bring forth what I saw when I encountered the postcards in the museum shop.

Exhibited items in Room 2

2.1 Antonio Canova, *The Three Graces*, marble, 173 × 97.2 × 75cm, Edinburgh, National Gallery of Scotland, and London, Victoria and Albert Museum. Photographs courtesy of V&A Images/Victoria and Albert Museum, London.

2.2 *Heinrich Wölfflin Looking at Antonio Canova's* Paris, photograph courtesy Fratelli Alinari, Florence.

2.3 Central detail of Antonio Canova, *The Three Graces*, marble, 173 × 97.2 × 75cm, Edinburgh, National Gallery of Scotland, and London, Victoria and Albert Museum. Photographs courtesy of V&A Images/Victoria and Albert Museum, London.

2.4 Raphael, *The Three Graces*, 1505–6, oil on panel, 17.8 × 17.6cm, Chantilly, Musée Condé. © Photo RMN/© René-Gabriel Ojéda.

2.5 Tommaso Piroli, *The Three Graces*, fragment of a fresco in *Le antichita di Ercolano*, Rome, 1789.

2.6 Attributed to Nicolo Fiorentino, *The Three Graces*, (reverse face of the portrait medal of Giovanna Albizzi Tornabuoni), *c.* 1485, bronze, 7.6cm diameter, London, The British Museum.

2.7 Antonio Correggio, *The Three Graces*, *c.* 1519, fresco, Parma, Camera di San Paolo. Courtesy of Ministero per i Beni e le Attivitá Culturali/PSAE di Parma et Piacenza.

2.8 Three views of Antonio Canova, *The Three Graces*, 1817, marble, 182 × 103 × 46cm, St Petersburg, The Hermitage Museum, photographs, Giraudon negatives # 1552–4. Courtesy of the Bridgeman Art Library.

2.9 Photograph of Antonio Canova, *The Three Graces*, marble, Innocenti Negatives.

2.10 Photographs of Antonio Canova, *The Three Graces*, marble, 173 × 97.2 × 75cm, Edinburgh, National Gallery of Scotland, and London, Victoria and Albert Museum. Photographs courtesy of V&A Images/Victoria and Albert Museum, London.

2.11 Detail of heads, Antonio Canova, *The Three Graces*, marble, 173 × 97.2 × 75cm, Edinburgh, National Gallery of Scotland, and London, Victoria and Albert Museum. Photographs courtesy of V&A Images/Victoria and Albert Museum, London.

2.12 Antonio Canova, sketch for *The Three Graces*, pencil on paper, 17.1 × 9.3cm, Venice, Museo e Biblioteca Correr (inv. no. A74.CL.III.1798bis).

2.13 Antonio Canova, *The Three Graces Dancing to the Music of Cupid*, 1798–9, tempera and lead white over chalk, 65.5 × 60.6cm. Reproduced courtesy of La Direzione del Museo Biblioteca Archivio di Bassano de Grappa.

2.14 Roman bas relief representing *The Three Graces*, Venice, Museo Nani, in Francesco Druizzo, *Collezione de tutte le antichita che si conservano nel Museum Naniano di Venezia*, Venice, 1815.

2.15 Camille Claudel, *Helen in Old Age*, 1905, bronze, 28 × 18 × 21cm, private collection, Paris. ADAGP/Paris and DACS/London.

2.16 Auguste Rodin, *La Belle Heaulmière/She Who was Once the Beautiful Helmetmaker's Wife*, bronze, 1880–5, 50 × 30 × 26.5cm, Paris, Musée Rodin. © Photograph Adam Rzepka.

2.17 Lilly Martin Spencer, *We Both Must Fade*, 1869, oil on canvas, 178.7 × 134.3cm, Smithsonian American Art Museum, Museum Purchase (1970.101).

2.18 Mark Richards, *Claire Chrysler*, 1997. Photograph, courtesy of Solo Syndication (Associated Newspapers, Mark Richards).

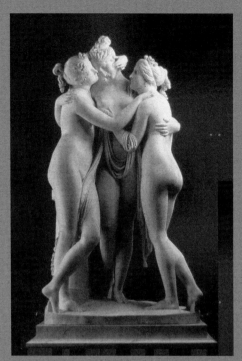

2.1

2.2

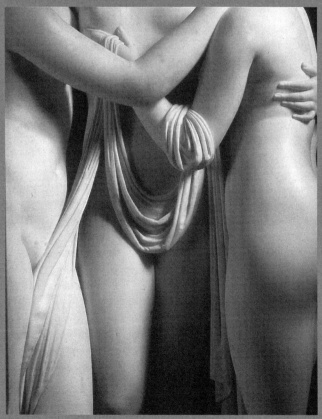

2.3

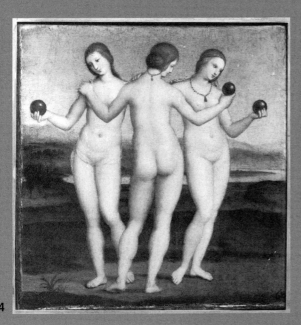

2.4

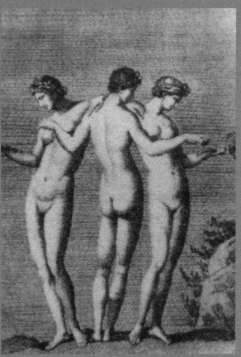

2.5

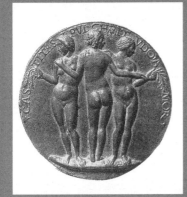

2.6

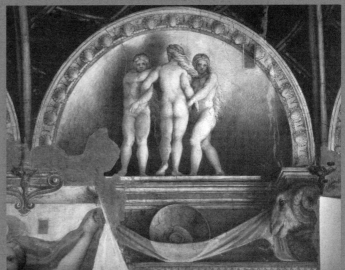

2.7

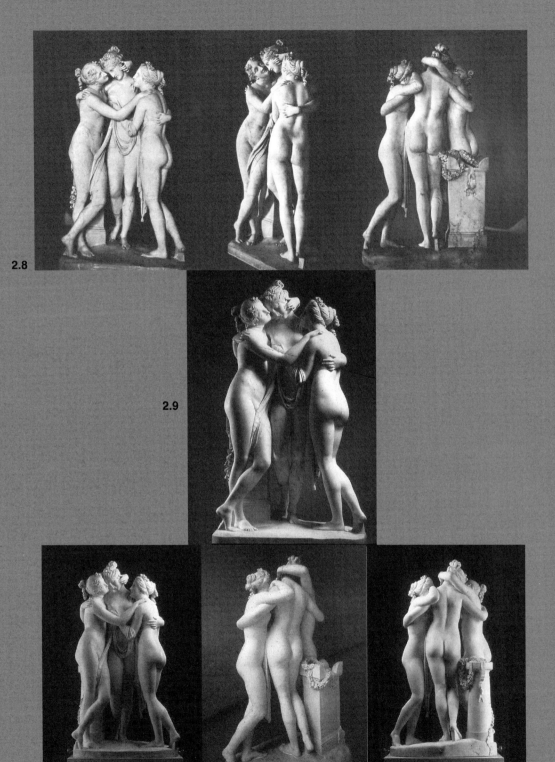

2.8

2.9

2.10

2.11

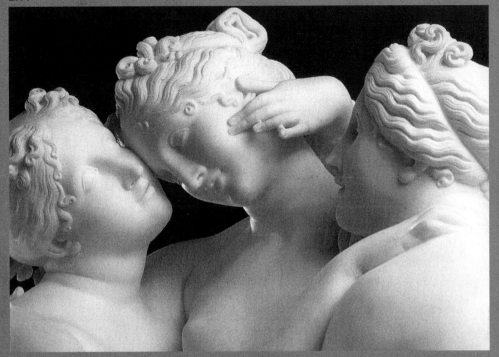

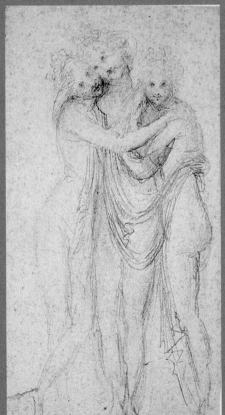

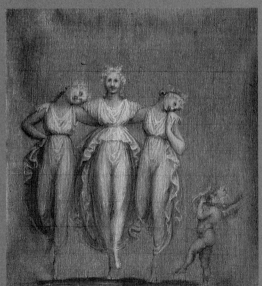

2.13

2.12

2.14

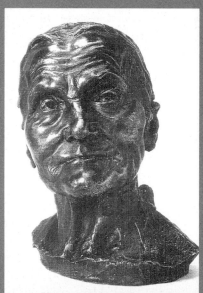

2.15

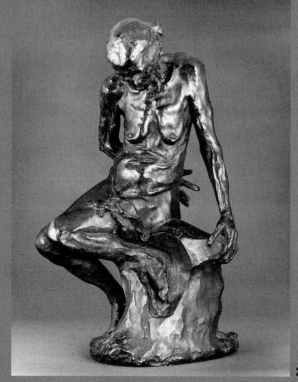

2

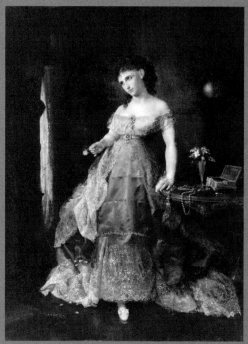

2.17

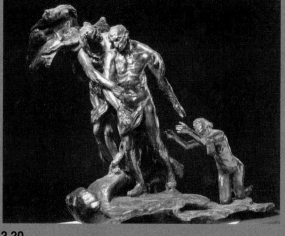

2.20

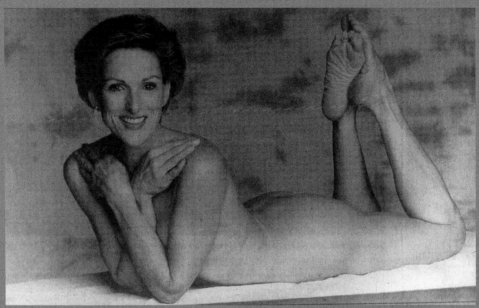

2.18

2.19

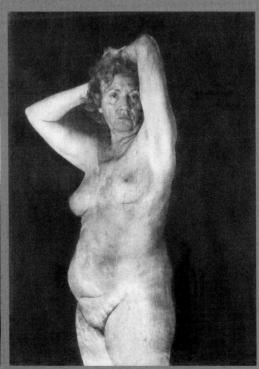

2.21

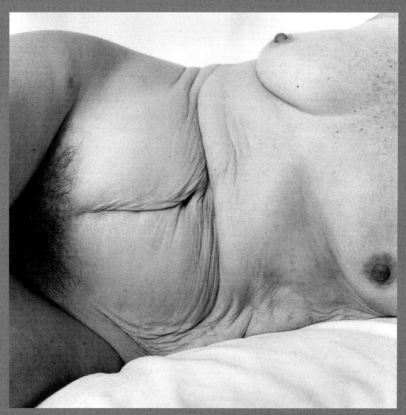

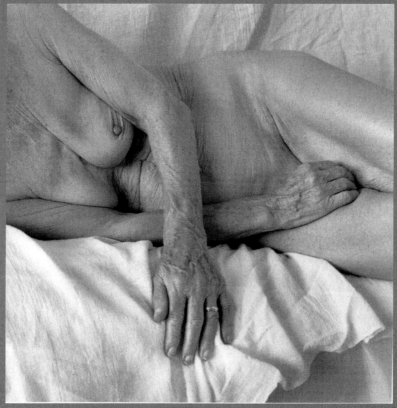

2.22

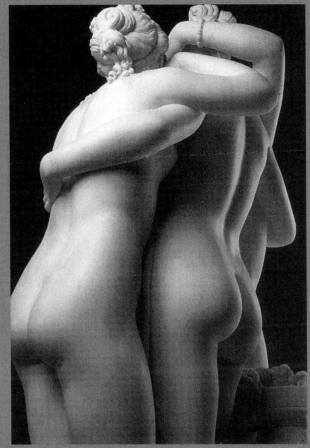

2.23

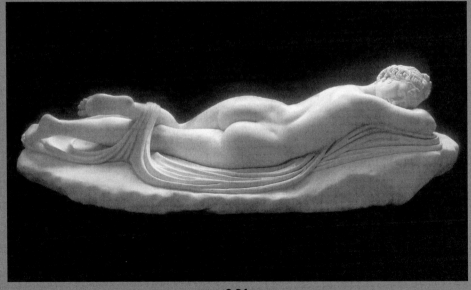

2.24

2.25

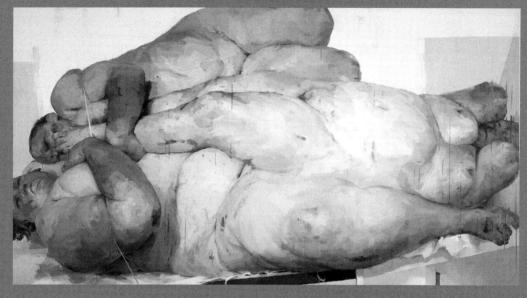

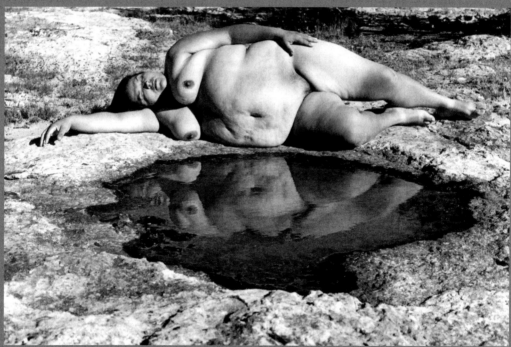

2.26

2.27

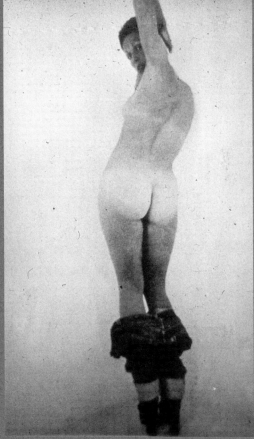

2.29

2.28

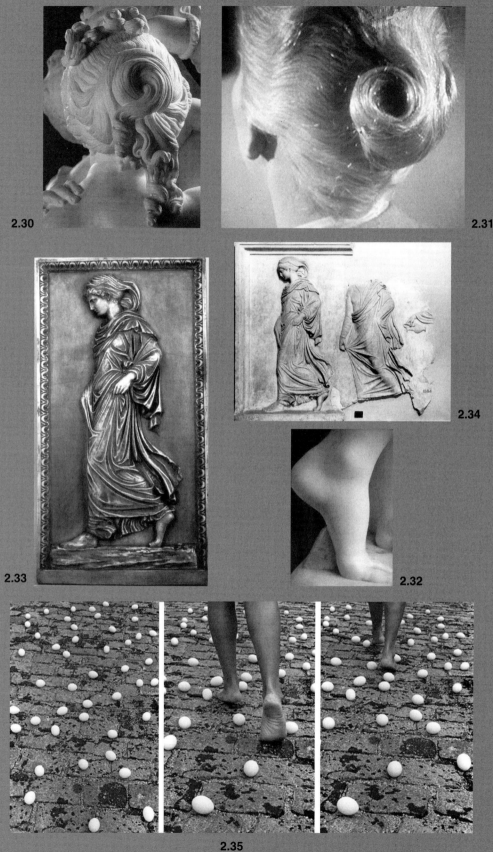

2.30

2.31

2.33

2.34

2.32

2.35

2

THE GRACE OF TIME

Narrativity, sexuality and the visual encounter

Of the postcards of this sculpted trio of *The Three Graces* by Antonio Canova (1815–1817) that I purchased in Edinburgh, there was one view of the intricately conceived and realised group as a whole (2.1). The rest offered close-ups of different details of the sculpture that I could carry away with me in suspended form through the eerie proximities created by a static photographic capture (1.1b). Disassembling the textual weave of an exquisitely wrought entwining of bodies, arms and inclined heads, the isolating 'quotations' strangely testified to multiple temporalities involved in any actual viewing of so complex a piece of free-standing sculpture. Yet the isolated close-ups petrified that mo(ve)ment of encounter into the monumental stillness and glacial permanence of the sculpture, reinscribing the antique accounts of a temporal narrative of seeing, sexual desire and the display of a sculpted female body.[1] As a counterpoint to the exploration of the temporality of implied and thus revealed narrativity of a masculine heterosexual visuality, I want to juxtapose with Canova's statue, thus disassembled by the photographically fragmenting details, representations of the mature and ageing female body by artists who explore that body as a sign of 'women's time'.[2] Why?

> Indeed, the time has come to emphasize the multiplicity of female expressions and preoccupations so that from the intersection of these differences there might arise, more precisely, less commercially and more truthfully, the real fundamental difference between the two sexes: a difference that feminism has had the enormous merit of rendering painful, that is, productive of surprises and of symbolic life in a civilization which, outside the stock exchange and wars, is bored to death.[3]

Julia Kristeva's historical-materialist and psycho-symbolic thinking about contradictory temporalities of sexual difference, language, civilisation, modern politics and aesthetic creativity implies a creative possibility and a theoretical resource associated with feminine subjectivity beyond the linear time of modern bourgeois nationalism and the modern bourgeois state in whose ideological parameters a disciplinary art historical practice was institutionalised.[4] Such a critical interruption/displacement, however, involves allowing traces of the differencing dialectics of death and sexuality 'in, of and from the feminine' to find a form of signification.[5] Yet any efforts to open spaces for such differencing to occur have to struggle with the phallic psychic economy that underpins the visual in relation to the fantasies of the corporeal which have only just begun to be theorised through a political use of psychoanalysis and a feminist challenge to that emerging canon.

1 To begin. . . .

The five postcards photographically reproduce a full-frontal view of the whole (2.1) and selected parts and angles of a major neoclassical sculpture, Antonio Canova's *The Three Graces*, acquired through new American oil wealth – J. P. Getty II – from old British aristocratic landed and slave-based wealth – Dukes of Bedford – to be shared between two British institutions, the Victoria and Albert Museum in London and the National Gallery of Scotland in Edinburgh. Commissioned in 1815 by John Russell, 6th Duke of Bedford from the then most famous Italian neoclassical sculptor, a man of working-class origins, Antonio Canova (1.2), as the second version of a statue originally commissioned by Joséphine Beauharnais: *The Three Graces* was completed in 1817 and delivered in 1819 to Woburn Abbey where it stood in a specially designed niche in the Temple of Liberty in the sculpture gallery.[6] In the mid-1990s, the sculpture became an object of nationalist cultural politics as J. P. Getty II came forward (with other donors and government agencies) to prevent his father's museum, the J. Paul Getty Museum in Los Angeles, from taking this neoclassical work out of the British Isles. In its move from private ownership to public icon of conserved heritage, three naked ladies in marble become the epitome once again of art.[7]

The first postcard (2.1) presents this group, however, in the nowhere space of photographic reproduction, already encoded by what Barthes has named the *rhetoric* of the image, the mythicisation or ideologically framed meaning that hides itself within the apparent transparency of a codeless photographic *reproduction*.[8]

We are not the first to worry about photography as translation. In the early decades of the twentieth century, the Munich-based art historian of style and the Baroque Heinrich Wölfflin (1864–1945) was already alert to the effects of photography on art historical interpretation because of the way photography pre-coded our visual encounter with the artwork. Wölfflin believed that there was an intended meaning in each sculpture and he argued that it depended upon a precisely plotted viewing position relative to which the formal whole synthesised into a statement (2.2). Wölfflin was concerned about the right way to photograph a sculpture so as to 'see' the artist's formal conception of the relation and hierarchy of parts. Typically he conjoined artistic intention and formal arrangement into a predetermining unified whole: the object, which necessitated, therefore, the art historian identifying *the* point of view from which this whole could be consumed. This seeing would lead to 'understanding' the meaning that formal organisation visualised for the spectator if s/he occupied the preferred viewing position.[9] We might quibble with Wölfflin's desire for or even belief in a single viewpoint through which the stable meaning of a piece may be perceived. Clearly anyone can move around a sculpture and find many different views and meanings. Wölfflin, however, represents a theory of art that privileges both artistic authorship and intention, and thus stands at the far end of the spectrum from current post-structural insistence on the polysemy of a text orphaned from its god-like creator. None the less, Wölfflin's concept of a privileged point of view imaginatively duplicates the projection on to photography of the mechanical means of delivering or realising such semantic stability, a fixity that yields itself merely to sight conceived as a kind of indifferent mechanical recording of a one-way projection of meaning 'embodied' in the worked form of the sculpture. Not only has the camera as eye been subjected to substantial critique in cultural theory, but our understanding of the social and psychic investments in, and desires at play within, visuality seriously complicate what we now think is happening when we look at anything, especially via the mediation of the fantasmatic, projective machinery of photography.[10] In

relation to the potential movement and hence narrativity that a sculpture in time and space inevitably incites, the still photograph of a sculpture denatures it, flattening it out as an 'image', entraining a different kind of visuality that offers mastery in place of contingency and sustained curiosity in the open encounter.[11]

The postcards as photographic reproduction, amongst many other effects, introduce into our visual encounter with sculpture's representations the paradox of narrativity through serial stillness. Instead of the synthetic concept of idea realised through a symbolics of form that Wölfflin posited, art reproductive photography dislocates sculpture from any originary or fixed site and initiates a quasi-cinematic space of fantasmatic visual encounter, transforming succeeding spaces of different framings of the piece into a certain kind of delusional time, alternating closeness and distance, movement and stillness, generating that cinematic mix of voyeurism (mastery and mobility) and fetishism (petrification and commemoratively ambivalent repetition). Sculpture in the age of photographic reproduction creates sequential framings that introduce a narrativity unhinged from allegory that is intensely susceptible, therefore, to the play of a psychic economy. This alters relations of the body both to the real time of viewing as movement (inciting voyeuristic fantasies) and to the temporalities metaphorically captured in an image of the body that seems to defeat time by holding it before us in a transtemporal permanence (the impulse of fetishism).

The colour photography of the postcards furthermore infused the white marble with an almost human warmth, moving its glacial artifice closer to living flesh. Its calculated lighting plays theatrically over the formal undulations of the sculptured bodies.[12] Orchestrated by the play of light that plots a possible viewing, a story emerges, dramatising a central core of veiled darkness at the exact point of the invisible pubic triangle, where the linking drapery loops, rising to the hand that nestles beneath a luminously tipped breast to fall between the legs of the left-hand figure. A secondary loop over a bent elbow repeats the covering veil but at the same time visually encodes the sexual folds the drapery disguises below. The loops of cloth link to the figure on the right whose buttocks glisten and dissolve in reflected light. But the detail I have chosen (2.3) to underline this point is not part of the original postcard archive. It exists because another viewer, a photographer, has also been arrested as I was by this negotiation of a new formal solution to the formulation to front/rear/front presentations emblematised by Raphael's tiny painting of *The Three Graces* (2.4) which we find also in the Pompeian fresco in the Museo Nazionale in Naples (2.5) and the medal of Giovanna Tornabuoni (2.6) or in the roundel by Correggio in the Camera di San Paolo in Parma (2.7).

This is one visual journey. Another is produced by a sequence of black and white photographs from Girardon negatives of the earlier, original version of Canova's innovative group, made for the Prince de Beauharnais in 1812, now in St Petersburg. Here I have heightened the dramatic chiaroscuro by photocopying (2.8). The darkness of the ground becomes almost material; darkness appears to draw the figures, incising a deep chasm down the backbone, between the buttocks and legs of the right-hand figure. The scratched glass surface, insisting on the nineteenth-century photographic process itself, echoes the marble's flaws and coloured grain, materialising this stony object from which has been fashioned a sculptural idea so radically different from the dematerialising effects of the polished, perfect, marmoreal fluency revealed by golden-hued lighting in the luxuriant fantasy world of the contemporary postcard. A photograph of the Bedford group produced for Innocenti Editori in 1952 (2.9) allows the unyielding chiaroscuro of photography to rewrite the sculptural forms, fading out great areas of the marble to highlight forms and shapes that threaten to become disassociated from the anatomical structure of each figure and the composition of

the whole sculpture itself. In powerful yet modulated play of photographically created darkness over the white marble, bodies are dematerialised into shapes, and yet that central sweep of drapery, the entwining arms and the lazy fall of the trailing drapery between the legs of the left-hand figure becomes a defining visual event of this 'image'.

A contemporary series of black and white photographs reproduced in an exhibition catalogue marking the acquisition of the sculpture for the nation allows us to explore the effect of sequential reproduction. In these varied points of view we are invited to follow a circling pan (2.10). We are propositioned to experience not only the sculpture in the round but a succession of still, differentiating views, each introducing a new narrativisation of the viewer's positioning in relation to the imaged/imagined female body that seems precisely revealed by the transitions from image to image. Like the cinema, this movement of frame and still creates a fantasy of the disembodied eye, detached from time and space, able to explore fantasmatically every aspect of the discovered other. The photographic mechanism of this scenario ocularises the experience of sculpture that is thereby less linked to formal and conceptual artistic thematics of a Kantian aesthetics and more susceptible to the exploration of what I would call 'the pornographic imaginary'.

What I mean by that term is not that photographic reproduction degrades the artwork to cheap and surreptitious erotica, a move that implies the moral problematics of high and low that have served art history in the past. (I am thinking here of the opening of Kenneth Clark's study of *The Nude* with its attempts to forestall the failure of the unsophisticated viewer of the artistic nude to see the way artistic practice elevates the body from its concrete sexuality into the ideal form: the body *re-formed*.[13]) The pornographic imaginary concerns the staging of desire for an erotics of a hypostasised visual encounter. Rather than fall back on early and necessarily crude feminist polemics against the image and the gendered hierarchies of a specific apparatus of looking, to whose regime all visual representations of the female body were subjected, I think we can allow that the act of viewing can solicit a number of different registers, of inflections, depending contingently on variable factors in the actual moment and situation. Thus any invitation of sexuality into the field of vision is not by definition sexist or pornographic, and not simply problematic in either case.[14] Closely observing the evolution of photography as a mechanism of the developing pornography industry does however, allow us to ponder what has to happen for that which we could call the pornographic effect to occur. The relations between movement and contemplation, stillness and arrest seem critical here in the generation of a labile sexual potential to the viewing situation, whatever the object of the look or the social framing of that exercise of the gaze.[15]

For practical reasons discussed above, sculpture and early photography developed an intimate relation at the latter's emergence. Sculptures were anthropomorphic, hence humanly interesting things of which to make images people might want to look at. Yet, if not dead, they were unlike human subjects, at least unmoving, hence easier to photograph with the long exposures necessary for the infant technology. A photograph of the *Head of Patroclus* was part of W. H. Fox Talbot's famous presentation of the new practice, *The Pencil of Nature* in 1847, and another photographic experimentation with a large sculptural group fell upon the Woburn *Three Graces* in a series around 1840 to 1841 in which Fox Talbot showed how photography could reinvent sculpture by multiplying any sculpture, creating overlapping contrasts, negative, positive, front, back (1.5).[16]

2 To move in closer. . . .

The second postcard (2.11) offers the close-up of the heads of *The Three Graces* in a formally calculated interweave of tender intimacies. We know from the evidence of preparatory sketches and models that Canova searched hard for the final compositional combination of three heads (2.12, 2.13). How radically different would have been the sculpture had all the figures addressed the spectator directly as in the drawings with their eyes the fixed point of reference. These drawings underline that point of encounter between surface and viewing subject. In the final sculptural solution, the neoclassical convention of unpainted marble creates a disturbingly blinded, purely stony surface where that beady sign of a virtual gaze once 'animated' the drawings. In the clay maquette, now in a private collection in Turin, Canova brought one of the flanking Graces round to drape her over the central standing figure, while her left arm hangs round the neck of the third Grace, who inclines her head over that arm, forming a line with the head of the now rear-viewed Grace who rests her own head on that same arm. The standing Grace looks down to the upturned face of this figure. Canova's final sculptural resolution creates a more flowing line of incline and inter-action. It has stretched ancient ideas of the dancing *movement* associated with the Greek representations of the trio (2.14), to distil a historically and culturally specific image of femininity of which grace – created by the formal rhythm of this interweave and the sightless gazes – becomes a 'naturalised' and visible attribute, an emanation of feminine being, seemingly revealed through the paradox of idealising naturalism. These close-ups of the faces recast the sculpture as the encounter of the viewing eye and mind with a gendering and gendered European conceit of a sexual difference.

Since Alberti recycled the ancients, there has been an allegorical tradition explaining the trope of the threesomeness of the Graces.[17] I am suggesting, however, that the neoclassical aesthetic restages any inherited iconographic conventions in so etiolated a way that its form alone predetermines the affect generated by the group for its historically disenchanted, declassicised modern viewers. In that register, these faces have become both non-allegorical and anti-narrative; they figure grace in the feminine in terms of a stasis of time, that is as perpetual youthfulness, and in terms of enclosure within a circle that becomes a mirroring repetition of a undifferentiated feminine. A viewer becomes witness to the waning of a pagan or renaissance allegorical imagination in favour of a surcharged formalist aesthetic that privileges the visual in which woman is made to appear as if finally revealed in an essence, that is all the more mythic for its apparent spontaneity. This 'revelation', however, opens the image to fantasy and its underlying psychic economies that simultaneously instate a sexual order (masculinity and its feminine other) and undo its fixities in troubling as well as pleasurably polymorphous ways.

By the early nineteenth century when this work was made, and now that we encounter this piece in the ever-renewed present of the art museum, or in an art book or postcard form through photographic rhetoricisation, the threeness of the Graces can no longer signify the ideas encoded once in three distinct mythic entities: Aglaie, Thalia and Euphrosyne. Nor can a female trinity function as iconic representatives of entities such as Wind identifies with the Three Graces in Botticelli's *Primavera*: *Voluptas*, *Pulchritudo* and *Castitas* as we see inscribed on the Tornabuoni medal (2.6).[18] Here I am entering yet another academic field with even greater trepidation. For the non-specialist who needs to borrow from the field of scholarship on classical religions and mythologies, there are certain precautions to avoid getting the wrong end of the stick. Stay with established authorities and authorised collations

of accepted opinion. The trouble is that there is a sexual politics of knowledge even here. Feminist scholarship has critiqued the framing of knowledge of the ancient world which, given the canonical role of classical Greece in the narrative of the West's becoming, will not be immune from its own selectivity, repressions and foreclosures.[19]

Let me explain. While researching the range of possible associations of the trio of female personifications of Grace, I read a large number of obvious reference books, encyclopaedias and dictionaries of Greek mythology and religion. What I gleaned intrigued me a great deal. It went like this.

The Kharites (or Charites) from the Greek word Kharis (Charis) were held by some to stem from ancient manifestations as chthonic, dancing deities that originated in Cretan religious rites and were worshipped as goddesses presiding over both harvests and funerals, i.e. the twin poles of life and death, renewals and endings. They were gift-givers associated with social harmony an-iconically worshipped first at/as pillars. When they ultimately entered iconic representation, it was always as a stately procession garbed in *chitons* (a belted female dress) and garlands (2.14). By classical times, that is after Homer and in Hesiod, the Kharites had been appropriated as daughters of Zeus, like other trios, the Horai, goddesses of vegetation, or the Moirai, the fates who embodied three ancient faces of the Goddess: daughter, mother and chrone, attendant at the birth of children – a residual form of which are the fairy godmothers around the cradle of the future *Sleeping Beauty*. In Greek records, the Graces acquired individual names – Agaliae, Euphrosyne and Thalia – and these stood for different attributes: Brilliance, Joy and Abundant Floweriness. Kharis itself means a combination of grace and beauty that can signify loveliness of form, but also nobility of action, eloquence and kindness, harmony and, most significantly for later tradition, gift-giving *and* gratitude. According to one source, in Cretan culture, the Kharites were associated with lunar time, worshipped by a pillar surmounted with a crescent moon, and their rites were practised at the death of the king's son, so they also seemed to preside over some notion of resurrection.

This kind of information which seems to open a vista on to a much longer and more complex history of the ritual origins of the deities and personifications of natural forces and other mysteries that lie at the origin of both religion and art is, however, not to be found at all in the entry by Evelyn Harrison in the most prestigious and scholarly of the research tools, the *Lexicon Iconologicum Classicae Mythologiae*.[20] This authority offers a more document-bound text that details only those interpretations or traditions about the Kharites that appear in Homer and Hesiod and thereafter, only in texts that themselves perform ideological revisions to ancient traditions in the service of emerging patriarchal social and cultural orders. Thus the dependence on certain ideologies of the patriarchal world for authority as historical sources for legitimated interpretations of the past significations attached to these figurations inevitably renders feminist questions anachronistic and illegitimate. From the more eccentric studies of Greek myths by poet-scholars such as Robert Graves or from the writings of the Nietzsche-influenced Ritualist circle of Cambridge classicists at the beginning of the twentieth century, which included Jane Ellen Harrison, who located the origins of Greek art and drama in ancient rituals and sacrificial cults, we find other ways of tracking what was signified by the travelling concepts that were belatedly embodied, personified and mythologised as the Three Graces.[21] Without adjudicating on the scholarly debates that are raging in ancient history and archaeology over shifting gendered or gender-blind 'ways of seeing', I draw inspiration once again from the work of Aby Warburg. Like Jane Harrison and her Cambridge colleagues, Warburg began to see in the petrified stasis of classical

sculpture's gestural repertoire a repository of once animated performances and dancing rituals, that carried in mnemonic form the legacy of once-enacted rituals and sacrifices, themselves the register in social and collective action of materially determined if psychically experienced emotions about life, death, desire and want. Warburg's famous concept of the *pathos formula*, of a recurring image as memorial signifier of affective traces of once powerful emotions and a pagan imaginary, seems utterly appropriate if we want to find new ways of talking about what we experience before a sculpture such as Canova's without killing it by seeing the sculpture only as the already dead outcome of a cerebralised tradition encoded as iconography and classical scholarship.[22] Warburg's attention to the unexpected persistence of aesthetic memory traces in visual images and aesthetic practices at all social levels across ages and cultures, as indices of the kind of archaic forms of psychic processes that his modernist contemporary, Sigmund Freud, would otherwise theorise through the synchrony of psychoanalysis, unexpectedly meets contemporary cultural theory that insists on our moving beyond art history's boring preoccupations with anterior narratives: narratives of biography, iconography and contextualism for which the artwork is reduced to a belated illustration, rather than a creative intervention both in and outside of [its] time.[23]

Let me take you back, none the less, to a historical rupture. Only in the fourth century BCE did the draped figures of the dancing or processional Graces (2.14) acquire a philo-sophically charged nudity which stripped them of their chthonic associations, and the associations with movement signified pictorially by the animation of their draperies: what Warburg called *bewegte Beiwerke*. Without that movement of form they could not convey transition and motion, and thus they lost their authority over life and death. Their represen-tation became instead emblematic of phallocentrically revised moral principles that were ultimately reinterpreted by the Romans (Kharites became Gratiae). In the renaissance revival of pagan antiquity, the Graces simply signified ideas of liberality and gift-giving indexed by the linkages of the threesome. By their nudification which is at once abstraction, idealisation and corporalisation, the Graces become bodies whose collective composition emblematises an idea not necessarily characteristic of their singular or collective quality as feminine/female forces or principles with privileged relations to life, death and change. It would be here that our understanding of *kharis*, *gratia*, or the Hebrew *chesed* – loving kindness – would open up to a philosophical discourse on the logic of a feminine association for such an idea. For instance, Julia Kristeva proposes that we understand the ethical resource of motherhood as that structure which transforms the violence of desire into the tenderness that allows an other to live. She thus insists that, apart from whatever choices an individual woman makes, culture needs the structure of maternity to deflect erotic and self-oriented violence into ethical or social practice, like friendship or pedagogy. Or Emmanuel Levinas suggests a privileged place for the feminine in any philosophical ethics since it enacts the gift of a life beyond the living of the giver.

Thus the link with the feminine is not as an attribute of any notion of women, then or now. It is an intellectual creation that may come to find a form of representation through personification (pagan thinking). It is an initiating conceptualisation that may deteriorate to being seen as the mere reflection of the body, or gender chosen, logically not anatomically or sexually to personify the idea of the ethical. To reduce the fundamental principle of grace which in Hebrew, *chesed*, forms one the foundations of the social human contract to some prettification of three agelessly eroticised young women is to empty out from modern thought any potential for the feminine as a principle, structure or logic derived imagina-tively from real processes around life, desire, death and the gift to contribute to the human.[24]

The intellectual redefinition of the Graces as allegories of giving required a formulation of an interlinking chain of alternative states rather than movement, in which each Grace represents but one moment of giving, receiving and returning, or one is giving and two symmetrically represent receiving. In his still major analysis of the allegorical function of the iconography of an intertwined trio in Roman thought and art, Edgar Wind derives his reading from the Stoic philosopher Seneca's account of Chrysippus' treatise on liberality, and he writes: 'Why the Graces are three, why they are sisters, why they interlace hands'; all that is explained in *De Beneficiis*, by the triple rhythm of generosity, which consists of giving, receiving and returning. As *gratias agere* means 'to return thanks', the three phases must be interlocked in a dance as are the graces; for the order of the benefit requires that it be given away by the hand but returned to the giver, and although 'there is a higher dignity in the one that gives, the circle must never be interrupted'.[25] According to Servius, a fourth-century Roman writer, the Graces are naked because grace must be free of deceit.[26]

This brief foray into Windian and Warburgian art history serves to make a simple point. A cultural idea that may enshrine archaic responses to the passage of time, invested first in religion and its poetical and iconographical systems, yielded to a patriarchal philosophical one. This then finds itself present only in an aesthetic practice that undoes all traces of the intellectual associations between the feminine and temporality. The emblem of a movement at the heart of the chain of life becomes instead a closed circle, and each figure is a mere facet of a single idea, caught in the image as meaning leeches from it so that its only message becomes a hypostatisation of the feminine as the sign of a weakened and corpore-alised notion of grace itself: naked, youthful, mindless beauty is the feminine, and the feminine is only naked, youthful, mindless, physical beauty.

Thus the second postcard that features the close-up of these three heads sent me off down a counter-chain of associations to bring back into representation other facets of the feminine: mother as well as daughter, the chrone as well as the maid. French sculptor Camille Claudel's remarkable portrait bust of 1905 titled *Helen in Old Age* (2.15) reminded me of a modern Helen, Marilyn Monroe. Her untimely death on 4 August 1962 left no images of her in old age – she would have been 80 in the year in which I first wrote this – I have found one double image of her mother as a young woman and in her sixties which might give us some idea of the family mode of ageing. Meditating on the process of ageing, this woman, stilled by the fatal attraction of a youthful beauty manufactured in contemporary media, Marilyn Monroe declared:

> I want to grow old without face-lifts. They take the life out of a face, the character. I want to have the courage to be loyal to the face I've made. Sometimes I think it would be easier to avoid old age, to die young, but then you would never complete your life, would you? You'd never wholly know yourself.[27]

Monroe's words point to a radical lack in our repertoire of cultural representation. In her multi-part installation on women and time, *Interim* (1984–90), Mary Kelly revealed the absence of figurations of the maturing of the feminine in and through time.[28] That is not to say there are not images of old ladies: but that image signifies something other than what Marilyn Monroe contemplated: a face and, we should add, a body that would itself be a record of time lived, an embodiment of its history, each mark and fold, each change the register of experience. Camille Claudel's thoughtful if imaginary portrait of an elderly Helen of Troy stands in stark contrast to the statue by her contemporary Auguste Rodin,

La Belle Heaulmière/She Who was Once the Beautiful Helmetmaker's Wife (2.16). Old women repre-
sented by men in art are there to terrify us as a *memento mori*; juxtaposed as scary witches,
hags, old bags to the soft fullness of the one moment of feminine desirability: youth. The
nineteenth-century American painter Lilly Martin Spencer's *We Both Shall Fade* (2.17) plays
ironically with the conventional identification of woman and not with the cyclical renew-
ability of nature (as we saw in Botticelli and inherent in the Graces) that lies behind the
pre-classical, pre-phallic conceit of the Graces that was favoured within Neolithic, gylandric
cultures, but with transience and decay.[29] Youth, as Kathleen Woodward has argued in her
analysis of ageing in modern cultural texts, becomes a masquerade behind which lies the
ghost of mortality that is so often imaged and imagined as the flaccid disintegration of the
de-idealised female body.[30] What was smooth, full and round becomes wrinkled, haggard
and desiccated. Flesh hangs off bones and bulges with the laxity of once-taut muscles.
Breasts that pertly met the world with pointed tips sag downward, emptied and derided. To
my counter-archive of women and time, I would join as a kind of imaging of intellectuality,
vision and old age a photographic portrait at the age of 80 of the American photographer
of, amongst other subjects, the flowers that form such a potent association for the transient
beauty of woman, Imogen Cunningham (4.15).

Another kind of counter-culture closer to Woodward's concept of the masquerade of
youth is there in full force in this sad image of Jamie Lee Curtis' body double in the film
Fierce Creatures, Claire Chrysler, aged 55 (2.18). This photograph repeats Jo Spence's playful
rehearsal of the classic baby picture, with all its disruptive demand for an encounter with
the fact of human time (2.19). Claire Chrysler reverts, however, to the pin-up mode to
juxtapose the mature face with the unwrinkled, still lean body, in a photograph whose *lapsus*,
however, is the unmanageable creasing on the soles of the well-worn feet – which, as Marilyn
Monroe suggested, testify to a lived life – to time.[31]

Contrast this identification with the visual image of the self through the management of
the body's resistance to time with Camille Claudel's profound attempt to conceptualise and
represent the experience of age as a matter of psychological maturity. In a now famous
benchmark analysis of 'Intellectuality and Sexuality' in Camille Claudel's sculpture, art
historian Claudine Mitchell contrasted her own feminist reading of Claudel's *L'Age Mûr:
Maturity* exhibited at the Salon of 1899 (2.20) with late nineteenth-century critics who read
the sculpture in terms of a male-centred narrative. The visibly ageing male figure was
interpreted by them as the psychological centre of the work and as the subject of a passage
from imploring youth behind to the enfolding embrace of an aged female figure represent-
ing death or destiny. Mitchell quotes a typical piece of critical interpretation: 'Youth, per-
sonified in a kneeling position, desperately stretches out her arm towards Man, who departs
from her, attracted and guided by Age into which he declines, filled with regrets.'[32] By
contrast, Mitchell argues that Claudel's audacious and radically novel dissolution of sculp-
tural unity and the intensified expressivity of gesture and face in the figure of the kneeling
Psyche makes this figure the central psychological subject of Claudel's conception. She
states:

> Psyche symbolises an awareness of experiences that one hoped to encounter or
> had encountered once and are no longer attainable. . . . the figure of the man
> appears to represent in concrete form Psyche's state of mind and the representation
> of an emotional state begs to be explained in a set of causal relations between the
> characters in a narrative.[33]

47

For Mitchell, Claudel differences the canon of gender forms in sculptural representation by refusing to use the conventions of existing personifications – such as the Three Graces would typify – in order to configure, that is, to use the figurative narrativity of symbolist sculpture, to give a visual form to a specifically feminine subjectivity and its consciousness of time as experience, change and altered hope.

The Three Graces by Antonio Canova (2.11) offers us three feminised faces of almost identical type, and appearance, each as perfectly vacuous as the other, each a replication of a cold idealisation, a repetition that asserts the timelessness of youthful feminine beauty. At the same time, the stone form serves a fetishising purpose, as a masquerade, a defence against the very process that the temporality of life between birth and death stretches as the field of experience, freezing into a perpetually pleasing image any means of imagining women's time.

How radically different are these stony icons from contemporary artist Melanie Manchot's project to provide a representation of the older woman through a series of, firstly black and white and, later colour photographs of the naked body of her 60-year-old mother (2.21). The mature maternal body, without clothes, is a complex topic to address, requiring more than the promise of self-evidence deceptively created by the fact of photography. Featured in Channel 4's series *Anatomy of Disgust* (2000), Melanie Manchot's works have solicited the typical array of both sexist and positivist feminist comments that underlie the problem her work addresses, but cannot resolve through the repetitions of the photographic image.[34]

The significance of Manchot's project lies in its daring as a gesture of cultural defiance. It is as if she is saying: 'I shall show you an old female body just as it is. But not any old body: the body of my mother, my female other.' Yet this is a representation of a body manipulated, however, by forms of photographic representation that define the body-as-image. It is thus the visualised body that the viewer encounters, the body sign in the field of vision. What the work might be said to lack is its active renegotiation of the profound – and never literally anatomical – fantasies lodged within both men and women, straight and gay, of and around the maternal body, precisely not as a figured object or visual sight, but as both a memory and an imago. Whether we think the maternal corporeality within which we were quickened to life and from which we have diversely separated through the very moves that make subjectivity possible, as acoustic, rhythmic, a borderspace, an enclosure, an uncanny home or a fantasised homeland, as something to be dreamt of as the origins of oceanic comfort or to be abjected as threateningly contaminating, sticky, fluid, transgressive, interior, cave-like, habitable, tomb-like, the list of ways in which this constitutive and always retrospective fantasy of m/other is imagined is endless, and, most importantly, structurally ambivalent and multi-faceted, hypercharged with affects, sublimations and repressions.

Maternal corporeality can be a figure of narrativity, hence of becoming, of beginnings and endings, of generativity, but also of possible co-emergences and necessary, if never total, rifts. Manchot's work may be said either to mistake the concrete body of a specific individual (Mrs M) who temporarily lent to her daughter her physicality as support for what will always be a fantasmatic structure: the m/other, or to have imagined that a photographed image of her actual mother's middle-aged body in her physical specificity could reveal anything of structural significance about the fantasies of the m/other which are a facet of the daughter-woman's psychic formation and not an attribute of the older woman's historically marked and lived-in body.

A similar but differently resolved engagement with women's time and the body occurs in the work of video art by the contemporary Palestinian artist working in London, Mona

Hatoum (b. 1952). Titled *Measures of Distance*, made in 1988, the video is composed of several sound-tracks working with and over several layers of imagery to convey the pain of separation and longing of exile as well as the affirmation of a culturally specific transgenerational feminine subjectivity and sexuality. Across what begins as a densely pixilated field grainily infused with intense colours forming at first no decipherable forms lies a superimposed grid, a blow-up of lined but now transparent writing paper covered with a handwritten Arabic script. On the sound-track, as if in an interior, there is the continuous sound of women's voices, chatting in Arabic and occasionally laughing. Two forms of intimacy are layered into each other yet marking a gap between them. From time to time, this ambient sound is overlaid by the carefully modulated tones of Arabic-inflected English in which a woman reads loving letters addressed to an absent daughter from her mother. The speaking woman is the artist Mona Hatoum, working in London and making the video in Vancouver. Her mother lives in and writes from Beirut which the daughter artist revisited during the mid-1980s.

The slowly changing video image is composed of photographs screened on a grainy surface, suffused with colour that only gradually reveals what we have been looking at in the pixilated graininess. It renders up the image of a mature woman, naked, taking a shower. We must read the imaged body as that of the mother whose letters form a screen before it, and whose thoughts and feelings are enunciated across the image by the voice of her now distant and absent daughter. In an interview in 1996 the artist commented on the relation of this project to the recurrent anxiety so often expressed in feminist art theory at the time about any representation of the naked female body, given the profound appropriation of that image by a pornographic, voyeuristic or sexually exploitative gaze that underpins most of Western visual culture.[35]

> Well, in early feminism the attitude was that any way of representing a woman's body is exploitative and objectifying. This question had to be reassessed later on because women vacated the frame and became invisible in a sense. When I made *Measures of Distance*, the video with my mother, I was criticised by some feminists for using the naked female body. I was accused of being exploitative and fragmenting the body as they do in pornography. I felt this was a very narrow-minded and literal interpretation of feminist theory. I saw my work as the celebration of the beauty of the opulent body of the aging woman who resembles the Venus of Willendorf – not exactly the standard we see in the media. And if you take the work as a whole, it builds up a wonderful, complete image of that woman's personality, needs, emotions, longings, beliefs and puts her very much in a social context.[36]

About five minutes into the sixteen-minute video, the voice-over tells us of the father's shock, during one of the daughter's rare visits home to Beirut, at finding his wife and daughter, together and naked, in the shower. His distress was further compounded by the fact that his daughter was taking photographs of her mother. This exchange of looks, recorded in the images on which the video piece is based, and commented upon in the exchange of letters that recall that moment of mother/daughter intimacy, captures a radical shift, a reorientation between the looker and the looked-at whose hierarchical and gendering asymmetry of knowing subject/known object have been encoded into Western art as both the elevated artistic nude and the base pornographic nudie pic.

Hatoum is exploring what happens to relations of sexuality and visuality when the other,

the object become subject, looks at herself, or at and with the body of the mother, a fantasmatic imago that quite differently and complexly underpins both the fantasies and the violence of men's representations of women's bodies in both art and pornography.

The video, *Measures of Distance*, is exemplary of a current aesthetic and feminist project to challenge the double legacy of what the feminist theorist Jacqueline Rose named 'sexuality in the field of vision',[37] by attempting to represent the female body as the site of her own proceedings, the sign of inscriptions on a cultural text 'in, of, and from the feminine'.[38] This phrase suggests that making a difference to established conventions and meanings around the representation of the adult and mature female body is not simply a matter of producing alternative 'expressions' that arise from a given gender identity consistent with the anatomical characteristics of the female body: women artists make women's art by expressing a given female bodiliness.

From a psychoanalytical point of view, the relation between the physical body and the sexual body is highly mediated by fantasy that cares not at all about perceptual or anatomical reality. What we are does not stem from the given facts of the bodies into which we are born; we inhabit physical potentialities through an erotic zoning that is a fantasmatic composite of libidinally invested boundaries and pathways. Much of the process by which the body's potentiality for pleasure and horror is encrypted into a psychic code becomes, by force of a symbolic law, unconscious, unknown to us while yet affecting us, as we enter into language. The subject, be it the artist who makes or the viewer who reads that artwork, *discovers* in an artwork, that evokes the fantastic bodily by luring into vision, something unforeseen about subjectivity and its complex relations to desire and pleasure. Art does not reflect what the subject knows about itself, its sexuality or its body. As an oblique mirror of the subject's formation, artistic representation refracts the hidden memories of archaic experiences and pre-Oedipal fantasies, confirming or shifting our sexed subjectivity at the point where we encounter and experience the image as fantasy.

By means of Hatoum's video's layering, veiling and slow disclosure of what we are looking at long after we have been drawn in by sound and voice, by utterance of mother-daughter desire and curiosity, shared but different moments of femininity, the full and mature body of a mother is reconfigured in the field of both her own and the daughter's exploration of desire.

The risk involved in Manchot's project is that the photographic encounter of artist and her mother, with all the intense and private feelings necessary for such a trusting covenant to have occurred, literalises the critical point of the way in which the fantasy of an eternal feminine youthfulness as the figuration of beauty, of grace, is already an imaging of the maternal as the ideal, prospective and already lost object of infantile sexuality. To rip away that masquerade, to disinvest the image of its delusional structure of commemorated and sublimated eroticisation, is to return our gaze to a body reduced to ageing flesh and thus to time. In that, there is little chance of viewing pleasure, because what we then contemplate is not only this other woman, but our death.

Outlining the psychoanalytical reading of the problematic of image, woman and age might therefore be said to set a new artistic challenge, one that Australian artist Ella Dreyfus took on in her photographic series *Age and Consent* in 1999.[39] An earnestly responsible feminist realism coupled with signed consent forms, and photographs taken of friends and neighbours in the comfort of the artist's own home does not begin to address the freight around our culture's profound loss of ideological and psychological support for the image of the feminine through time, linking the feminine to both Eros and Thanatos in psychically

productive ways. What I think we have lost is so different from a frank picture of an older woman's body in the nude: the nudification of the Graces represents already a cultural sea change we call patriarchal. Can the photographed naked body offer us an image of the imagined and fantasised? Two of Ella Dreyfus' troubling photographs arrest me, however, precisely because of the exact balance between what the photographic process can make me see and how it can produce a texture in the visible, a skin ego of the ageing body, presented both intimately (close up) and impersonally (without portrait head) (2.22). As photographs of bodies whose extraordinary presence is presented through the shock of something never seen, yet here so carefully pursued, such images, I would suggest, induce a feeling of tenderness and memory along with curiosity and the possibility of identification with a female body that registers time through its skin. The softly creasing skin of these headless but not depersonalised bodies is the furthest distance I can theoretically travel in my virtual feminist museum from the frozen, perpetual fixation of the Graces' youthful heads.

3 Looking up and askance. . . .

The third postcard (2.23) swoops us around the back of the sculptural group and lowers the viewing angle so that we are now excluded from the open intimacies into which we were drawn by the previous detail. Naked female figures sculptured in the round will have backsides. Such a photograph makes a feature of them, offering us that alternating swelling and cleavage with all its sexual and erotic ambiguities. In the Louvre's famous sculpture *Sleeping Hermaphrodite*, a Roman copy after a lost original from the second century BCE, to which the Baroque sculptor Bernini added a mattress on which the reclining figure rests, the gender ambiguity of the buttocks and its varying sexual connotations is exploited (2.24). The viewer approaches a sleeping figure from the rear, and links its swelling buttocks with its feminised face and passive position to assume that the image represents a sleeping woman suffering the typical feminine inability to keep her drapery over her body. Only by moving around the sculpture or leaning over it is the shock of this dual body revealed: male genitals, in fact erect, with 'swelling' breasts, the echo but difference of the buttocks. The view of a body from the rear, without this particular tantalising difference, therefore, offers a sexually undecided view of the body – open to different visions of sexuality and the body.[40]

At the same time, the unusual viewpoint, lowered and looking upward, allows the bodies held within the logics of known territories by the frontal or close-up views to wander into strangeness. The *Lexicon Iconologium Classicae Mythologiae* provides a comprehensive survey of representations of the Graces allowing us to chart the key shift from Greek to Roman iconography. But seeing photographic reproductions of variations on the theme of the Three Graces *en masse*, as it were, in the authoritative *musée imaginaire*, something else intruded upon my attention as it flashed through the recurrent image of the Graces with two front-facing figures and one seen from the back. Intrigued by the idea that art originates in ideas and emotions and not in mimesis, I found myself seeing in this movement from one body to the other an alternating grapheme of the triangle

and the doubled J

which has nothing to do with later anatomical knowledge of the body. As traces of a conceptualisation of the body and sex, these graphemes alternate between an external mark for an imagined (since the ancients did not perform autopsies or have extensive anatomical knowledge through dissection) interior space and a description by symbol of multi-purpose openings or borders of the body. The pubic triangle as a sign placed hairlessly on the front of the female body necessarily dispenses with the actuality of pubic fur, since the architecture of the body is not derived from a scientific conceptualisation. What I am suggesting is that the artistic formulation of the female body in the Western canon moving over time towards a kind of figurative realism can easily lead us to miss the point still marked by these graphemes which suggest to me the progressive enfleshment of an abstract but culturally vibrant concept: genesis. The grapheme of the buttocks is doubled and open where the inscribed or traced pubic V is closed: not I stress to deny the sexual anatomy of vagina as to mark the outside with the idea of space – the enigmatic space that lies within. The buttocks could perhaps be read then as the external and visible sign of the parting flesh from which the child comes forth, a form that conveys the idea of parturition and duality, a passage to the outside as well as an opening to the inside.[41]

Such speculations of how we might allow our projections on to the archaic modes by which signs come to be associated with bodies to clear out residual positivism help us to approach the comparisons brought to my mind by postcard number three. The work of the contemporary British painter Jenny Saville has consistently elicited strong reactions for her paintings of the female body, often her own or composites of several bodies forged in the paintings from mirror images and photographic fragments. The most mundane of responses lead critics to speak of monstrously fleshy or big women when viewing her massive paintings such as *Plan* (1993, 9 × 7 feet, London, Saatchi Gallery) or *Interfacing*, (1992, 4 × 3.5 feet, London, Saatchi Gallery). As Alison Rowley pointed out in one of the first serious feminist analyses of this painting practice, most viewers, however, confuse size of body and scale of painting, and thus fail to engage with the painting while being overwhelmed by the image they take to stand for an actual body of disturbing excess or grandeur.[42] The paintings are indeed large-scale works, much larger than life-size. Thus the viewer is dispossessed before Saville's painted effigies precisely of the kinds of mastery that the usual phallic management of scale ensures before the sight of the female body. Dispossessed of a single viewing position enabling us both to grasp the whole of the work and experience the surface and the *matière* by which it has become a painted work, our bodies come into play and the sense of the grandeur of the painted bodies is an effect of a *psychic* diminution of the viewer created by the painter's favoured scale of painterly enlargement. Yet there is no doubt that the bodies are intended to appear substantial and incarnated as skin, flesh, substance, even when we know their model is a woman of average height and body form. But Saville's practice, I would suggest, following on from what I stressed above about a conceptual body, offers an idea that finds a form of realisation in the artist's manipulation of scale, framing, perspective and viewing position. The paintings deliver a doubled dose of body sensation:

how it feels to be a bodyscape imagined by its subject as limitless and how it feels to have to confront an image of such a sensation from the place of your own embodiment, itself more fantasmatic than physiologically precise or anatomically correct. Indeed, neither of these registers has much to do with either painting or looking.

Two paintings from a New York exhibition at the Gagosian Gallery in March 2000 by Jenny Saville take her project into the space of postcard number three with its unexpected vistas of created body combinations and perspectives. *Rubens' Flap* (1999, oil on canvas, 10 × 8 feet) offered us a Saville version of *The Three Graces*; three bodies seep into a single form, creating an uninterrupted morphing of different anatomics atopped with three not quite complete heads. The eye is positioned to follow, like the postcard, up the bodies, finding itself confronting a landscape of body parts freed from their conventional fixities. But this painted field of fleshly colour and form is held in place by a steady gaze from the central figure that steadies the visual field and demands a response in kind, eye to eye. More challenging is *Fulcrum*, 1999 (2.25), since this painting moves on to the horizontal axis and thus not merely links but actually layers the three bodies on top of each other. Lying and not standing, they pile up upon one another, varying the two/one rhythm of the Three Graces by laying the middle figure toe to head between the two others whose torsos are bound tightly together around the painted toes of the third figure, toes that stroke the compressed heads. All three heads are exiled to the edges of the canvas, denying their eyes the role of stabilising us as viewers of the human form. We are truly displaced, dispossessed and obliged to remain with our gaze fixed at the centre of the universe where three pubic triangles create a deterritorialised rhyme of female specificity or to move in one of two directions towards the not-quite encountered faces of sleeping or dreaming women.

To call such formal inventiveness of ways of imaging the female body and presenting it in the visual field of painting with its icy blues and sharp pinks the mere showing of fat women, a relentless embodiment of our worst fears or anxieties about corporeality and gender, is to miss the point entirely.[43] The point is the body is a conceptual problematic, a symbolics of form, not a mimesis of physical morphology. The point is a proposition of the body as idea, and, in art, as a formal possibility that Jenny Saville has reclaimed, knowingly or by that artistic unconscious (like Jameson's political unconscious) that is both the pleasure and the horror of Canova's sculptural invention and his creation in sculpture of a vision of curves and mounds, cleavages and indentations. The invention is revealed to us as much by the camera angles of postcard three as by going back to the sculpture after having seen the paintings of Jenny Saville, reconsidering the glacially hard, white sculpture through the coloured flesh of her materialist paintings of bodies presented in equally disturbing impossibility and artifice.

But if we have raised the question of the buttocks as a destabilising sign of sexual ambiguity, available either to read the bodies without the gendering signs that mark the front views or to read for other sexual desires, and if we have also suggested through the work of Jenny Saville a shift in perspective towards the maker's identification with the body made through art, what about the body of the desire for the woman who desires women? Los Angeles-born Laura Aguilar (b. 1959) began a series of photographs in 1986 titled *Latina Lesbians*, marking the very invisibility of both women of colour and women who desire women from the world over which Canova's *The Three Graces* canonically rules. In her *Nature Self Portrait No. 4* if 1996 (2.26) Aguilar places her own body in the Californian desert landscape, linking the woman's body and stone in a manner that resonates back across time to the earliest carvings of the female body in Neolithic cultures, sometimes in stone, on bone and tusk, but

even in landscape itself. Some archaeologists identify the mounds and surrounding water channels at Silbury Hill in England as a reclining female figure giving birth – a drama revealed by watching the light of the moon pass over its forms at certain times of the year. The monumental forms of the female body stretched out are reflected in the pool. The reflection reduces our sense of the actual body and translates its core features into a sculptural assembly of forms and shapes. Set against the harsh rockiness of the landscape the weight of ample flesh, subtly reshaped by gravity in this pose, acquires its own luxuriant beauty. In photographic tonalities, it becomes a reminder of the very quality of human existence so reduced and denied by the timelessness of marmorean sculpture even when, as in the case of this postcard number three, it seems to place us childlike before the moulded, swelling fleshiness of the human body.

4 Backing on. . . .

With postcard four (2.27) I enter the territory that Nanette Salomon has examined in her work on *contrapposto* in the classical male nude.[44] The fourth postcard offers a simple head-on, rear view of the central standing Grace that places us in the indeterminate zone of the sexual body that is, as I argued above, neither the gendered nor the anatomically distinct body. This postcard fragments the whole, isolating a single portion of a single figure in its classic *contrapposto* with its promise of movement by the subtlest of shifts of weight from one foot to the other that produces *dehanchement*, the slight raising of one hip. This postcard recalls for me one of the early advertising images upon which I inflicted my primitive feminist semiotics in the 1970s, when we first puzzled over the meaning of the body in representation and its ambiguous relation to ideologies of sexual difference (2.28). The golden-hued bared buttocks bearing the sewn markers and logo of Levi's jeans unsettled the would-be semiotician seeking to link commercial nakedness with the connotations of the female nude as already coded as available. It became clear that the extracted body part, the buttocks, with their distinctive *dehanchement* of the Greek male nude, left a kind of undecidability as to the gender of the body. As sexualised signifier across different sexualities, this rear view of buttocks and thighs 'opens' a sculpture so far entrapped by a dialectics of heterosex with its over-feminisation of face, gesture and body arrangement to more mobile and undetermined erotics. Discovered, found, desired, this close-up screens out all narratives discussed so far and reminds us that who views is what ultimately activates the effects of what is viewed, except when Lynda Benglis gets in on the ironic act and undresses that classic cheesecake offering of the buttocks and strips it back to the arty nude (2.29).

5 Getting in a knot. . . .

The final postcard (2.30) provided another back view, another close-up, of the back of one of the heads where the smoothness of the marble that stands for skin and rarefied artistic nudity is ruffled by the volutes and vortexes of the classical sculptural convention for hair. Bodies smooth and glacially marmoreal are cleansed of all matter that grows and that might mark them as sites of continual processes of cell production and decay. By negation of time and hence death, they call to mind a story told by Sigmund Freud. He describes his real terror when his mother's prosaic insistence on Judaic anti-transcendentalism robbed him of the comforts that his Catholic peasant nurse had provided with her stories of heavenly resurrection. Having lost his sibling rival, a brother named Julius at only 8 months old,

Sigmund Freud's infantile guilt was assuaged by his nurse's comforting Catholic beliefs of life beyond the grave. Her dismissal, his parents' financial difficulties and a move to Vienna all coincided with a new death. When Sigmund questioned the Jewish insistence on the idea of dust to dust, his beautiful young mother Amalia rubbed her hands together and showed her son the sloughed-off cells that proved the body's substance as mere coagulated dust. The classical absenting of body hair on the female nude and its conventionalisation as semi-autonomous aesthetic form functions as a powerful negation of such intimations of our *materi*ality.

Head hair, moreover, in an image of woman is, as we know, a displaced sign of the repressed, secondary sexual furriness, which incites, so we are told, in the little chappy, a narcissistic terror sufficient to incite a fetishising fantasy of the Gorgon's wreath of phallic snakes as multiple substitutes for what is not nestling in the woman's sex. Freud's theorisation of conversion hysteria revealed an easy path for the psyche to displace charged anxieties about what is and what is not to be seen in actual erotic zones to less charged locations that inherit oblique evocations of what must not be imagined and certainly never seen since amidst Medusa's hyperphallic hair her gaze is deadly: castrating.

The Freudian trail of this postcard takes me to the cinematic, to a film in which a whole narrative is built upon such a highly culturalised displacement of the fantasy of the mother's sexuality onto the knot of a woman's hair. Alfred Hitchcock's *Vertigo* (1958) offers intriguing associations for this text, and would surely be playing in the cinematèque of the virtual feminist museum at this point (2.31). Its opening sequence offers us first some lips, then two eyes, then one, and out of the pupil of an isolated orb spins the vortex that will be the conceptual theme of the film: a spinning void that will find its temporary incarnations in hairstyles as well as its spiral staircases and tunnels in dreams of falling. Shortly after suffering a terrible fall that leaves Scottie, the police detective, disabled by vertigo, the detective is asked to watch a woman who is threatening suicide. He follows and observes her in a manner that only cinema can render, for we see him seeing and connecting, but then we see what he sees and connects, what he finds worthy of attention, signalled by the moving in of camera shot and the holding of impossible close-ups where tiny details of paintings and hairstyles fill the screen. Thus Scottie (James Stewart) notices the uncanny resemblance of a French knot on the head of his soon to be idealised Madeleine and the twisted bun of a figure in a portrait of Carlotta Valdès – rather the camera finds for us the details that signify a connection in his mind's eye that itself is the sign of Madeleine's (apparent) identification with Carlotta. All is a ruse, however, for this Madeleine is not the real woman bearing that name, but Judy (Kim Novack) playing a part that she will later be called upon to recreate right down to, and indeed critically, the French knot. It is not the grey suit, the elegant handbag and shoes, the platinum blonde hair that makes Madeleine for Scottie, but the twisted knot of hair. It is a detail of such peripheral significance that it alone can in fact sublimate and at the same time fetishise the sex/the vortex and the void/that makes her other, woman for this man undone by love and loss.

In his analysis of the impossibility of love, Mark Cousins has analysed this repeating image of the knot of hair in Hitchcock's *Vertigo*.[45] Cousins tracks the relations between the camera's discovery of the recurrent swirl of a French knot on the heads of both a portrait of Carlotta Valdes and the fake Madeleine to the fear of heights and falling that is cinematically conveyed through both a famous dream sequence and the strangest of uncanny pans at the end of the film when Scottie (James Stewart) realises that Judy (Kim Novak) and his lost love Madeleine are one and the same, but that, by that token, she is a fake and a

deceit. Mark Cousins suggests nothing so banal as that the coil of hair with its mysterious empty centre is a Freudian symbol of the mother's sex. It is, of course, just that. But Cousins suggests precisely that it is only through necessary chains of displacement/substitution that the continuing intensity of its uncanniness with its now dread anxiety at its recurrence finds its imprint in cultural forms, or even generates those forms as its unacknowledged vehicle. Freudian argument is not about literalism and a reductive notion of the symbol with a kind of one-to-one relation between meaning and sign. Psychoanalysis acknowledges the force of archaic imagoes and psychic ideations that can only play on and with us through the chains of association whose linkages we must trace non-reductively but honestly, not for their final destination or origin, but for their relationality and play.

We short-change the creativity of our psyches and the necessity of inventions of forms – formulae of affects and unconscious thoughts – for what has none in dismissing the inventiveness with which what cannot be imaged, none the less, lends its energy to the finding of forms that then flash upon the visual screen the unremembered yet affecting site of a quickening to and final delivery into life. Thus the maternal body will find its inscriptions precisely in the distance of created sign be that fetish or phobia. This is a reminder of what betrays feminist tendencies to a non-Freudian reliance on realism as some kind of delivery from the inevitable polymorphousness of psychic ambivalence: love and dread, desire and anxiety. Rather than confront phallic regimes of representation and their sexual economies with a literal display of living, time-bound flesh (as if any apparatus of representation and viewing could ever be literal), perhaps we need to seek other pathways and other displacements, less subject to the fetishisation and castration anxieties that generated the sculptural language which Canova deployed with compelling mastery. Yet all this shows that something escapes even that logic; the psychic life of the sign is never simple.

6 And so the end. . . .

This initial foray into the virtual feminist museum might be read as a feminist version of the Warburgian *Mnemosyne Atlas*, a psycho-semiotics of the museum, denying the chronological and narrative strait-jackets within which relations between images are typically confined. I have been tracking some relays across cultural forms, sites and historical moments, finding both continuities and shifts that tell us something of the relations of sexuality before/beneath/beyond representation. I can, however, locate the freedom I have given myself within some kind of theoretical framework: the scene of analysis that will allow one final play around a body fragment, a trace, a step and an arched foot (2.32).

In Edmund Engelman's famous 1938 photographs of Freud's apartment at Berggasse 19 in Vienna, which he would shortly pack up and leave in order to escape the tightening grip of Nazism on Austrian Jewish lives, the consulting room resembles a novel kind of museum, a treasury of relics, reproductions and hangings[46] (3.4). We will discuss this in more detail in Room 3. Each and all are there to assist the analysand in a kind of time travel that involves not so much a going back as a movement between temporalities layered into the very apparatus that constitutes subjectivity between memory and anamnesis which Freud would try to theorise through the repeated and varying use of 'the archaeological metaphor'. The image plays a vital role within psychoanalysis as both a mnemic carrier of lost meanings, as a translation into a rebus-like language system, in dreams, for instance, that can be otherwise deciphered, and as a screen, a displacement, a deception that, none the less, makes meaning possible despite censorship and repression.[47]

Around the orientally carpeted couch in Freud's consulting room is a deeply significant installation of images that George Dimock has so wonderfully analysed in his reading of Freud's rooms as a kind of self-portrait.[48] At the foot of the couch hangs a reproduction of Ingres' *Oedipus and the Sphinx* (1808, Paris: Musée du Louvre): a condensation of a complex story about lameness, travel, and the three ages (youth, maturity and old age) of a human tracked through crawling, walking and leaning that, through what happens after this encounter between the young man and the Sphinx when he marries his own mother, will increasingly become the core myth of Freudian psychoanalysis. Dwarfing this image, however, is a large-scale replica of a bas-relief of a running female figure (2.33) that Freud had seen in the Vatican Museum in Rome but which had featured in a novella by Wilhelm Jensen in 1903 – the novel prompting Freud's first significant reflections on psychoanalysis and aesthetics, 'Delusion and Dream in Jensen's *Gradiva*' published in 1907.

Sarah Kofman calls this essay a pivotal work in the elaboration of Freud's aesthetics, for it hinges on a double play.[49] At first, Freud lulls us into thinking that he is merely the delighted psychologist who has found that the artist/writer has already imaginatively discovered the processes of psychological operations such as dreams and delusions. Thus Freud confirms that everything that Jensen reveals about his hero's dreams and delusions can be 'scientifically' supported by the clinical findings of psychoanalysis. The poet precedes the psychologist in insight into the human mind, it seems.

Jensen's hero is an archaeologist who has fallen prey to an overwhelming fascination for a sculpted image of a young woman in classical garb walking swiftly: what Warburg would classify as one of the key *pathos formulae*: the *nympha* or young woman with flying and wind-swept garments. Norbert Hanold fantasises about the metal woman forever held in mid-movement before him through the sculpture: he thinks she must be Hellenistic and thus perhaps lived in Pompeii. He is enamoured especially of her rising foot that exposes its sole in walking. Because of her running gait he gives her a Latin name, *Gradiva*. He then dreams that he himself is present in Pompeii on the day of its destruction in 79 CE and sees this very woman tripping across the street to a temple where she lies down and gradually turns to stone as she dies beneath the veil of volcanic ash that will preserve her image in killing her in body. Disturbed by his dream, Hanold wanders to Italy, and of course finds himself in Pompeii. There, in the midday sun, he encounters what he deludedly takes to be the living revenant of his fantastic idol.

At this point in the novel, the reader's allegiances are switched. Is this a ghost story or a study in delusion: it is revealed that there is a real woman in Hanold's life, who has been screened behind his fantasy. She is a young German woman living nearby in his university town whom Norbert Hanold has known all his life. As puberty precipitated her into love, he retreated into archaeology, the science of the dead, the stony relics of lost cultures, unable to make the transfer of infantile affections to the adult surrogate life had offered him in the person of a young neighbour called *Zoë* – meaning life in Greek, and thus linked to *Havvah*, Eve, which has the same meaning in Hebrew. Her surname, however, is *Bertgang*, for which the direct Latin translation is *Gradiva*. Both words mean sprightly gait: the very term of movement of the dancing figures of the Graces and other ancient Greek personifications of seasons, change, life and death, and a *pathos formula* marked by her flowing drapery – *bewegte Beiwerke* that gives a visible form of motion to the invisible signified of lively emotion. The word *Gradiva* attaches itself to her foot in Hanold's fetishising imagination, forever stayed in its rising position even while it implies the lightness of movement, a promise of someone going somewhere.

The story of Gradiva, just as the story of Oedipus and the Sphinx, poses a riddle: what is the reason for Norbert Hanold's fascination with the relief, i.e. what is the psychic investment in looking at art and at the sculpted foot in particular? The story itself reveals the answer: the image is the displacement of a real love, which once 'dug out from the ruins' will pass from childhood to adult heterosexual union and thus solve the riddle in a classic marital move.

Kofman, however, identifies Freud's second move: to analyse the psychic process of poetic creation itself. The book, art, the image, does not just stage a story of subjectivity; it is itself its performative enactment with its own lapsus and, more importantly, the imprint of the unconscious. 'The Gradiva essay is the narrative account of a riddle which figures in miniature the riddle constituted by the work of art as such.'[50] Just as Norbert Hanold suffers a delusion in the story, so Jensen's text weaves its own web of illusion to veil and protect itself against the return of its own repressed. The actual text is itself both what reveals and hides: like a tissue, its threads work in the paradox of proffered transparency and structural encoding. Norbert Hanold, like Oedipus, is able to read surface riddles. He can decipher some of the questions history, our own, or cultures deliver to us through traces, relics, artefacts. He, however, fails to connect what is outside with what Freud would call the 'Pompeii inside', his own psyche, the repressed but preserved history of his own formation as a subject. Without a psychoanalytical concept of repression, Jensen, none the less, stages it through a literary symbolic, through his use of a figure, Pompeii, a seemingly probable setting for a story about an archaeologist and an ancient sculpture, but one that provides an image of a psychic structure of repression.[51] But the text itself is a symbolic – repressed – encoding of its own author's subjectivity: in Jensen's recurrent trope of revenant ladies at midday, Freud identified a knot of affect for the historical author Wilhelm Jensen that repeats across his novels.

In structure of the novella, furthermore, Freud finds the recurrence of childhood echoes – echoes that have hitherto had no representation, that is, until the novel re-staged them by means of the story. Thus the work of art is a repetition of an always-lost memory: the lost mother is the lining of the affect the encountered image invokes. But it is, as Kofman insists paradoxically, an originary repetition; for that non-memory had no charge, no shape, was no part of consciousness without the image that prompted its apparent re-emergence through what is necessarily the creation in art/literature of a form by which to know, as if for the first time, what 'causes' the image to be sought or created. Kofman can show, therefore, that there is not a psychic source and its secondary representation. In effect, there is only one text, and the artwork is to be understood, therefore, as the paradox of an originary double.[52]

Thus Freudian aesthetics radically rejects the idea of mimesis, and all notions of naturalism. The relation between the image and its meaning at this level is a repetition that is occasioned only when there has been a repression which had dislocated the signifier, the name Zoë Bertgang, for instance – from the referent, the German girl next door as object of potential desire. Zoë Bertgang, translated as *Gradiva*, can then float as a disconnected fragment, which may co-operate with other elements to create a compelling but delusional system that seemed to find a home, a resting place and a coherence still charged with unrecognised affects in the bas-relief. The work of art, like a case of hysteria, generates symptoms to be deciphered but on (other), represented bodies that, magnet-like, attract to them the unformed non-memories which, finding an echo through the discovered artwork, then become its delusional veiling.

Within the novella, and more insistently so through Freud's reading, the figure who

becomes the site of truth, in the structural relay between analyst, analysand, hysteric and barred subject position, is Zoë Bertgang herself. I am going to claim her as the figure of the feminist cultural analyst, situated in but also floating free from historical time. Zoë Bertgang performs three important tasks: she raises buried unconscious material to the surface; she matches her interpretation to the cure; and she awakens feelings, restoring affect and thus desire.

We know that Freud was sent a postcard by distinguished archaeologist Emmanuel Löwy that drew his attention to the work of a scholar, Hausner. Hausner had proposed a reassemblage of various classical fragments of bas-reliefs (2.34). It transpires through diligent art historical and archaeological hypothesising that the *Gradiva* relief used by Jensen and then bought in reproduction and placed so strategically in Freud's analytical museum is a fragment, belonging to one of two reassembled trios, that may have represented the *Horae*, those ancient cousins of the Graces when the feminine was imaginatively associated with movement, the dance, and thus with time, cycles of life and death, beginnings and endings, so far removed from the frozen stasis that reaches its apogee in eighteenth-century European neoclassical sculptural conceptions of the feminine. Thus while Warburg was assembling his pictorial atlas for a historical psychology of the image, Freud surrounded himself in his work with images that shared this sense of their being memory-bearers for an amnesiac culture. There at the foot of the couch where the analysand lies still, but travels in psychic time, was the figure of the dancing feminine.

In my opening remarks I presented this project as research under two related rubrics. One concerns resuming, but with a feminist post-structuralist and psychoanalytical turn, the recently reinvigorated legacy of Aby Warburg's psycho-semiotics of art. My montage of images that resist the usual, musealised, art historical classifications of style, period, nation, genre or artist draws freely on Warburg's discovery of patterns and persistences across time, location and media. Warburg hypothesised repetition, displacement and deeply structured recurring psychic investment in place of art historical commonplaces of style, descent, influence and development. As Julia Kristeva argues, we live simultaneously in several temporalities; that of linear narratives of nation and history, and that of monumental and cyclical encounters which touch on aspects of life experiences that do not change so swiftly or visibly as those tracked by linear narratives. In this latter category, Kristeva places what we could call the time of sex, of sexual difference, as well as temporalities vivid for those of us sited in female bodies which dispose us to particular relations to cyclical time and the time of repetition, life and death. Her formulation of 'women's time' owes much to the insights of psychoanalysis, itself a discourse and practice that could be said to have co-emerged with the time disciplines of archaeology, anthropology and, of course, art history, while diverging significantly from the latter. Prompted by the fundamental structure of art history's exclusion of women as the subjects of art-making (as opposed to the subject matter) from, and its difficulties in acknowledging sexual difference in, its preferred linear, nationalist, periodised and stylistic stories of art, my feminist project now turns to other resources to develop differencing modes of historical, transhistorical or subhistorical engagement with what artistic practices do and how they think. The plates of Warburg's cultural memory, with its metaphorical association with both the conscious, knowledge-seeking mind and the unconscious mind, offer an appropriate alternative to the linear plan of the universal survey museum and the unidirectional layout of the art history survey book or lecture course.

The second rubric I introduced has a relation to my book *Differencing the Canon*. Its subtitle, *Feminist Desire and the Writing of Art's Histories*, declared a mongrel psychoanalytical frame for writing more – and different – stories about and with art. I desire difference, for difference is the condition of desire. But difference, sexual difference, is not the difference of woman from man. Too often, in what Ettinger makes clear is a phallic logic, difference is, in fact, forestalled in a fetishising move that cannot tolerate difference and thus disavows it through a memorialising substitute: the fetish that both replaces a missing phallus and yet marks its absence. Stilled by fetishistic metonymy – the linking of the phallus to a substitute down a chain of connections – fetishism is also metaphoric, and as metaphor must constantly be re-performed so that the difference of the feminine – not the difference from the masculine (lacking the phallus) – is obscured by a paradox. The feminine disappears behind its over-representation as an image that is made, in its transparent immediacy of manufactured 'truth' (here is the female body and this is what it looks like) to 'the visible', to affirm its negative otherness to that privileged masculinity which is produced, in this same representational move, as the invisible but all the more potent for that disguise, site of mastery, knowledge and self-sovereignty.

Feminist interrogation has moved on from the hammer blows of direct critique of phallocentric regimes of representation to a creative playfulness, inspired by Cixousian deconstruction and her injunction to write our 'sexts', to rediscover the imaginative potentials in the subjectively experienced feminine body from which the feminine subject has been imaginatively and intellectually exiled.[53] Thus the virtual feminist museum is not an alternative collection, inverting the negative valuation of work by women to create a counter-canon. It is a work of revisiting and reframing, a reconnecting and rereading of art in the visual field informed by a relation to desire that seeks to install feminist conceptions – necessarily plural and unpredictable – of time, of movement, of change, of futurity, that might place us finally, as Freud realised in his writings, on the side of life, not death. For all its banality, the questions posed by playing off relations between a canonical work of art, Canova's *The Three Graces*, with works about time and the body by a range of artists who are women, are ultimately, as I think feminist thought and practice are, about life and not death. We have to dare to breach a number of disciplinary conventions that are confining the study of art within a concept of linear, nationalist, masculinist time, and of history that, by having foreclosed on the difference of the feminine as itself a source of human meanings and subjective capacities – risk killing the liveliness of art past and present. Student of both Burckhardt and Nietzsche, Warburg's concept of *Nachleben*, afterlife, best translated as *persistence-in-transmission* embedded in re-activatable *pathos formulae*, was often, dangerously, in contact with that liveliness, in all its danger and desire, but at least he could recognise it in the figure of lively gaited woman – Warburg's *Nympha* or Jensen-Freud's *Gradiva*.

As fragments, assemblage and an other scene of meaning have structured this first foray into the virtual feminist museum, let me segue into the next room by following a modern, political, non-Gradivan fantasy delivered by Brazilian-Italian artist Ana Maria Maiolino's *Entrevidas* (2.35). It is a photographic image of a performance of a woman walking barefoot in a mossy street of cobbled stones littered with eggs. Her liveliness in gait is given its poetic moment in the tiny stone embedded in the sole of her rising foot which we see from behind, following. Image, stone, life: how shall we encounter the grace rather than the terror of time? We have to be going somewhere.

Exhibited items in Room 3

3.1 Jon Wood, installation of *Sigmund Freud's Desk* at the Henry Moore Institute, Leeds, 2006.

3.2 Max Pollak, *Sigmund Freud at his Desk*, etching, 1914. Courtesy of Freud Museum, London.

3.3 Edmund Engelman, *Sigmund Freud's Desk at Berggasse 19, Vienna*, 1938. Courtesy of Freud Museum, London.

3.4 Edmund Engelman, *Sigmund Freud's Consulting Room, Berggasse 19, Vienna*, 1938. Courtesy of Freud Museum, London.

3.5 André Brouillet, *Un Leçon de Jean-Martin Charcot à Saltpetrière*, 1887, print after the painting of 1875. Courtesy of the Freud Museum, London.

3.6 Display table in Edmund Engelman, *Sigmund Freud's Consulting Room Berggasse 19, Vienna*, 1938. Courtesy of Freud Museum, London.

3.7 Edmund Engelman, view of the images installed at the couch end, *Sigmund Freud's Consulting Room Berggasse 19, Vienna*, 1938. Courtesy of Freud Museum, London.

3.8 Page from Freud's copy of Ludwig Phillippsohn's German–Hebrew illustrated Hebrew Bible, 1858, given to Freud on his thirteenth birthday by Jacob Freud and rebound and regifted in 1891 on Freud's thirtieth birthday. Courtesy of the Freud Museum, London.

3.9 *Freud in his Study*, photograph, *c.* 1905, with reproduction of Michelangelo's *Dying Slave*. Courtesy of Freud Museum, London.

3.10 *Isis Suckling the Infant Horus*, Egyptian, Late Period (26th Dynasty), 664–525 BCE, 21.5cm. Courtesy of Freud Museum.

3.11 *Head of Osiris*, Egyptian, Third Intermediate Period, 1075–716 BCE, bronze, 18cm. Courtesy of Freud Museum, London.

3.12 *Athena*, Roman, first or second century, after a Greek original of fifth century BCE, 104cm. Courtesy of Freud Museum, London.

3.13 Drawing of the dream of the 'Wolfman'. Courtesy of Freud Museum, London.

3.14 *Baubo*, possibly Alexandrian-Roman. Courtesy of Freud Museum, London.

3.15 Line drawing of a Baubo illustrated in Sigmund Freud, *A Mythological Parallel to a Visual Obsession* [1916]. © The Institute of Psychoanalysis and the Hogarth Press for permission to quote from *The Standard Edition of the Complete Psychological Works of Sigmund Freud*, translated and edited by James Strachey. Reprinted by kind permission of The Random House Group.

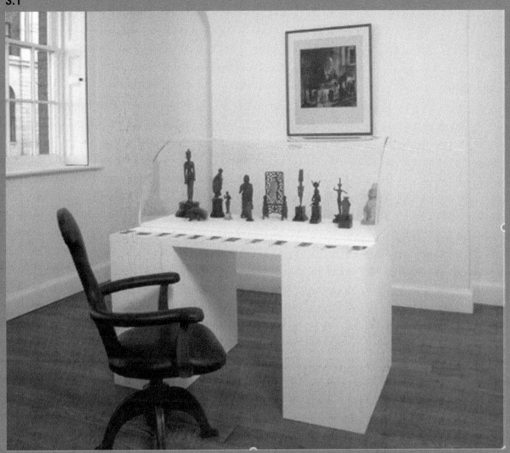

3.1

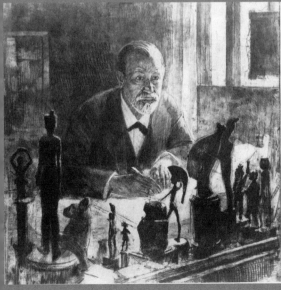

3.2

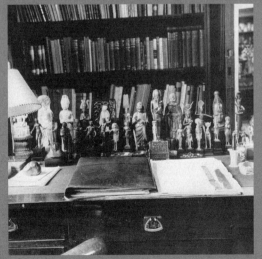

3.3

3.4

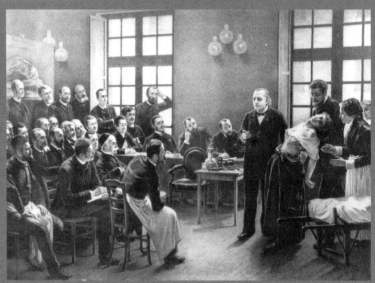

3.5

3.6

3.7

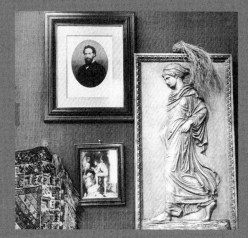

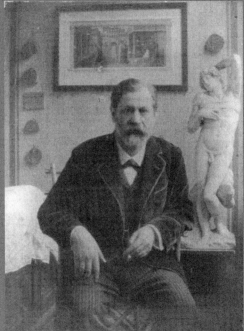

3.9

3.8

3.10

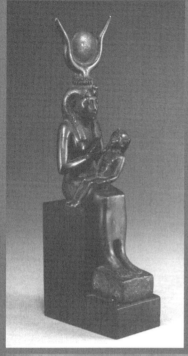

3.11

3.12

3.13

3.14

3.15

3

THE OBJECT'S GAZE IN THE FREUDIAN MUSEUM

I have sacrificed a great deal for my collection of Greek, Roman and Egyptian antiquities, and actually have read more archaeology than psychology.

Sigmund Freud, 1931[1]

As part of the 150th anniversary celebrations of Sigmund Freud's birth during 2006, an exhibition was curated by Jon Wood, first at the Henry Moore Institute. It was subsequently installed at the Freud Museum in London. The exhibition presented the sculptures that populated Freud's desk as an installation (3.1). The visitor was enabled to sit in a replica of the anthropomorphic chair specially designed for Freud by Felix Augenfeld and commissioned by his daughter Mathilde and to occupy the position in which Freud himself confronted, or was confronted by, an array of often tiny, delicate but culturally loaded figurines from Egyptian, Classical and Chinese cultures.

Continuing an interest pioneered by Lynn Gamwell in the 1989 exhibition *Sigmund Freud and Art: His Personal Collection of Antiquities*, Jon Wood was, however, introducing a different perspective. He opposed the ways in which Freud's collection had been presented in the Gamwell publication. There, each item was photographed in aesthetic isolation against a suitably neutral background. Wood argued that the collection on Freud's desk formed a meaningful ensemble; it was a statement that depended on relations, connections, oppositions, conversations both between the viewing subject and the group and between the group's varied members. There exist several images that represent Freud in an intense relationship with these antique sculptures. One is an etching by Max Pollak (1986–70, 3.2); a second is the series of photographs by Edmund Engelman taken in 1938 (3.3) In this chapter I shall explore the Freudian Museum which, by virtue of the science of the mind founded by Freud himself, raises profound questions of archive, time, space and the image. If Freud had merely been a collector of works, classifying and displaying his hoard, this would not be so. Psychoanalysis emerged, it seems, under the object's gaze.

The Freudian virtual museum

If we follow Jon Wood's insight, we must assume that the objects functioned as images and that their arrangement constitutes a Freudian virtual museum; a museum of forgetting and remembering, holding and re-presenting, vivid in the virtualities held before the eye and available to the hand by a plastic form. Art history, as a historical discipline, is ostensibly one of its culture's practices of remembering – hence also of amnesia and repression. Like

other disciplines forged in that gap which modernity created between *milieux de mémoire* (organically maintained environments of social memory) and *lieux de mémoire* (formally created institutions and sites for the manufacture of *historical* memory) which historian Pierre Nora argues gives rise to history and the necessity for the specialist – the historian – art history recovers from traces of the past, left deposit in the present, the possibility of a reconstruction and interpretation of what happened before.[2] But all remembering, all work on the archive, is riddled with complexities of repressions, censorships, blindnesses, and 'holes'. This, now forcibly made to be self-conscious by post-structuralist historiography, we know. Yet we suffer from *Archive Fever – mal d'archive –* the passion of the archive, as Derrida defined it.[3] Derrida made Freud, or rather psychoanalysis, the necessary monitor as well as analyst of that affliction. To study Freud's museum is of necessity to think about the archive with Freud's theses on the divided human mind with its very peculiarly structured relays between memory, amnesia and anamnesis.

Confronting these perplexing documents of the material space of psychoanalysis' genesis, we must ask ourselves: Why did the modern, atheist neuro-psychologist, promoting his new science in a medical practice, live intellectually and affectively in a world populated by such fragmentary image-bearers of its antithesis, namely mytho-poetical, cultic and religious thinking? Why so much pagan art in the place of modern science? Not for Freud Gauguin's Oceania or Picassso's Africa, but the pagan cultures of the ancient worlds: Egypt, China, Greece, India, Etruria and Rome spoke to and of his desire and his childhood dreams framed in a still potent Jewish heritage within a Germano-Christian culture.[4] Psychoanalysis emerges, therefore, in a musealised space, reflecting back to us the modernist consciousness that needs, invests in and mis-remembers the many pasts and prehistories the museum holds in its keeping before its own culture through recovered images.

This is where we can position Sigmund Freud, the contemporary of the great archaeologists such as Schliemann and Evans, the avid reader of nineteenth-century anthropology, who was a passionate collector of antiquities. Edmund Engelman's photographs of Freud's study and consulting room on the eve of his escape in 1938 are as surprising as they should be predictable (3.4). From every surface, and in some cases in assembled cohorts, relics of past civilisations stare back in an addictive confusion as if their owner felt more at home in their enigmatic and silent company than amidst the living beings he treated professionally.

Psychoanalysis does not provide an iconography of the unconscious. It offers a provisional, still troubled and faulty method for working with human subjectivity that it poses as a complex interweaving of corporeal, imaginary and symbolic registers; as a rebus working across what we can only call temporal space which produces an accretion of every element but combined in different levels that oscillate between repressed memory and anamnesis. Thus comparing the historicity of the human individual as socio-psychic subject to the history of human civilisation is not a simple analogy. It is a composite one in which the several metaphors of archaeological excavation – of sedimented ruins and recovered fragments – vie with the anthropological search for the rules by which human cultures make meaning and create/are created by signifying systems.[5] Psychoanalysis lends its hermeneutics to any study of culture. All three disciplines – archaeology, anthropology and art history – see something of importance in those products of individuals in society which are the external, endopsychic forms of this socio-psychic fabric we call human culture. Art history, however, bears more of an affinity with the delusional structure described in *Gradiva* and analysed by Freud's reading of the novel by Jensen. In its institutionalised forms, canonical art history

wants to remain adamantly ignorant of the cultural, gendered, racialising story it is telling without analytical self-consciousness of either repression or displacement.

In Freud's reading of the novella *Gradiva*, the dead, lost object, the revenant, is replaced by the intellectually acute and empathetic Zoë Bertgang, a feminine site of a dis-illusioned knowledge necessary to release Norbert Hanold back into a living rapport with both life and knowledge, desire and futurity. At the end of the story, when the lovers are reconciled and engaged, Norbert asks her one last time to trip across the paving stones of Pompeii, revealing that famous gait. Clearly meant ironically, it serves as a warning about the fixation with the image that leads to fetishism against which even the living intelligence of women investigators cannot stand. Forgetting and remembering are deeply political. The lesson of Freud is that we are made by what we repress and move on only when we are prepared to confront the overdetermination of all knowledge by its structuring repressions: the unconscious which archaeologically determines our actions and feelings from a past that is elsewhere: the other scene. Psychoanalysis does not offer a means of interpreting the image. Rather, it reveals how the image interprets the complexities of subjectivity to us.

The object's gaze

It is one of the truisms of recent cultural theory that Freud initiated a major shift from his teacher Jean-Martin Charcot's highly *visual* regime of nosography which was accompanied by his own, somewhat theatrical, performance – indexed by the famous painting by André Brouillet of Charcot's *Leçon de Mardi*, 1887 (3.5) – a print of which hung in Freud's consulting room in Vienna in the doctor's direct line of sight and took pride of place over the couch in the set-up in the new installation at 20 Maresfield Gardens, London. Writing his obituary in 1893, Freud called Charcot 'un visuel' – a doctor who used the newly invented technologies of photography to document the passage of his epileptoid vision of hysteria that would bequeath to modernist culture a whole new repertoire – iconography – of the female body avidly taken up by Degas and passed on by Picasso into twentieth-century popular culture. Charcot also collected paintings and prints for his other famous publication *Les Demoniaques dans l'art* (Paris, 1887). Contrary to what Brouillet presents as the medical scene of hysteria in which the mute woman is pathologised in her submission to a field of masculine, epistemophilic gazes, Freudian psychoanalysis is said to take place 'blind'. But this is not for any apparently theoretical reason. Freud created his protected position vis-à-vis the analysand because he could not bear to be stared at all day – seeing eight patients a day would have submitted him to relentless gazing. Freud thus testifies to a certain understandable anxiety around being constantly looked at – even stared at – having to engage in constant eye contact with another, which I hope to show plays a vital role in his surrounding himself, at work, with embodied gazes in the form of figurative sculpture of human forms and faces. Thus in analytical work, Freud secluded himself behind the head of the patients while he, however, could still survey their faces and bodies which, of course, can also be loquacious, becoming especially eloquent in the verbal silences. Freud's analytical theatre is, therefore, a complex space of dislocated vision, focusing, as the general argument goes, on the acoustic rapport between analyst and analysand, and specifically on language as the scene periodically deformed and unwittingly determined from the unconscious, for whose movement the analyst is listening in order to determine the cause of psychic distress and the manner of its narrative amelioration.

Yet, according to our photographic evidence, the scene of analysis is intensely visual in its

mis-en-scène (3.4). Why did psychoanalysis emerge in the presence of so much imagery? Why did Freud, the atheist neurologist, seek to situate his modern scientific clinical practice surrounded by the miniature monuments of pagan antiquities that introduced into the scene of transferential analytical work the silent gaze of so many others? How must we understand psychoanalysis – the study of 'the private memory-theatre of the analysand' – emerging in this private museum of the analyst? What possible resources might we find on closer examination of Freud's museum for a feminist intervention into the conceptual as well as the material culture of musealised art history?

With the documentation of the home and work spaces of the Freud family at Berggasse 19 taken surreptitiously by the young photographer Edmund Engelman under the perpetual gaze of the Gestapo who were checking that no objects of value were being smuggled out of the professor's house without paying due charges, we now encounter spaces almost shocking in how much they offer to the eye. The rooms around Freud are filled, with books, obviously, but also with his by then extensive collection of antiquities. As Jon Wood has suggested, we can distinguish between key installations and those other objects carefully musealised in glass cases and thus made a spectacle precisely by being housed inside display cabinets as collected series of works, glass, bowls, statuettes and so forth. Untouchable and remote, they represent collecting, owning, compiling in the pre-modern sense; a cabinet of curiosities not yet ordered by the museum's stricter classifications and isolation. Wood's modernist isolation of the statues in his exhibition of the desk reminds us of a different kind of display that fosters a visual and even tactile intimacy between the object and the subject who inhabits the same space with what s/he is viewing.

Two sets of objects in Freud's consulting and study rooms interest me: the table display in the consulting room and that on his desk. The display on the table in the consulting room lies in the analyst's – Freud's – direct line of sight (3.6) but is not available to the analysand who is instead gazed down upon by a print of the Great Sphinx at Geza (whose sightless gaze is directed at the analysand) or who might catch out of the corner of an eye the lively tread of the nympha *Gradiva*, accompanied by a tiny black and white photograph of Ingres' *Oedipus* (Paris, Musée du Louvre) solving the riddle of the shadowy Sphinx of Thebes where another dead foot emerges in the yellowed tones of the recently mortified (3.7).

In his exploration of Freud and Judaism, historian Hayyim Yerushalmi has already noted that only some of Engelmann's photographs of this table display two Kiddush cups – the special goblets used for wine during the Kabbalat Shabbat, the welcoming of the Sabbath home ceremonies – ceremonies that, much to Marthe Bernays' dismay and eternal pain, Freud absolutely forbade in his atheistic household. No doubt inherited from his father and mother, these cups serve Yerushalmi as indexes of Freud's relation to a religious Jewish tradition. I would argue, however, that any such relation is thus re-positioned by the display on the plane of a larger cultural history and memory, taking its place with his collection of other bowls, jars, goblets, all container forms, some of which we can see on the shelves behind this table display. The bowl is both the most basic in a utilitarian sense and the most charged with corporeal and symbolic significance. The bowl, the cup, the goblet, and all those combinations of containment that also connect with orality, support an image-fantasy that is at once connected with the primary container and nourisher, the mother and with the archaic moments of oral bliss of the infant drinker.

Seen frontally in another photograph, many of this collection of items are Egyptian wooden funerary figures, six of which are human in form. The aniconic goblets which carry the implicit signification of holding and hence nourishment appear momentarily with the

foregrounding of the iconic reminders of death. Falcon-headed Horus is almost hidden behind a male figure on the left – one of the few with animal head forms. On the shelves above are Buddhas, a classical Greek head and an Egyptian Uraeus – the erect cobra – the phallic but also feminine-eternal emblem of everlasting Pharonic power. In notes on the Engelman photographs, Rita Ranshoff references the Horus image to a story Freud told about an anxiety dream he had around the age of 7 or 8 in which he:

> saw my beloved mother, with a peculiarly peaceful, sleeping expression on her features, being carried into a room by two (or three) people with birds' beaks and laid upon a bed. I awoke in tears and interrupted my parents' sleep. The strangely draped and unnaturally tall figures with birds' beaks were derived from illustrations to the Philippson's Bible (3.8). I fancy they must have been gods with falcon's heads from an ancient Egyptian funerary relief.

'In his self-analysis,' concludes Ranshoff, 'the anxiety is traced "to an obscure and evidently sexual craving that had found appropriate expression in the visual content of the dream".'[6]

This anecdote brings three things into view. The selection of specific items for the collection was pre-shaped by their echoing of Freud's formative childhood memories. Second, these memories themselves were the already encrypted visualisations of even earlier, *obscure 'cravings'* that, however, generate anxiety when they recur in these occluded and haunting forms: dreams populated by borrowed images. What if these antiquities not only hold their own historical memories as memory-bearers but become, through entering other networks of association and psychological history, the memory-bearers of the subject Freud – the analyst/analysand?

Many scholars have noted the coincidence of the death of Freud's father, Jacob, in October 1896, Freud's first trip to Florence in the autumn of 1896 which we think was the first occasion on which Freud bought plaster copies of sculpture and photogravures or prints of paintings (Letter to Fliess, December 1896) (3.9) and the genesis of the first major book of psychoanalysis, *The Interpretation of Dreams* (published late in 1899 but dated 1900) which was the product of Freud's own self-analysis following the death of his father during which he abandoned his trauma theory of hysteria, rooted in seduction, and 'discovered' the deepest core of psychoanalysis: the Oedipus Complex; or perhaps we should say he identified the traumatic structuring of the human subject into gender and sexuality at the intersection of language and the cultural law of the incest taboo which delimits the acceptable field of human desire and displaces it from its genesis in intense rivalry with, and attachment to, the parental couple. Endowing this shockingly counter-intuitive psychic structure with the respectability of Greek tragedy – Greekness being synonymous with both civilisation and Germanness at that time – and its legends, the topic is equally present, but differently, in Egyptian mythology in the quartet of Isis, Osiris, Seth and Horus.

In 'If Freud was an Egyptian', Joan Raphael-Leff has raised the question of why Greek versus Egyptian mythology in Freud. Raphael-Leff argues that the legend of Osiris and Isis with Horus, their strangely conceived child, would have served better the purposes of psychoanalysis than the incestuous myth of Oedipus and his murderous parents, not only because the Egyptian myth deals with a more complex network of generational and intergenerational conflicts that were resolved with the promise of new life but because it is altogether less melancholic and tragic than the Oedipus myth and its bonds of the Mother and the Son.[7]

Statues of Osiris, Isis and Horus appear on the doctor's desk (3.10 and 3.11) – the second scene in which Freud's gaze directly encountered what all note as a kind of audience when he sat to write, to undertake his own creative thinking, dreaming, planning and discovery (3.2 and 3.3). The figure of Isis with Horus at her breast is one of the latest of Freud's acquisitions offered to Freud by his dealer Robert Lustig in the mid-1930s. This tiny piece suggests the origin of the Madonna and Child iconography in the much more ancient and extensive Mediterranean world cults of Isis, the cow goddess, and as such bears witness to persistence.[8] It is interesting that Horus, the son of Isis and her lifelong companion, is not identified in the account of the dream of Freud's dead mother that only speaks of figures with birds' beaks rather than acknowledging the falcon-headed son as the figure bearing his beloved mother to her sleeping grave. The dream work moves through the graphic reproductions of Egyptian statuary presented in the Philippson Bible to stage, in the necessary displacement and condensation of dream forms, feelings that Freud presents as sexual cravings – a hidden infantile desire to sleep with his mother or to gaze upon her in sleep – hence to be her intimate. Secreted within that is both a wish for and a terror of her death. It would seem to me, therefore, that the initiation of collecting after the death of Jacob, which left Horus-Sigmund with Isis-Amalia Freud, and the collecting of statuary, of sculptures that embodied the drawn figures from his childhood Bible, signals a particular dynamic that is overdetermined in relation to Egyptian sculpture.

So much of what could be collected after the expanding archaeological rediscovery of Pharonic Egypt initiated by Napoleon's conquest in the 1790s was funerary. The excavated objects had been buried with the dead, and preserved by this burial – a condition Freud would use to explain to his patients the nature of the unconscious as the preserving burial of the archaic history of the subject. Freud's whole thesis of subjectivity – thought through contemporary, *archaeological*, metaphors – functions as the atheist's adult rejection of the infantile comforts of religious ideas of resurrection and eternal afterlife that are lined with, and comforted by, another notion of persistence – the persistence in the crypted unconscious of the impossible loves and terrifying fears of infancy. Freud's final work at the desk which Engelman photographed was *Moses and Monotheism*, a profound and brilliant psychoanalytical thinking through of the dynamics of cultural memory, of tradition, persistence and sustaining identifications of an apparently aniconic people.

The overt content of Freud's book on the origins of religion and specifically the meaning of Moses is the proposition that an ethical monotheism, Judaism, was created by an exiled Egyptian follower of Akhenaten; that the people upon whom he tried to impose his religion rebelled and murdered him; that the Mosaic tradition survived with a remnant, the Levites; that a memory trace of the murder survived in oral rather than official tradition; that varied hybrid compromises followed the murder; that eventually the trauma of the repressed murder returned in the distorted form of an elevating and resilient acceptance of the rigours of the once-repudiated Mosaic system which became the defining character of a collective identity. Mosaic monotheism then provided those who embraced it with an unshakeable self-respect based on the grandeur of the One, the unique creator deity that had 'chosen them' and on the ethical elevation and intellectual uplift provided by the aniconic call for social justice and righteousness in place of gratification of instinctual, infantile pleasures managed through ritual and sacrifice. The core problem of tradition, Freud reveals, is not persistence; time can only weaken the grip of the original events. The challenge is to theorise both the 'gap' between the murderous event as an acting out of violent emotions and its re-inscription in a distorted form through the concept of a *return of the repressed* – a

presence of repressed materials that will unconsciously shape and impress even the mode of amnesia. Religion, then, or what Freud saw it as cultural tradition that marks the interface of individual and social identity, is not the cause so much as the site of this symptomology, a field where a psychoanalyst can read both aspects of the historical constitution of human subjectivity and our recurring attachments to those repressed foundational fantasies that, however, only our repetitions activate as their foundations.

What makes Freud's argument *psychoanalytical* is the attention to three core mechanisms: trauma, latency and return of the repressed. Many cultural theorists express dissatisfaction with the current use of psychoanalytically based trauma theories in cultural studies. They cannot see how we can move from individual psychological mechanisms of psychic registration and repetition to thinking about similar formations in historical, group experience. This is precisely what Freud addressed in this final text. Freud suggests that if the individual subject is an archaeological palimpsest of his/her own formation that is itself shaped not only by contingent biographical events but by constitutional factors such as language, so too we might allow ourselves to consider human history as such a sedimentation of its own formations and relays between the contingency of individual histories and structural predispositions that make society/culture possible – such as shared systems from ritual to language. These are traumatically impressed and subject to returns of repressed materials, unarchived secrets, that allow us to discern patterns in their repetitions even if we do not yet have a full theory of the mechanisms of transgenerational transmission.

Freud hints that it is precisely where those general elements of a human social formation are psychologically significant and emotionally charged for each individual subject *qua* human that the strings of cultural memory link individuals into group formations in a kind of mirroring exchange that is not identity but individually re-enacted identification on a group scale. This is, therefore, not the collective unconscious in any way. Freud offers a real, if still flawed, attempt to theorise precisely how the *dynamics* of culture, of the archive as depository and haunted house, catch us individually, but also generationally and in groups, within traditions that persist only through that animation provided by actual people's emotional/psychological repeating investments, charged up in each case by their own traumatic surpluses from the crucible of both historically singular and psychologically structural infantile experience. The relevance of this investigation to the moment that witnessed the mass mobilisations of fascism needs little underlining.

The key concept is trauma: that is, 'early impressions experienced early and forgotten later to which we attach great importance in the aetiology of neuroses'. Trauma can either be positive – impelling us to repeat its originary situations in the search for repeated gratifications – or negative, causing us to bury all traces. The power of the cultural bond that makes the Jewish people a people, providing the cultural cement, is not mere persistence through social repetition – the Halbwachs thesis on collective memory that inevitably becomes an alibi for nationalism.[9] Nor is it phylogentically based: an alibi for essentialism and racism. Tradition acquires its power from the *rupture* created by the negotiation of conflict, the effect of the rebellion and its aftermath of guilt. This gap is the now much abused concept in trauma theory of latency.[10] Cultural historian Jan Assman, who has taken up the challenge of this question of cultural memory, notably through his studies of the Moses question in Egyptian history, remarks:

> Freud's great discovery and lasting contribution to this discourse is the role he
> attributed to the dynamics of memory and the return of the repressed . . . one

should acknowledge that the concepts of latency and the return of the repressed are indispensable for any adequate theory of cultural memory. They need, however, to be redefined in cultural terms. Freud reminded us of the fact that there is no such thing as 'cultural forgetting' or even 'cultural repression'. Since Freud, no theory of cultural can afford not to take these concepts into consideration.[11]

In a book that fascinatingly juxtaposes the first and last of Freud's major writings, Ilse Grubrich-Simitis' *Freud's Study of Moses as a Daydream* was combined with a later article on the earliest of Freud's published psychoanalytical studies, *Studies in Hysteria*, of 1895. Grubrich-Simitis argues that there is a thread which ties the early to the late Freud: they represent two completely different stages in the development of the psychoanalytical concept of trauma.[12] In the early trauma theory, neuroses are predicated on an event, an external shock such as parental seduction or witnessing the primal scene whose effects are registered in delayed fashion because of the child's psychic prematurity and the intervention of primal repression. 'This' clearly happens and does generate the after-effects of trauma. With the beginnings of Freud's own analysis, however, in the later 1890s, Freud also theorised a complex internal world of the subject shaped by drive theory. Unlike the trauma theory with its exceptionality of external events, drive theory addresses 'the psychogenesis of everyone'[13] by plotting out the impressing structure of the drives that form a register of infantile psychic experiences. These become the unconscious matrix of adult psychological life. Ilse Grubrich-Simitis speculates that late Freud was seeking to reconcile these different theories. Could he think through both the impact of a real, external historical trauma, posited by the anthropology of religion, and one being visibly enacted in a contemporary political situation that might also explain, psychologically, the force of cultural patterns in which what must be analysed as a means of liberating us from their current danger is the structure that keeps initiating a return of the murderous repressed against a specific teaching: the Mosaic now embodied in those designated as Jews?

By plotting out the histories of Egyptian Aten monotheism, Judaism, Greek religion and Christianity with its still vivid pagan underbelly, Freud was struggling to interpret the then current ideologies of anti-Semitism that threatened his and others' lives on the basis of a genocidal paranoia about the Jewish people, a Nazism that had rhetorically already called for their extinction. He had to offer a *psychoanalytical* interpretation of the deep, constitutional structure of human culture, taking varied historical forms, sometimes encoded as religious tradition, which remained dynamic and were being ever more potently mobilised in politically appropriated pseudo-religious anti-Christian forms such as fascism. In modern times, therefore, the structure had migrated into secular, political ideologies, emotively more effective by virtue of that migration. These psychic forces provided the drive-based and identificatory resources exploited and harnessed by the political aesthetic of Nazism, what Benjamin termed the aestheticisation of politics, that in the 1930s claimed the passionate attachment of German masses to a fascist demagogue through the orchestration of spectacle, emotion, anxieties, paranoias and longings for reconsolidation of threatened boundaries and destablised, injured narcissicisms.

Freud, it may be said, was attempting to create a *non-fascist* response to the conditions of psychic disintegration aggravated *en masse* in periods of profound political and economic destabilisation: very pertinent to current political problematics of defensive fundamentalisms and xenophobic anti-immigration conservatisms in Europe. Instead of essentialising collective memory, Freud wanted to explain the phenomenon of the *massification* of singular

psychic crises.[14] Writing in 1951 on the mass psychological base of fascism, Theodor Adorno drew on Freud to show how group processes repeat individual conflicts and provide the permitted space for a release of individuals from unconscious repressions that are part of the civilising process. Thus mass movements are not made up of primitive men; they are formed by people who are allowed to display archaic impulses 'contrary to their normal rational behaviour'. The move from violent emotions to violent actions in fascist politics is not so much imaginary as prehistoric. The actualised destructiveness of fascism is itself testament to such a primordial violence which now emerges in rebellion against civilisation in a manner that Adorno argues is not simply the recurrence of the archaic but is its reproduction in and by civilisation/culture itself.[15]

The invisible other of Freud's Moses text, therefore, the counter-image that is its haunting spectre, are the Nuremburg Rallies and the iconisation of a Führer, in whose fascist excesses of aesthetic manipulation of anxiety, paranoia and narcissistic mortification we can see the dangerous opposite of the aniconic vision of an ethical monotheism which Freud deduces idealistically from his depiction of the religion offered to the world by Moses *the Egyptian*.

Religions draw their power from the 'acting out' rather than from a therapeutic, dynamic remembering of primal impulses that are murderous. Idealisation of the father is shattered by some discovery of his failures. Recall Freud's disappointment at Jacob Freud's submission to the anti-Semite who knocked off his hat. To compensate and shield the boy-child's narcissism that was once enhanced by the idealised but now dethroned father, a hero figure is phantasied as an identification. Traces of the powerful feelings for the father and the child's own (reparative) phantasies of omnipotence are projected on to the hero. Psychoanalytically, Nazi fascism both punished the failed fathers of traditional Germany's old and new cultural establishment and offered the comfort of an even more omnipotent and authoritarian ego-ideal disguised in the form of the hero, following the classic legend of the lowly soldier elevated to absolute power (the very opposite of the Moses legend). Reading Freud himself psychoanalytically, Grubrich-Simitis argues that Freud was haunted by his own archaic, murderous wishes towards the sibling Julius, who supplanted him at his young mother's breast, an intense and dangerous wish that appeared to have been realised when the unfortunate baby died early, casting his mother into profound grief. Freud transposed this discovered force in his own psychic life to a larger picture, deriving its power not from historical documentation but from the symptomology of culture as repetition, in the form of the social as a form of amnesiac memory – the return of the repressed wishes that stem from the crucible of human experience, the pre-verbal hence traumatic intensities of infancy, with all their rivalries, hierarchies, devotions, narcissism, libidinal investments: *drive theory*.

Freud's image of Mosaic monotheism is not, I suggest, the product of his ambivalent Jewish identity. He was confidently what Isaac Deutscher anatomised as the 'non-Jewish Jew', a Jewish atheist.[16] He portrays monotheism as the humanising discovery of unpleasant truths about what is necessary for social existence: rules, prohibitions, subjection of the pleasure principle to the reality principle, internalisation of a super-ego, and sublimation – the domination of *Sinnlichkeit* by *Geistigkeit*. Sensuality or indulgence in immediate gratification is opposed to something that lies between the English words spirituality (too religious) and intellectuality (too cerebral). By *Geistigkeit* we might understand the adult capacity for reasoned rather than rationalistic judgement and self-management with an eye towards self-elevation beyond immediate and bodily pleasures. *Geistigkeit* is not a natural given of rational

man – the broken reed of Enlightenment modernity; it is an always fragile victory willed only by psychologically honest self-understanding and acknowledgement of guilt for the dangerous power of our counter-impulses generated in the intense moments when we are written into human becoming by the force of drives and our emerging passions and hatreds. For Freud, psychoanalysis must replace religion as the mode of cultural memory in order to make each individual responsible for the psychic freight he/she invests in the social whole which can work for progress, *Fortschritten in die Geistigkeit*, or which can fall into regressions into asocial, unethical but mass submission to the infantile drives solicited and culturally enacted by fascism's success.

So the Jewish people defined by Freud becomes the paradoxical example of growing up on the basis of guilt. First comes a rebellion of childish violence resisting the imposed authority of the adult, the Father, the rule of culture that decrees the incest taboo and makes possible the sublimations on which adult and social creativity are built. That is the first stage which creates the conditions for the coming into being. The guilt associated with the uncognised return of the repressed – the murderous revolt – forms the psychological motor for the assumption, as a dynamic rather than a residual tradition, of the very discipline that was initially rejected. This assumption transforms the very terms of subjective experience with a positive and enhanced sense of self that both founds self-respect, but also, unfortunately, attracts the violence of those unprepared to take the same step. In fact, the core of Freud's thesis is precisely an argument that cultural memory acquires its potency from the gap – the mark of the traumatic past and the delayed reaction to the trauma out of which a cultural form is made as fidelity to the demanding vision of a human sociality built on a justice that disciplines us against the violence of narcissistic infantile wishes to kill, to have, to disregard others for the sake of immediate pleasures. Far from specifying a genetic or phylogenetic inheritance of any sort, Freud was theorising a possible response from within the very out-group currently turned on by the fascist masses in the 1930s that might counter the latter's *current* rebellion against Enlightenment generalisation – i.e. departicularisation – of Mosaic human ethical sociality which aspired to make religion redundant in the name of social, non-theistic principles such as ethics, justice and realism.[17]

Playing between the social realm of political terror and Freud's self-analysis of the early traumas of the arrival and death of his mother's second child, Grubrich-Simitis addresses what Freud could not acknowledge, what his self-analysis began to reveal as he struggled with the traumatic anxieties generated by the rise of fascism. His insistently Oedipal story of rebellious sons and overwhelming father-worship screened the force of earlier traumatic impressions that involved experiences of isolation, loss, discontinuity and instability in the *mother*/child bond staged before him in the tiny statuette (3.9). It was loss of the archaic mother that was reactivated for Freud by the threatened loss of home and birthplace – as a result of the rise of fascism – which could become the trigger for an overpowering traumatic repetition. Grubrich-Simitis suggests that such inchoate and disintegrating anxieties were released in the octogenarian by the terrors of Nazism and the imperative to flee, jaggedly inscribing their pain into the compulsively rewritten text that served as a daydream escape into a vision of a world in which the outcome of a paternal murder – identified inevitably with his own professional assassination hidden in the Moses legend – was the gain of a victory of ethical social justice, a means to enhance sociality by a renunciation of the instincts which is the project of psychoanalysis.

If Freud is correct that the Moses murder was passed on both through fragmentary survivals in oral tradition that insinuated themselves as traces even in canonical biblical texts

and through unconscious traces that pressed negatively on the texts as repressions (a point accepted by Derrida), and if Freud is correct in suggesting that that which acquires the compulsive power to be repeated as religion is both secondary repetition and repression of an even more ancient murder of the primal father, where, we must ask, are the traces of that which even these stories screen and render secret?[18] Where are the traces, except in their almost total repression, of the other powerful archaic presence: the Mother, the transformational subjectivising figure of early pre- and post-natal becomings?

In his Moses text, Freud does briefly insert a matriarchal phase in his hypothetical history of religions between the primal horde (where the sons rebel and kill their overweening father, whom they later resurrect through the totem they ritualistically consume in annual festivals) and the revival of worship of the father god. Even in its brevity Freud intimates that the mother–child bond is also capable of giving rise to an ethics and a structure of sociality. But he radically eviscerates its potency by allowing it only a transitional place in his psychoanalytical anthropology. This hardly remembered and theoretically proscribed repression opens the space for feminist cultural analysis as *my* political daydream in a newly fascist and dangerous world that is trying to cast feminism back into a historical waste bin (as another brief moment between two kinds of phallocentrism). Julia Kristeva and others have dared to suggest, in the study of the sacred and the feminine, that this censorship of the maternal puts our human survival at risk from the murderously rebellious and damaged sons and equally aggressive and disinformed daughters. Kristeva defines maternity as a structure: a structuring rather that transforms the violence of eroticism into the tenderness that allows the other to live. Kristeva claims:

> Outside motherhood, no situations exist in human experience that so radically and so simply bring us face to face with that emergence of the other. I like to think that in our human adventure, we can encounter 'the other' – sometimes, rarely – if, and only if, we, men and women, are capable of that maternal experience, which defers eroticism into tenderness and makes an 'object' an 'other me'.[19]

In contradistinction to a Christian concept of the resurrection of the eternal spirit liberated from the decaying materiality of the body returned to the earth to rot, Egyptian culture believed passionately in persistence and thus prepared bodies and their surrogate attendants for eternity in dry Mediterranean caves hewn from the desert rock. Egyptian high culture was dedicated to its cult of the dead as its fetish against the unthinkable mortality of the selectively elevated human subject. Death cannot be represented as such: yet this was the culture that focused vast wealth and creative energy and ritual upon its negation – and monumentalisation. Fetishism – one of Freud's great discoveries as the capacity to sustain incompatible knowledges simultaneously to disavow and memorialise in the same monument – arises in relation to love and death before the issue of sexual difference – to which I will return.

In his essay on 'the Uncanny' [*Das Unheimliche*], 1919, Freud defines that curious thing, the uncanny, lying between concept and domain as an effect to two possible conditions: the return of what was once familiar but later repressed (this concerns castration and interuterine anxieties), and the revival of infantile beliefs later surmounted by adult understanding, such as led one to believe in the omnipotence of one's thoughts. Freud admitted to his murderous jealousy of his mother's second son who died at the age of 10 months – a searing memory that seemed to have confirmed the toddler Sigmund in the dangerous

power of his own murderous thoughts. In his essay on the uncanny, Freud disowns his susceptibility to uncanny sensations of the first order. Yet he decides to use himself as experimental object – and brings back into view this specific cause of uncanny anxiety: the power of thoughts.

While scrupulously avoiding any reductive biographical reading, I want to plot out the field of memories, thoughts and politically precipitated anxieties held in creative partnership by the presence of these largely funerary statues – these comforting companions in Egyptian death and afterlife – for a man whose brilliance lay in daring to confront within himself the humbling and disintegrating forces of infantile feelings and fantasies, daring to use that insight to recognise and map out these movements in others, so that psychology moved beyond a science of individual abnormality and pathology to become a genuinely post-religious humanistic study of subjectivity's multiple temporalities and conditions. Beyond that lies the insight that subjectivity, while experienced intensely at the personal and individual level, is in fact a historical and cultural process that may be traced through many registers and modes: language and its aporias, images and their distortions, jokes, parapraxes and so on. Without knowing each other, I think Freud shared with Warburg a concept of a psychology of the image – the image as a kind of cultural memory-bearer, a register of common feelings, anxieties and desires.[20]

But far from agreeing with the bourgeois myths of his time that blinded the bourgeoisie to the necessity for seeing that we are not going anywhere (delusions of progress) but are fated to repetition unless we took responsibility for it, Freud refused a progressivist telos. Thus his engagement with antiquities of Egypt, China, Asia and the Mediterranean was comparable to Aby Warburg's anti-Winckelmannian stance. Warburg did not look back to Greece to find perfect, self-consolidating origins, to find a mirror of unacknowledged sexual or ethnocentric desires. For Freud, the sculptures were not erotic others (although this is not to say that they could not as objects become tactile objects) as Antoninus was for Winckelmann. They related more to the intertwining of death and thought.

The antiquities held before Freud's contemplative and listening gaze in the consulting room, or musing and reflecting when looking up from his writing paper in his study, an interrogative otherness that challenged the delusions of modern bourgeois Enlightenment, while also confirming Freud's atheistic vision of the necessity of confronting the powerful impulses and fears that drive the human subject, but which, sacrificed to cultural law, allow us to become adult, creative, loving, thinking and self-aware. Like Kant, he wanted to help us to cease to be children; and, in some profound way, the embodiment of desire or anxiety in aesthetic forms that offered the uncanniness of a double of the human presence, already pointed the way to sublimation: to creative transformation of the core impulses and anxieties that were both index of them and symbolic transformation, while holding a reminder of such intensities in an aesthetic projection before our contemplation: a creation through the image of the space for thought and self-analysis.

Sometimes a statue is only a statue, concludes Freud's biographer Peter Gay. Yet no one approaching Freud's collection of antiquities can resist some psychological speculations about the meaning of his collecting per se and the significance of what he collected in Freud's own psychic life. We have already noted, as do all commentators, the suggestive correlation between the date of his earliest purchases – reported in a letter to Fliess in December 1896 and the death of his father Jacob Freud following a lengthy illness in October 1896. Freed from the financial burden of maintaining his ailing parent, Freud's limited income could now be spent on something that he also named in this same letter as a

source of exceptional renewal or comfort. Mourning, money, fathers and projective identification are immediately in play around the first acquisitions of casts and prints of Florentine works encountered in the still uncorroborated trips to Florence in the autumn of 1896 while his father was dying. The photograph of *c.* 1905 (3.9) which shows Freud with a print from the Brancacci chapel and a plaster copy of Michelangelo's dying slave interestingly juxtaposes the now middle-aged son-doctor with the beautifully pathetic body of the bound young man – not the dying elderly one. It is Freud's gaze that confronts the viewer, framed by the two works and other fragments on the wall. This image contrasts powerfully with a photograph taken in 1938 by Edmund Engelman (3.3). His camera arrives in the empty spaces during Freud's absences and thus the photograph of Freud's desk with which we are now all so familiar occupies Freud's own point of view, setting us to encounter the carefully organised display of tiny statues arrayed on the desk framing the large leather folder which holds the final manuscript of Freud's literary *oeuvre Der Mann Moses*, known to us as 'Moses and Monotheism'.

Freud conceived and practised psychoanalysis as an ethical project in the continuous analysis of history – obviously the histories of each subject who came to him as a patient. He also traced a cultural history of human societies in what are often now found to be embarrassing anthropological speculations such as *Totem and Taboo*. In this he belongs as a hinge figure between the formations of new disciplines such as archaeology and anthropology during the later nineteenth century and their twentieth-century consolidation as university sciences. It was through this combination that Freud appears to be practising a kind of Warburgian art history in which the image is if not specifically a *pathos formel*, functions, none the less, as a transmitter of what Warburg would seek as a psychology of the image. Freud's writings on literature form the basis of many readings for and of a psychoanalytical aesthetics. We have Freud's initially anonymous essay on Michelangelo's *Moses* – the only major text on a work of visual art apart from the study of Leonard's Double Mothers in his painting of the *Virgin and Child with St John and St Anne*. Yet the practice of collecting images, investing scarce financial resources in this particular passion, suggests a meaning in the accumulated works that shared his thinking, writing and doctoring spaces, cluttering their surfaces, filling numerous cabinets and accompanying him on his intellectual journeys as much as those of his patients.

Not an antiquarian or an aesthete, Freud's relation with the sculptures he collected was an active one and deeply embedded in the creation of psychoanalysis and a practice of anamnesis as a decoding of memory. The images constitute a mnemonic of a culture. They are fundamentally fetishes that mark the spaces of psychological anxiety in cultural forms that both pre-date the scientific exposition through psychoanalysis of the structures and substance of human subjectivity, and offer a mute consolation of its premises.

While Freud found repeatedly in literature from Hoffman to Shakespeare, Sophocles to Jensen and Dostoievsky verbal evidence that the poets and writers already intimated what psychoanalysis would articulate both as topic – castration anxiety and return of the repressed – and as structure – delusion, repression and obsession – the sculptured image was mute. Condensed into a single unity, its meanings resisted incorporation into his explanatory systems. Yet these sculpted images held key mysteries before him in a plastic form that rendered them human surrogates – even on their tiny scale. Companions in his work, the images functioned as forms of memory, coded like a dream in which the formal representational elements become affect-ladened signifiers for a signified otherwise inexpressible: in which the body can be an alphabet for the psychic: hysteria.[21] To overcome the classical and

Christian splitting of mind or soul from body, to deliver us from the derogation of the body as lowly, earthly, transient, with the mind as in-dwelling spirit that death releases for its eternal de-corporealised life, Freud's most challenging work of 1905 – we believe the date of this photograph – concerned sexuality. It is my contention that his *Three Essays on Sexuality* propose a theory of the subject in which sexuality, far from being an inchoate, inborn force, is complexly constituted and is precisely what makes us human, what provides the energies for human creativity, ambition and pleasure.[22] Thus we struggle continuously to grasp the implications of psychoanalysis insofar as it was so radically modern in its supersession of the hierarchies of mind and body that had dominated Western culture, anxiously articulated through Helleno-Christian concepts of the immortal soul and sinful body.

What if we think about the mute presence of pagan sculptures as something Freud recognised, therefore, as significant for his project, but could not theorise: something that would have to do with their plasticity, their use of the human form, their endowment of a representation of a body with a presence that is a kind of metaphor for a psychoanalytical conception of human subjectivity as a psychically charged materiality, a living being burdened by the knowledge of his own finitude?

In the light of this speculation I want to look again at the etching by Max Pollak dated to 1914 (3.2). Freud is shown seated at his desk, meditating at a point beyond and framed by his collection shown in dramatic *contrejour*. Lynn Gamwell talks of the desk array functioning as an audience for Freud at work. Pollak's dramatic chiaroscuro makes the encounter far more charged. It is as if Freud and his writing are somewhat encircled by the incoming gaze of the objects. Psychoanalysis is known primarliy as an acoustic practice, shielding both analyst and analysand from the interrogating medical gaze associated with Charcot. This representation of a visual encounter between Freud the analyst/writer and the objects that, although tiny in form, are endowed by us with the power to allure our looking and create a field of reciprocal vision reveals the charge of that encounter. As we know from *Moses and Monotheism*, Freud spent hours looking, and no doubt did so while listening to patients, and when writing, inviting his objects out of their cases to function as interlocutors, bearers of meanings of human histories he was replotting through his writings. In a way, the interrupted presence of his passing patients is contrasted with the constant and accumulating accompaniment by the sculptures which he allowed to gaze constantly at him.

In 1914, Freud has a much more sparse array than is shown in Engelman's 1938 photograph of the desk (3.4). Central is the superb bronze head of Osiris (3.11), the identificatory other perhaps of Freud himself. But there is also a very tiny stuatuette of Athena (3.12) in the centre of the antiquities on the desk: her presence brings me finally to the interlocking of themes of gazing and of constitutive anxiety: castration casting this whole structure however entirely into the masculine – where it can only be because of Freud's honesty; he could only speak from and to the specificity of his anxieties as a man – which, in this case, exceeds the distinctions between masculine sexualities.

On the breast of Athena is the Gorgon Medusa's head, an image that condenses the displaced relation between looking at and seeing the apparently deficient genital formation of the female body – which is at the same time the discovery of the mother's sex from which one issued as her by-product – her shit, not to put too fine a point on it. This latter aspect could not even be admitted by Freud, although feminist psychoanalysts have dared to confront it.[23] Ferenczi was the first to identify in the Medusa a registration or reflection of this trauma:

In the analysis of dreams and fantasies, I have come repeatedly upon the circumstance that the head of Medusa is the terrible symbol of the female genital region, the details of which are displaced from below upwards. The many serpents that surround her head ought – in representation by the opposite – to signify the absence of a penis, and the phantom is itself the frightful impression made on a child by the penis-less, castrated genital. The fearful and alarming starting eyes of the Medusa head have also the secondary meaning of erection.[24]

Freud had already begun to think about the equation: *to decapitate = to castrate*.[25] (Osiris survives as a head; in the myth the only part of him never recovered by his widow after his brother cut his body into pieces was his penis.) The terror of Medusa is thus read as the complex and paradoxical imaging of the terror of castration linked to the sight of something. The abstract anxiety about mutilation or annihilation of the narcissistic whole self is signified in the field of vision, in relation to a sight that operates both as threat and reassurance. Thus Medusa is the castrated feminine whose genital insufficiency has been displaced to the face, where facial elements – hair and eyes – take on, and thus restore, phallic functions. The apparent absence that causes the terror is allayed by multiplying phalloi on her head. The sight of Medusa, however, makes the viewer stiff with terror – arousing the male member into comforting erection which the eyes both stand for and create while holding terror and compensation in the same sight. We can usefully juxtapose here the famous drawing of the wolves dreamt by the Wolfman (3.13) – whose erect tales and staring eyes functioned as this kind of doubled image of castration anxiety with the decapitated head fragments arrayed in Freud's study – to catch the aspect of the object's gaze that seems to me so striking in analysing not merely the collection – the repetitions and multiplications – but the frontal form of their display within which Freud placed himself. It is the writing of his own anxiety across their number, their forms and their gazing – yet they are metal, wood and stone – Medusa-ed, petrified and thus unable to threaten. Precisely in this recurring thematic of castration, we can suggest, that everywhere the statues are as whole male bodies or fragmented heads, there is a hidden discourse of the disavowed but beloved mother.

My final move takes us there: Athena wears the Medusa/Gorgon's head as breastplate apotropaically; by displaying the terrifying genitals of the mother, she, the virgin goddess born of her father's head, declares herself unapproachable. In 2005, South African artist Penny Siopis created an installation in the Freud Museum entitled *Three Essays on Shame*. Hidden in the cabinets in the London home of Freud, she found a tiny sculpture of a figure identified as Baubo (3.14). Baubo is a character in the story of Demeter and Persephone: the duet of mother and daughter who are the alternative structure to the mothers and sons represented by Jocasta/Oedipus or Isis/Horus. In her grief at the loss of her daughter when Hades rapes her, the enraged and mourning Demeter went to Eleusis in search of her lost child and was given lodging by Dysaules and his wife, Baubo. Refusing all sustenance, Demeter was made to laugh when Baubo suddenly lifted her skirts. Freud reports this incident in his 1916 paper 'A Mythological Parallel to a Visual Obsession'.[26] A patient obsessively repeated a word which was invariably accompanied by an image: the naked lower portion of his father's body, without genitals but his face painted on his abdomen. This visual image translated his corruption of the word 'patriarch' into *Vaterarsch* [father-arse]. While studying Salomon Reinach's *Cultes, Mythes, Religions* of 1912, Freud came across mention of excavated finds of figures representing Baubo which show 'the body of woman without head or chest and with a face drawn on the abdomen: the lifted dress frames this

face like a crown of hair'. He illustrates a tiny line drawing (3.15). What is remarkable, however, is that the marks on this body are positioned in such a way as equally to suggest two nipples and an umbilicus. The lines marking the invisible genitals – i.e. not in fact showing the vulva and labia to which Baubo openly points – appear to smile, endowing the image – that should, according to the Medusa model, be terrifying – with joyfulness. The image Freud illustrates does not, in fact, perform the apotropaic exposure. In the Baubo figurine acquired by Freud, the whole body is present and Baubo points openly to her opened vulva: the seated female figure, crowned and even enthroned with opened legs, pointing to the sexual opening of her body, does not appear to me as a ribald image but rather a sacred one. In the story Baubo showed her vulva – not to terrify or even to amuse, but to cause Demeter to recall her own motherhood, frankly signified by her sex – the very sex it appears that the Greek sculptors otherwise found hard to incise onto their female nudes or Freud to allow into view.

Baubo must derive from an ancient remnant lodged in the transitional myth of the Earth Mother who survives into Greek mythology as Demeter – a mother who is forced into a compromise with the violent force of the new Olympian male pantheon.[27] Her daughter is raped by her father's brother with his compliance, and although the daughter is restored, Hades slips some pomegranate pips (semen?) into her mouth which means that she must always return to the underworld – men ruling an underworld previously imagined as the womb of the Earth Mother. Demeter also finds a tiny place in Freud's collection in the form of a terracotta crowned head dating to the sixth century BCE. Demeter, as Ellen Handler Spitz and Grubrich-Simitis point out, is one of the very rare female figures in this collection – a reminder of what Freud could not see. In her fascinating exploration of the complexities of the Demeter-Persephone myths in its many variants and contemporary feminist interpretations, Ellen Handler Spitz draws out the conflicts and violence encoded within it. What is the nature of Demeter's rage and grief – that she herself abducts another woman's child and acquiesces in the end to merely sharing her 'raped' daughter? What is the fate of Persephone who apparently never became a mother herself, caught in the 'dark parallelism (nuptials and death) [which] evokes the recent work of classicist Nicole Loraux on congruities between marriage, death and virgin sacrifice in Greek tragedy'?[28] While plotting the emotional dramas of mother and daughter separation and reconciliations from the myth itself to contemporary psychological situations, Handler Spitz also invokes feminist scholarship that sees in the Demeter–Persephone myth two particularly significant aspects. One might be considered to be the inscription of a socio-psychological need for female–female sociality and identity confirmation in an otherwise alien patriarchal society – what Caroll Smith-Rosenberg would name in a nineteenth-century context 'a female world of love and ritual'.[29] The other concerns

> the question as to whether antiquity actually offers metaphors for the female body other than its lacking or 'being' the phallus. The image of Demeter, mythical mother, symbol of harvest, wandering the earth in search of her daughter, suggests a possible answer. . . . In bypassing it, Freud lost an opportunity, perhaps, for a theoretical elaboration of feminine psychology.[30]

Freud did attempt some elaboration of feminine psychology, notably in two key papers from the early 1930s – 'On Female Sexuality' [1931] and in the chapter on 'Femininity' in the *New Introductory Lectures on Psychoanalysis* [1932–3]. There he admits that the key to

femininity and female sexuality lies in the child's complex relations to her first love object: the mother. Yet it was neither suspected nor easy to grasp:

> Our insight into this early, pre-Oedipus, phase in girls come to us as a surprise like the discovery, in another field, of the Minoan-Mycenean civilization behind the civilization of Greece.
>
> Everything in the sphere of this first attachment to the mother seemed to me so difficult to grasp in analysis – so grey with age and shadowy and almost impossible to revivify – that it was as if it had succumbed to an especially inexorable repression.[31]

The first sentence refers to the then recent excavations by archaeologist Arthur Evans at Knossos on Crete which punched a further hole in the back wall of European history by extending its brilliant antecedents. Minoan culture included figures of the doubled goddess/ priestess mother-and-daughter couple. Yet Freud finds the most archaic periods of the feminine subject's psychic life apparently 'grey with age' confusing historical antiquity with early uncharted infantile experiences. But Freud realises that much of the failure to grasp this shadowy world of his women analysands lay in *his* inadequacy in the transference – his inability to take up the place of the mother – that is necessary in the analytical re-staging in the present time of psychically antique relations and impulses that only come into play through this analytically invited repetition in fantasy. None the less it was vitally important, and perhaps somewhat underestimated, that Freud allowed his knowledge of archaeology to provide some terms for his recognition of a whole sphere of feminine subjectivity that is not merely chronologically pre-Oedipal but forms its own vital and active psychic sphere as the pre-Oedipal phase that is a determining part of femininity. This leads him to at least pose a question that resonates today with contemporary feminist theories of the feminine: 'What does the little girl require of her mother? What is the nature of her sexual aims during the time of exclusive attachment to her mother?'[32]

Although Freud would rapidly subsume these insights into his contorted and distorting narrative of how girls shift their sexual aims from mother- to father-figure and undergo 'castration', the question remains: what women want may primarily be forged in a relation to a woman which is staged in the passionate and difficult drama of Demeter and Persephone. Bracha Ettinger has offered an elaborate proposition about this vital question of what the girl-beneath-the-woman wants from the 'other woman' that is fundamental to her coming into feminine sexuality and which has repercussions not merely for the local treatment of suffering women, but for the culture of systematic 'inexorable repression' and damaging amnesia about the potentiality of the Mother to play a role in human subjective formation as more than a 'greying', i.e. elderly, aged relic.[33]

Behind Freud's strange choice of words lies the return of the repressed of the phallocentric unconscious in which the difficulty of acknowledging the power (not the desirability) of the mother leads to an association and a displacement of all that the Demeter–Persephone couple momentarily flash up into Greek culture from the worlds it superseded. In his essay 'The Theme of the Three Caskets' [1913], Freud notes in Shakespeare's play *The Merchant of Venice* a woman having to make a choice between three caskets. The theme of such a choice is easily explained by reference to mythologies that suggest gold is linked to the sun, silver to the moon and lead to the youth-star. But mythological explanation explains nothing. Myths represent projected human material, not divine truths. Thus Freud begins to

track the theme of the threesome, noting how often the third child, or the third box, figures in stories from myths to fairy-tales. The three are often sisters, as we have seen in *The Three Graces*. But in the stories with which Freud is concerned in this paper, it is only the third who is selected for importance. Who is this third woman? In the Judgement of Paris, the third goddess awarded the prize is Aphrodite/Venus – who appears to have said nothing to win her prize. Dumbness, Freud proposes, is the story's sign for being dead. So who is the third goddess? Is she a dead woman, or is she Death, the Goddess of Death? Who are the other sisters? Moerae/Moirae (singular: Moira), says Freud. (These are different transcriptions of the Latin/Greek vowels; thus both spellings occur.)

> The earliest Greek mythology (in Homer) only knew a single Moera, personifying inevitable fate. The further development of this one Moera into a company of two sister-goddesses probably came about on the basis of other divine figures to which the Moerae were closely related – the Graces and the Horae (seasons).[34]

The Horae were originally, Freud tells us, goddesses of water and the sky – fertilising the land with rain led them to be linked with vegetation and thus the seasons. They retain their relation to time, giving their name to Latin-based words such as *heure* and *ora*, French and Italian for *hour*. Development led the nature myths in which these deities were founded to give way to human myth, and thus the Horae become goddesses of Fate, linked to and even substituted by the Moerae. But this still leaves Freud with a puzzle: How in the Judgement of Paris and subsequent versions of the choice of three does the third goddess, of Death, become the most desirable, goddess of Love? I shall need to quote Freud at some length: 'However, contradictions of a certain kind – replacements by the precise opposite – offer no serious difficulty to the work of analytic interpretation.'

This is the core of Freud's hermeutics: a logic of psychological inversions that leave the trace of what we do not want to acknowledge in the very form of its opposite:

> [W]e shall remember that there are motive forces in mental life which bring about replacement by the opposite in the form of what is known as a reaction-formation; and it is precisely in the revelation of such hidden forces as these that we look for the reward to this enquiry.

Freud then rehearses contemporary theories of myth such as he would have read in Frazer's *Golden Bough* and have come down to us in Robert Graves' *White Goddess*.

> The Moerae were created as a result of a discovery that warned man that he too is part of nature and therefore subject to the immutable law of death. Something in man was bound to struggle against this subjection.

Cultural signs in the form of mythological entities mark a deep and shattering emotional experience that is perhaps the frontier of the human: the recognition of death, which can only acquire significance if there is a human consciousness aware of time, and that involves the accumulation of memory in the spot that is the subject such that the continuity of what is recorded as memory which forms the past becomes desired permanently so that the very awareness of an end becomes a feeling of annihilation. Certain ancient cultures dealt with this discovery by offering two kinds of compensation: the projection of eternal life beyond

physical death which is paramount in Egyptian culture and the ritualistic relation to rhythm of the earth itself, temporal and seasonal. A figure of continuity is posited: the earth from which we come and to which we return as if in a supra-individual cycle. The mother-goddesses become the figurative forms of such thinking. But Freud is dealing with a moment of culture in which a 'man' emerges in revolt against this solution:

> So his imagination rebelled against the recognition of the truth embodied in the myth of the Moerae, and constructed instead the myth derived from it, in which the Goddess of Death was replaced by the Goddess of Love and by what was equivalent to her in human shape. . . . The third of the sisters was no longer Death; she was the fairest, best, most desirable and most lovable of women.

Here perhaps is intimated that most perplexing of transpositions and confusions: Why is the sexual desirability of woman for heterosexual men considered 'fatal'? Why is there a connection with eroticism and death?

> The Goddess of Love herself, who now took the place of the Goddess of Death, had once been identical to her. Even the Greek Aphrodite had not wholly relinquished her connection to the underworld, although she had long surrendered her chthonic role to other divine figures, to Persephone, and to the tri-form Artemis-Hecate. The great-mother goddesses of the oriental peoples, however, all seem to have been both creators and destroyers, goddesses of life and fertility and goddesses of death. Thus the replacement by a wishful opposite in our theme harks back to a primaeval identity.

Here Freud acknowledges a pre-existing imaginative order which could intellectually and emotionally accommodate the duality of life and death, beginnings and endings without reaction formation. This passage seems to admit that a mental universe figured through the duality of the feminine was not but a passing phase between two moments of father-right, but a primeval moment, a founding identity in human attempts to negotiate human consciousness of time which is fundamentally about life and death. But the atheist Freud will always bring these grandiose imaginative schemes called myths or projections back to the basic conditions of human life and immediate experience. Thus he returns at the end of the paper to Shakespeare's *King Lear* in which the theme of the three sisters appears in an unusual narrative setting. It is not the young Paris who is to choose but an old and dying man – who Freud interprets as defying death in the persona of Cordelia, the youngest of the three daughters, hence the Goddess of Death. Lear, old and dying, still wants to be loved. So what was Lear really staging?

> We might argue that what is represented here are the three inevitable relations that a man has with a woman – the woman who bears him, the woman who is his mate, and the woman who destroys him; or they are three forms taken by the figure of his mother in the course of a man's life – the mother herself, the beloved one who is chosen after her pattern, and lastly the Mother Earth who receives him once more.

In this almost lyrical passage Freud offers resigned acceptance of the continuity of time represented by the mother within which is set historical time as that of a man's sexual

history (like the Sphinx's question to Oedipus when she asked what starts on four, stands on two and ends on three marking the three ages of the human being). Yet Freud once again leaves no room for the question of what is the meaning of the mother's time for a woman. How does a woman live her historical life in relation to the recurring cycles of being born, desiring and yielding to death?

We know that Freud finally chose to die when the pain of his relentless mouth cancer became unbearable. Freud chose to die in his study surrounded by his collection of antiquities. Peter Gay wrote:

> After a long illness, Freud chose to die in his study, around him his famous couch, the desk at which he had created a new theory of the mind, his library, and his lifelong collection of fragments from a buried past: his ancestors of choice, his most faithful colleagues, and the embodiments of his excavated truths of psychoanalysis.[35]

Indeed this collection *embodied* ideas and feelings, not merely *pathos-formulae* but also more rebus-like indications of the reversing logics of the human mind in its dual form of conscious and unconscious and of the work of repression, forced amnesia, anxiety-precipitated forgetting. They were embodied memories – sculptures attesting to figuration as corporealised thoughts, fears and imaginings, all the better to lure us with the object's questioning gaze, a gaze that held open before Freud the enigmas of what their human makers had crafted into these surrogate, suggestive, myth-bearing forms of human others.

Part II

FEMININITY, MODERNITY AND REPRESENTATION

Having tracked the freight of meanings and affects in the long histories of images curated by two forays into the Warburgian and Freudian museums, Part II begins to negotiate the inscriptions of desire 'in, of and from the feminine'. This work presupposes the importance of women's creative engagements with modernist, avant-garde culture, but also points to the disjunctive temporalities of that engagement because women as artists are negotiating deeper conflicts between 'men's time', the time of linear national history and 'women's time', the time of sexual difference.

Exhibited items in Room 4

4.1 Harry Bates, *Pandora*, 1890. Marble with ivory and bronze. 105cm. Tate Gallery, London.

4.2 Georgia O'Keeffe, *Nude Series X*, 1917, watercolour on paper, 30.2 × 22.5cm. New York, Metropolitan Museum of Art. ARS/New York and DACS/London, 2007.

4.3 Georgia O'Keeffe, *Nude Series VIII*, 1917, watercolour on paper, 45 × 33.7cm. Santa Fe, The Georgia O'Keeffe Museum. 1997.04.11. Gift of the Burnett Foundation and The Georgia O'Keeffe Foundation. Photo: Malcolm Varon, 2001. © Photo Georgia O'Keeffe Museum, Santa Fe/Art Resource/Scala, Florence. ARS/New York and DACS/London, 2007.

4.4 Ernest Ludwig Kirchner, *Modern Bohemia*, 1924, oil on canvas, 165.42 × 125.1cm. Minneapolis Institute of Art. Gift of Kurt Valentin.

4.5 Käthe Kollwitz, *Head with Nude Model*, 1900, graphite, pen and black ink, 28 × 44.5cm. Stuttgart, Staatsgalerie, Graphische Sammlung.

4.6 Pan Yuliang, *It's Getting Cold*, 1952, ink painting, 71 × 94cm. Anhui Provincial Museum.

4.7 Georgia O'Keeffe, *Two Calla Lilies on Pink*, 1928, oil on canvas, 101.6 × 76.2cm. Philadelphia Museum of Art: bequest of Georiga O'Keeffe for the Alfred Stieglitz Collection, 1987. © The Georgia O'Keeffe Foundation/ARS/New York/DACS/London, 2007.

4.8 Georgia O'Keeffe, *Gray Line with Black, Blue and Yellow, c.* 1923, oil on canvas, 120 × 75cm. Houston, Museum of Fine Arts. Agnes Cullen Arnold Endowment Fund. ARS/New York and DACS/London, 2007.

4.9 Edward Weston, *Tina Modotti on the Azotea*, 1923, photograph. University of Arizona, Edward Weston Archive.

4.10 Tina Modotti, *Pregnant Mother with Child in Tehuantepec*, 1929, photograph. Courtesy Riccardo Toffoletti, Comitato Tina Modottti, Udine, Italy.

4.11 Tina Modotti, *Calla Lilies, c.* 1925, photograph. Courtesy Riccardo Toffoletti, Comitato Tina Modottti, Udine, Italy.

4.12 Tina Modotti, *Roses*, 1925, photograph. Courtesy Riccardo Toffoletti, Comitato Tina Modottti, Udine, Italy.

4.13 Edward Weston, *The White Iris*, 1921, photograph. University of Arizona, Edward Weston Archive.

4.14 Imogen Cunningham, *Self Portrait*, 1913, photograph, Imogen Cunningham Trust. © Imogen Cunningham Trust, 2007.

4.15 Crawford Barton, *Imogen Cunningham 1974*, 1974, photograph, formerly collection of Richard Lorenz, Berkeley, California.

4.16 Imogen Cunningham, *Calla Lilies, c.* 1925, Imogen Cunningham Trust. © Imogen Cunningham Trust, 2007.

4.17 Alfred Stieglitz, six plates from *Portrait of Georgia O'Keeffe*, 1918–30, paladium print, 24.1 × 18.2cm. New York, Metropolitan Museum of Art, gift of Georgia O'Keeffe through the generosity of the Georgia O'Keeffe Foundation and Jennifer and Joseph Duke, 1997. Photograph, rights reserved, The Metropolitan Museum of Art.

4.18 Man Ray, *Virginia Woolf*, 1934, photograph. London, National Portrait Gallery. © Man Ray Trust/ADAGP/Paris and DACS/London, 2007.

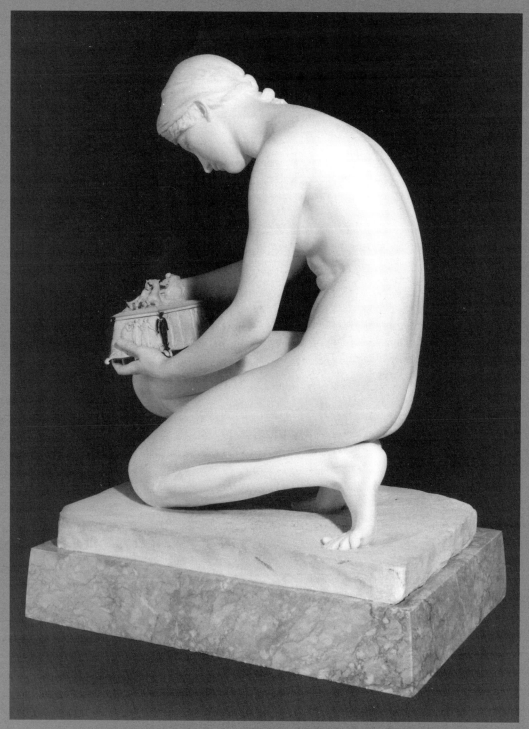

4.1

4.2

4.3

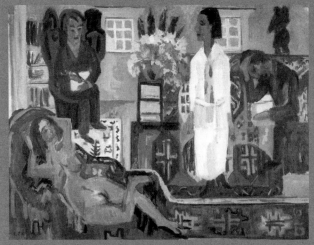

4.4

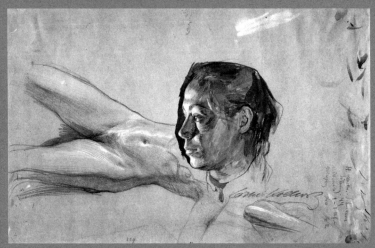

4.5

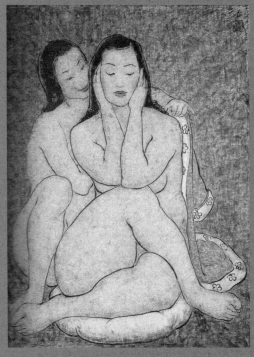

4.6

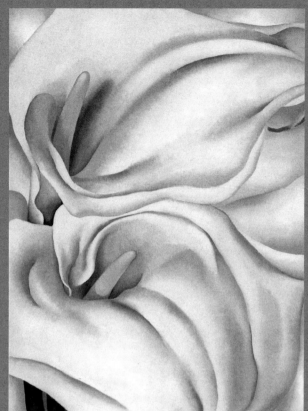

4.7

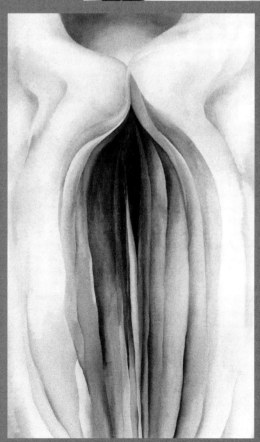

4.8

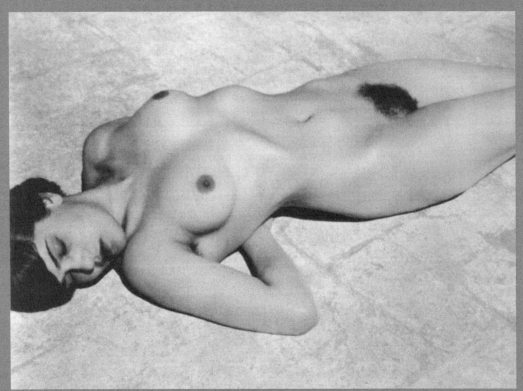

4.9

4.10

4.11

4.13

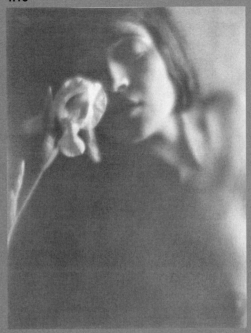

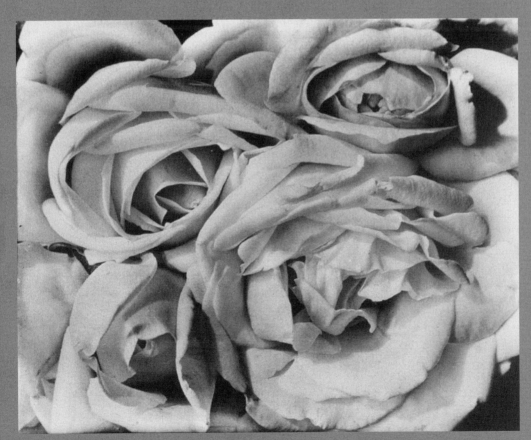

4.12

4.16

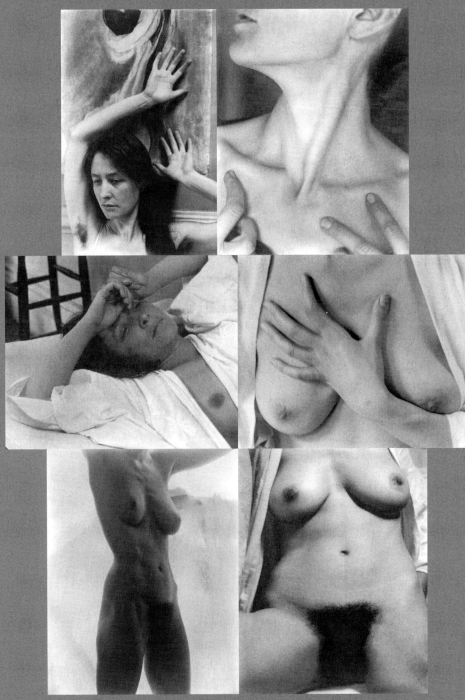

4.17

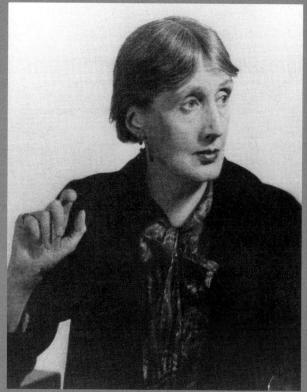

4.18

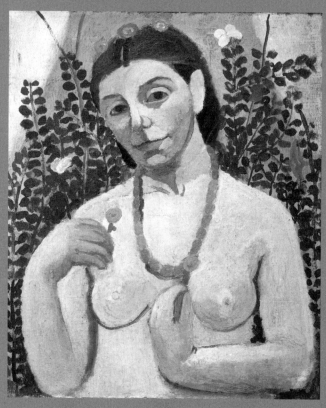

4.19

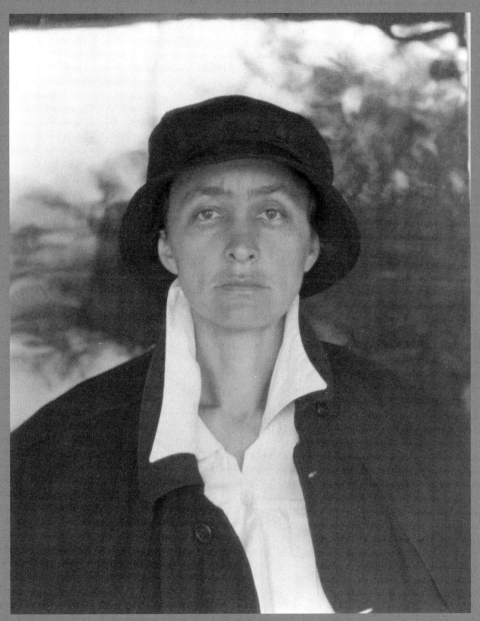

4.20

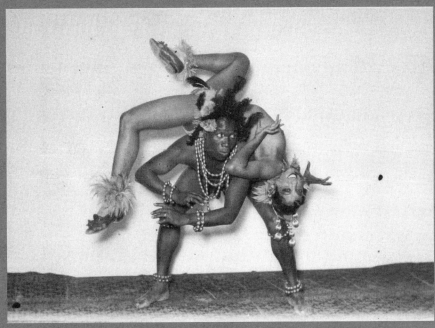

4.25

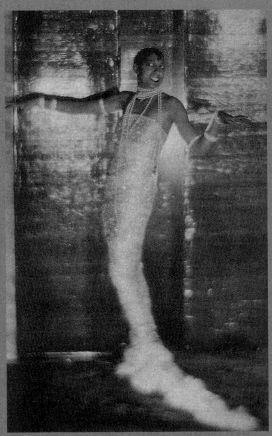

4.26

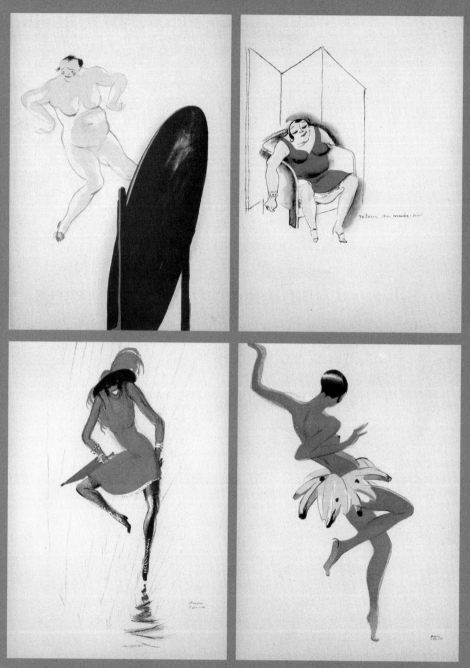

4.27

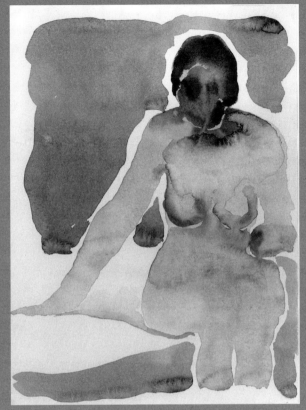

4.28

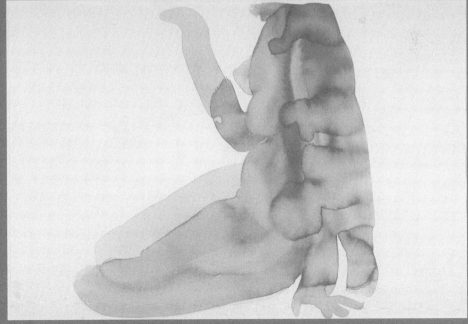

4.29

4

VISIONS OF SEX *c.* 1920

As art historians we are trained to study our designated objects 'in the flesh'. Where do we find these 'real' things? In museums. I have noticed, however, that in the introductory, not fully plotted spaces of museum lobbies, petrified 'flesh' is often placed as a taster of the art to come. Often classical but also modern, these sculptures hardly warrant close attention. Yet they specifically mark out the fact that we have crossed a threshold from the everyday world into the domain of art.

One snapshot from my collection shows the entrance to the Corcoran in Washington, DC where two female nude sculptures are positioned before us as we mount the ceremonial staircase from cashier to collections. One is a classical nude in the Greek *Pudica* pose of shame. The other is a modernist modelled and then cast bronze torso missing head and arms, not through antiquity but as a result of a modernist strategy to undo the bodily unity represented by its opposing, classical prototype. They juxtapose the originating moment of the Western female nude and the modernist disfiguration of this fundamental image within Western artistic imaginary that binds femininity to a silenced and sexually effaced or, modernist, frankly, or brutally, exposed physicality.

For many years the entrance to the Tate Gallery in London was occupied by Victorian neo-classicist Harry Bates' monumental sculpture *Pandora* (1891) based on the famous classical prototype of the crouching Venus (4.1). Kneeling, a naked woman is opening a box from which, according to the myth of Pandora – the giver of all gifts – will escape all the evils of the world save Hope. Pandora, like the Christian interpretation Eve, links feminine curiosity, especially about her own sexuality to transgression and danger. The interior of the feminine body evoked by the image of the box itself must remain closed and must never be opened – known – by a woman. The myth of Pandora or Eve forecloses woman to herself, denying her both self-knowledge and any supplementary knowledge for humankind that might come to us all through exploring 'the invisible sexual specificity of the feminine' as a source of meanings.[1]

The virtual feminist museum now invites you into an imaginary exhibition, invites you to take the part of Pandora, reading with the woman's body as Nancy Miller suggests (epigraph to Chapter 1) and Nick Turpin's chance photograph of the sculpture looking back, reading from the 'lady's place', a phrase that itself recalls the late Jacques Lacan's suggestion that if we are ever to know anything of the other (non-phallic) *jouissance*, it will have to be reported from the 'ladies' side'.[2] Yet Lacan rightly noted that although the psychoanalyst can ask women what it is that woman wants and what is her *jouissance*, for lack of signifiers, she cannot report on it. Re-visioning the relations between representation, femininity and the body that has been encoded and mystified by the tropes of the *Venus*

Pudica and the myth of Pandora/Eve so often installed in our museums as an index of the culture's deep, phallic unconscious, the virtual feminist exhibition allows us curiosity and desire for knowledge.

During the 1920s, women from all over the world were drawn to one city in Europe: Paris, which was then the capital of modernism. It became the hothouse for women's cultural revolution that is only now becoming subject to both research and full appreciation of its significance. There were, of course, other sites of modernity and other modernisms responding culturally to the varied time-scales of economic and political modernisation. It is my purpose to trace a different journey among women's varied cultures, ethnicities, nationalities and sexualities, joined here by a shared interest in representing their varied senses of living in and thinking through a feminine sexual body and in finding some knowledge of engendered, classed, ethnicised embodiment and difference from the work on representation and the body made possible at the intersection with several aspects we call modernity: from formal experimentation through photography to performance in the sphere of popular culture.

Beside the body in this modernist moment, the virtual feminist exhibition also stages another recurring image in this archive at the intersection of femininity, modernism and representation, an image deeply associated with the feminine and with temporality: flowers, and particularly one flower: the Calla Lily.[3] Both subjects are quite trite and the analogies between women and flowers have a long history in sexist ideology where both women and flowers are considered faithless, superficial, and inducive of melancholy because they appear beautiful in youth but are destined to fade and die. Thus transience links femininity and the flower to both alluring appearance but ultimately death.

In the modernist era, however, both the female body and flowers became sites for a challenge to such ideological associations. The potential feminist significance of women's reworking of the female body and the flower has easily been missed because of the stereotypical associations between the two. Could the flower, so often seen as an analogy for feminine interiority, become a signifier for same-sex feminine desire? Why do we associate such strange composite forms as flowers with female sexuality anyway and how could they become a means of visualising what is otherwise invisible? To answer such questions, I invite you to undertake a guided tour around the exhibition in the virtual feminist museum. Here is the ground plan: see p. 107 opposite.

Room I Preamble

In 1917, while working as a teacher in Texas, the white American artist Georgia O'Keeffe (1887–1986) painted a series of watercolours (4.2 and 4.3). Thirteen images form this series of female nudes which are singular in the *oeuvre* of a painter known for landscapes, cityscapes, still lives and abstract compositions. There has been uncertainty about who is their subject: a friend of the artist or the artist herself. It is now generally agreed that these are self-portraits, probably in a mirror.[4] Watercolour, with charcoal, was O'Keeffe's preferred medium at the time, inspired by Kandinsky and Dow's teachings, and used to capture the drama of weather and times of day in the Western landscapes or to discover the possibilities of organic abstractions, and here, and only here, to catch an extraordinary image of the unclothed female body.[5] It has been argued that these images are a response to watercolours by Auguste Rodin, exhibited in New York at the 291 Gallery by Alfred Stieglitz and illustrated in the photography journal he edited, *Camerawork* no. 34–5, 1911. I shall have more

I **Preamble** O'Keeffe Pandora Kollwitz Matisse Kirchner Pan Yuliang	IX O'Keeffe Nudes 1917	VIII Finding Herself Josephine Baker	VII Differencing the Feminine Gluck (Hannah Gluckstein)
	II American and Modern Georgia O'Keeffe		VI A Room of One's Own Virginia Woolf
III Photographer and Revolutionary Tina Moldotti	IV Young and Old Imogen Cunningham		V Portrait of Georgia O'Keeffe

to say about these watercolours when we have completed the visit to the exhibition, as they are both the beginning and the end-point of this journey.

While viewing these extraordinary studies of medium – watercolour – and the image of the female body created by a woman painter as a woman painting nude, we need to recall Linda Nochlin's question, posed as early, in terms of feminist thought, or as late, in the history of modern art history, as 1973: How can women know themselves in a country – art – where they have no language?[6] How can women know themselves if there are no representations – or spaces of/in/for representation in which we can read for what I called in 1996 'inscriptions in, of and from the feminine'?

The feminine here refers to a psycho-sexual position in culture and language, neither the essential effects of a female anatomy nor the conventional characteristics assigned sociologically or culturally to women as constructed gender. In my work, 'the feminine' is a positional effect of the way subjectivities are formed psycho-linguistically under a phallocentric (and a potentially non-phallic shifted) Symbolic. Using a Lacanian framework, however, requires us to recall that underpinning the Symbolic are two further registers: fantasy and trauma. These Lacan earlier called the Imaginary and the Real. Thus there are intensities associated with unthought and unrepresented corporeality which have effects but which we cannot know directly. Impacting upon the shape of the psychic domain in which the body is a fantasised collage of surfaces, orifices and impulses, in parts, as a whole, and as the site of pleasures and desires and raised by signifiers to the level of thought, the corporeal and its non-verbal intensities and energies cannot be dismissed from our speculations. Indeed they may be vital to our very understanding of aesthetic virtualities in the modernist era.

To invoke 'the feminine' is to suggest a potential for fantasy and thought, as well as a traumatic dimension – trauma refers to an event that happens without our having the means

to know it while we are, none the less, shaped by its effects – arising from our becoming a subject both at the intersection of a phallic Symbolic and a sexually specific corporeality which is a virtuality not an anatomy. Thus despite the risk of terminological confusion, the invocation of 'the feminine' can also open out a dimension beyond the feminine phallically defined only as other of the masculine. It promises as yet under-theorised or even unrecognised resources for a sexual difference 'in, of and from the feminine' hitherto fore-closed by phallocentrism (foreclosed means rendered unthinkable because it has no signi-fier). Because we are talking about psycho-linguistic positioning and not bodies or essences, phallocentrism is not the attributes or ideologies of men. It is a logic of on/off, presence/ absence that shapes a Symbolic order by which we are produced as masculine and feminine asymmetrically, as a relational difference: masculine (plus term) and feminine (minus term). The effect is that we only have *one* sex, and hence under phallocentricism there is neither sexual difference nor sexual relation since the other sex, the feminine, remains, as Freud named it a 'dark continent', or for Lacan, meanings that do not yet exist.

In a phallocentric Symbolic, the feminine dimension of human subjectivity, as a sup-plementary dimension that promises a sexual difference (not a complement) to the one sex, remains just as unknown and unavailable to 'women' as it is to the rest of culture. As 'women', we therefore do not know ourselves except through the disfigurement of being simply the other (the negative) for the one sex. We can only know that which the languages and images of our cultures represent to us, allow to be spoken or drawn.

It now appears that in the encounter between modernism and femininity at the beginning of the twentieth century in the field of visual art, something of this other, unarticulated sexual difference of the feminine was intimated precisely through experimentation with the potentialities of radical artistic practice undertaken by women emboldened by modernist potentialities as itself a challenge to existing languages and conventions of culture even while, as we have seen, key modernist practices re-installed a mythically masculine image of its feminine other.[7]

We are still in the process of learning to decipher these events in early modernism as potential 'inscriptions in, of, and from the feminine'. Indeed it has taken a century or so, for what these artists-women planted into culture, to de-phallicise culture, sufficiently to gener-ate the theoretical and conceptual tools with which to read for the sexual difference inscribed into and across this work, which, none the less, as ever, formed active relations at the same time with the dominant cultural trends within modernism. Feminist intervention catches the double-thread of art made by women who are, at once, tactically as canny and thoughtful as their masculine peers in the modernist movements they collaboratively cre-ated. Yet precisely the novelty of the modes of making art we call modernist potentially – virtually – registered other traces, other desires, and opens on to other possibilities that require the covenant of reading by those who desire this difference and have worked as a movement in thought to create feminist terms appropriate to reading the traces and desires, with embodied minds fertilised with feminist theories urgently seeking to be otherwise represented so as to be known otherwise.

This exhibition is to be understood, therefore, as a kind of laboratory – a place of research in which are assembled a series of image-texts that we must decipher as if we were archaeologists attempting to break the code of a lost civilisation. Freud used the archaeo-logical metaphor derived from Arthur Evans' excavations at Knossos which revealed a hitherto unknown Minoan civilisation as a way to explain his own emerging awareness in the early 1930s of a different domain of archaic relations between mother and daughter in

the formation of femininity whose territory remained enigmatic to him.[8] I am not proposing that what we will discover as feminist archaeologists of the radical cultural moment of the 1920s is an archaic femininity attached to the mother operating on a purely psychological plane. It is rather the dialectic between that moment of emergence – virtuality – and our moment of reading that may produce the grounds on which the analysis of artistic practices as inscriptions both consciously tactical in the making of art, and unconsciously overdetermined in the aesthetic space as a dimension of subjectivity and enunciation can allow us an encounter with 'the feminine' – 'the' not signalling a false universality, but a domain singularly articulated and inflected by all the differences between women in their living social, cultural, sexual and intellectual particularities.

What 'the feminine' might be will not be, as culture now tells us, simply visible. It will not be grasped on the register of the visible and scopic, though the field of aesthetic practices in the visual arts may be one route to its entry into culture and hence recognition. We shall have to use what Bracha Ettinger has named 'the erotic aerials of the psyche' attuned to a different waveband to sense the co-existence within these images of several dimensions (dimensions of severality) which enables their work at once to belong to the generally accepted notions of the culture of its period and place and kind of practice and to 'difference' that emerging canon.[9]

But first we must appreciate why there is such difficulty in attempting to make the sign – the female body – signify the subjectivity of the woman who inhabits this corporeal schema and its psychic fantasies, and lives its rhythms, its changing forms, its possibilities for images, sensations, memories and meanings without having the means, within a monistic phallic signifying economy, to signify them.

As we have seen above, it is now a Western feminist truism that the female nude has become a core sign of Western art. As image and sign, the representation of the female body in art in effect signifies its positivised antithesis: the masculine artist as the possessor of both an aestheticising and an erotic gaze, who invests the pathways of sight and its objects of visual representation with the scopic terms of his sexuality (voyeurism/fetishism/scopophilia) and its sublimation into a creative practice (4.4).[10] The studio with the artist and his model, always the implicit condition of the production of art, emerged into modern art as its symbolic space and recurring, self-defining subject. This gaze of a working artist at his model in this symbolic and actual scenario connotes the foregrounding in modernism of *work*. It also lays bare the co-emergence of desire and the search for new forms. Sexuality implicit or explicit finds a much more prominent place in this moment of modernism, making the question of sexuality and subjectivity, sexuality and modernity, erotics and aesthetics, a prime subject, a topic that brought forth what we now consider to be some of the most significant artistic products of early European modernism.[11]

But what did that turn in modernism mean for those women who wished to participate in modernism's formation, its radicalisations and formal experimentations? How do women negotiate their participation as artists in a shared programme while gender difference inflicts a major obstacle because it is already structuring the modernist programme through the trope of artist/model, inscribed as a binary opposition that identifies the feminine with the material, the object, the other, and the masculine as the proprietor and subject of the investigating and creative gaze?

I have always argued that women artists make art as much because of as despite the difference of their positioning according to historically and cultural variable gender structures. The challenge of *differencing the canon* is one of finding the means to read the work by

women artists as creative negotiations of both participation and differencing. If modernism as exemplified by the Europeans Matisse and Picasso so profoundly restaged the encounter with the sexual body of the female other as a core trope of modernism's formal and erotic modernisation of art, any participant in that project will have to negotiate both the difficulties and the possibilities of that conjugation of sexuality, formal innovation and the staging of the subject and object of vision: the gaze. Whose gaze at whose body – what did it reveal and how could it be otherwise configured? What would that differencing produce – were we to read for it? What relations other than the standard museum categories must we allow in order to find its traces across work otherwise divided into nationality, school, movement, medium, style and *oeuvre*?[12]

I want to investigate if and how this visual art sign – the female body – could be refashioned through the radically transformed artistic codes of modernism and inscriptions in the visual field to speak 'the feminine' as the site of women's own sexuated subjectivity exploring its own hitherto unsignified dimensions.

On a page from the sketch-books of German social realist artist Käthe Kollwitz, seemingly incompatible visions of woman find themselves curiously misaligned (4.5). The self-portrait head is sharply defined by the heavy swirl of black ink. It is positioned, however, where the head of the headless nude – a study for a triptych *Life* (1900, Graphische Sammlung, Staatsgalerie Stuttgart) – should be. It is swivelled around so that it appears to be looking down the line of the body, which is, in its own field, an upright not a reclining figure. Writing of the difficulties of this image, British feminist art historian Rosemary Betterton argued in 1996:

> Kollwitz's image suggests something of the violence that the split subjectivity might engender for the woman artist. Her inability to resolve the separation between the self-portrait head and the nude body reveals the division between the artist who assumes the right to look and the female body that is offered as mere object of the gaze. In this violent splitting of head from body she places herself at one and the same time in both a masculine and a feminine position, at once subject and object, a division that was impossible to resolve within a contemporary discussion of woman and art.[13]

But that impossibility was to change with the radical coincidence between modernism and feminism in the following decades.

To underline this shift, we need to recall that the relations between these terms took place internationally and, once viewed from elsewhere, the significance of the Western trope of the female nude is further differenced. The case of the Chinese painter Pan Yuliang (1895–1977) is instructive. Pan Yuliang went to Paris from Shanghai to study Western painting where she painted a large body of female nudes unknown in and rejected by the traditional conventions of Chinese painting.

Orphaned at 8, Pan Yuliang was sold into prostitution at 15 by her uncle. Initiated by rape, she was offered by her townsfolk to an incoming civil servant Pan Tsan hua, who as a liberal reformer refused 'the gift' but took the girl in, married her as his second wife in 1913, educated her and supported her when she turned to art in 1917. Pan Yuliang benefited from what would become the 4 May Movement which broke out in 1919 as a students' and intellectuals' campaign for liberalisation through widespread education. As a result many more Chinese women went to school and university including art schools. Pan Yuliang

enrolled in the Shangai Arts Academy in 1918 and, with thirteen other women art students, won a scholarship to study in Lyon in France in 1921 before being admitted to the Ecole des Beaux Arts in Paris in 1922 where she studied under Lucien Simon (1861–1945). In 1925 Pan Yuliang won the Grand Prix de Rome which enabled her also to study in Rome. She returned to China in 1928 as a professor of Western painting in the Shanghai Arts School. Established by a major retrospective she then moved to Nanking, but the social caste system of China, despite the struggle for modernisation, was unforgiving, and social slurs due to her lowly and sexually stained origins were now linked with the scandal of her Western-inspired oil painting of the female nude, and drove her back to Paris in 1937. Her years in China allowed her to mingle her Western *Ecole de Montparnasse* training with a study of Chinese water and ink drawing which combination she used in a sustained exploration of the female body that must also invite analysis for its discourse on embodiment and same-sex desire. She never returned to China but, living in always precarious financial conditions, she became an active member of the substantial Chinese Overseas Community in Paris. Her only consistent patron was a Romanian. She was displaced during the Nazi occupation and painted a work titled *Genocide* as her response to witnessing fascist Europe. She had exhibitions in New York and San Francisco in 1963 and died in 1977, bequeathing her entire *oeuvre* of 4000 works to the Art Museum in Anhua Province where she was born.

Pan Yuliang was only lately acknowledged by a retrospective in Beijing in 1992, another in Taipei in 2006 and a biopic, *A Soul Haunted by Painting* (Huang Shuqin, 1995), starring Gong Li in the title role. Pan Yuliang's work as it is now revealed internationally presents the challenge of analysing the cultural conditions under which her combination of modern Western and traditional Chinese art practices led to her reconfiguring Western art's most signal difference from the Chinese tradition: the painting of the female nude as a means of exploring an ethnically specific sexual corporality seen through the eyes of woman – as artist? as desiring subject? as explorer in the country of women? Her paintings of women and her teaching of painting from the female model seem to have exceeded the cultural conventions of even modernising Chinese art worlds after the May 1919 liberalisation and Westernisation movement. Thus she was forced to return to a Europe in which she was rendered invisible as a Chinese foreigner, her work's delicate play with line and volume illegible in that European context (4.6).

Hence this chapter's title 'Visions of sex' and the need for an encounter across time and space with those residues of an avant-garde moment endowed with particular significance in the radically interrupted temporalities of what I call the unfinished business of the modernisation of sexual difference.

Room II American and Modern

Given the sobriquet by her champion Alfred Stieglitz, 'American and Modern', Georgia O'Keeffe (1887–1986) became the most renowned American women artist. Since her death she has become increasingly known through the terrible curse of popular fame, so often inflicted on women artists in lieu of serious scholarship, associated with her paintings of the interiors of gigantic flowers, whose complex elements and convoluted internal morphologies are rendered disturbingly, and unintentionally, erotic by magnification (4.7).[14] Her exploration of abstraction through charcoal drawings, watercolour and daringly pastelled oil paintings carry on this same charge without allowing easy interpretation of these forms or associations (4.8).

Georgia O'Keeffe was also a painter of desolate and arid landscapes of New Mexico, of bones and skeletons dried and bleached by a relentless sun. She is, moreover, known for a work about, but not by, her: the multiple photographic *Portrait of Georgia O'Keeffe* by her husband Alfred Stieglitz, which we shall encounter in a later room of this exhibition. Stieglitz was the founder of Photo-Secession in New York, the American avant-garde journal *Camerawork*, the avant-garde gallery *291* on Fifth Avenue where Stieglitz pursued his twin passions: the promotion of photography as a modern art form and the discovery of an indigenous American modernism which could rival the modernists of Europe such as Rodin, Picasso, Braque and Matisse whose work Stieglitz introduced to the Americans at his gallery *291*.

Following the art critics of the 1920s, American feminist writers of the 1970s claimed and celebrated the art of Georgia O'Keeffe as the direct and even revolutionary revelation of what they saw as an intrinsic and corporeal femininity.[15] This was her reputation from the moment Alfred Stieglitz proclaimed on seeing her abstract drawings in 1917: 'Finally, a woman on paper.'

In 1924 Paul Rosenfeld wrote that her painting derived from:

> the nature of woman, from an American girl's implicit trust in her senses, from an American girl's utter belief, not in masculinity or in unsexedness, but in womanhood. Georgia O'Keeffe gives her perceptions utterly immediate, quivering, warm. She gives the world as it is known to woman. . . . What men have always wanted to know and women to hide, this girl sets forth. Essence of womanhood impregnates color and mass, giving proof of the truthfulness of a life.[16]

Earlier in 1922, Rosenfeld had written in *Vanity Fair*:

> It is female, this art, only as is the person of a woman when dense, quivering, endless life is felt through her body, when long tresses exhale the aromatic warmth of unknown primeval submarine forests, and the dawn and the planets glint in the spaces between cheek and brow.[17]

In her subtle and intelligent study of three artists, all American, all women, all modernists, Anne Wagner address the question of the 'femininity' attributed so approvingly by critics to Georgia O'Keeffe's work in the 1920s. She concludes:

> O'Keeffe's art and career also serve to demonstrate that at least earlier in the century, for a woman to represent the body at all is to give herself over to her interpreters; to become hostage to their limited notions of a woman's world as simply and only an extension of her bodily feeling . . . I think she continued to see these new pictures as stemming from her long-standing effort to find a space both within and outside the body, and to conceive of a body both within and outside gender.[18]

In order to explain the paradox at the heart of the artistic project we call 'Georgia O'Keeffe', in which the flower somehow comes to stand for the displaced body, Anne Wagner cites Merleau-Ponty as an alternative way to frame an artist who never fully recognised the freight her imagery carried yet always sought to make her mark lie between its

sexuality and its negation: 'There is no transcending sexuality any more than there is any sexuality enclosed within itself. No one is saved, and no one is totally lost.'[19]

For the American critics of the 1920s, longing for a distinctive American modernism, the work of Georgia O'Keeffe, particularly on paper, offered at the same time what seemed like a direct, spontaneous almost unconscious revelation of a distinct concept of 'true woman-hood' quite different, however, from that which had prevailed during the preceding era of Victorian bourgeois culture. For the first time it was possible to conjugate ideas of the New Woman, woman modernised, with sexual experience as the grounds for a new autonomy and self-expression. In contrast to the still dominant ideal of pure, sexless Woman, modern women were being considered as sexual – yet still within a contradictory, phallocentric perspective. The enthusiasm of some of the advanced critics for Georgia O'Keeffe's work as symptom of this paradoxical notion that allowed woman a sexuality only if it were unconsciously, almost naturally a sexual nature – hence the floral association – was add-itionally shaped by then current American involvement with Sigmund Freud's radical theories of sexuality disseminated following Freud's only lectures at Clark University in the United States in 1909.[20] Greenwich village cultural leader Mabel Dodge's Salon at 23 Fifth Avenue was a major channel for the dissemination of Freudian ideas in the teens: 'there was no warmer, quiet and more intensely thoughtful conversations at Mabel Dodge's than those on Freud and his implications.'[21]

I want to suggest, however, that Georgia O'Keeffe's work after 1917 did inscribe within the visual field of American modernist practice something so visually shocking that only the radical sex talk of the novel Freudian discourse could begin to articulate what it seemed to touch upon: a woman as the enunciator of her own sexuality in a manner so radically distinct from the existing representations of sexuality that it offered, visually, intimations – unknown and unknowable to its author – of a sensualised and corporeal subjectivity that was differently sexuated. Georgia O'Keeffe herself resisted any idea of a sexual difference in art, and rightly so, if she was reacting against nineteenth-century ideas which assumed that woman's art was different from men's by virtue of intrinsic difference. Seeking access to a higher plane by engagement with abstraction and modernist practice, she resisted the imposition of prejudged meanings on to her work because of her gender as author. But we can, with a feminist psychoanalytical perspective, address the question of what occurred in her work for which we might read as indices of a difference, sexual, that we do not already know tipped into visibility precisely by the adamant pursuit of art-making under the terms of a pursuit of authenticity and newness.

So, what was on offer was not Woman – an already over-familiar stereotypical, utterly conventional myth in decadent as much as modernist discourse and representation where the antimonies of feminine purity and female degradation and vice were regularly recycled. What was glimpsed in her extraordinary images of organic semi-abstraction and then gigantic still life was the possibility that an unsignified dimension of sexual difference could be articulated precisely through the radical, new possibilities of attention to form in avant-garde art: modernist practice itself. Artworks that hovered between abstraction and figuration through organic analogues and sensuous colour could evoke an otherness of another sex that is much more than the fiction of Woman as the other of the One, namely the mascu-line sex as we have learnt from Luce Irigaray.[22] The novelty of the New Woman would lie in that possibility of investing the New Art with foreclosed elements of the feminine subject unknown to herself that a modernist evocation of the body would allow to pass into cultural representation.

Room III Photographer and revolutionary

Into this scene of the feminine, modernity and representation, we must add the complications of class, culture, nationality, professional training by introducing Tina Modotti (1896–1942).[23] Tina Modotti was a young Italian working-class immigrant to the United States. She lived in Hollywood and, in 1919, became a star of the silent cinema just before she met and became a model for the Californian photographer Edward Weston (4.9). Weston became renowned for his obsessive photography of the female nude. In the struggle to secure artistic status for photography – so early a tool of art's underside: pornography – the representation of the female nude was a Derridian *pharmacon*: it was a necessity since the female nude had become the symbol of ideal art at the very moment when a commercialised sexual economy claimed the female body, in fact and image, as its major commodity in pornography.

A photograph, like a painting, signifies its own conditions of production. The photographer seeks to stage his own vision. Thus Weston sets the scene for the play of his fantasy in the creation of a fantasmatic body, formulated according to a voyeuristic logic where the viewer can enjoy, from a precisely calculated and thus protected distance, a visual scenario that is eternally fixed in a fetishising moment of suspended revelation. According to Freudian legends of the subject's formation, so often imagined through such a visual snapshot, the masculine subject's encounter with the sexual specificity of the female body can only be traumatising. The little boy sees 'nothing': not anything, but *nothing* that he desires to find as confirmation of the integrity of his own idealised phallic body that must narcissistically function as the *only* norm. From the troubled 'memory' of a vision he could not comprehend when confronted with the apparently visual difference of the sexes, the little boy constructs, psychically, the means to survive the unexpected revelation of diversity which threatens him with what he imagines is a mutilation, a loss of what he has, and thus an image of a loss he has already sustained as a subject inducted into language over the separation and abjection of the maternal body. The boy child cannot simply recognise a different configuration, a potential for invisible sexual otherness. While seeming to recognise what he takes as absence – ab-sense, a lack of intelligibility – when confronted with the feminine genital form, he misrecognises the scene, in the same moment producing what Freud theorised as fetishism: the ability to sustain two contradictory knowledges simultaneously. The logic of fetishism reattributes to the other body what appears to be lacking: the missing appendage necessary for the maintenance of the masculine subject's *amour propre*. Yet, in that very act of re-imagining a phallic presence, the subject marks the perpetually troubling spot, the hole of a dangerous memorialisation of absence, of the loss of that which guarantees him at the centre of a system of meaning.

With its stunning dedication to the endless search for the perfect nude, with its repetitions, its violence of pose and sadistic looking, its misogynistic obsession with the taut and strained female body, that hides behind the veil of so classical and formalist an aesthetic, the photography of Edward Weston demonstrates the operations of, and relations between, voyeurism and fetishism. In neither perversion can there be any satisfaction. Thus is born the compulsion to repeat that produces the necessity for re-enacted endeavours. The series of nudes is theoretically infinite, because no single image can assuage the dread that lurks within the desire to see again. Another photograph, another image, another pose. . . .

Tina Modotti entered the scene of modern art as but one of these bodies appropriated to support the inscription of the paradox of hetero-masculine psycho-sexual formation which

installs itself on the terrain of modernist representation in images of naked woman that tell us nothing about this woman, about women, about the feminine and *its* psycho-sexual formations, fantasies or desires. In 1923 Tina Modotti travelled with Edward Weston to post-revolutionary Mexico where she herself took up photography as a professional practice. Under the powerful influence of her communist politics, she tried to reconcile the simplicity and formalism she had learned from Weston's work with the political forces of revolutionary modernisation in which Mexico was currently engulfed.

Under her sobriquet, used by biographer Margaret Hooks, 'Photographer and Revolutionary', Tina Modotti made a series of photographs of working-class Mexican women and peasant women from an area of the country, Tehuantepec, renowned for the courage and strength of the women.[24]

Modotti's photographs of pregnant women and nursing mothers offer us the antithesis of the images for which she herself had once modelled for Weston (4.10). Modotti sought out and created a vocabulary for another image of feminine corporality and sexuality which, at the same time, does not simply collapse into the equally powerful masculine fantasy of the Great Mother so prevalent in the statuesque landscape paintings and sculptures of modernists from Renoir on. Instead of abstracted forms fetishised by light or a sharp contour that encloses the projections of masculine anxiety with the definite boundaries of an almost unearthly form, Tina Modotti nestles up to the physical curves of a lived subjectivity, imagining a body sexualised by maternity within the equally powerful force field of proletarian labour and social exploitation. Here we encounter the glimpse of what artist and theorist Ettinger has called 'severality'.[25]

The photographs stage Modotti's enquiry into this state of doubling, severality, in which the viewer is not allowed to fantasise a Madonna – the lost memory of the Mother – for we are not given the head and face. Yet the fragmented body does not read as a violent decapitation, a mutilated fragment such as I saw in the entrance of the Corcoran. The viewing position places us close to what we, none the less, cannot know about this other – woman, Mexican, pregnant mother, so specific in her class, her national and cultural history. Tehuantepec was an enclave of matriarchal customs. The woman, whose locus of individual identity – her face – is screened from us, is, at the same time, presented even through her body as the subject of relations with an unknown other, the becoming child within, relations as intimate as any can be while being always with an unknowable object of her own fantasy. Julia Kristeva has suggested that pregnancy in which this other grows within the body of its bearer precipitates a distinctive fall into maternal psychosis for the relations within the condition of pregnancy appear, to the phallic imaginary with its phobia about corrupted boundaries, unsignifiable and thus without a subject. In contrast, Bracha Ettinger proposes that the *severality* that is advanced pregnancy for the mother and pre-partum prematurity for the infant can be signified through the symbol she names the Matrix. The Matrix signifies an unconscious space of non-Oedipal encounter, what she names 'relations-without-relating' or 'proximity in distance' of *partial* subjectivities (not mothers and children, but unknown elements of more than one subjectivity sharing a borderspace in radical alterity and jointness at the same time) at the borderline of at least two that can become a threshold for shared affect, fantasy, even trauma registering differently in each partner of this co-emergence.[26]

This psychoanalytically theorised proposition of a symbol, that realigns an expanded Symbolic and its related Imaginary by allowing some dimension of invisible feminine specificity to be signified, permits a different reading of Tina Modotti's work from that to which

it might be condemned by phallocentric logic in which the female procreative body is perceived, without subjectivity, as merely a vessel, a frame, a space, and not as the threshold of encounter and the exchange of mutually subjectivising fantasy.

Side by side with the photographic representations of a different phantasm of the feminine body are extraordinary photographic studies of flowers that open a bridge back to the work and myth of Georgia O'Keeffe, a contemporary woman modernist in New York unknown to Tina Modotti, the Italian communist working in Mexico (4.11). Once this juxtaposition has been made, the thesis of the exhibition becomes clear: what was going on in the concurrent recurrence of the image of the female body and the image of the flower at this moment in the work of artists no doubt uninterested in either seeing bodies or flowers as reflections of conventional notions of social femininity or imagining a link between Woman and Nature.

In Modotti's close-up of *Roses* of 1925 (4.12) the viewer is placed in an immediate proximity to four flowers whose varying stages of *floraison* are uncannily encountered by the spectator head-on, full-face, yet in a flattened, airless, compressed modernist space, dislocated from both reality and rationally explicable vision. Wherein lies the *affect* of sexuality that such botanical immediacy creates? Is it in the denaturing of so complex a flower as the rose so that I must scan the dense image for the layering, the veiling, the tiny 'mouths of darkness', the stilled possibility of graceful opening that would then suggest the final fall of petals and the ultimate loss of all the flowers' 'skirts'?

In one photographic study by Edward Weston, Tina Modotti appears with an iris (4.13). In this image, however, she has become the *femme fatale*, mysterious, withdrawn, moody, a cliché of *fin-de-siècle* imagination which had survived into silent cinema and early modern pictorialist photography. With her eyes closed, her body naked, the dreaming woman leans towards the inclining flower, an iris, with its provocative, suggestive, sensual, sexualised form that so easily becomes a metaphor for the woman towards which it leans, as if it makes visible the invisible interior of feminine sexuality while, none the less, containing it so cleanly within its sharp, dry forms. In Edward Weston's image, we can grasp the metaphorical equation of woman and her unconscious submission to her own unknown sexuality – a conflation so dominant in the discourse on Georgia O'Keeffe. The image depends for meaning on the juxtaposition of elements – proximate face and flower, opposing nipple and iris – in a field of mistily undefined dreamspace.

What do we do when we find the same elements in work by O'Keeffe or Modotti, considered radical and renovatory, and in work by male contemporaries that obey so compellingly the laws of phallocentricism? Is there a difference we can reclaim that stems simply from the gender of the author? *No.* Do things, bodies, flowers signify in and of themselves, or are they inflected by the representational strategies of the artist who manipulates them for unexpected ends? Between the productive consciousness of the artist and the signifying potential of culturally freighted signs, how will we decide our interpretation? Does it depend upon our desire to see difference?

Let me take a favoured flower in art at this moment: the Calla Lily. The morphology of this waxy white flower seems perfectly matched to a sexualised perception with its so obviously phallic stamen jutting out from the flower's cup: erection and interiority, a sexual morphology within one object. Do these associations derive from cultural conventions established in the nineteenth century or is it the baneful effects of the Freudian revolution which infuses every shape with the omnipresence of sexuality? If Freud is indeed responsible for

116

over-tuning our perceptions, from him we derive the psychoanalytical concept of the body as *phantasm*, a fantasy fabricated at the psychic level by elements detached from any anatomical actuality, charged by an eroticisation of pathways grooved by the drives that are indifferent to perceptual reality or conscious knowledge. So I am arguing that there are, in simple terms, no visions of sex; but representations that activate the fantasy that is sexuality without the use of reference, analogy or morphology. It is the image's form, its formalist self-assertiveness as art which renders an observable object from the world of nature and bodies as uncanny, *unheimlich*, suggestive of the repressed, the very formation of our sexuality in its infantile, non-genital, corporeal and fantasmatic forms.

This is not quite correct. The image borrows a recognisable thing from the world we know which functions analogically, or in semiotic terms, iconically. The image looks like something and thus, as denotation, we recognise the visual resemblance and interpret what we see as . . . a lily, a woman. Yet this form is the displaced sign that allows into the visible screen of representation an archaic memory, a prompt for fantasy that is not bound tightly to a signifier. Obeying the psychic law of *Nachträglichkeit*, the *après-coup*, the fantasmatic body that has been shaped by drives and fantasies, invested with a restless and objectless desire, seeks a mode of its own representation that would bridge the division between the precocious formation of subjectivity in its infantile polymorphous perversity and the disciplining entry into language by the sacrifice of that archaic corporality to the demands and defiles of the – up until now – uniquely phallic signifier.

I do not want to read the female bodies and flowers for the ideologically normalised associations between femininity and nature's transient beauty. I am more interested in using the format of the exhibition to reveal the insistence of *repetition*, a moment of cultural overdetermination which should alert us to the workings of the unconscious, and the pressure of those imaginings, fantasies and affects that existing cultural vocabularies have not enabled us to think, imagine or be shaped by. We should allow this moment of modernism, this incompletely written chapter of the avant-garde in the mixed geographies of modernism in the 1920s that foregrounded something about femininity, sexuality and modernist representation, to trouble us so that we do not fall into the banal, and patently ludicrous idea that flowers resemble the sex of women. Any visual assonance needs to be rethought, retheorised and rendered perplexingly strange, and estranging.

Room IV Young and old

My third exhibitor is a link figure, Imogen Cunningham (1883–1976), whose portrait appears in two important photographs with flowers: *Self Portrait*, 1913 (4.14) with a narcissus tazetta, and *Imogen 1974* by Crawford Barton, where an elderly Cunningham cups a single Calla Lily with her elegant but aged hand (4.15).[27] Enthralled by the pictorialism of Alfred Stieglitz and Gertrude Käsebier that Imogen Cunningham came to know through her reading of Stieglitz' important photographic journal *Camerawork*, the early self-portrait might seem to recall Edward Weston's photograph of Tina Modotti with iris in its romanticising use of light and soft focus, a kind of dreamy experiment with the Victorian photographer Julia Margaret Cameron's ethereal beauties. Cunningham's evolved photographic aesthetic radically rejected such romanticist baggage for an unforgiving clarity, a sharpness of focus and even lighting that places the viewer face to face with a strange beauty, an unnerving encounter with the uncanny oddity of flowers which, normally, we never see so closely examined, so enlarged and detailed, and so isolated from both movement and habitat (4.16).

The concentration of our looking, and the revelation of form which follows it, echoes the startling effects achieved by comparable strategies in paintings of lilies, poppies or irises by Georgia O'Keeffe. How do we interpret this correspondence of attention and difference of affect across diverse media?

Art history would propose influence or something vague such as 'it was in the air'. More theoretically and critically informed studies of the visual arts tend towards other kinds of explanation than art history's favoured games of establishing genealogies, lines of influence and patterns of descent. Texts are perceived as inscriptions that are, at the same time, both calculated representational interventions in social semantics and unexpected registrations of the discourse of 'the other scene'. Within modernism especially, any artist must be at home with the languages and possibilities of contemporary artistic practices which define the field of play at that moment. Any artist must calculate the nature of the intervention in order to be recognised as a player in the game of avant-gardism.[28] But the process of making art, which can last over hours, days, years, disposes the text towards that other scene, that enters uninvited, to allow the play of fantasy and unconscious elements that form an undertow of other meanings and affects. Beyond that, any representational act is open as a moment of creation to signifiers which assemble to make possible the inscription, on this newly created screen, of psychic materials that may have hitherto been foreclosed. 'Forclusion' – foreclosure – is a Lacanian term for those elements which become psychotic through the lack of a signifier that might conduct them towards the sociality of language and an enunciated subjectivity. The lack of a signifier of feminine difference (as opposed to the feminine as the signifier for phallocentricism of difference/lack/not-man) condemns the feminine to foreclosure and women to psychotic dereliction.

The repetition of this fascination with what modernist idioms produced in the representation of female bodies and flowers may be interpreted as a trace that is as much a residue of (art) historical determinations as of psychic investment. If we follow it across the work of several painters, photographers and even performers, we might catch a glimpse of an important set of relations between femininity, modernity and representation on which press the question, not so much of the nature of sexuality (a bourgeois positivist question), as the production of sexual difference.

This is why I reintroduce Crawford Barton's portrait of Imogen Cunningham at 79 with a single Calla Lily (4.15). Woman is an ideological fiction and the juxtaposition of woman and flower creates the metaphoric chain between youth, beauty and the passage of time that inverts both: age, decay and death as I discussed in Chapter 2. Behind the screen of feminine beauty hides the terror of disavowed mortality.[29] In his sculpture *La Belle Heaulmière (She Who was Once the Beautiful Helmetmaker's Wife)* (2.16), Rodin created a talisman of his terror: the emptied body of an aged woman, flesh limp on its desiccated form, breasts like flattened sacks, an old woman is the ghastly alignment of age, desiccation and death. In Crawford Barton's portrait, the lily cupped by the delicate and still agile hand of an elderly, alert artist detaches the flower with its virginal associations from its doubling role as simile for woman and decay in order to confront us with an artist and her 'intellectuality', signified by the glasses that stand for her sharp and thoughtful vision, standing outdoors but with the object of her artistic analysis which her working hands caress tenderly.

Room V Portrait of Georgia O'Keeffe

We must now re-encounter Georgia O'Keeffe – who, dying at the age of 98, also exists in visual memory of photographs of her as the solitary female ascetic living in the desert. This image of O'Keeffe is very important as a counterpoint to that which it has displaced, the more than three hundred photographs of his lover in her youth taken by Alfred Stieglitz that formed his enormous project, a collective and sequential *Portrait of Georgia O'Keeffe*. It was begun in 1917 when the young teacher visited New York from Texas for a mere three days to see her one-woman show at Stieglitz's *291* gallery. The project lasted until the 1930s when O'Keeffe was photographed with her famous Ford, the sign of her independence and gradual separation from Alfred Stieglitz, whom she had married in 1924.

In 1921, however, the grand master of the New York scene held a retrospective exhibition of his photography at the Anderson Galleries in New York. He showed forty-five photographs of O'Keeffe under the title *A Woman*. It was thus that the larger New York art public was introduced to the artist Georgia O'Keeffe: as Woman seen by her lover. She is not represented in a studio, with palette and brushes, at work with models and objects. She appears as a body fragmented into elements and parts that in turn attract Stieglitz's analytic and obsessive gaze: face, neck, breasts, torso, sex, thighs, feet, and always her refined hands (4.17).

For art historians, and especially those with feminist agendas, this event and its archive presents difficult questions. Is this evidence of Georgia O'Keeffe's objectification under the lens of Stieglitz? How could she have submitted to this 'abuse'? Did Georgia O'Keeffe become a model like Tina Modotti? Or are we looking at an extraordinary artistic and personal collaboration that had meaning *for her*? Georgia O'Keeffe was a New Woman, politically a feminist, who aspired to the freedom of sexual experience as much as to gender-less liberty in her aesthetic practice. In this series, I suggest, she is *seeing herself being seen through the eyes of a heterosexual man who desired her* in all the ambivalence in which masculine heterosexualities are forged. The *Portrait* disturbs our common sense because we may feel we are positioned as voyeurs who have interrupted a post-coital photo-session. Hardly, outside (and even within) the frank depictions of sex we call pornography have we encountered such an evocation of the space and effect of sexual relations written on and through the body of a woman who must have been a conscious partner in what she was doing when she played her role before the lens of her lover-photographer who interrogates her body, her skin, her sex for what she dares not imagine, but with the same acuity and passionate detachment Imogen Cunningham applied to the interior surfaces of the Calla Lily or the bark of a tree.

I want to ask: What would Georgia O'Keeffe have seen in this indirect mirroring? Was it useful as a distancing device, manufacturing the necessary space between the proximity to the body she felt and reproduced in her own work that seemed too revealing and the possibilities that, she glimpsed, might mobilise her experience of her own sexualised and desiring body in an aesthetic shared by herself with Stieglitz that was profoundly rooted in photography as a means of seeing and representing?[30]

This photographic *pas de deux* had, I suggest, two authors. The *Portrait of Georgia O'Keeffe* cannot only be the sublimation of the twin faces of desire and misogyny enacted in ana-lytical distance of Weston's formalism, for instance. It is the declaration of intimacy in which the subject, who is not merely a woman-object-of-the-gaze, was an active partner. How radical this was cannot be underestimated. Whatever the actual sexual experiences of

women in the nineteenth century, and historians dispute the evidence, the dominant discourse disallowed it entirely. Within the dominant discourse Woman was not a sexual subject even if her major function was reproductive motherhood or sexual commodification, rendering her, in Michel Foucault's words, saturated by her sex, yet not its sexuated subject. Even if the ideology belied the actual practices and pleasures of women in their sexuality, feminine sexuality was condemned to silence: it was not so much repressed as censured.[31]

Room VI A room of one's own: Virginia Woolf

Here I must introduce another personality, not so much into the space of my expositionary discourse as into its underlying enquiry: Virginia Woolf whom we know in such different guises. Photographed in 1902 in a very Victorian mode by George Beresford, Woolf appears incisively as the modern intellectual in Man Ray's 1934 portrait (4.19). Between these two historical moments lies the date when Virginia Woolf claimed the world changed: 1911, the moment of the post-impressionist exhibition in London, the arrival of European modernism in Edwardian culture. There was also a more gradual transformation that was absolutely essential to her emergence as a professional writer of twentieth-century modernism. Giving a lecture in 1931, Virginia Woolf dramatised the struggle of the woman artist or writer for access to the sense of self required to write or make art. She described a phantom that haunted her. She named it the *Angel in the House*, a figure from a nineteenth-century poem by Coventry Patmore celebrating the ideal of bourgeois femininity that Virginia Woolf's own mother had lived, and from which she had died, all self-sacrifice and submission. Virginia Woolf fought against this phantom that threatened to 'take the heart out of her writing'. She tells us frankly that she murdered her.

> Had I not killed her, she would have killed me. She would have plucked the heart out of my writing. For, as I found, directly I put pen to paper, you cannot review a book without having a mind of your own, without expressing what you think to be the truth about human relations, morality and sex.[32]

Virginia Woolf then touches upon the violence of the struggle for women to gain access to their own interiority through the figuration of the body as sign of sexed subjectivity. She evokes the image of the woman artist as a fisherman, lying sunk in dreams on the edge of a lake, with a rod held out in deep water – as if fishing in the depths of unconscious being. The line slips easily through the woman's fingers; the imagination rushes along, only to be brutally halted by a sudden smash against something hard and resistant, stunning the flow of excitement by its absolute prohibition. The woman is in distress. 'To speak without figure, she had thought of something, something about the body, about the passions which it was unfitting for her as a woman to say. Men would be shocked. She could write no more.' Virginia Woolf concludes that although she did kill off the pernicious voice of bourgeois ideology, the Angel in the House, and find her own voice as a modern writer, she never resolved telling the truth about her own experiences as a woman's body – 'I doubt that any woman has solved it yet.'[33]

Since 1973 when Carol Duncan first argued that we could read the evolution of modern art as a sexual narrative where ideas of liberty were figured as sexual freedom by images of sexual frankness in the symbolic space of artistic creation – the studio – we have learned

to read images of the artist and his model (4.5). These frequent self-portraits by men artists juxtapose the active man and his nameless, faceless model, a lump of female matter which the artist is in process of aesthetically transforming into his signature art on his canvas.[34] The artist in his studio – the symbolic site of artistic modernism – was a recurring trope and an obsessive subject for Matisse, the other Fauves, the artists of *Die Brücke*, Picasso. Their images dramatised the rapport between modernist themes and the progressive fractions of the bourgeoisie. Watching the artists who lived a lifestyle of apparently sexual bohemianism imagined so vividly in their wild paintings, the collectors vicariously enjoyed the liberty of unchained masculine heterosexuality claimed and celebrated in their art.[35]

The German painter Paula Modersohn Becker came to Paris in 1900, 1903, 1905 and 1906 where she saw the works of Cézanne, Van Gogh, Gauguin and Manet – all of whom helped her to devise a new style that, in terms of colour and form, breached the regional ruralism and naturalism of the German art colony in which she lived at Worpswede. As summation of her Parisian studies, and witness to the difficulties of the attempt to attach herself as a woman to the modernist movement, the *Self Portrait with Amber Necklace* of 1906 (4.19) is a painting that shows the definite impact of the work of Gauguin, while revealing the enormous contradictions, for a painter who is a woman, of the embedded tropes of his modernism. Its very sign was the refashioning of the female body to signify a renewed relation with (bourgeois concepts of) nature, the archaic, the ancient and the simple forces of life, sex and death. In trying to use her own body as the sign of a New Woman attempting aesthetically to modernise herself and thus her femininity, Paula Modersohn Becker challenged this new ethos by forcing it to accommodate the reference to an actual, contemporary, professional European woman in the space of a representation that typically functioned precisely by always being the space of a displaced other – either working class, prostitutional, or from another culture and ethnicity perceived through the distorting mirrors of colonialism – African, Polynesian, 'pre-modern', the condensed sign of racial, social and sexual alterity.[36] Could the female body that signifies nature (in these exoticised settings) or matter (as faceless model in the studio) be infused with a sense of sexuated subjectivity? Could it be made to incorporate the sexuality *and* the intellectuality of the author as New Woman – woman claiming her own authorship within modernity?[37] Simply to paint another woman nude is to risk the collapse of everything within the image into the overdetermined modernist sign of woman as the silent, dumb, mindless body, not the experiencing subject of artistic transformation, even though the artist as woman will, perhaps, bring a different point of view, a sympathy with a body she knows. Despite its impossibility, Paula Modersohn Becker's *Self Portrait* challenged that emerging modernist regime in ways that she could never fully recognise except in the attempt.

Here lies the problem I am trying to investigate: at the beginnings of European modernism, sexuality became a metaphor in Western culture for a new truth, a new beginning, a reconnection with powerful forces of human nature that would signify the escape from the stultifying regularities and disciplines of work and social etiquettes of both traditional societies and the recently formed industrial and professional bourgeoisies. The patrons as much as the artists indulged in this fantasy world in which the confrontation of the creative masculine artist with his defining truth and freedom was to be imaged in a complex cultural relation to a female body that, by being painted under the influence of the styles of non-European cultures, would signify exotic otherness and primal access to this fundamental 'truth of being'. As Michel Foucault would have it, sexuality is not our truth but under the bourgeoisie, this facet of the body, its pleasures, health and perversities were

represented as the truth of being – and the source of social danger as well as exciting liberation and became its own kind of racism.[38]

At no point, however, was this concept of sexuality imagined as feminine heterosexual or homosexual. Yet cutting across this field, and emerging, as Michel Foucault has argued, from the dysfunction of the bourgeois family and its regimes of sexuality, psychoanalysis developed as a discourse promising to make sex speakable and to provide a tour guide to the dark continent of femininity. Psychoanalysis was initiated by the shift from the medical gaze at the hysterical female body perceived as the unknowing site of its bodily pathologies to the attentive listening to the symptomology of hysterical young women's speech. The hysteric, symptom of the malfunctioning of the bourgeois family, cannot find herself within its sexual orders. Disturbing these impossible and unlivable positionalities, the hysteric poses the radically unsettling question of the instability of gender: Am I a man or a woman? Psycho-analysis may be understood as one of the modernisms: psychological modernism or the modernisation of psychology, and further, the modernisation of sexuality. Psychoanalysis allowed sexuality into discourse, relieving it of the blockages that detoured it into neurotic symptoms such as hysteria. It was Freud's work that provided a vocabulary used by the American critics in the 1920s to embrace the drawings and paintings of Georgia O'Keeffe as a dehystericised but still unconscious effloration of female sexuality as something which 'flowered', dispersed, luxurious, sensual, and in excess of the singularity of the phallus. Like the Freudian analyst, these critics displaced Charcot's medical-scientific gaze at the voiceless hysterical body – Charcot's photographic iconography of its performance remaining a critical visual trope in modernist art from Degas and Picasso on to modern advertising and cinema – in order to trace the inscription of the feminine in discourse that might give access to another scene, another sex.

But what the critics heard was distorted by their own fantasies of the otherness of Woman. In the *Portrait of Georgia O'Keeffe* by Alfred Stieglitz, there are hundreds of images which are disturbing in their diversity and even contradictoriness. How can we reconcile the sensuous abandon of the naked woman possessing her body with the severe, strict image of the clothed woman in her stark black and white suit, drawn back hair and unflinching gaze (4.20)? Susan Fillin-Yeh has read these latter images in terms of the Dandy which links Georgia O'Keeffe's fabrication of the self to the spirit of Marcel Duchamp with his female *alter ego* – Rose Selavy (Eros is Life).[39] Both of these examples belong in a wider context of radical questioning of the gendering of the artist by putting into visual play a sense of sexual fluidity and the discontinuity between identity, desire and the social regulation of bodies, appearances and fashion codes. Indeed, the cross-dressing of the 1920s emerges as a critical outward sign of that conflict which the psychoanalyst Joan Riviere was beginning to articulate in her critical paper, 'Womanliness as Masquerade'.[40]

Room VII Differencing the feminine: Gluck (Hannah Gluckstein)

It is in this context, namely a move back to the 1920s as the decade of an intensification of women's participation in cultural modernism and a moment of creative fluidity and sexual experimentation, that I want to introduce another artist in the imaginary exhibition who adds another dimension of ethnic and cultural difference as well as issues of same-sex desire: Gluck. Born Hannah Gluckstein (1895–1978), Gluck, as she renamed herself, was the daughter of a noted Jewish dynasty in London. At 17, she ran away from home to join a

colony of artists in Newlyn in Cornwall where she first imagined herself as a character from an Augustus John painting, as a gypsy – which is how Alfred Munnings sketched her in 1916. Refashioning herself, she began to wear what she called 'outré clobber', men's clothes, and cut her hair, as she appears in two photographs, one more tentative from 1919, when she was 24, and more assured by Howard Coster, *c*. 1924 (4.21). Like many woman artists and writers who flourished in the 1920s, she was openly lesbian.[41] The question of sexuality becomes more complex when one adds to the debates around self-representation by O'Keeffe, Modotti and Cunningham the explosion on to the modernist cultural scene of the intellectual, social and cultural force of women who love and desire other women. What knowledge of the feminine body as both self and other might we anticipate from their works and how will they fashion novel forms of self-representation to fabricate a distance from both the dominant phallic conventions of femininity and the modernist tropes of the 'primitivised' sexualised female body as instrument of a heterosexual masculinist fantasy of the artist?

Sheri Benstock's extensive study of *Women of the Left Bank* offers a substantial account of the literary culture of lesbian intellectuals which included as partners artists such as Romaine Brooks, whose *Self-Portrait* (Washington, DC, 1923) is one of the key images of this moment. Romaine Brooks also painted a portrait of Gluck as *Peter (A Young English Girl)* (4.23). Sheri Benstock notes how almost all of her key players – Djuna Barnes, Nathalie Barney, Sylvia Beach, Kay Boyle, Bryher, Colette, H.D., Janet Flanner, Mina Loy, Anaïs Nin, Jean Rhys, Solita Solano, Gertrude Stein, Alice B. Toklas, Renée Vivien, Edith Wharton – have been considered marginal to canonical stories of modernist art and literature. If at all, they have been allotted merely supporting roles. She writes:

> The roots of the misogyny, homophobia and anti-Semitism that indelibly mark Modernism are to be found in the subterrain of changing sexual and political mores that constituted the *belle époque* Faubourg society. . . . The story . . . writes the underside of the cultural canvas, offering itself as a countersignature to the published modernist manifestos and calls to the cultural revolution. This female subtext exposes all that Modernism has repressed, put aside, or attempted to deny.[42]

Jewish, British, Lesbian, as dedicated as Virginia Woolf to assassinating the Angel in the House, Gluck appears in the archive as a figure traversing this 'female subtext' through painted and photographic portraits of the artist and her circle, and through paintings of flowers (4.24).

Indeed, it was her exquisite 'portraits' of distinctively modernist floral arrangements, influenced by her lover the designer and renovator of interior decoration Constance Spry, that became the dominant subject of Gluck's painting after 1932, when she was first given an arrangement by Constance Spry that she painted as *Chromatic*, the centrepiece of her 1932 exhibition. It was at this exhibition that Gluck designed her signature Gluck frame – a stepped series of pure white rectangles that aimed to integrate her paintings with their radically modernist settings. While Gluck daringly tackled the complexity of floral combinations, subduing potential disorder by a disciplined classicism of sharp contours and varied tones of white, her painting *Lilies* (4.24) confronts the fascinating ambimorphism of the Calla Lily that had been examined so variously by Georgia O'Keeffe, Tina Modotti and Imogen Cunningham.

Gluck's publicly declared and artistically inspired sexual orientation usefully plays havoc with the ideological analogy between Woman and Flower, freeing the image from the

reflexivity which I have been wanting to explode. The flower appears to offer a homology for female sexuality as conceived in its heterosexual modes. Yet, of course, its own bisexuality makes the flower an undecidable, a natural hysteric, without one sex, for it has too many and can be read both as interior and receptive, and active or projective. We need to dissolve its antithesis: that women who do not conform to the stereotypes of femininity troped as nature and artifice, as innocence and perversity, that the fragile beauty, transience and menace of flowers has been used to signify, are 'manly' or masculinised. For Freud, publishing his famous essay 'Psychogenesis of a Case of Homosexuality in a Woman' in 1920, female homosexuality was explained as a masculinity complex, a position slightly modified by Helene Deutsch in her *Psychology of Women*, published in 1947 and reviewed by contemporary lesbian theorists to allow us to understand psycho-sexuality positionalities as complex combinations of potentialities and deflections of the drives, whose vicissitudes were determined in each individual's family history. For current-day viewers accustomed to fashionable cross-dressing, however, these photographs of Gluck, taken by fashion photographers who specialised in modern masculinities, Ernest Hoppé and Howard Coster in the 1920s, have lost the power to shock us by their hitherto unimaginable coincidence of codes of masculine dress and signs of femininity that do not depend upon dress. It may be that such images mark the visual space of what Judith Halberstam names 'female masculinity' – separating masculinity from maleness – thus allowing certain tropes to be released from their grounding in bodies and gender and to become possible sources of pleasure and sexual self-fashioning.[43]

Despite that possibility, I want to retain a larger field for the possibilities of a diversity of 'the feminine' and to see the cross-dressed self-fashioning and self-presentation before these cameras of specific photographers of men as part of a moment of cultural exploration of the still uncharted country of women and desire. There exists a photograph of the artist's mother, taken in 1894, just before Gluck's birth and one of Gluck as a little girl taken in 1899. They visibly record the late Victorian froth of femininity dispersed through all layered accoutrements that excessively assert the bound, decorated, frilled, coiffed, feathered, laced, bejewelled masquerade that was meant to be the essence and nature of *haute*-bourgeois femininity. The photographs record the fashion codes against which the modernist economy rebelled in every facet of design, and against which radical modernist woman adopted the simplified lines of men's clothing, created in what Flügel, the social historian of gender and costume, called the 'Great Masculine Renunciation': by which Flügel meant the radical despecularisation of masculinity that took place over the nineteenth century, whose correlate was, however, the hyperspecularisation of the feminine as display.[44] As men abandoned the show of costume for the 'universal costume of mourning', as Baudelaire would describe it in 1846, so Woman became the focused carrier of the gaze, turned into its spectacular object through fashion and, with the consolidation of capitalism, through identification with the commodity itself.[45]

Not the active appropriation of masculine identity, cross-dressing by lesbian and straight women in the 1920s signified a dissident refusal of the excess of external appearance and artifice identified as 'feminine' in favour of a sartorial and personal space for the production of other forms of womanness: other ways of signifying being a woman than through the available terms of the artifice of spectacular femininity. This did not mean becoming a man. There is a space that we must tentatively recover between these closed alternatives, to see inscribed in diverse ways the struggle to signify femininities that refuse the monosexual sexual model of phallocentric society in which, as negative other and cipher, the feminine is

abject matter or compensatingly fetishised masquerade. Womanness is my neologism, attempting to force into discourse an equally socially created condition, but one in which the female person is, insofar as anyone can be, the author of the meanings she makes her body signify for herself as much as for others. As Monique Wittig has argued, a lesbian is not a woman, not because she is not female, but because she refuses to participate in the 'class relations' of patriarchal society in which woman means only the economic vessel and sexual object of men.[46] Gluck's tailored appearance is a revolt against what the outward form of the femininity decreed for her by her mother's generation implied for her social, sexual and personal space, while it is also the garb in which she could accommodate and visually signal a love of women. At the same time Gluck was fabricating an image of social and personal freedom 'in borrowed clothes' expressive of aesthetic independence: a modernist sexual/ aesthetic revolt. The dream of expressing women's longing for political freedom and cultural autonomy had, for fifty years, focused on dress reform: since Amelia Bloomer first invented her own pantalooned costume and Aurore Dupin dressed herself as George Sand in trousers. Thus radical styles of dress had larger connotations in terms of new women, modern women and emancipation, resonating as sexual codifications only within knowing subcultures – until 1928.[47]

Over the early decades of the twentieth century, therefore, styles of heterosexual femininity would be modernised and a late portrait of Mrs Gluckstein in widow's weeds, *The Artist's Mother* (1930), renders the once frothy young woman of 1894 in the severe black and more angular silhouette of 1930s women's fashion. Against the massive, unmodulated black of her fir-trimmed coat and feathered hat, broken only by the tense flexing of the ungloved hands, the drawn features and large, saddened eyes of the woman create a poignant, almost melancholic image, its affective core enhanced by the starkly simplified contours of contemporary female fashion. But even beyond this change, there is something else tipping into the visible when we scrutinise the photograph of the artist by Hoppé of 1926 (4.22). Here Gluck offers her strong-featured profile to the camera as the central luminous point in an image made interesting by the angular shapes of her hat, upturned great-coat collar, shirt and tie. There is a tension between this frame of tailored clothing and the undecidable quality of the face that, refusing any visual formulation of gendered appearance, opens up to the representation of embodied subjectivity that defies our desire to make categories visible, to bind subjects to known categories by means of clearly coded visual signs and conventions. Instead of knowing that we see a Woman or a Man, signs anchored in the social semiotics of fixed gender categories, we see a new kind of image in which neither the masculinity nor the femininity of familial heterosexuality is registered, but a dream of another way of being a woman that must mark its specificity more in the distance from the emptiness of the feminine masquerade than in its fear of borrowing from its brothers the sartorial signs of a historic 'despecularisation'. Men's clothes are a universal possibility, a liberating freedom from corsets that had made it hard to breathe, tight seams and sleeves that made it hard to move one's arms, costly fabrics in which anything other than being passively decorative risked despoiling the expensive commodity of which the woman was the clothes-horse.

I am suggesting that the photographs of Gluck are to be read as neither feminine nor masculine, while yet neither transvestite nor inter-sex. What these images tip into the visual field, like the Stieglitz photographs of Georgia O'Keeffe, is a femininity in the process of self-redefinition in relation to a staged *being seen*, that was in excess of the commodified image of modern femininity soon to be distilled on the cinema screen by the famous contemporary Louise Brooks who also sported a modernist crop. Having named this performer,

I shall introduce my final exhibitor, the African-American singer and dancer and political anti-racist activist Josephine Baker, who made her name on the stage of Théâtre des Champs-Elysées in *La Revue Nègre* in 1925 at another nexus of self-fashioning and finding a sexual self through the gaze of another – this time not merely the question of the new women's sexualities and erotics of the gaze, display and self-display, but the culture's reading of ethnic difference: race.

Room VIII Finding herself: Josephine Baker

During the early 1920s, St Louis-born Josephine Baker (1906–75) was marginally famous for comic performances as the girl on the end of the chorus line who got it wrong. Using her sinuous body and labile joints as well as her expressive features, she made her audience laugh. But in one famous dance, *La dance sauvage*, performed as the finale of the new *Revue Nègre* in Paris in 1925, (4.25), Janet Flanner recounted that:

> She made her entry entirely nude except for a pink flamingo feather between her limbs; she was being carried upside down and doing the split on the shoulder of a black giant. Midstage, he paused, and with his long fingers holding her basket-wise around the waist, swung her in a slow cartwheel to the stage floor, where she stood like his magnificent discarded burden, in an instance of complete silence. She was an unforgettable female ebony statue. A scream of salutation spread through the theatre. Whatever happened next was unimportant. The two specific elements had been established and were unforgettable – her magnificent dark body, a new model that to the French proved for the first time that black was beautiful, and the acute response of the white masculine public in the capital of hedonism of all Europe – Paris.[48]

We cannot escape the ocean of European fantasy that swept over and engulfed this performance in its colonial heterosexual imaginary when we read André Levinson, the dance critic, writing of Baker as Baudelaire's Black Venus: 'The plastic sense of a race of sculptors come to life and the frenzy of African Eros swept over the audience. It was no longer a grotesque dancing girl that stood before them, but the black Venus that haunted Baudelaire.' As Henry Louis Gates and Karen Dalton have written of the shock: 'No one had ever witnessed such unbridled sexuality on stage. Words like *lubricity, instinct, primitive life force, savage, exotic, bestiality* and that particularly loaded word *degenerate*, raced through the capital.'[49] Shock at the display of sexuality was registered through the racist troping of a modern African-American jazz dancer as an African sculpture come to life. A primitivising European Pygmalion called into flesh and bendy bones his African Galatea while not noticing that it was a dance, a routine, an image, fabricated by a modern city girl from East St Louis in a complex and knowing reclamation of the very terms of her ancestors' enslavement and abduction from an Africa she had never known.

How are we to read the moment of Josephine Baker's emergence as an internationally acclaimed musical star in 1925 within the context of the peculiarly painful convergence of the colonialist and a masculine eroticising gaze at the spectacularised black female body? Was there another script, lodged inside, yet working against the grain, that could allow women access to a sexuality that might be the basis of a self-realisation? Writing in 1984, Hortense Spillers identified

black women as the beached whales of the sexual universe, unvoiced, misseen, not doing, *awaiting their verb*. Their sexual experiences are depicted, but not often by them, and if, and when by the subject herself, often in the guise of vocal music, often in the self-contained accent and sheer romance of the blues.[50] (emphasis added)

Spillers sees this as a historical legacy of slavery which 'relegated [blackwomen] to the marketplace of the flesh, an act of commodifying so thorough-going that the daughters labor even now under the outcome'.[51]

In a surviving piece of archive film in which Josephine Baker performs her infamous banana dance in *La Folie du Jour* in 1927, we see her dancing in a setting that specifically positions her as an exotic African dancing before a dozing colonial European dressed in colonial white. At the end of her routine she turns her back towards the colonial master and, jutting her buttocks at him, accompanies the movement with a turn to the audience and an ironic smile. The bodily gesture of complete disdain for the white man marks into the script of Baker's dance an already postcolonial use of her own movements to claim her subject status even within an apparently objectifying situation of the *mise-en-scène*.

Josephine Baker's performances may thus be considered a dangerous game: playing with fire, we might say. In her many autobiographies, Josephine Baker provides some important glosses on this breakthrough in her career and cataclysmic moment of cultural revolution. Paris, the first city in which as an African-American Baker was served in a café by a white man who called her Madame, was both a haven from American racism and a city being transformed by the presence of so many creative African-Americans. Since the end of the war in 1918 many black GIs had remained, and a steady stream of writers, musicians, poets and performers had created what Tyler Stovall names 'Paris Noir'.[52] Josephine Baker made a place for herself that has remained in the archive for longer than many of her contemporary singing and performing peers probably because of her unique relation to the image. Benetta Jules-Rosette has made a special study of Josephine Baker as image and icon.

> Real life notwithstanding, Baker lived her life as an echo, or reflection of her art. These multiple back and forth reflections built her larger and larger until her image became more than even she could have anticipated, it became an icon that represented an entire generation and a foretelling of the future. Absorbing new influences instantly, she appropriated others' images of her as her own and added new and unanticipated facets to them. Later in life, Baker used her own images and ironic sense of the camp, the cliché, and the retro to encode more new messages. This was part of what she called 'doing Joséphine.' Baker's life in review allows us to see how an individual epitomizes her era, and how life and the art of the performance mirror each other in the production of new art forms.[53]

Many other scholars have noted the significant relations of Baker to the intersection of popular culture, commerce, cosmpolitanism and the avant-garde in Paris. As singer, dancer and night-club 'hostess' – a term used by Janet Lyon to argue that we should read Baker's evenings at her club as a cultural Salon similar to Mabel Dodge's or Gertrude Stein's – Baker seemed to challenge analysis by drawing into herself so many complex and contradictory threads in that Parisian moment of modernism.[54]

What I find fascinating in this tapestry of myth, legend and Baker's own words in her various retellings of her own becoming is the encounter of the modern American dancer

with the classic structures of the modernist French studio. Baker has described her sessions modelling in 1925 for the artist Paul Colin which appeared in 1927 as *Le Tumulte Noir*. In the painter's studio, under the compelling gaze of the masculine artist whose erotic scrutiny of the living woman he asked to unrobe before his hungry eyes has been the object of feminist interrogation, Josephine Baker experienced, by her own account, a coming into her own sexuality through the gaze of this other, this white man, this European artist.[55] The puritanism inflicted on African-American women in defensive response to the atrocious abuse of their labouring and sexual bodies by European slave-owning society was unexpectedly displaced through a scenario – the classic artist and sexually encountered model in the studio – that held open the door to Josephine Baker's experience *of her own sexual beauty* and potential: she is reported to have said: 'under his (modernist) eyes, for the first time in my life I felt beautiful.'[56]

These images stage an artistic gaze in the masculine at the body of a black woman who is then transformed into an image that reflects back upon him. Colin claimed he had discovered Baker – unclothed her and, in true European fashion, found the truth of her body, her truth as body, in its classic form – the nude, which is but a pathway to actual sexual possession. In the TV biopic rendering of her autobiography, *The Josephine Baker Story* produced by David Putnam and starring Lynn Whitfield, Josephine Baker sneaks from Colin's bed after modelling and unrobing has led to sex, to contemplate herself in a mirror, looking back down her own gaze, to enjoy the beauty of her body and recognise a powerful sexuality available for her art form in dance hitherto masked by a defensive masquerade as a defensive comic parody of blackness. Could we read this moment, however banal it seems in this narrative, in relation to Hortense Spillers' notion of a black woman's finding her own *verb* – her own means of signifying herself as a sexual subject, looking down the borrowed gaze of the desiring white male other to claim back a means to become the author of her own artistic self as a dancer in which she claimed the musicality of her athletic, agile and creative dancer's body for a sexuality focused on her ownership of her own desirability and its activation in modern African-American dance knowingly using doubly freighted tropes of that dance's ancient heritage and its contemporary colonialist currency in negrophiliac Paris?

This may seem so trite: woman finding herself in the sexual glance of a desiring man, especially when we should make no assumptions about Baker's own sexual orientation. Yet it was under the eyes of an artist, a white man, a Frenchman, that Josephine Baker, like Georgia O'Keeffe with Alfred Stieglitz and his camera, found a look coming from another place, down which to glimpse another vision of herself formerly disallowed by the cruelty of racist society, a vision of herself as a sexual being, which she could appropriate as the author of that charge, that inevitably narcissistic reflection that folds into sexuality. The so-called masculine gaze, institutionalised in art and cinema, that feminists have identified only to decry, could, we might argue, have other uses. It could be instrumentalised by a woman as a visual pathway in which another reflection could bring to the surface something that Virginia Woolf, still the child of that Angel in the House, found barred and blocked: a truth about her own experiences of her own body. As Josephine Baker describes it, she found someone: 'she' had always been there although she had not been able to see 'her' – a resource in black femininity and sexual subjectivity that could fuel her authoring of her own modernist performance art through the literal instrument of her moving body in dance. In finding the musicality of her own sexuality, Josephine Baker translated the most prototypical of the European negrophiliac fantasies in which her performances were undoubtedly

caught into a resource for her own creative transformation while at the same time doing something equally radical in terms of dance and sexuality that resonates in culture beyond that complex, contradictory and dangerous moment.

This moment in the studio of Paul Colin echoes the photo-sessions of Alfred Stieglitz in New York and in doing so allows another way to elaborate my argument about the distance between the ideological ascription of a nature to Woman, called her essence, which she must passively embody, and the idea of a masquerade. The masquerade, as Mary Anne Doane has argued, could also be the aesthetic fabrication of a distance between this ideological 'nature' and the subjectivity of the creative New Woman.[57] In order to become not just a political subject, via the suffrage with political rights, but a Subject, the at least partial author of oneself, through the creation of both a personage and an aesthetic practice that can affirm and enunciate each woman's singularity, women needed a means to articulate a history of the body – the body as space of phantasy, of pleasure, of anguish, the locus of loss, of memory and objectless desire.

Josephine Baker was, at that moment, a modern, professional American, not an African (4.26). Yet she wrenched from the negrophiliac Europeans the terms of her own self-invention and self-projection.[58] She reclaimed, in a way quite different from Paula Modersohn Becker's equivocal play with modernist coloniality, the other body that had been coloured and colonised by Gauguin, rendered primitive and mindless. She animated the body with the musicality of sex of which she was the choreographer and author. Balanced precariously between gross racism and the possibilities of that *époque* created in colonialism's ambivalence, Josephine Baker's dance at the Théâtre des Champs Elysées was a historic moment for the creation of female sexuality and its aesthetic signification.

Baker made several films in the early 1930s with her partner Pepito Abatino to build on her success. In *Zouzou* (1934) Baker plays an orphaned Polynesian child raised in the world of the circus with a 'brother' whom she grows up to love, only to be disappointed by his choosing her best friend. None the less, she becomes a music-hall star. Her signature song is about this unacknowledged love for the one man she wants – which becomes a hollow refrain when she has lost him. This shows a different Baker – the glamorous *chanteuse*, absolutely at home in the French music-hall tradition – yet even here, in her stagy settings and curiously feathered evening dress, she brings a gamin charm, and a quite different kind of vitality and personality to the rendering of this love song. At one point in this film she appears in a cage like a human bird – an image used on the film's poster. The film is interesting in terms of France versus the United States: the narrative premise of the film is the potential love between her brother played by Jean Gabin and Baker – crossed not by racist ideologies but the vagaries of love. Yet this juxtaposition on the poster reveals the political unconscious of the film restoring to the white order the blonde – the whiteness of the white woman – as the object of desire and contrasting the romantic portraiture of the couple with the figuration of the black woman as a caged bird – singing, but trapped and herself combining a non-classical nudity with references to the animal world. We seem back with the resilience of the colonial imaginary. Although the racial structure was different in France, allowing Josephine Baker public freedom in all those spaces where segregation still ruled in the US, allowing her to succeed, make money, share the stages and compete on equal footing with other stars of several nationalities, the narratives in which she starred could not allow what they did imagine and this visual image reveals as the yawning divide.

In her next film *Princess Tam Tam* which recalls the French colonial imaginary by setting the film as part reality, part dream of a French writer who winters in Tunisia to find inspiration for a flagging career and a failing marriage, Baker plays Aounia who is a wild-spirited shepherd girl from the local hills whom the writer and his side-kick Pygmalion-like decide to 'civilise' in order to bring her back to Paris and pass her off as an Oriental princess. Success is ensured for their African Eliza Doolittle until she is plied with alcohol by a friend of the jealous wife and is tempted by the beat of the drums to leap off the balcony on to the stage, stripping away her fetishistically confining evening dress so as to lead the dancers. The music is modern but the dancers on the stage are initially the regulated mechanical chorus line of Ziegfeld and the Folies-Bergère analysed as the cultural equivalent to the Taylorist production line by Kracauer in his article on the Tiller Girls. Their costumes and bare white limbs look ridiculous and entirely without allure. Once Baker takes over the stage and begins a dance which is no longer burlesque bump and grind or anything of the 1920s shimmying, but something that shows some knowledge of North African dance, an entirely different effect is created. Yet the film lodges her performance once again within the frame of an enthusiastic white audience, enthralled it seems by a performance that their corseted and primped bodies would never emulate.

I want to return finally to Paul Colin's drawings for *Le Tumulte Noir* made in 1925. The published version creates a narrative in which the black bodies of named dancers appear as a kind of dream not of the colonial man but of the white bourgeois woman. She appears in the first image dreamily recalling what she has witnessed at the music-hall. She will appear again, cruelly exposed in her plump nudity attempting to perform before her own mirror the body gestures of the Charleston which Colin has otherwise drawn using figures that carry their contemporaneity and American modernity in their contemporary costumes as well as an entirely new repertoire of the body (4.27). What seemed so new, exciting and desirable to Colin's fat, middle-aged female *alter ego* was the agile, articulated body that had shoulders, arms, and above all hips and buttocks. Colin had unrobed Baker all the better to understand a different body and sexuality signified through movement from that which operated in the white Euro-American aesthetic in which female bodies were stilled in the classic nude or refashioned by extreme costuming that at once exaggerated and veiled the facts of femininity's swelling parts.

This other body, the locus of envy, and desire, was then punished in representation. Colin made it caricatural in its exaggerations of the skinniness of the women, with their elongated limbs that swung in different directions and opened the body, and the leanness of the leering men. Except for the drawings of Josephine Baker.

Colin's images of Baker are curiously at odds with the rest of the volume. In the two images in which she is shown in her dancing costumes rather than as a fashionably dressed flapper, she is drawn only from the back. In the painting of her wearing her skirt of phallic bananas, her body forms an elegant descent across the page, and although one arm is extended and the other severely bent these limbs do not disturb the rhythmic line of the body itself. Note too the pointing toes and almost balletic lightness of the body so at odds with either of the dancing styles that we have on film which use either contemporary African-American or the North African dance footwork. The image of Baker dressed only in a grass skirt of fronds is somewhat more angular but it too cannot catch the gyrations of her hips nor the fluidity of the hand movements – which we can see in archive footage. Her extremely modern hairstyle, shiny with its heavy waxing soon to be adopted as the sign of the modern American woman in the European casting of Louise Brooks in several films by

German director Pabst – and her false eyelashes – pull in a very different direction from the ethnographic costuming of the semi-nude brown body.

Do these images tell us what a typical Frenchman saw when he looked at Josephine Baker dancing in his studio – or do they register his confusion, his *inability to submit* the subject he encountered to the tropes the critics were bandying about – we know them all too well to repeat here. Much of the tenor of the French critics' responses which linked Baker to Baudelaire's fantasy of a Black Venus and to the novel aesthetics of the recently imported appropriated sculptures and masks from various countries in West Africa shows one culture struggling to find words in which to express what the new African-American urban music and dance represented as a cultural force. Far from acknowledging that this was the contemporary artistic vanguard of an explosively energetic but cogently, culturally and historically founded articulation of a people's creative reconfiguration of a traumatic history, the Europeans could only try to place it over there in space, and back there in time, the place where they wanted to keep their Africa whose modernity they would systematically rob and stifle.

It might be that Josephine Baker had such an impact in that short and strange period of her initial success as a Folies-Bergère dancer in the 1920s precisely because she inhabited their fantasy costumes that bespoke their desire to conjugate the African with the primal, the animal, their vitalising but subordinate other, while in her actual performance she charmingly undid it all because she was actually dancing in a modern style to the music of a vernacular urban modernity.[59] Baker found something in the spaces and gazes of Europe – in France more than anywhere – that clearly did support her artistically and politically in ways that were denied to her as a black woman in the United States. Baker still had to negotiate the historical conditions of a colonial imaginary that imagined her as a wild Tunisian, a young Polynesian, an African, and never saw her as a modern American. Perhaps those narratives were easier to refashion as the foundations for her own elaboration of what she was never going to experience in a society still so profoundly unable to process its mutual but different traumatic histories of slavery. Perhaps Josephine Baker unexpectedly found the colonialist fantasies less damaging, more easily turned back on themselves, more amenable to being used as a springboard for her finding of her own verb; a verb in which she could speak her own singularity and experience that growth that comes from trying different things and having the space and freedom to decide who to become through work, through art, through love, through politics in which being black was found beautiful, interesting, in ways that did not compromise her fundamental humanity as a person.

If France did something for the 20-year-old laundress' daughter from East St Louis around 1925, she certainly did something very remarkable for France which led to the outpouring of emotion and respect when she passed away in 1975. Juxtaposing film, photographs and drawings, this installation in the virtual feminist cinematèque has tried to pose some of the questions and offer only some speculations on how we can link these seemingly incompatible scenes – of her half-naked entry on Joe Alex' s back in 1925 and her exit as a humanitarian campaigner and visionary, in dignity and national respect from her adopted country for whom she had fought in its dark moments. In this puzzle, Baker's finding the 'verbs' to link musicality, creativity, sexuality and black femininity, investing them all with a joyous and infectious vitality faithful for a while to jazz and its dance, makes her one of the crucial figures of modernity, fit to sit at the tables of history and plan new futures if only we could take the time to understand what it was that she did when she got off the Berengeria and made Paris her theatre of life.

Room IX Return: some concluding reflections

With my title visions of sex, readers may be afraid that this chapter would be about images of the body's sexual parts or the refined artworks which promise an aestheticised experience of something close to pornography. The word 'pornography' means writing about prostitutes; it would be an interesting but impossible digression to consider at what point the intimate relation between vision and sex comes about with all its complexities. Is sex visual? What happens to us when it becomes connected with a certain kind of visual representation? Does it not put the viewer under the sign of the voyeur, the perverse desire to bind sexual pleasure to the line of sight that objectifies what it looks at from a protected distance? We are also made into fetishists – curious and fearful at the same time, wanting to disavow what we think we see or do not see *on* the female body.

Women are not voyeurs, according to Freud, nor fetishists – for the fear of castration does not operate in a similar way to make the two primal scenes at the core of psychoanalysis – the primal scene of the parents' sexual union and the moment when the boy child 'sees' a woman's naked body – the formative moments of a psycho-sexual identity retrospectively built upon these sights. What is it to look from one of the multiple positionalities of women? What relations are there between sexuality and sight if at all 'in, of and from the feminine(s)'? Are there differences – and what might these be? I do not study artists who are women with any fixed ideas, for such ideas could only come from the culture which had shaped me within its phallocentric regime. We are schooled to look at the world through straight white men's eyes and see ourselves performing the femininity – its masquerade – required for that gaze. The feminine might then be theorised as the renegotiation of the gaze in order to install in culture some other means of signifying subjectivity and shaping meaning from the hitherto unsignified space of feminine differences.

Under the possibilities experienced as modernity and modernism in the 1920s, I suggest there were some important experiments carried out by artists who were women – often with other, more purely formal questions on their mind. I do not think that these artists knew what they were doing at every level, even while there would be no art at all unless there was an intending subject, thinking, making, reflecting. I do not believe in the intentionality of the artist securing the entire meaning of the work. Art does not simply express its creator. The artist is a strategic producer of artwork, making decisions and negotiating the art world into which she intervenes. But the point at which the artwork acquires its effective possibility of meaning is its encounter with the world, with an other in the moment of viewing or reading and in the encounter with other works co-present with it, or invoked and referenced by it. All art is conversational, sometimes real, sometimes imaginary, and its effects hover in that space between its objective existence in a form and as an object and its processing by the subjects invoked to be its witness and thus to enter via imagination and identification a lost world, that of its producer. But the very characteristics of modernism that tended towards a preoccupation with formal questions, with the process, with materials and their possibilities, loosened the control over representation. It enabled the kind of semiotic renovations which Julia Kristeva names the avant-garde. Part of my project is to consider the particular conditions under which that semiotic renovation if not revolution opened some tiny chinks through which the beginnings of the complex process called the modernisation of sexual difference would be glimpsed.

We now return to Georgia O'Keeffe in 1917 until recently a teacher in an art school in Texas, having just had her first exhibition in New York. Just before she was taken by Paul

Strand back to Stieglitz in New York, she did a series of watercolours we now think are self-portraits. When Stieglitz had seen Georgia O'Keeffe's charcoals in 1915 he had declared 'finally a woman on paper'.[60] This is an ambiguous phrase. Finally, woman has been represented on paper, or finally a woman can truly draw. Was Stieglitz talking of the image or of the artist – as we have seen the ideological framing of O'Keeffe collapses the necessary distance between the two as did the *Portrait of Georgia O'Keeffe*? O'Keeffe became *Woman* on paper before Alfred Stieglitz's camera. But these extraordinary watercolours forming two series suggest we may have found that point of initial intersection between the exploration of a modernist idiom and a particular artist's reflexive attention to the body of herself as other who is, by being female, the site of a particular condensation of memory, fantasy and curiosity for the artist who looks at her body and paints a bodily trace in fluid colour on paper. Freudian theory suggests that women are neither voyeurs nor fetishists: Laura Mulvey has suggested that the model of Pandora's curiosity might be useful for women to think about the notion of a desire for knowledge of the feminine, its invisible sexual specificity, its particular array of fantasies about the maternal body, the identificatory body, the body of feminine as other. She writes:

> Pandora's gesture of looking into the forbidden space, the literal figuration of curiosity as looking in, becomes a figure for the desire to know rather than the desire to see, an epistemophilia. If the box represents the 'unspeakable' of femininity, her curiosity appears as the desire to uncover the secret of the very figuration she represents.[61]

Mulvey examines the Pandora legend which confirms the myth of the dangerous nature of both feminine interiority and curiosity, while she uses this analysis to propose a revision:

> To sum up, there are three 'cliché' motifs, elements of myth, that are central to Pandora's iconography: a) femininity as enigma; b) female curiosity as transgressive and dangerous; c) the spatial and topographical figuration of the female body as an inside and an outside. And I would like to reformulate them, to illuminate the tautology, as follows: a) Pandora's curiosity acts out a transgressive desire to see inside her own surface or exterior, into the inside of the female body metaphorically represented by a box [or in my argument, a floral calix] and its attendant horrors; b) a *feminist* curiosity transforms the topography of Pandora and her box into a new pattern or configuration that can then be deciphered to reveal the symptoms of the erotic economy of patriarchy; c) feminist curiosity can constitute a political, critical and creative drive.[62]

Perceived under the rubric of such a radically demythicising curiosity, the 1917 watercolours by Georgia O'Keeffe are dark and strange, full of a disturbing combination of energy, even force, and moments of breathtakingly tender attention to the vulnerability of a person as their body. Rarely is the face depicted, or even shown, and when it is, its representation is slightly shocking (4.28).

The colours are fleshly yet also reminiscent of blood. When displaced to the face, the colour turns the eye sockets into dark pools which weep their blackness into the surrounding red. There is no peering into the sex of these bodies and their poses do not fragment or contort them. The images leave the women unexposed yet agile and expressive in a bodily

presence that is clothed in the artist's fluid washes (4.29). These inscribe so vividly upon the page the hand that has fluently drawn the form, found the shape, defined the posture, expressed a gesture. The body on the page, the woman on paper is neither model nor artist, neither she who is seen nor the gaze of she who sees. The image as a corporeal spectre, a veil of colour, is that of a borderspace between the several, embodied, sentient and reflective feminine subjectivities that momentarily occupied the space and time of artistic practice in Texas in 1917, while being both susceptible, and resistant, to the many voices, memories and images that daring to confront the body of woman in art would necessarily invoke.

The point of this journey through a virtual exhibition leaves the questions of interpretation more fluid than the compulsion to closure of interpretation within a 'finished' text might normally expect. I have summoned these works into the space of contemporary encounter by means of an imagined exhibition that breeches all the current protocols: I have mixed media, sites, projects, countries, purposes and effects in order to create between the representational practices a space for something more than interpretation: the will to know, to classify, to contain by explanation, by revealing an inner truth. My assemblage – re-membering – is a *reading of an archive* that allows a re-vision of the past perceived through the urgencies and theoretical possibilities of the feminist present. The legacy of what was unfinished in the modernisation of sexual difference and its representations in the 1920s awaited the repoliticisation of the question of gender during the 1970s. In the thirty years since there has been a theoretical revolution in the means to think about and analyse sexual difference, discursively, in artistic representation and at the psycho-symbolic level.

I want to leave you, my virtual visitors and real readers, with the watecolours by Georgia O'Keeffe, not as objects of traditional art historical interpretation, but as moments in a history of the intersection of visual representation, femininity and modernity: stories of artists' bodies and sexual difference. I could not begin to see these works at all without the complex work of re-creating, via my virtual exhibition, their possible encounter which exceeds the usual categories of art history: style, period, *oeuvre*. Their radical potential – virtuality – was formed by the historically retrospective moment of feminist curiosity now coupled with the opportunities created then by an astute and calculated attention to the formal questions and stylistic innovations that have been rightly inscribed into our Museums of Modern Art. But modernism has been made into a museal text in ways that leave the works by, rather than the bodies of, women, a dark and illegible artistic continent. These images of bodies and flowers write other texts that are neither blank nor dark and indecipherably other to those of us for whom these uncanny visions of sex 'in, of and from the feminine' form a contemporary necessity, resource and challenging pleasure in opening up possibilities we can reconsider once we have differencing histories of art and expanded understanding of the many dimensions and indeed bodies created in the feminine visions of sex.

Part III

AFTER AUSCHWITZ
Femininity and futurity

Instead of continuity and a ceaseless forward flow of artistic developments sealed autonomously against the pressure of historical events, the virtual feminist museum registers the ruptures and catastrophes of the twentieth century. Women's participation in the modernist cultures of the avant-garde was fractured by the rise of fascism, whose many determinations and facets centrally involve a politics of gender, and constituted a profound anti-feminist reaction against everything that women of the modern worlds were striving for. *Kinder, Küche, Kirche*, the famous slogan, easily turned, as John Heartfield showed, into making women of the Third Reich body factories for soldiers and workers – while certain women, Jewish and Roma and Sinti, would be killed in order to prevent them from carrying the germ-cell of the continuity of their own people. Gender and the Holocaust only slowly emerged as a speakable topic, as if the enormity of genocidal murder could contemplate no distinctions. But many scholars have shown that gender was already deeply embedded in fascism and the impact of fascism on its victims was qualified and intensified in different ways by gender. In Part III, the work of two artists caught in this history will be studied. They straddle the moment that divides us from the early twentieth century, Auschwitz, and their works raise the questions of trauma, memory, looking back and the feminine. In unexpected ways they are both connected via the myth of Orpheus and Eurydice, and they both call up a secondary musical dimension of aesthetic affectivity. The late-coming provides the means of analysing the precedent.

Exhibited items in Room 5

The indicative titling in [] is the author's; the works are identified by their inventory numbers in the Jewish Historical Museum (JHM).

5.1 Charlotte Salomon, *Leben? oder Theater?*, 1942, gouache on paper, 32.5 × 25cm. [The apartment] JMH 4168. Collection Jewish Historical Museum, Amsterdam. © Charlotte Salomon Foundation.

5.2 Photograph of Charlotte Salomon aged 8 years, Berlin. Collection Jewish Historical Museum, Amsterdam. © Charlotte Salomon Foundation.

5.3 Charlotte Salomon, *Leben? oder Theater?*, 1942, detail. [Title page] JHM 4155–1. Collection Jewish Historical Museum, Amsterdam. © Charlotte Salomon Foundation.

5.4 Charlotte Salomon, *Leben? oder Theater?*, 1942, gouache on paper, 32.5 × 25cm. [The artist at work] JHM 4351. Collection Jewish Historical Museum, Amsterdam. © Charlotte Salomon Foundation.

5.5 Charlotte Salomon, *Leben? oder Theater?*, 1942, gouache on paper, 32.5 × 25cm. [Painting by the sea] JHM 4925. Collection Jewish Historical Museum, Amsterdam. © Charlotte Salomon Foundation.

5.6 Ernst Ludwig Kirchner, *Friedrichstrasse*, 1914, oil on canvas, 125 × 91cm. Stuttgart, Staatsgalerie.

5.7 Charlotte Salomon, *Leben? oder Theater?*, 1942, gouache on paper, 32.5 × 25cm. [Charlotte Knarre's suicide] JHM 4156. Collection Jewish Historical Museum, Amsterdam. © Charlotte Salomon Foundation.

5.8 (a and b) Charlotte Salomon, *Leben? oder Theater?* 1942, gouache on paper, 32.5 × 25cm. [Fränziska's suicide] JHM 4179 and 4181. Collection Jewish Historical Museum, Amsterdam. © Charlotte Salomon Foundation.

5.9 *Sigmund Freud and Anna Freud on Holiday in the Dolomites*, 1913, photograph. Reproduced courtesy of the Freud Museum, London.

5.10 Charlotte Salomon, *Leben? oder Theater?*, 1942, gouache on paper, 32.5 × 25cm. [Family holiday in Bavarian mountains] JHM 4173. Collection Jewish Historical Museum, Amsterdam. © Charlotte Salomon Foundation.

5.11 Charlotte Salomon, *Leben? oder Theater?*, 1942, gouache on paper, 32.5 × 25cm. [Fascists invade] JHM 4304. Collection Jewish Historical Museum, Amsterdam. © Charlotte Salomon Foundation.

5.12 Charlotte Salomon, *Leben? oder Theater?*, 1942, gouache on paper, 32.5 × 25cm. [Departure] JHM 4833. Collection Jewish Historical Museum, Amsterdam. © Charlotte Salomon Foundation.

5.13 Frida Kahlo, *My Grandparents, My Parents and I (Family Tree)*, 1936, oil and tempera on metal panel, 30.7 × 34.5cm. New York, Museum of Modern Art. Gift of Allan Roos, and B. Mathieu Roos. © Banco de Mexico Diego Rivera and Frida Kahlo Museums Trust. © Digital image The Museum of Modern Art, New York/Scala, Florence.

5.14 Charlotte Salomon, *Leben? oder Theater?*, 1942, gouache on paper, 32.5 × 25cm. [Grandmother's genealogy of suicides] JHM 4294. Collection Jewish Historical Museum, Amsterdam. © Charlotte Salomon Foundation.

5.15 Frida Kahlo, *The Suicide of Dorothy Hale*, 1939, oil on hardboard with painted frame, 50 × 40.6cm. Phoenix, Arizona, Phoenix Art Museum. © Banco de Mexico Diego Rivera and Frida Kahlo Museums Trust.

5.1

5.2

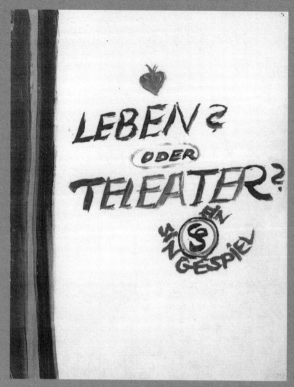

5.3

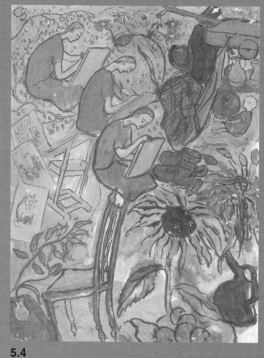

5.4

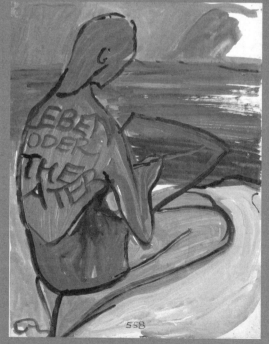

5.5

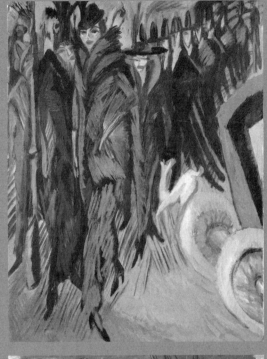

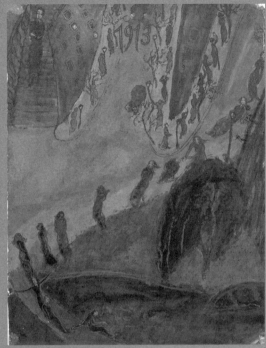

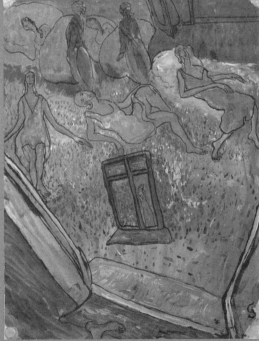

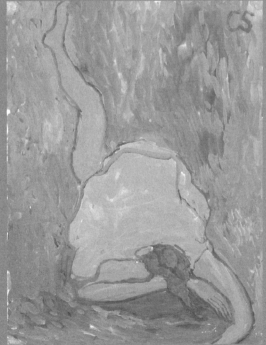

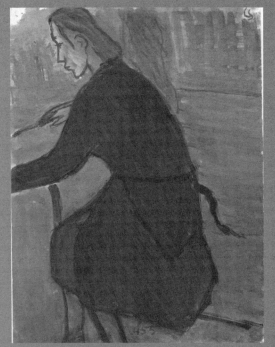

5.12

5.13

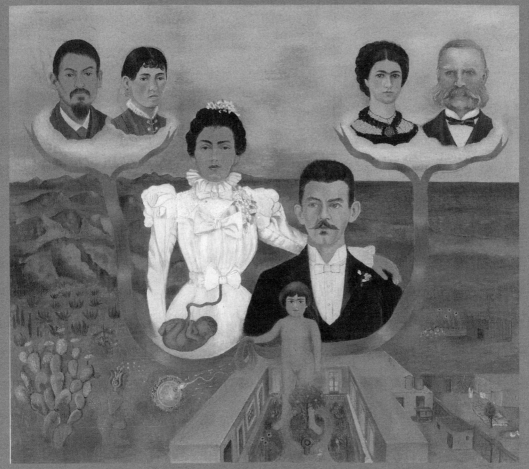

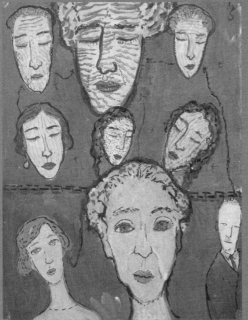

5.14

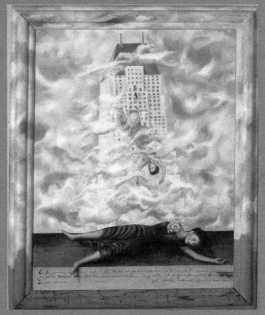

5.15

5

JEWISH SPACE/WOMEN'S TIME

Encounters with history in the artworking of Charlotte Salomon 1941 to 1942

> It has been said that all great works of [art] establish a genre or dissolve one – that they are, in other words, special cases.
> Walter Benjamin, 'On the Image of Proust', 1929[1]

Scenario I Radio days and a Berlin childhood

We are to imagine ourselves in an apartment in Berlin sometime between 1929 and 1933. A young girl, born in 1917, will sit in its well-appointed blue salon to listen to special programmes for children on the radio, broadcast by Berliner Rundfunk. They are called *Aufklärung für Kinder* (*Enlightenment for Children*). Perhaps we are in this apartment, shown as it was in 1916, but painted from memory in 1941 to 1942 (5.1).

The painting is neither an architectural nor a topographical representation. The painter has taken the roof off its interior as if it were the lid of a doll's house. God-like, the viewer can look into a network of living spaces. The painting 'remembers' the interior as a set for living. Its compartments are colour-coded. They thereby make visible a complex of familial and professional relations that will be formally staged within, and by, these lived – *erlebt* in German referring to experienced, lived through – spaces.

The blue salon in the upper left with its elegant sparseness and large piano will be the special space of the original lady of the house who is musical and melancholic. She sings and plays the piano but suffers from depression. There is a gloomily serious dining-room to the right for major festival and family meals or social entertainment – Albert Einstein and other luminaries of Berlin Jewish culture will sit there in the 1930s – and a passageway off which we see the bodily rooms: a modern kitchen that comes complete with attendant maid/cook Augusta, and the bathroom. Bright and hygienically white, these functional rooms are linked colouristically to the prospective baby's nursery on the other side of the corridor, and to the sleeping spaces. In a slightly darker set of grey-whites and reds there is the parental bedroom and, almost lost, is the maid's little bedroom. Without indication of its access, the earnestly sombre left-hand part of the apartment is designated as the doctor's study and consulting room in tones which vary from a green-based darkness to a reassuring pale hospital green.[2] Gender and class are instantly visible in their spatial inscriptions, as are the functions of work: Augusta and the doctor; of sex – the primal space of origin of the artist who is painting this 'history' in space; of cleanliness and of the future place of the artist, the baby yet to come, who will create this image of her family home only twenty-five years later as part of a vast project of what I have named a 'theatre of memory'.[3]

From external evidence we know that this apartment at 15 Wielandstrasse, in the

fashionable Charlottenburg district of west Berlin, seen in what we might call, borrowing from cinema, a crane shot, was beautifully and creatively decorated with a collection of fine Persian rugs and Baroque paintings which were the prized possessions of the doctor, with many newly published art books (perhaps Meier-Graefe on Van Gogh, as the source of the sunflowers and boots that appear in the later work: 5.3) and with a superb piano from which will later come beautiful sounds accompanying a deep and resonant alto-soprano who, after 1930, took the place of the original musical lady of the house, Franciska, and sang Bach's pathos-ladened lament *Bist du Bei Mir*.[4] As a result of Franciska's suicide in 1926, her lonely daughter lives here with a distant, highly educated and ambitious father who has become a Professor of Gastro-intestinal Surgery. He remarries a well-known alto-soprano, a woman of great warmth and firmness who is the stepmother, an ambivalently beloved one, of the lonely child who lost her mother when she was 9. This is a well-equipped and modern household and the newest technology is its radio.[5] Across the radio waves of the Berliner Rundfunk between 1929 and 1933 comes a voice broadcasting twenty-minute talks for children. The speaker, known for the notorious complexity of his thought and opacity of his prose that prevented him from getting a university position so that he makes his living through such part-time journalistic exercises, simply tells his children listeners stories about Pompeii, the Lisbon earthquake, a Scottish railway disaster on the River Tay, a history of toys and many other interesting things. The man's name is Walter Benjamin.[6] The child may have been Charlotte Salomon (1917–43) (5.2).

Charlotte Salomon was born in Berlin on 16 April 1917 and was murdered, when she was five months pregnant, on 10 October 1943 in Auschwitz. Her surviving magnum opus, *Leben? oder Theater?* comprises 784 gouache paintings selected from a stock of 1325 in total created in a period of six to twelve months in 1941 to 1942, many with transparent overlays, on which are written commentaries, dialogue and suggestions of the melodies, classical, operatic, and contemporary popular, to which the accompanying texts should be sung. It is presented, however, as a musical play – the title-page is inscribed *Ein Singespiel* (misspelt) which is followed by a playbill listing family and friends of the artist from Berlin as humor-ously renamed Brechtian characters: Knarre (groaner), Singsang, Klinklang, Paulinka Bimbam. The list includes an *alter ego* for the artist called Charlotte Kann (Charlotte is Able) who is distinguished thereby from the artist as author who signs herself 'CS'. This mono-gram disowns both her Jewish identity revealed in her surname and her gender signalled by her given name. In addition, CS marks a distinctive, creative authorship, suspending identity in a visual configuration that itself plays visual games with the deadliest of con-temporary images: the swastika under whose menace Charlotte Salomon adopted both the activity of CS and the persona of 'Charlotte Kann' who 'lived' in the space introduced above (5.3).[7]

The vast project of painting over 1325 paintings that, selected and numbered in two differing sequences, became *Leben? oder Theater?* was undertaken in the summer of 1941 and finalised by August 1942 when the painter was living in isolation in the Hotel Belle Aurore in St Jean de Cap-Ferrat on the Côte D'Azur. This opus persists into our time, however, by the mere chance of its being largely about a group of people who held no interest for an American woman, Ottilie Moore, to whom the project was dedicated on its second page in gratitude to her for having offered refuge to a stateless German-Jewish exile. Moore had bought many of Charlotte Salomon's watercolour landscapes and portraits while the young woman lived with her also exiled grandparents in Moore's villa, L'Hermitage in Villefranche, near Nice. These other works were lost for many decades and are only now resurfacing.[8]

Salvaged from Moore in 1947 by the artist's father Professor Albert Salomon and step-mother Paula Lindberg, who had survived in hiding in Amsterdam, all the while imagining their daughter safely stowed away in the South of France, this strange and enigmatic vol-ume of musically inspired paintings annotated with text and suggested melodies has only recently begun to be considered as a modernist or avant-garde artwork at all.[9] Indeed, the history of its exhibition since 1961, initially at a modern art museum, and thereafter most often at Jewish historical and Holocaust commemorative museums, its donation in 1971 to the Jewish Historical Museum and recent entry into feminist as well as modern Jewish cultural studies is itself an index of both the uneven history of the emergence of the Holocaust in cultural memory and the challenge posed by this unique case.

First exhibited in Amsterdam in 1961, the year of the Eichmann trial that brought what we now know as the Holocaust into widespread public awareness, Charlotte Salomon's remarkable undertaking of a huge cycle of narrative painting, melody and text was easily positioned as a pictorial parallel to the *Diary of Anne Frank* that was first published in 1947, translated in 1952 and made into a play in 1955 and a Hollywood film in 1959, by which time this other young German-Jewish girl had become the face and icon of the as yet unnamed Holocaust. Framed either as a *diary in pictures* or an *autobiographical play*, Salomon's work has predominantly been read as an autobiographical monument to the tragic life and suffering of its author.[10] I do not want to diminish the impact of the trauma of the life of Charlotte Salomon. It was unimaginable. But we risk losing sight of the artwork as the work of painting and representation if we render it transparent, looking through the medium and the complex structure of the final work only to delineate another tragic heroine of cata-strophic times whose 'courage' we, the late-comers, use to assuage our anxiety in the face of the horrors they faced and in which they died horrible deaths.[11]

As a unique combination of image, music and text, *Leben? oder Theater?* deals with time, space and the archive. It was forged under the pressure of a fascist – and hence deeply anti-feminist – history that ruptured the continuity of women's modernist revolutions of the 1920s, discussed in Part II. It thus opens on to a specific and significant chapter in any analysis of modernity, femininity and representation.

By means of the doubled identities disowned by the monogram CS, Jewish and feminine, *Leben? oder Theater?* will be here considered as a *working through* of the historically significant conjunction of *Jewish space* and *women's time*. 'Women's time' acknowledges Julia Kristeva's theorisation of the relations between sexual difference, language and subjectivity within non-synchronous temporalities.[12] Women's time operates beside and beneath the linear, narrative time of nations, politics and history into which women have struggled since the nineteenth-century suffrage movements to intervene in order to achieve a fuller realisation of their civic and political humanity. This struggle represents one generation of feminism: women's social and political movement for rights and security within the polis. Fascism actively reacted against feminist claims and resisted the new freedoms of women of mod-ernity. Beyond/beneath political time, however, Kristeva proposes other temporalities: the time of reproduction, the cyclical time of repeating generations that are linked with and experienced so bodily by women, and the monumental time of the deeper mysteries of life, death and desire in relation to which we inconsistently but always significantly confront the very question of sexual difference which is figured to us symbolically through an anthropo-morphic illusion: man and woman. The meaning and potential mythic and poetic signifi-cance of sexual difference, how we take on 'woman' as a psycho-social position, led to the second generation of feminism, emerging in the later twentieth century in opposition to

equal rights feminism. This second generation investigated, celebrated and 'wrote' feminine difference: *écriture féminine*, wanting to explore through cultural practices the meanings of psycho-sexual differences of sexuality and time. Kristeva, however, dreams of a third generation that, in Hegelian fashion, suspends and overcomes the opposition between political egalitarianism (to reduce the difference between men and women socially and politically) and poetic exploration that stresses, however it is created, sexual difference. The third moment will recognise that we cannot afford to lose the insight into the human dilemma and possibilities created by sexual difference as a psychically inscribed symbolic effect of access to culture and language – the Symbolic – while we must ensure realised human rights but without the risks attendant on feminism as it has come into existence in these two generations. The risks involve ignoring the sphere of the psycho-sexual and its long-term temporalities or the turning of feminism of either inclination into a substitute religion, believing too much in women as is the case of the various schools of feminine difference studies or too little in the issues still posed by sexual difference by the purely political and social egalitarians.

How does this impinge on the work of Charlotte Salomon? *Leben? oder Theater?* is, in my view, not primarily an autobiographical narrative. I argue that it is instead an interrogation, a question posed to the lives and deaths of three women and one man about whether to live or die. Salomon was moved to undertake such an investigation into femininity at the threshold of life and death (monumental and cyclical temporalities of sexual difference) precisely under the historical conditions of linear time: the moment of a radically anti-feminist, fascist regime which, in withdrawing the rights and freedoms aspired to by feminists in favour of an ideology of *Kinder, Kirche und Küche* (Children, Church and Kitchen) remythicised woman in extremely phallocentric terms.[13] Finally, the nature of that regime's racism politicised sexual difference. It was at once indifferent to gender, refusing to treat Jewish women as women in the mythical ways reserved for the Aryans, thus submitting them to dehumanising treatment aimed precisely at destroying their sense of identity through sex, motherhood, modesty, menstruation, physical appearance or freedom from hard labour and physical abuse. At the same time, the regime was utterly aware of the meaning of sexual difference for their policies of genocide. Mary Felstiner argues that: 'Genocide is the act of putting women and children first. Of all the deceptions a death camp settled on, this one went down the deepest. This is the hard core of the Holocaust.'[14] Young fertile Jewish *women* were seen by the Nazis as the threatening bearers of what the protocols of the meeting at Wannsee (1942) that determined the policy and practice of the Final Solution named 'the biological reserves' or 'the germ cell of a new Jewish revival'. Pregnant women and the mothers of young children were targeted for immediate destruction on the ramps of Auschwitz. Charlotte Salomon was killed in Auschwitz because she was five months pregnant.

Charlotte Salomon's project and the political shadow under which it was produced interweave the doubled strands of linear and monumental time, the time of political history and the time of reproduction, the contingently historical and the deeper structures of phallocentrism as well as a feminist quest for understanding subjectively the significance of sexual difference in such a world. In doing so the gendered, sexual bodies and the tormented or creative subjectivities of those women she summonsed through her painting to her theatre of memory to play out their living and their dying as women, and as Jewish women, cross over women's time with Jewish space. Jewish space, however, opens on to two other dimensions. Modern art itself was reclassified by the National Socialists' cultural policies as a Jewish space. German culture was to be cleansed of its Jewish practitioners and

of the Jewish substance of modern art by de-accessioning all such 'degenerate' art from German public collections. Second, there was a new Jewish relation to lived urban space resulting from Nazi policies towards its Jewish citizens: private space was invaded in the violence of pogroms such as that of 9–11 November 1938, while Jewish presence in public spaces was forbidden. Jewish men and women were excluded from work space. Familiar spaces were left behind through exile. Then there were the horrifying novelties of the camp space, and finally, the very question of the relation of subjectivity to space, and of course, memorial space emerges thereafter.

Theatre is, as the title of Salomon's work itself suggests, an ironic conceit created by a visually and musically imaginative as well as art historically informed artwork that dared to bring into play so many of the aesthetic freedoms invented by an expanded avant-garde culture (across music, literature, illustration, graphic art, cinema, theatre, as well as painting) of which Charlotte Salomon was the unlikely inheritor and faithful redactor. She trained to be an artist-illustrator from 1935 to 1937 – but in a Germany where, as a Jewish subject, she was under severe restriction (a quota system for 'full Jews' at the art school) and constant surveillance (her work shows brown-shirted Nazis in her art classes). She made the work as a Jewish dis-emancipated, non-citizen escaping, in 1939, a fascist regime to become a suspected, stateless refugee exile in what became, after 1940, a collaborationist country. Salomon was a survivor of the end of the modernist era in Germany, her work its belated archive.

As Nanette Salomon has pointed out, it is difficult to imagine where the modern and art historical museum would place Charlotte Salomon.[15] She cannot be positioned simply as a German artist of the twentieth century, since her government murdered her because it disowned her as Jewish, having outlawed her entire people from existence and identified the modern art she espoused even in the midst of its fascist dethronement as degenerate, as 'Jewish'. Perhaps Nazism's grotesque caricature of rejected modernism, staged so dramatically in the vast exhibitions titled *Degenerate Art* in Munich in 1937 and later in Berlin in 1938, which was, ironically, Hitler's greatest gift to an art-hungry student, compounded the embrace Charlotte Salomon declares in one of her representations of her *alter ego* in *Leben? oder Theater?*. Charlotte Kann is represented at work, positioned as moving away from the graphic illustration of Germanic fairy-tales (which she was taught by the anti-Nazi Professor Ludwig Bartnung at the Vereinigte Staatschule für Freie und Angewandte Kunst) and towards clearly declared allegiances to the modernists, Picasso, Van Gogh and Cézanne, each invoked by means of favoured motifs and stylistic mannerisms on the right-hand side of the painting[16] (5.4). By the time Charlotte Salomon began to paint in a manner evidently impregnated with European avant-garde culture, Nazism had outlawed that culture as 'degenerate' and most of the radical artists, Jewish and non-Jewish alike, had fled from Germany.

Moreover, *Leben? oder Theater?* was not made in Germany but in France. Yet that cannot mean that her work can be placed under French Art of the Occupation, for instance. Although Dufy and Matisse were also on the Côte d'Azur during the war, Charlotte Salomon was living in a German-Jewish refugee subculture and later in isolation and virtual hiding, clearly not part of any francophone visual art communities or culture around Nice, whatever exhibitions she may have sneaked in to visit while living briefly in Nice in 1940.

Instead, like Anna Frank, Charlotte Salomon marks the terrible gap or traumatic hole in the archive of twentieth-century art and culture, cut into its fabric by the murderous horror of fascism. Not only must we mark, often without knowing their names or achievements, the

millions of artists, composers, poets, thinkers, scientists, doctors, social workers, designers, actors, playwrights who were killed by Nazism's industrial killing machine. But we, who come after Auschwitz, must live with the knowledge of never knowing what kind of culture we would have inherited had so many more of the radical modernists of the early twentieth century survived into maturity, come into their own, or, like Anna Frank and Charlotte Salomon, carried forward a continuity from that generation of the women's cultural revolutions of the 1920s that they inherited through to us. The horrific caesura of the Shoah/ Holocaust, and 'the genius and the wit, the learning and the laughter that were lost' because of it, delivers to us now a fractured archive, a gap in the museum, an empty place in the library from which there is no recovery.[17]

The manner in which, belatedly, we have begun to read the chance surviving artwork of Charlotte Salomon, *Leben? oder Theater?* reveals the necessity for another kind of space-time archive such as the virtual feminist museum that must now also register the rupture and the break, the absences in the history of women and modernity in the twentieth century that museal-art historical narratives of nation, period, style, and reigning individual masters cannot comprehend and would seal over in their progressive narratives of art's seamless unfolding. To create a new, museal category which is emerging increasingly in contemporary publishing and exhibitions, *Holocaust Art*, is to reveal precisely the failure of art history as a discipline to understand that historical events like the Shoah ruined and changed the conditions of our practice, ethically as well as politically. I am arguing that Charlotte Salomon's work defies the art historical museum's attempts to place it. Instead, we need to read its dislocated existence and its self-positioning work as a *critique in advance* of that attempted assimilation of artworks testifying to and negotiating life and death under the shadow of the Shoah.

Produced in the terrifying fascist time of 1933 to 1941 – what I name the nightmare 'before Auschwitz' – *Leben? oder Theater?* looked back from its vantage point of 1941 to 1942, when it was actually painted (the period precisely of the secret implementation of the Final Solution minuted on 23 January 1942 at the meeting on the Wannsee) to the period from 1913 and even before, to the Wilhelmine era and thence across the Weimar period of recent German history through the prism of the lives and feelings of several women who had been contemporaries with the artists and movements discussed in Part II of this book.[18] On the precipice of an actual but still unforeseen annihilation, already psychically experienced through accumulating personal traumas of pogrom, exile, witnessing the suicide of her grandmother and learning belatedly of the *suicide* of her mother, incarceration in a concentration camp in Gurs, attempted incest and attempted rape, Charlotte Salomon used her invented theatre of memory to ask the dead and living women in the generations above her, and one man who had survived the horrors of the trenches and slaughter of World War One (the war that shaped this theatre of memory as to date the most horrific and epoch-breaching), whether to live or to die. The traumatic depth of having to face such a question cannot and should never be slighted by our will to master and classify the art that such a question occasioned as the means of answering it by travel in artistic space through time into the time-space archive of Jewish-feminine memory.

To avoid the isolating iconisation of a perished victim of the Shoah and to resist the attempt to slot her work into a newly created museum category that fails to interrogate how and why art might have been made under novel and traumatising conditions of total rupture, I propose, through the device of the virtual feminist museum, three imaginary scenarios, each based on some historical possibility, none secured with documentary proof,

through which to study both *the work* and *the figure* of Charlotte Salomon in that rupture that fascism, as the vicious reaction against feminist modernity, sliced into women's as well as Jewish European history.

My purpose is radically to revise the narrative, autobiographical reading of the artwork *Leben? oder Theater?* and to imagine other art historical and analytical ways of reading its practice and its production. I am primarily suspicious of the habit of reducing all work by women artists generically to confessional, personal or testimonial autobiography. We think of the pathologising tragic visions of disabled Frida Kahlo, doomed Eva Hesse or resiliently angry Louise Bourgeois as examples of this tendency. Second, because such reduction to biographical interpretation is a confirmed habit within such art history as bothers to speak at all of artists who are women, applying this model to the exceptional case of a German-Jewish artist working between 1941 and 1942, erases the historical and cultural specificity of the examination this work may have undertaken *through a painting practice* of the question of what life is and what makes it possible to choose it over death in circumstances so overwhelmingly traumatic as those that afflicted the historical 23-year-old refugee in July 1940 when the work was precipitated by incarceration in a concentration camp of Gurs on French soil. Most scholars acknowledge that what is never represented directly in the work – the camp space – is in fact the traumatic void around which the whole exuberance of visual representation emerges to blot out its horror. Third, the vastness of the work comprising between 784 and 1325 paintings and the fact that two-thirds of it is a pictorial study of a philosophical treatise about trauma, the voice and creativity, requires us to approach it art historically with varied frames, allowing the inconsistency within even what was boxed together in 1942, let alone what was excluded but preserved, to challenge us to find more extended cultural frames and terms of analysis of this work. Finally, I wish to propose that the apparent narrativity of the prologue and epilogue veils from us deeper structural elements, traceable through repetition and transported through colour. Because it was remade as a whole after the paintings themselves had been produced in sequences and groupings we can no longer reproduce, this secondary revision reshaped the work to conclude formally in fact where it psychologically began. The final image – a visualisation of the curving forms of the monogram CS – is a representation of the moment the painter took up her brush to begin a work that plots the journey through pictured memory to that very moment of its own beginning beside the blue Mediterranean (5.5). Thus the project is inverted so that what is so often presented as a narrative moving forward through time is, in fact, more like a sustained cinematic flashback, filling in the back history that led to the possibility of the work's emergence, which lay in the creation, as the artist reveals in a section of writing excluded from the final work, of 'a name for myself'.[19] As both product of such a deep journey to the borders of life and death and the map of the same voyage, the work needs to be read for deep structure not surface narrativity, for the play of Jewish space and women's time – which I shall intimate here through my three imaginary scenarios.

I cannot prove in any way that Charlotte Salomon listened to Walter Benjamin's broadcasts for children. The very possibility of this acoustic-intellectual link between these two dislocated figures of catastrophic European modernity opens up important lines of enquiry that do not depend on establishing direct influence, but render significant possible confluence. What would it mean to our cultural understanding of the work of Charlotte Salomon as a structure for thinking through the challenges of modernity 'in the feminine' to read it through the prism of Walter Benjamin's vision of a world caught between fraud, catastrophe and

messianic hope or a world where one studied the living past in the present through attention to its unofficial, marginal and seemingly quotidian indices? Could we see what others perhaps rightly see as autobiographical references as Benjaminian traces of historical processes? As one instanciation of such an intellectual conversation, I want to ponder the recurrence of two themes in both: the city of childhood as a *theatre of memory: as a space/time archive* that punctuates the radio broadcasts for children as much as an important contemporary text by Benjamin that considered the relations of cities, childhood and space in memory. In his *Berlin Chronicle*, Benjamin wrote:

> Reminiscences, even extensive ones, do not always amount to an autobiography. And these certainly do not. . . . For autobiography has to do with time, with sequence and what makes up the continuous flow of life. Here I am talking of a space, of moments, of discontinuities.[20]

Thus Benjamin distinguishes between a retrospective coherence created by narrative projections of a predetermined life-plot, and the flashing into meditative recollection of scenes and moments that refuse to produce a life-story, yet hold truths about how the subject of such reminiscence was shaped by encounters with place. In 1932, on the cusp of a major political cataclysm, Berlin-born Walter Benjamin wrote an unpublished memoir about his Berlin childhood. There he muses: 'I have long, indeed for years, played with the idea of setting out the sphere of life – bios – graphically on a map.[21]

His projected map of recollections of a young man's subjective becoming supports the writing of the social and historical life as the register of emplacement, cultural space and social worlding more geographical than historical. It undoes the individualist problematic that makes us mostly so wary of the traditional, hagio-graphic and ideological uses of the biographical by using space to set the fragments of returning memory, themselves peppered with forgetfulness.

> For the important thing to the remembering author is not what he experienced, but the weaving of his memory, the Penelope work of recollection. Or should one call it, rather, a Penelope work of forgetting. Is not the involuntary recollection, Proust's *mémoire involontaire*, much closer to forgetting than what is usually called memory? And is not this work of spontaneous recollection, in which remembrance is the woof and forgetting the warp, a counterpart to Penelope's work rather than its likeness?[22]

I want to use Benjamin's idea of a life-map, of a *graphically* registered living – in the old sense of the hand writing or drawing its signs – as a way to focus on the issues of childhood, place, memory and their inflection through exile that also haunt the prologue of Charlotte Salomon's *Leben? oder Theater?* which maps the life-histories of three women into whose web her *alter ego* Charlotte Kann is woven as an incident rather than its centre of remembrance.[23] Through this Benjaminian frame, *Leben? oder Theater?* can be read as a work of and on history through a tracking of subjectivity as the effect of history and place as the invention of memory. Benjamin writes:

> First I envisaged an ordinary map, but now I would incline to a general staff's map of a city centre, if such a thing existed. Doubtless it does not, because of ignorance

of the theatre of future wars. I have evolved a system of signs, and on the grey background of such maps they would make a colourful show if I clearly marked in the houses of my friends and girlfriends, the assembly halls of various collectives, from the 'debating chambers' of the Youth Movement to the gathering places of Communist youth, the hotel and brothel rooms that I knew for one night, the decisive benches in the Tiergarten, the ways to different schools and the graves that I saw filled, the sites of prestigious cafés whose long forgotten names daily passed our lips, the tennis courts where empty apartment houses stand today, and the halls emblazoned with gold and stucco that the terrors of dancing classes made almost the equal of gymnasiums. And even without this map, I have the encouragement provided by an illustrious precursor, the Frenchman Léon Daudet, exemplary at least in the title to his work, which exactly encompasses the best that I might achieve here: *Paris vécu*. 'Lived Berlin' does not sound so good but is as real.[24]

For Walter Benjamin, Berlin, the city of his childhood, was the remembered site of his subjective becoming. His imagined bio-map, therefore, is a theatre of memory, conjured up through word-images as a chronotope: a time-space or a spatialised temporality. His retravelled memorial space offers not merely the subjective perspective of the man on the street, the *flâneur* he would study in the work of Parisian poet Charles Baudelaire. It traces the psychological resonance of place with its selective and psychically invested locations for a plethora of formative experiences. The city is imagined as an exciting relay of spaces where formative experience takes place. Such experience inhabits the subject by providing the spatial co-ordinates by which the formation of the located subject can be recalled, linked and assembled into the subject-sustaining structure: memory which is the cushion of assembled scenes over time on which a sense of self, as always selectively recalling, depends. This inner space of memory uses images as its mnemonic, predetermining our attachment to the photographic technology that will, by means of the snapshot, externalise and fix these moment-spaces of individual and cultural histories. Thus we have both a representation of an urban space and the use of that space as a metaphor – a carrier and means of translation and transference for the interior cartography of subjectivity which finds double correspondences in the tripartite spatiality that I have elsewhere proposed for the analysis of painting as visual representation: the spaces that are represented; the space of representation and the psychic-social space from which representation was produced that inscribes one possibility of its space of reading.[25]

Walter Benjamin is best known to many of us for his work on the Paris of the mid-nineteenth century, the metropolis of modernity, *par excellence*, and on Charles Baudelaire whose poetry yields the most symptomatic figure of that modernity at the intersection of gender, class and sexuality: the *flâneur*. The *flâneur* is a figure (not a real person) for a freely moving anonymous wandering subjectivity that feels imaginatively 'at home' amongst the crowds and sights of the expanding modern city. As I have argued elsewhere, the gaze of the *flâneur*, stimulated by the exciting spectacle of commodities and entertainments, is ultimately an erotic and eroticising gaze whose prime object is an extended chain of femininities stretching from the familial (out walking and in the parks) to the prostitutional (out walking or confined in brothels) with less certain and more ambiguous spaces of cafés and entertainments lying between the obvious pole of respectable and not respectable femininities. In representation, the city is imagined as a space privileging an eroticising masculinity: and that is what the *flâneur* signifies as a figure of modernist visual and textual rhetoric.

There is another dimension of relevance here. Following the teachings of the German-Jewish sociologist Georg Simmel whose lectures he attended in Berlin, Benjamin's writings make us pay attention to this specific feature of this ideal figure of modernity: the freedom to wander in the streets unnoticed and unremarked while drinking in the myriad sights and shocks of the metropolitan city: a new kind of being at home, outside and unobserved. It seems to me to be highly significant that Simmel and Benjamin, theorists of this dimension of modernity, were Jewish. They were thereby, historically and culturally, subjects emerging out of a previously marked and confined minority community for whom the emancipation to roam unmarked, unconfined and anonymously in public was a recent and precious acquisition after centuries of othering that had decreed that Jewish Europeans could only live in designated ghettos, and had to apply for and pay for the right to enter Christian cities and be visibly marked as other by badges and hats, as well as later by costume, language and religious practice. It was, however, precisely this mark of modernity's freedom – *flânerie* – that was suspended for those who were *re-marked* as Jewish by the Nazis' Nuremburg Laws after 1935 with the effective reversal of Jewish emancipation by the German state after 1933. Once again, Jewish subjects were excluded from the public spaces, curfewed and excluded from commerce, professions, universities and the arts. Later they would have to wear stars and have 'J' stamped in passports with every man renamed *Abraham* and every woman *Sarah*. What began with exclusion from the free participation in the city would lead to 'transport' and 'resettlement', the horrifying deceptions that veiled a programme of annihilation from any living space at all.[26]

Charlotte Salomon's *Leben? oder Theater?* was not conceived as a map of life. Yet whatever text was being woven had to take place and hence, pictorially, make space. Her created images of the *lived Berlin* she remembered from the distance of lonely exile were distinctive in ways that inflect many inherited possibilities for using the image of urban space as a means to examine Jewish and feminine living before and during its suspension.

Salomon's Berlin is the city of three generations of women: a grandmother Marianne Knarre (Benda-Grunwald) and her two daughters (Charlotte and Franciska) and the family of one granddaughter (Charlotte Kann) dominated by the new stepmother-diva (Paulinka Bimbam). Thus the memorial topographies are marked by the specific relations to both the domestic settings of marriage, birth and death and public spaces as women experienced them, both of which were shaped over a significantly changing historical period in the history of Berlin by the gendered and ethnicised experience of modernity which, as many commentators have noted, did allow women increasing access to the city, but not in a manner accorded to the *flâneur*, a masculine trope.[27]

Let me explore one such example. The modernising city of Berlin was a major trope in various avant-garde art movements in Germany in the early decades of the twentieth century which shaped opposing tendencies towards both expressionism and new objectivity. For instance, Ernst Ludwig Kirchner undertook a series of paintings, pastels and prints of the city streets in which smartly dressed, heavily made-up women dominate the disturbed image of urban space haunted by single men marked out by their black suits and top hats. *Friedrich-strasse* (5.6) turns the uniformly dressed men into a single file lined up behind the elegant and confident women standing, hands on hips, in postures that solicit a specific kind of look and response from the proposed spectator. Like many others, Kirchner's is a city of women implying sexuality for sale. Other more apocalyptic visions of the city were produced by George Grosz in *The City* (1916/17, oil on canvas, 100 × 102cm, Thyssen-Bornemisza Collection, Madrid, Spain) and Otto Dix's *Metropolis* of 1927/8. Charlotte Salomon's

Berlin rehearses none of these modernist tropes or these visions of the city as metaphor for a disintegrating Weimar Republic in which sexual violence and excess stood in for political corruption. Thus in her work we can identify a different/differencing set of spaces that, once plotted out, can be recognised as the spatial-subjective system of the work itself.

There are many images of interiors – those very spaces we first encountered in the doll's house view of the Wielandstrasse apartment (5.1). Many scenes take place in the interiors of apartments, in sitting-rooms stiff with proper furniture and difficult exchanges, where dinner parties take place, conversation and musical entertainment, redecoration and child-ish games. There are bedroom scenes where newly wed couples embrace in smart hotels on their honeymoon and pregnant women await a soldier-husband's return. There are scenes of family celebrations, dinner parties, homework, music-making. There are corridors and bathrooms, where women try to take their lives and little girls flee to escape menaces to which they cannot put a name. Often the image of an interior is, however, punched open at its centre by the threshold to the outside that is the recurring and significant motif of the window. Gazing out, the feminine subject with whom the viewer identifies in the picture is inside, longing somehow for what lies outside.[28]

There are also images of what lies beyond; the move from the inside to the outside is, however, often involved quite shockingly with dying. Thus the city is the setting for two terrible deaths of two sisters who both escape one apartment – their family home – by these desperate means. The opening scene, the first dystopic image (5.7) with which *Leben? oder Theater?* begins, rhymes with its final utopic painting (5.5). It is a scene in which another woman called Charlotte drowns herself. It initiates the trope of feminine death in the city. The covering transparency declares baldly:

> On a November day Charlotte Knarre left her parents' home and threw herself into the water.
> Scene I

The date 1913 appears in Gothic lettering above a scene of a city at night. The lights of a car appear to shine amidst lighted streets around the written date. On the upper left is an apartment which defies architectural logic, enabling us to see both its exterior and its interior. As an external wall curves inward – two single windows alone illuminated in its dark façade – its interior is opened to reveal a grand staircase. If not informed by the famous expressionist film sets of *Dr Caligari's Cabinet* (Robert Wiene, 1919–20), and the distorting spaces of the artists of Die Brücke, the very possibility of such a visual device depends upon its legacy itself enabled by paintings of urban scenes such as Jacob Stein-ardt's *The City* (1913) or posters for other Weimar films such as *The Street* (1924) or F.W. Murnau's *The Last Laugh* (1924).[29]

Peeling open to reveal a staircase within, the painting places the single figure of a young woman, arms crossed at her waist, descending. A single woman leaving an apartment at night raises questions at the juncture of the 'night scene' and the date, 1913; Weimar painters such as Grosz, Dix and Kirchner represented Berlin at night as the city of the inevitable modernist figures of prostitution and the decadent, slumming bourgeoisie.[30] The city of night is the city of entertainment, eroticism, spectacle and sometimes death. In her book on *Lustmord* – sexual murder – Maria Tatar has explored the emergence and obsession with violently explicit images of the sexually motivated murder of women during the Weimar Republic.[31]

But here the street is not the Kurfurstendam or Potsdamer Platz, but Kochstrasse, Berlin,

a respectable residential neighbourhood where no burghers are out and about. The streets this young woman wanders are otherwise empty, save for one parked car. Yet the painting is full of figures. An only slightly distorted scene of city streets becomes the stage for a disorienting multiplication of this one woman, thirty of whom plot a path from that red-carpeted staircase in an impressive apartment building to the inky waters along the lower edge of the painting into which she plunges, her figure outlined against its enveloping darkness in red. This colour combination, black and red, will come in the time at which this image was being painted to bear its own symbolic menace to the life of another Charlotte: Charlotte Salomon, a Jewish-German who must face such a question of life and death in the circumstances delivered to her by the political party whose colours these are.

In this painting we are not being offered celebratory or ironic images of the decadence of the modern metropolis liberated at night from the routines of labour to indulge and spectate in the artificially illuminated city centre. In this painting, empty, ghostly streets of the city at night are a stage for imagining the progressive psychological alienation of the young woman on her lonely journey to suicide. She is portrayed at the upper left, her hunched body suggesting despair made more dramatic sometimes by outstretched arms, at other times by crouching or falling, before the final act of plunging into the inky pool of the lake in the south-west suburbs of the city, the Schlachtensee. Only by following this journey are we, the viewers, made witness to an otherwise private, or even secret act: *Selbstmord:* the murder of the self or murder by the self. In this painting, the exit of the young girl from within the domestic building, her solitary walk and final act, create the counter-image to the prostitutional street-walker, the public woman, the woman of the night so dominant in German culture's modernist urban imaginary and revises an inherited expressionist rhetoric to enable it to register a very different subjective space externalised visually through the image of the passage of a desperate young woman through the city to her death.

If the painting seems quietly to work against the very iconographies and visual narratives the painter clearly knows, it may be that it is also reworking the residual narrative conventions of that painting tradition as well. It is not a composition of several figures all of whom convey aspects of the same 'event' we, the viewer, decipher as the painting's subject. The sequencing of the same figure visually signifies an otherwise invisible inner state of mind; repetition becomes the sign of the conflicted interior dialogue of a subject divided within itself, speaking its despair, arguing for or against the action towards which the body, as instrument of the anguished psyche relentlessly moves, winding through symbolic streets that bridge a considerable distance between the apartment house and the morbid lake. Suicide is thus represented not as a sudden act, but as an outcome of an inner struggle, an anguished state, a self-questioning sustained over the trajectory of the young woman's departure from home and arrival at her watery grave.

If the upper part of the painting invokes and revokes the terms of contemporary German painterly and cinematic modernism, the image of the solitary young woman and 'her watery grave' invites a reference to a very different cultural representation of femininity and death: Shakespeare's Ophelia, who was inadvertently drowned by her own madness. Delacroix's lithograph *The Death of Ophelia* (1843, Paris, Bibliotèque Nationale, Cabinet des Estampes) imagines, as so many other painters have done, the tragic death reported by Queen Gertrude (*Hamlet*, Act IV, 7: 164–85). Delacroix suspended his Ophelia as she falls from the broken bough to her 'muddy death'. As Elisabeth Bronfen has argued, the conflation of femininity, death and the aesthetic is an image of virginal, feminine purity whose rejected love reveals the pathological instability of femininity so that, when imaged, the

figure beautifies and naturalises our gaze upon the otherwise tragic if not traumatic fact of another's dying.[32]

In Charlotte Salomon's painting, however, the fetishisation of the feminine body as an image is not allowed to occur so that the potential 'Ophelia effect' of a painting of the suicidal death of a young woman is represented by a counter, resistant logic to that which Bronfen perceives as endemical in Western culture. The city streets become the stage for a unique and terrible act by a feminine subject: her own annihilation by drowning. Feminine death by and in water is thus the opening proposition of *Leben? oder Theater?*. No explanation is ever given for the action of Charlotte Knarre, and thus, coupled with the bald statement with which the work begins, this willed death functions as the enigma, the disturbance upon which narrative – or even discourse – is predicated. This event contains a meaning, not deducible alone from what we must, none the less, work to decipher from its critical rework-ing of the contemporary modernist tropes of the city at night so that this woman's relation to urban space is marked by gender and death.

The city of Berlin is, following this initiating scene, above all the Berlin of the artist's fictionalised re-creation of the subjectivity of her dead mother, the sister of this first dead Charlotte, a mother the artist hardly knew. Dying when her daughter was only 9, it would be impossible for that daughter to know her well enough to comprehend the despair within her marriage and motherhood that led her to leap from the window of her parents' apart-ment in that same Kochstrasse in February 1926. Apart from a brief period of professional freedom as a nurse at the front during World War I, Franciska's world was confined to the limits of two apartments in the city: an increasingly emotionally unsustaining domestic space from which she ultimately escaped by leaping from a window to her terrible self-inflicted death that the artist makes herself visually witness by imagining a body crushed and bleeding on the harsh stone pavement of a Berlin street (5.8).

In stark, gender contrast there is, less richly elaborated, the father's Berlin which is a place of work – with its own achievements and disappointments. His is a bloody space of surgical research that opens up the body but in order to heal it. This long struggle for professional space is, however, also constricted after 1933 by fascist exclusions of Jewish professionals (JHM 4036–37). There is also the singer's cultural Berlin: the city to which Paulinka Bimbam comes from a small town, Kurzberg-am-Rhein, to work first as a domestic servant and nanny and then to train as an opera singer with some of the world's greatest Bach experts. Hers is a world of performances and applause, of creative arts and musicality, that lead to travels to other cities and the tumult of fame before the same voices call out vile slogans such as *Raus – Jews Out!* (JHM 4250, 4038).

There is, however, the young girl's Berlin as a place of her own coming of age that spans the last moments of Weimar and the dreadful installation of the Third Reich after 30 January 1933. This Berlin involves cemeteries, apartments, synagogues and schools. It also involves trips to the cinema. Embedded in the image (JHM 4236) is such an outing to see the daringly anti-militaristic lesbian love story by a woman director, Leontine Sagan, *Maedchen in Uniform*, from 1932. In this film the young heroine also dies a tragic death, falling from a high staircase in an image that anticipates those Charlotte Salomon would herself paint of two suicides.

Interspersed, marking the kind of freedom of movement and travel momentarily enjoyed by the German-Jewish urban bourgeoisie are joyous scenes of vacations out of the city presented in some of the most complexly articulated compositions in which the family enjoys what the Germans call *Die Natur* – beach holidays on the North Sea, trips to the Black Forest and Bavarian Lakes and to the Dolomites – favoured locations for German

travel shared with an Austrian-Jewish family, the Freuds.[33] A photograph of Sigmund Freud and his daughter Anna similarly show the acculturated Jewish doctor on holiday in the Dolomites wearing plus-fours while Anna Freud sports, as does Franciska Kann in Salomon's painting, a folkoric dirndl (5.9 and 5.10).

Berlin, however, changed radically and violently on 30 January 1933 (5.11). Filled to bursting with a fecal tide of militarised masculinity, the streets became a dangerous space. Words or signs are painted on to scenes so as to function as a visual shout, catching the ugly acoustic violence of the Nazified city that now negatively interpellates the Jewish subject as disowned and dislocated in the very streets of his or her only home. Retrospectively deploying the cinematic massifying that marks the fascist aestheticisation of its violence and disciplining of the ranked bodies into spectacular demonstrations of fascist authority, yet parodically undermining its dreadful terror through inverting the swastika back to its original Hindu, and hence peaceful origins, Charlotte Salomon utilises the brownshirted SA to represent the Nazism that flooded the streets of Berlin as bodily filth. Scenes of violence show this overwhelming physical sense of the invasion of the streets in a way corroborated by the artist Gustav Metzger (b. 1926). Spending his childhood in Nuremberg in the 1930s, Metzger remembers vividly the effect on him, as a child, of marching political groups, left and right. He has talked of the amazing sight of streams of human beings filling the streets to bursting with their stamping feet and military music, their raucous voices shattering silence with sinister threat.[34] This tide of street violence reached a peak with the worst anti-Semitic pogrom of modern times on 9–11 November 1938 known as Kristallnacht or Pogromnacht which is represented by Charlotte Salomon in two paintings. The first, dark and crowded, places a large placard representing the anti-Semitic diatribe from the Nazi newspaper *Die Stürmer* that whipped up the pogrom following the assassination of a Nazi official in the Paris embassy by a young Jewish man outraged at the violent expulsion of his aged parents from Germany as 'foreign' Jews (JHM 4761). A splash of red with a contorted swastika marks the National Socialist flag carried by a mass of people who are reduced to a packed forest of raised, Hitler-saluting hands. This image is followed by a street scene painted in faecal brown (JHM 4762). Anonymous crowds riot in the street before apartment blocks from whose windows Nazi flags wave. 'Perish Judea! Grab what you can!' is directly printed on to the painting itself. In the foreground a noticeably taller brownshirt watches over the proceedings, while green-uniformed police kick bowed-headed Jewish prisoners being marched away to concentration camps.

Despite the bans on Jewish participation in public space, which had been legally Aryanised, the character Charlotte Kann defies these prohibitions; she attends an art school, walks the streets and enters public places, like the railway station, in pursuit of a man called Amadeus Daberlohn who daringly refuses to be diminished by the fascist laws. Defiant, they sit on Aryan-only public benches and go to cafés where Daberlohn delivers his endless lectures to an attentive listener. They even dare to go boating and swimming in none other than the infamous Wannsee (not far from the Schlachtensee) in whose beautiful summer palace, on 20 January 1942, the Final Solution would be minuted. There Daberlohn and Charlotte Kann row upon the lake and there, it would seem, she was initiated into the strange experience of male sexuality which is represented by her passive body being overwhelmed by what I can only call a seminal flood; the narrator names it a 'fiery stream' (JHM 4701). This event is represented as a bubble of yellow in the middle of the painting where colour envelops both bodies on the lake's sandy shore, but there is no surrounding landscape to moor this moment to locality.

The main part of *Leben? oder Theater?* (the work is divided into a prologue 1913 to 1936, a main part 1936 to 1939, and an epilogue 1939 to 1940) ends with the moment of flight by Charlotte Kann from a Berlin that has become too dangerous for her to remain. The Professor, arrested following the Kristallnacht pogrom, has only just been released from Sachsenhausen, half-dead. Charlotte Salomon had to leave Berlin before her twenty-first birthday, when she would have needed an independent passport to travel (which would no longer be possible to acquire as Nazi policy shifted against emigration). Both parents' passports had been confiscated by officials (her stepmother worked for the underground resistance). They too would soon have to flee to Amsterdam, with the assistance of the underground and on false papers.

The scene of farewell rhymes with the painting that introduced the apartment we entered like an eagle (5.1). That 'shot' followed a scene in the main railway station where the musical woman (she who will become the artist's mother) remains alone, behind, as her new surgeon husband leaves for the front (JHM 4167).[35] Long before the iconography of the train became, partly through Claude Lanzmann's use of it in *Shoah* (1985), one of the iconic devices to signify the Holocaust, Charlotte Salomon incorporated this modern mode of transport as a recurring sign – used repeatedly to frame outward and return journeys on joyous holidays or educational travel to Italy. The prolonged farewell traverses thirteen paintings (JHM 4821–33), as if each moment of this painful separation was being relived in slow or even delayed motion. The sequence constructs an extended image of psychological desolation, impending loneliness and intense longing that visualises the subjective meaning of departure across the images which, of course, accumulates in retrospect as its dreaded finality of complete loss and severance from loved ones is realised. These images lead up to the moment that the painter lives as the end of her relation to the city of her childhood. This departure promises no return and only uncertain futures. Close analysis of the painting in which the train finally rushes away reveals a tiny figure desperately reaching out from the window straining to remain in contact, signifying the terror of being thus snatched away from all that is loved and familiar. Then suddenly we are in the carriage, situated now with the lonely traveller (5.12), one of the few large-scale images the artist painted of her *alter ego*, an image that rhymes, therefore, with the final painting where the work will begin this journey into places of memory (5.5).

Scenario II On the streets of Paris

Imagine the streets of Paris in early 1939. A diminutive but exotically dressed woman, limping slightly, with striking black eyebrows and black hair coiled on top of her head, dressed in the costume of Tehuantepec women of Mexico, wanders disconsolately amongst the galleries of Paris' art worlds. She is angry with the surrealists, notably André Breton, who have invited her to Paris from Mexico with the promise of a one-woman exhibition. But Breton has done nothing and the works are still sitting in customs. Fortunately, Marcel Duchamp is better organised and finally arranges to retrieve the works and organise her participation in a show at the prestigious Renou et Colle Gallery between 10 and 25 March. Breton surrounds the artist's seventeen paintings with nineteenth-century Mexican pictures and a lot of bric-à-brac he purchased in the markets of Mexico. The Louvre buys its first ever Latin American artwork when purchasing this artist's *Self Portrait (the Frame)* from the show. Appearing on the cover of *Vogue* magazine for March 1939 and admired by Schiaparelli, this artist was warmly acknowledged by Picasso, Juan Miró, Yves Tanguy and

Wassily Kandinsky. She, however, did not care for what she found in a 'rottening' Europe or the tedious, self-centred and over-intellectual Europeans, although she was part of them, being the daughter of a Hungarian-Jewish father. The artist on the streets of Paris in 1939 was Frida Kahlo (1907–54).[36]

Now imagine a lonely, withdrawn but eager art student, also wandering the streets of Paris to see its galleries and discover a whole new world of French modern painting. After she escaped with her tennis racket, a recording of Paula Lindberg singing the lead in *Carmen* and a single suitcase on the pretence of a weekend 'visit' to her grandmother in Villefranche in France, it appears that Charlotte Salomon was allowed to go to Paris for a month or so between January and March 1939. This event is recorded only in the first exhibition catalogue of her work at the Fodor Museum in 1961 where a brief chronology includes the statement that after her arrival in Villefranche she was able to travel to Paris and study there for a few months.[37]

If it happened, the visit to Paris would have been an extraordinary experience. Frightening for such a shy and solitary young woman alone for the first time in the world, it could also have been a gift for a young artist starved of exposure to contemporary art after the abusive abjection of all modernism under the Third Reich's vigorously anti-modernist policy that herded all modernism under the umbrella of Degenerate Art in 1938 to 1939. It might explain the evident knowledge of French modernist painting exhibited in references to Dufy and Matisse and her changing use of colour. But we can also imagine the sudden joy of freedom once again to walk the streets not stalked by a constant fear of discovery as a prohibited 'Jewish' subject and hence subject to verbal or physical violence. To be Jewish and invisible in a non-fascist, modernist capital must have been intoxicating. To be an artist starved by Nazism of visual resources it must have been joyous. I imagine these two artists from different continents and political worlds passing in the one place they might ever have met.

The further possibility that Salomon saw Frida Kahlo's exhibition, that two women, who otherwise stand out as 'exceptional' and unplaceable cases in relation to our museal charts of modernist art movements dominated by the great men, might have had an encounter, opens our minds to correspondences that mutually enhance our understanding of their projects, each so singular, so unclassifiable and yet so rich in art knowledge and cultural reference, and so distinctively concerned with bridging the segregated spheres of public and private, intimate and political, domestic and political by means of forging, forcing new ways of using the space of painting and hybridising resources from different cultural registers of the modern.[38]

In their landmark exhibition of the work of Frida Kahlo and Tina Modotti in 1982, an exhibition that already showed us how important it is to place women artists in conversation with each other and with their own larger cultural spheres, Laura Mulvey and Peter Wollen proposed some important frameworks for the study of revolutionary modernist women that reflected the new preoccupations of feminist theory and cultural history. Mulvey and Wollen identified the following thematics: margins, women, art and politics, interior and exterior, roots and movements, and the discourse of the body. They positioned the works of both Frida Kahlo and Italian Marxist photographer Tina Modotti, working in different ways and through different media, as the articulation of the gendered body in its various political registers. What counts as history was extended, however, beyond the public and political space of organised revolution to include the psychic space of sexed subjectivity in its dialectic with place, history, family and memory. In ways that interestingly parallel Charlotte Salomon's project, Frida Kahlo, uniquely and knowingly, combined a range of cultural

references and visual forms to explore the inscription of sexual identity, the marked body and political resistance in relation to the question of becoming within a culturally marked family history.[39] She, too, questioned history and identity, place and subjectivity, honestly facing up to the question of life in circumstances of political hope and physical as well as emotional despair. The fate of Frida Kahlo to become a cheapened iconic artefact, more notorious than seriously studied, rendered transparent as a biographical subject of suffering and disappointed barrenness rather than as an artistic producer of a genuinely revolutionary cultural inscription of ethnically self-conscious, politically gendered explorations of space, body and trauma, has meant that substantial art history has been too often neglected in favour of tokenism and iconisation.[40]

But there is a long tradition of significant and serious analysis of this work. Drawing richly on the work of Mexican and German art historians, Israeli scholar Gannit Ankori has most recently enabled some much richer confluences to emerge in filling the volume of work on femininity, modernity and representation. Across politically and geographically distinctive situations, key issues resonate to produce the solid tone of women modernists' preoccupations, that displace the mere reiteration of women as marginalised and privatised sites of pain and misery. Relevant to this putative scenario of a Kahlo/Salomon encounter is how Gannit Ankori has specifically explored the ways in which Frida Kahlo made sense of and introduced into representation her European-Jewish heritage.[41]

Frida Kahlo was the daughter of Wilhelm, renamed Guillermo, Kahlo, from a Hungarian-Jewish family (originally Külo) who moved to Baden-Baden where he grew up before emigrating to Mexico at the age of 19. There he worked as a professional photographer and an amateur painter. Ankori draws special attention to the painting *My Grandparents, My Parents and I (Family Tree)* 1936 (5.13). Ankori resists the 1938 critic who called it an 'amusing family tree' to see instead a complex statement of heritage, identity and politics. A 2-year-old girl child, identified as the artist's younger self, stands firmly and nakedly in the courtyard of her familial home, *la casa azul*, built by her father, surrounded by plants, rooted and growing in this 'outside inside'. She holds a red ribbon that frames two figures: a woman in bridal white on whose lap, tied by a red umbilicus an unborn foetus curls in late pregnancy, and a moustachio-ed man in formal dress. The artist's parents are represented from a wedding photograph, signifying both the marriage of which the standing child is the product and the father's profession. The ribbons open up to hold, resting on beds of cumulus clouds, two further couples. On the left are the parents of her mother Marthilde Calderón, Antonio Calderón and Isabella Gonzales, and on the right those of her father, Henriette Kaufmann and Jakob Kahlo. Each face records both likeness and ethnicity that reveal the dual Mexican indigenous and Spanish heritage on one side, and the European Jewish descent on the other. We notice the strongly marked resemblance between the tiny Frida and her paternal, Jewish grandmother. Ankori suggests two important external inflections on this work of genealogical representation that index its making to the same contemporary field of the rise of fascism that marked the life and work of Charlotte Salomon. One is Mexican and relates to a visual tradition of *Las Castas*, images of two parents from different ethnicities and their mixed offspring which illustrate the diversity resulting from historical intermarriage in colonial Mexico. The other is more contemporary and suggests a purposeful reference to and defiance of the local repercussions of the Nuremburg Racial Laws (1935), under which Frida Kahlo, had she been in Europe as were her father's extended family, would have been racially classified as Jewish. Frida Kahlo had attended the German school in Mexico City, spoke the language and studied the culture. During the

1930s, this German school became Nazified and local Germans were encouraged to produce family trees to prove their 'racial purity,' Ankori concludes:

> Thus, Kahlo's adaptation of the genealogical chart as a model of a 'family tree' cannot be viewed as purely formal. Her deliberate inversion of the device recommended by her former German school teachers to prove *pureza da sangre*, in order to stress the opposite – her 'impure' blood – must be viewed as an expression of her 'mixed' origins and a reflection of her implicit identification with her Jewish heritage.[42]

Charlotte Salomon was offered a kind of family tree – of suicide. In the prologue of *Leben? oder Theater?*, the re-staging of her mother's life and death hypertextually opens on to the life-narrative of her grandmother, therein renamed Marianne Knarre, who tells, from her own point of view, of the deaths of her daughters but also of many other members of the family. In one painting they cluster arround her as sleeping faces (5.14). This image visually signals what another painting sequence from the epilogue (JMH 4860–5) will represent as the ceaseless flow of traumatising words from the emotionally insenstive grandfather who recalls all the horrors of the repeated family deaths that left the grandmother, and now the granddaughter, as the only survivor of that maternal clan. Would it also be possible to see, across the vast expanse of *Leben? oder Theater?*, a more extended questioning of the nature of inheritance and genealogy, of identification and ambivalence with father figures and mother figures? What shall I be, the one that comes from two, is the core question of the Oedipal crisis. How do I, the little one, make sense of where I have come from? What do my paternal and maternal histories offer as a basis for identification or resistance? Juxtaposing Charlotte Salomon's investigations through a prolonged visual investigation of her maternal (and indirectly her paternal) heritage with Frida Kahlo's exploration of gender in periodic cross-dressing, and in clearly planting her biological becoming in her mother's womb but her personal identity in the frame of her artistic father in this significant statement painting, opens up the nature of Salomon's own suspension of gendered identity – CS – or switches of gender by signing in the masculine an opening statement in the work: *Der Verfasser* (JHM 4155–6). It also makes us see more clearly why Salomon needed to explore her maternal genealogy, visually plotting out not her mere descent, but the descent of aunt, mother and grandmother to self-inflicted death. In the climate that suggested suicidal tendencies were not symptoms of deep emotional distress and psychological alienation but genetic degeneracy, did she fear that inheritance or did the work, by staging in pictures the emotional spaces of these women's desolated subjectivities, refute such racist nonsense and open, as did the work of Kahlo, a means to make modern art address questions of feminine interiority and its spaces, private, public, bodily, psychic, artistic?

The artist 'Frida Kahlo' whom Charlotte Salomon may have encountered in 1939 would pre-date most of the now hallmark self-portraits. The oeuvre would include the physically tiny but symbolically grand-scale works of the 1930s, the anti-Nativity paintings as Gannit Ankori names *Henry Ford Hospital* 1932 (Mexico, Museo Dolores Almedo Patiño) and *My Birth* 1932 (Madonna), paintings that mark the loss of a child and the death of a mother. But alone in the history of art of that period we find another image in Kahlo's *oeuvre* that daringly showed a woman's suicide. To the horror of the woman who commissioned it, Clare Booth Luce, *The Suicide of Dorothy Hale* (1938–9) shows the actual death (5.15). A skyscraper rises up through the clouds. High up, we can just detect a tiny figure at a window.

Below we see a still tiny body, and below a larger version of the same body enveloped in cloud, tumbling upside down through the air, to be repeated yet a fourth time, lying lifeless and bloodied on the ground, in a beautiful cocktail gown with a corsage of flowers, one shoeless foot breaching the imaginary space of the surreal painting and shadowing the painted inscription at the point where we can read the dead woman's name. The lower part of the frame seems to be drenched in her blood. Critics in the 1930s, and Clare Booth Luce in particular, found the hard-headedness and frankness of Frida Kahlo's visually staged encounters with the abused body tough and even shocking. Art historians are tempted to explain it as a clash of cultures, Mexican culture seemingly more at ease with talking about and imagining death. But the dying and other physical processes Kahlo treated in her art were gendered, and, as Darcy Buerkle has shown, Charlotte Salomon is one of the few artists to breach the cultural repression and silencing of the nature of feminine melancholia and to give it a face, and a body, even in its own self-destruction.[43]

Although I have argued that we are wrong to consider Charlotte Salomon's *Leben?* *oder Theater?* as a diary, it is, none the less, distinctive in its combination of image and text. Hence one final space of productive conjunction: in her own extremity in the 1940s, Kahlo would also turn to the smaller spaces of the journal, creating a text-image combination in what has been published as the *Diary of Frida Kahlo* – a reworking in scripto-visual form of the apparently intimate space of the private page that belongs in the genealogy of other modernisms with the work of Charlotte Salomon.[44] Within the frame of such a possible encounter and its deeper resonances in parallel practices, we might ask: How does the body then appear in Charlotte Salomon's work and how does she explore the issues of psychic pain and of sexuality, of relations of her own and other's desire? Given the tragic legend to which she has been assimilated and as a victim of the Holocaust, discussions of Charlotte Salomon's sexuality, her possible hysteria, have been dismissed as improper. In extended conversation with an artistic practice such as that of Frida Kahlo, they would become historically significant. A meeting, even belatedly in the spaces of the virtual feminist museum, between these two artists opens up feminist exploration of the surrealist use of non-geometric, non-logical spaces, often from children's, cinematic, popular or folkloric culture as a forcing of Western pictorial space to encompass other, feminine dimensions of subjectivity, diverse, multiple, hybrid, fracturing, dreaming.

Interlude:

May 1940 France was invaded and by 14 June Hitler entered triumphantly to claim the city of Paris. The population of 78,000 German-Jewish refugees in and around Nice ceased to be safe. They were rounded up and sent to concentration camps in May (men) and June (women), and those released because of age or the need to care for the aged, and thus licensed to stay in France and then forced into hiding when the Gestapo moved into the Côte d'Azur were finally tracked down and deported first to Drancy and then to Auschwitz in autumn 1943. Charlottte Salomon was deported on 7 October and murdered on arrival on 10 October 1943.

Scenario III Amsterdam 1997

It is 1997. We are in an apartment in Amsterdam that houses beautiful Persian rugs and other framed images near a beautiful piano. Outside the windows, the sound of water can occasionally be heard as a boat moves along one of the many canals that give the city its

peculiar and entrancing character. To celebrate the eightieth birthday of a distinguished painter, an equally well-respected art historian, herself aged 68, has come to do an interview. They both share a history, having been born German-Jewish in a century and a country that decided this was sufficient reason to be annihilated. Both used their talents, the younger as a writer, the older as a painter, to sustain themselves through terrible ordeals and to compel themselves to find a reason to live and to hope. One wrote in her diary of her intention to become an art historian, or at least to do something worthwhile, if she survived.[45] The other made 1325 paintings to pose the question whether to live or to succumb and kill herself. The art historian is now a famous novelist. Her name is Anna Frank and the painter she has come to interview is Charlotte Salomon to review a long career begun under terrible circumstances that produced a massive outpouring of work during 1941 to 1942 that thereafter became a treasure house of pictorial ideas and philosophical reflections that have been mined and harvested for more than fifty years of continuous artistic creativity now being celebrated in the atmosphere of renewed feminist acknowledgement and research.

Such a scenario flies in the face of a historical reality. I have otherwise insisted that we must acknowledge without the fetishising comforts of art's immortal overcoming of the premature death of its maker. In my article 'Stilled Life' I have written at length on the contrast between the iconisation of the image of a smiling young girl as the narrative fetishising face of the Holocaust in contrast to the disavowed, and dreadful, dying of Anna Frank, made more poignant by the documentary *Anna Frank Remembered* by Jon Blair (1995) in which we meet the surviving contemporaries of Anna Frank, childhood friends and those who were with her in Bergen-Belsen in the winter and spring of 1945 when she died of starvation, typhus and desolate hopelessness.[46]

But I dare to hypothesise this virtual encounter politically, precisely in order to underscore, affectively, the very nature of the gap between the deadly reality of their loss and what might have been.

Had both Anna Frank (1929–45) and Charlotte Salomon (1917–43) survived, I wonder what questions the younger novelist and part-time art historian would have put to the older artist as they jointly reflected on their younger selves, young women on the cusp of a modernity that both promised them new futures as women but, in a perverse, fascist turn, attempted to destroy them as Jewish women. Anna Frank had written openly about her sense of sexuality in her diary – fascinated by the specificity of her body and its responses in ways that shock today's young people who imagine that no one of her generation knew about such things let alone wrote of them so openly in 1943. They were censored from the original edition of the diary by her father, himself disturbed in the discovery through the diary of the daughter he had not fully known even as they lived couped up for over two years. Anna Frank's first forays into diary writing explored a world limited by the walls of the annex in which the process of adolescence was placed under duress in the hothouse of such confinement. No outside existed except in the virtual space of her writing that became the only space through which to plot her changing relation to her over-critical mother, her passionate over-identification with her father, her momentary sexual flirtation with a dull boy, her sense of intellectual ambition and her refusal of the limits of housewifedom and domesticity that limited the world her mother imaginatively inhabited. Reading her diary in its now unexpurgated version is a guide for every parent to the psychological complexity of adolescence and the pain adults' inability to recognise the emerging personhood inflicts upon their still fragile and emotionally mercurial egos. Uncannily, Anna Frank's writing

seemed to anticipate, in its consciously feminist revolt, the kind of young woman I found myself becoming in the later 1960s, rejecting the path offered to me by my mother and imagining that its only other was that of identification with my father. My joy knew no limits when I read that Anna Frank had considered becoming an art historian, a profession I never heard of until I was 20. In daring to propose this scenario, I want to imagine what kind of young woman I might have been had there been no gap, no rupture, no forgetting, caused by so many murders of European women, but the kind of continuity of feminist thinking and the laying down in culture of the work of women such as Frida Kahlo, Anna Frank and Charlotte Salomon to function as intellectual and artistic 'mothers', endowing that line of descent with the desirability of their brilliance, toughness and thought 'in, of and from the feminine'.

What would Anna Frank have written about Charlotte Salomon's work as they both aged and plotted out with their incisive vision and poetic skills the stages of women's lives in changing histories as women bearing within them the continuity of twentieth-century women's struggles for self-realisation? We cannot tell. The question, however, reminds us that in order to write the histories of women we have to create contexts populated by many women. Each a singular intellect, shaped by her own double axis within generation and geography and hence different in their particularities, none the less, the collective history of many women allows us to recover the complex created worlds of women engaging critically, aesthetically and politically with the challenges of femininity, modernity and representation.

This last scenario is thus the cruellest of all. For neither of these two women lived to become famous for a long life of creativity and thought. Anna Frank died a solitary and horrible death from typhoid, starvation and despair in Bergen-Belsen just a few weeks before the camp was liberated. She was not yet 16. She had written her diary which was found and preserved because the Gestapo who arrested her wanted the satchel in which she stored it to take away other papers. None of her stories, what she considered her writing, survive. Through this diary Anna Frank became the most famous icon of the Holocaust – shaping its cultural memory through the figure and face of this perpetual female child, full of impudence and ambition, frozen for ever in her childish hope that was never allowed to reveal the true horror of her dreadful dying. No Salomon was there to make us see it.

It was Otto Frank, editor and publisher of his dead daughter's diary, to whom fellow German-Jewish survivors Albert Salomon and Paula Lindberg-Salomon showed the strange package they had rescued from Villefranche in the South of France in 1947 – a package containing 1325 paintings of which 784 had been placed in order and framed by text and music and titled *Leben? oder Theater?* with which they did not know what to do. He advised them to donate the work to the Jewish Historical Museum in Amsterdam, a decision which has framed this work as a document of disaster despite the immediate interest of the Director of the Stedelijk Museum of Modern Art, Willem Sandberg, on seeing the work, and who brought about its first exhibition as art to take place in Amsterdam in 1961.

It is possible to hold Charlotte Salomon and Walter Benjamin in a theoretical and historical frame as she is precisely the kind of child who might have listened to his broadcasts and become one of the first artists to work with his catastrophic and messianic vision of modernity. It is possible to speculate sensibly on the relays between Charlotte Salomon and Frida Kahlo – the latter having access to some of the former's world through her Hungarian-Jewish father. But this final scenario flies in the face of all history. The irony teaches us something so easily ignored. As the cruel and real product of an active fascism that is, at its deepest, an anti-feminist project, the Holocaust has feminist implications. The Holocaust

destroyed a generation or two of women modernists, whose thought, literature, social and political activism and modernised life-worlds held a vital history of gender modernisation. The horrific caesura strands those of us who come after fascism's brutal assault on the early twentieth century's radical legacies. Because of fascism's victory during the 1930s, modernity was radically interrupted and indeed set back by the perverse assimilation of many of fascism's gendered ideologies by the victorious allies; think of the 'back to the home' ideologies of post-war Britain and America. Modern art history, compiled in the presence of the most intense participation of women in contemporary culture, has played its unanticipated part in writing its gender-exclusive histories of art that leave out all of the great radical experimentations by women at the beginning of the twentieth century, annihilating, in spirit and knowledge, women in culture as certainly as those who killed them in body. Against the gender conflict that denied women recognition of either their creativity or their differencing the canon of modernism, my final scenario functions as a feminist re-invocation of the lostness of that generation not only of Jewish modernist women, but of entire cultural moments of transformation and challenge in the field of culture and sexual difference of which Anna Frank and Charlotte Salomon were themselves the beneficiaries and analysts.

I wonder what it would have been like to become an art historian in a world where these two women, Anna Frank and Charlotte Salomon (as well as so many whose legacies we have lost), had been continuously active in their respective creative professions, where we did not need to start from scratch in 1970 to rediscover the erased histories and cultures of women from the same generation as our mothers that culture had failed to remember for us. My greatest fear now, of course, is that even without such a catastrophic destruction as the Shoah, my generation of feminist thought and the creativity of women it fostered and remembered will be swept away by an impatient, ignorant and complacent anti-feminist culture calling itself post-feminist, which finds the great questions that engaged Benjamin, Kahlo, Frank and Salomon too serious, too demanding, too challenging, too revolutionary.

What is it to choose life, to look history in the face, to create an ethical art? The virtual feminist museum has to remember and mark the rupture of such deaths as well as think again about the significance of what their work asks of us.

Exhibited items in Room 6

6.1 Raphael, *The Three Graces*, detail, 1505–6, oil on panel, 17.8 × 17.6cm, Chantilly, Musée Condé. © Photo RMN/© René-Gabriel Ojéda.

6.2 Bracha Ettinger, *Eurydice* 17, 1994–6, oil and xerox on paper mounted on canvas, 25.4 × 53cm. Private collection.

6.3 Raphael, *Fire in the Borgo*, 1514, fresco, width at base: 670cm. Rome, Stanza dell'Incendio di Borgo, Palazzi Pontifici, Vatican. © Scala Images 2007.

6.4 Bracha Ettinger, *Autistworks no. 1*, oil and photocopic dust on paper mounted on canvas, 32.5 × 28cm. Courtesy of the Artist.

6.5 Raphael, *Fire in the Borgo*, 1514, fresco, width at base: 670cm. Rome, Stanza dell'Incendio di Borgo, Palazzi Pontifici, Vatican. © Scala Images 2007.

6.6 Titian, *Orpheus and Eurydice*, c. 1514, oil on canvas, 39 × 53cm. Bergamo, Academia Carrara (inv. no. 547).

6.7 *Orpheus's Farewell to Eurydice Led Back to the Underworld by Hermes Psychopopmpos*, second century BCE, marble copy of Greek original, c. 420–400 BCE, Naples, National Museum. © 1990 Photo Scala and Ministero per i Beni e le Attivitá Culturali.

6.8 *Bluma Fried and Uziel Lichtenberg Walking in Lodz with a Friend Later Killed by the Nazis*, 1937–8, photograph, from Installation Bracha Ettinger's Family Album at Nouveau Musée de Villeurbanne, France, 1992. Courtesy of the Artist.

6.9 *Bluma Fried Lichtenberg and her Two Children in Israel*, early 1950s, from Installation Bracha Ettinger's Family Album at Nouveau Musée de Villeurbanne, France, 1992. Courtesy of the Artist.

6.10 Bracha Ettinger, *Eurydice* 27, 1994–8, oil and xerox on paper mounted on canvas, 36.7 × 25.7cm. Courtesy of the Artist.

6.11 Bracha Ettinger, *Eurydice* 10, 1994–6, oil and xerox on paper mounted on canvas 27.8 × 28.1cm. Courtesy of the Artist.

6.12 Bracha Ettinger, *Eurydice* 9, 1994–6, oil and xerox on paper mounted on canvas, 32 × 26cm. Courtesy of the Artist.

6.13 Installation of Bracha Ettinger, *Eurydice*, at *Face à l'Histoire*, Paris, Centre Pompidou, 1996.

6.14 Bracha Ettinger, *Eurydice* 23, 1994–6, oil and xerox on paper mounted on canvas, 25 × 47.5cm. Courtesy of the Artist.

6.15 Margaret Bourke-White, *Jewish Prisoners, Buchenwald, May 1945*, 1945, photograph. Reproduced courtesy of Getty Images.

6.16 Bracha Ettinger, *Eurydice* 15, 1994–6, oil and xerox on paper mounted on canvas, 25.2 × 52cm. Courtesy of the Artist.

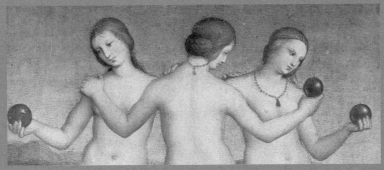

6.1

6.2

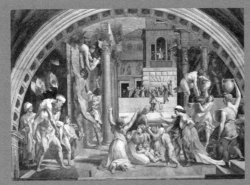

6.3

6.4

6.5

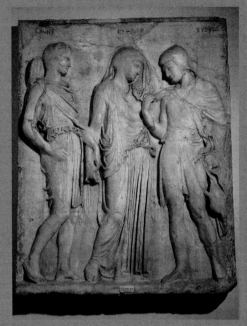

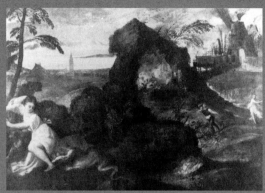

6.6

6.7

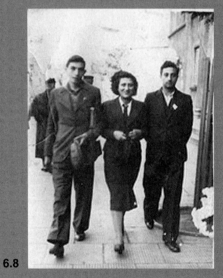

6.8

6.10

6.11

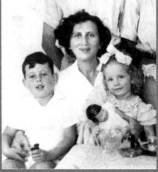

6.9

6.12

6.13

6.14

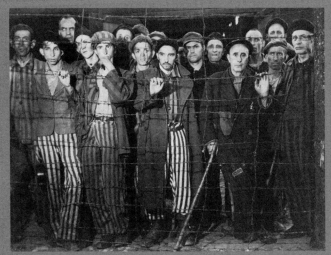

6.15

6.16

THE GRACES OF CATASTROPHE

Matrixial time and aesthetic space confront the
archive of disaster

In the work of mourning, it is not grief that works; grief keeps watch.
Maurice Blanchot, *The Writing of the Disaster*[1]

Art and catastrophe

In 1513, on a small panel in oil paint, Italian art star Raphael painted one of the canonical pagan representations of the feminine. In *The Three Graces* (2.5 and 6.1), three nude female figures present identical ideals of female corporeal perfection culled from the remnants of classical sculpture. Each body and face is the same despite their different aspects. Each beautiful female face is as vacuously inexpressive as the other. Doll-like, they are offered as a surface for the viewer's projection while their unseeing eyes reflect upon the spheres each holds as an image of her own emptiness. In this room, I want to explore the rupture between Raphael's High Renaissance moment of pagan renewal signified by the ideal figure in an ideal landscape and our traumatised epoch, 'after Auschwitz'. After what happened to the human body at the heart of Europe where millions were horrifically murdered in its verdant landscape, is that Greco-Christian European tradition of art still possible, or has history, the Holocaust, shattered it?

I shall explore this question through a virtual exhibition focusing on a painting practice that daily meditates upon what we shall have to call '*the graces of catastrophe*': the *Eurydice* series of paintings 1992 to 2002 by Bracha Ettinger (6.2). In many, not all of this series, the artist returns to encounter three figures from a perpetrator photograph that captured a 'frieze' of unclothed women and children at Mizroc in the Ukraine about to be shot by the German *Einsatzgruppen* – special forces who systematically murdered by mass shootings the Jewish communities of the Soviet Union following Hitler's invasion in June 1941. Actively drawing upon the material resources of the tradition of oil painting epitomised by Raphael, Ettinger's paintings are built over a photographic archive of historical atrocity and unspeakable suffering. If beauty is signified by Raphael in the form of the female nude, and violence is done *in extremis* to women whose humanity was reduced by their cruel nakedness before their executioners willing both to shoot and to photograph them as they stood 'between two deaths', was the tradition of the West of which Raphael became, for the academy, the epitome, also traduced upon the killing fields of Nazism? How, after such suffering, can art function at all?

In 1516 Raphael painted an image of violent catastrophe and terrible human anxiety in the halls of the Vatican. In *Fire in the Borgo* (6.3) a huge fire burns on the left, turning a section of the city of Rome into an inferno from whose engulfing flames athletic *ignudi*

rescue the old and infirm, or stretch their well-honed muscles to reach a desperate mother handing down her swaddled child. On the right, *nymphae* (6.5) – a drawing for one figure appears in Warburg's *Mnemosyne Atlas*, (1.4) – in fluted garments illogically harassed by an unseen wind, appear as water-bearers who stand or call to each other with expressive faces and energetic postures. One, statuesque and sculptural in form, is shown in *profile perdu*; another turns on the spectator her desperate wide-eyed appeal. In the centre of the image we find a frieze of rescued women and children who perform the rites of lamentation in classically defined gestures. Looking daily at a reproduction of Raphael's painting of a fiery disaster, which appears as a ghostly trace in *Eurydice 16*, Bracha Ettinger sadly remembers that in the great fire that engulfed her people between 1941 and 1945, there were few rescuers. After such horror, could anyone now, after Auschwitz, ethically paint such a redemptive picture as Raphael's *Fire in the Borgo?*

These Raphaelesque figures are also the ancestresses of Ettinger's *Graces of Catastrophe* that hover in the paint-evoked borderspace of the painting series *Eurydice* (6.2), a trio more visible in a previous series, *Autisworks* (6.4), drawn from an iconic photograph of the Holocaust shown in the first commemorative documentary film on the Holocaust, Alain Resnais' *Nuit et Brouillard* of 1955.[2] Ettinger attends to a woman seen from behind in *profile perdu* as in the Raphael, and her look at the inhuman beyond is lost forever. Another comforts her tiny child in the classic gesture of cradling. A third turns, as in the Raphael *Fire*, in mute appeal to whoever stood there to take this photograph and in doing so left us, belated witnesses, a place to meet her eyes. The brutal photograph of naked women fetishises the horror through the conventional linking of femininity and death, risking the intrusion of porno-graphic eroticism back into moments of extreme human suffering. These three graces, however, become the daily companions of Ettinger's fidelity. This asks us: Who are we now when we look back at this or any sight of extreme human suffering?

Why name this series of painterly thoughts on art and trauma *Eurydice?* This feminist painting, after Auschwitz, at the intersection of Jewish and feminine difference, swerves back unexpectedly to catch the threads of the opening sections of this book: threads picked up from the work of Warburg and of Freud, threads that deal not so much with persistence of a pagan mythic storehouse of *pathos formulae*, but with the virtuality of meanings held in myths that Freud exposed as having archaic resonances vivid still in each historic subject formed by culture and language as its engendering and sexuating unconscious. The tradi-tional museum keeps art apart through the imposition of strict chronologies. Both subject-ivity and the artistic imagination do not function according to these classificatory rules. Thus the virtual feminist museum exhibits unexpected genealogies as well as marking thereby the nature of the dissonances as much more significant than the fact of different time zones or dates. Eurydice (and her masculine murderer Orpheus) traverses such time zones to mark a psychically charged archive that has much to say about trauma and sexual difference.

On a tiny panel painting of 1514, Venetian painter Titian visualised Ovid's story of *Orpheus and Eurydice* (6.6) taking place in a dramatic and contemporary, sixteenth-century landscape. Linked to the Raphael by its invocation of a hell imagined as a terrible furnace, it uncannily finds its place in this moment of the virtual feminist museum focusing on Ettinger's feminist reclaiming of the mythic figure of the twice-killed Eurydice. Titian's painting narrates three parts of the story stretched across a single imaginary space. At the lower left, watched over by the campanile of a distant town, Eurydice, in bridal white, is alone, not accompanied by the nymphs of Ovid's telling, when she turns to look with shock

at the death-dealing bite of a serpent. At the opposite axis of this painting, the upper right, a burning town with its gaping jaw of fire signals a Christian vision of the horror of Hell to which this venom will condemn the pagan nymph rather than the damp, dark halls of a classically imagined underworld, Hades. In the undulating folds of land before its glowing gate, the third part of the narrative is being played out, or rather its core dramatic moment is visualised. By turning back to glance at his almost-resurrected wife, Orpheus afflicts her with a second death. This is visually signalled in the drag upon her forward-facing body as it is drawn ineluctably back towards that gaping mouth of fire: Hell. The painter's rhetoric invests with meaning the space that he opens up between these bodies, which, in peeling apart, signify the irrevocable death that now reclaims Eurydice. Her unwilling body is being pulled back towards Hades, forever denied the space of life towards which past the forward-leaning Orpheus was leading her in his movement across the canvas back to the world on the left of the painting. Temporalities collide in almost late medieval fashion, juxtaposing before and after in a coterminous present tense of repeating trauma. While the serpent's puncture of her skin infused a deadly venom, her second death is less tactile. She dies from what we must now name 'an Orphic gaze'.

Both the suffering that these paintings by Raphael and Titian depict and the *pathos formulae* that these paintings deploy fall on the far side of a radical rupture burnt into Western, if not world, history by genocide, the Shoah. Such is the magnitude of this break that it suspends the possibility of aesthetically bathing catastrophe or loss in the beauty of a consoling landscape or expressing its anguish by means of classically ideal and expressive bodies, however agitated by emotion. Raphael's or Titian's visual metaphors for horror, for Hell and for catastrophe remain within the realm of the known or imagined; they cannot speak to the trauma that is the 'unthinkable' – a concept I borrow from the French resistance writer and camp survivor Charlotte Delbo: 'You can prepare for the worst, but not the unthinkable.'[3]

This is the meaning of trauma: an event of such extremity that we cannot anticipate it with necessary anxiety or later encase it in words, in thought. Our psychic apparatuses are simply overwhelmed; they lack the means to grasp the shock which then psychically wounds us by installing its literal force within our unprotected psyches in ways that we do not even know. We are, thereafter, occupied by its alien but unthinkable presence, finding ourselves made strange to ourselves by the hallucinated flashbacks, shocks, sensations, terrors, that retain their force without our having the means to tame, to understand, to negotiate a place for the event as remembered pain and bad memories tinged with fantasies already predetermining their shape.

The works of Titian and Raphael operate by means of the viewer's specular identification with, but also distance from, the represented, idealised human forms and the imaginary spaces of the pictured action: their then newly formulated regime of oil painting and visual narrative representation offered the viewer a beautifully fabricated image of the idealised human body whose expressive gestures and expressions visually signify interior emotions such as fear, anxiety, distress and relief within a tableau that incites affectivity but also aestheticises it through reanimated classical *formulae of suffering*. Viewed from our newly sensitised epoch *After Auschwitz*, as Theodor Adorno named our present, the fact that both Raphael's and Titian's paintings so vividly imagine a disaster by fire, and that both unconsciously deliver to us a vision of a furnace of destruction, acquires the uncanniness of impossible foresight. At the same time their imagery becomes banal in the face of a terrible realisation – becoming real – of hitherto merely theological imaginings through a historical

actualisation of a crematorial hell on earth, administered by a modern state for millions of fellow citizens demonised by racial or political absolutism. In that totalitarian gesture in which the imaginable became the possible, the floodgates of further totalitarian horror were opened. Hannah Arendt, the deepest thinker about the meaning of totalitarianism's novelty, argued that with this event, everything became possible. This is the true terror of our age.[4]

The world we inherit now after so much horror inflicted by humans on each other throughout the modern epoch is so radically at odds with the comfort offered by Raphael's painting where there is rescue and blessed survival. In this caesura burned by the crematoria furnaces of the Nazi death camps and other concentrationary universes into human history, Eurydice – that suspended figure of the feminine between two deaths – is taken up by Ettinger as a mythological figure inserting a differencing and invocatory gaze into this space between the human and the inhuman, between beauty and the sublime, that we need to understand now. Ettinger writes:

> The fragility of Eurydice between two deaths, before, but also after the disappearance, the figure of Eurydice seems to me to be emblematic of my generation and seems to offer a possibility for thinking about art. Eurydice opens a space for rediffusion for the traumas that are not reabsorbed. The gaze of Eurydice starting from the trauma and within the trauma opens up, differently from the gaze of Orpheus, a place for art, and it incarnates a figure of the artist in the feminine.[5]

Just as Freud drew on Greek legends to explore aspects of both cultural history and psychic life, feminist theorists have reclaimed feminine figures from this mythological resource. *Eurydice*, the collective title of a prolonged series of painterly meditations on a photographically indexical archive of women from the Shoah, is a figure suspended between two deaths. Killed once as a young bride on her wedding day by a jealous rival of her husband who sent a poisonous serpent to bite her, and killed a second time by her husband's backward gaze, she became a silenced icon, the support for one of the great mythic, masculinised representations of the artist, Orpheus, in which death and desire co-mingle over the void of a dead woman. Orpheus entered signally into modern culture, with the creation of the art form, opera, *c.* 1600 to 1607, in Italy, under his name.[6] In a distinctly feminist move, Ettinger identifies with Eurydice in her momentary place abandoned at the mouth of Hell. She asks: *What would Eurydice say?*

In a serial painting practice that creates its own non-Orphic fidelities, repetitions, and returns to the potential threshold of encounter across time and space through aesthetic transference and yearning for contact, Bracha Ettinger encounters her Eurydices, suspended photographically between two deaths. Sometimes Eurydice is her mother, snapped in a street photograph in Lodz in 1937 to 1938 (6.8), smartly dressed in a tailored suit and tie, walking between her Orpheus and Hermes (6.7) striding confidently towards a modern future that fell into the abyss of Auschwitz within a few years, stranding her between the death she did not physically endure but psychically suffered, in the loss of all but a fragment of her family and the life lived under its shadow, a shadow that fell through her encrypted mourning upon the child she bore in the 'after' time. To the face of this woman as later the artist's mother, Ettinger returns in the Eurydice series (6.11, photo source, 6.9), searching it for the signs of affective reciprocity the child needs in order to recognise its own human configuration. Locked in an unrecognised mourning, her living suspension between two dyings as the survivor, this mother 'lives with the dead'. Where must the child go to meet that mother?

In her painted re-apparition (6.11), the now unsighted adult woman has looked on death, has in fact died, but, living still in a resilient body, refuses, none the less, the human connection that the child needs to find itself within the mirror of human *being*. Thus the companion painting *Eurydice 9* (6.12) may be read as the artist's surrogate, autistic self-portrait. She presents herself through the face of the childhood toy she holds in a family photograph (6.9). But a doll is inanimate. Its blank and beady eyes can stare out of its mouthless face, but it does not see. It does not enter any loops of connectivity, any semantifying communicative exchange of looks, any humanising reciprocities. The artist tells us in her journals that she was born anorexic. She describes the daily violence of her mother's attempts to feed her, that is to keep her alive, while the child assumed and acted out, orally, from its long pre-natal sojourn, the emptiness that lined her mother's living husk.[7] Thus, the legacy of survivor-trauma which we can call death-in-life transfers itself from unseeing face to uncanny death-mask of the artificial, pseudo-person, the doll child in perfect, traumatic parody of the ideal dyadic figuring of mother and child.[8]

In her slowly evolving practice the artist refuses to abandon her *Eurydices* – the unknown Jewish women of Mizroc or the intimate strangers who are her mother and her child-self at the mouth of hell. Hence we encounter an art of perpetual return that she calls *gleaning*. Gleaning occurs at the vanishing point where loss and longing meet the impossibly fading text of history. The artist desires to remain arrested by the testimony of this image-trace to an unconscious holding. The image contains both of the conditions of the archaic drama of life and death played out between mother and child and the predetermining trauma of the historical drama of life and death of which this woman who has become mother is only a partial survivor. Surviving within this still extant person is the imprint of the deaths, death ghettos and death camps and death marches from which as Auschwitz survivor Charlotte Delbo has written no one ever returns. The mythic Hades of a less troubled classical era has been rewritten in ghastly fact by the fascist imagination that created something worse than death: those who were not killed in their death machine have been condemned to live on between two deaths. As many psychologists have attested, the will to resist complete internal, if not physical, annihilation, drove many Holocaust survivors to reaffirm life by the creation of children they might never fully parent, being themselves terminally bereaved and suspended between the before (signified here by the uncanny photographic record of a moment of being in the modern world as hopeful members of a modernising generation of metropolitan Europeans) and this new but insubstantial world of life after Auschwitz.

Barely retraced in grains of photocopic dust, the found images are, however, bathed by the artist in a partial veil of colour created by the pulsing repetition of tiny horizontal brush strokes that slowly weave a coloured membrane across the impossible point of meeting between the apparition on the screen of art and the incoming gaze of the artist, the gleaner of the Shoah's ashen remains. The colour builds its own, secondary tactile screen at the place where the gross masses of the interrupted photocopier deposited its trace in black grains. The paint mark is a *touching* that appears as colour in the field of vision. For colour in its vibration creates space, and the space it creates becomes an affective threshold that reaches out to embrace the viewer in a thickening of what lies between viewer and image, now and then/m, that binds seer and seen, world and subject, image and psyche.

In these paintings, the violet veils are the colour of a grief that keeps watch, but also of *nichsapha*, of yearning, the longing that persists as the fabric of the artist's living because the gap that marks her loss is not absolute. Her mother is not dead. But in some profound way, she is not there. There are people around the survivor child but they live with the shadows

of the once loved and long-since dead. Where will such a child have to go – psychically – to find her m/Others? Will she too have to live in the realm of the dead? Will she have to become a Eurydice who has visited and now is suspended between these shaded worlds?

Ettinger's painting becomes both the material screen for a matrixial virtuality, an encounter defied by historical events, sustained by trans-subjective psychic transmission, and replayed through the practice of painting as an aesthetically summonsed site of encounter that may become the transport-station of trauma.

> The place of art is for me a transport-station of trauma: a transport-station that, more than a place, is rather a space that allows for certain occasions of occurrence and of encounter, which will become the realisation of what I call *borderlinking and borderspacing in a matrixial transsubjective space* by way of experiencing with an object or with a process of creation. The transport is expected at the station, and it is possible. But the transport-station does not promise that the remnants of trauma will actually take place in it; it only supplies the space for this occasion. The passage is expected but uncertain, the transport does not happen in each encounter and for every gazing subject.[9]

Bracha Ettinger was born in Tel Aviv of Polish-Jewish parents who escaped the terrifying and deadly conditions of Lodz Ghetto to fight as partisans against the occupying Third Reich before settling, after the end of the war, in Israel. Using the very loaded term *transport*, with all its connotations of the trains that *transported* innocent civilians to their deaths in their millions, Ettinger takes us to the heart of the trauma she, a child of survivors and a child of the twentieth century, none the less, cannot escape. Yet this idea of art as a transport-station is also a sign of movement, linking, transmission. It opens up a pathway between past and present that she says not only hurts us but may also solace us in that moment of enlarged capacity to feel with others and for ourselves in this moment of recognition and *re-co-naissance*: in a Derridian move, Ettinger uses and abuses the French word *reconnaissance*, meaning recognition, to reveal within it the idea of a *rebirth* that is shared across several subjectivities. She, therefore, proposes that such rebirthing is always collective: a co-rebirthing that involves partners-in-difference across time and space. In and through theory that arose upon its seed-bed, Ettinger the painter explores the process of creating a possibility of a human *co-response-ability* – an ability to respond to the other and be responded to – in the place of the inhuman that was the calamity of fascist genocide.

Writing in 1972, Judith Kestenberg first identified the psychological experience of generationally transmitted trauma that she named 'transposition' through her psychoanalytical work with children of Holocaust survivors.[10] Touching some but not all children of traumatised parents, such transmission overlays a child's own ego and present with the past of others whose pain the child has not itself experienced. Often named for dead relatives, the children live doubled lives in which a non-experienced past inhabits and even dominates a child's present.[11] Without knowing of this growing body of analytical case work, Bracha Ettinger theorised such a condition, non-psycho-pathologically however, from the reflections of what occurred in her own painting which she recorded daily in her notebooks.[12] She understands this transmissibility as a creative capacity for a non-psychotic trans-subjectivity of partial elements of an I and a non-I which is traumatising. We can be wounded by the pain of the non-I. Yet that same trans-subjective capacity is also a means of transporting the pain of the past to a future, providing an event with its missing witnesses where it is

otherwise transformed in ways that are indicative of what underlies our aesthetic capacities themselves. From the heart of this historic trauma, Ettinger has formulated, therefore, a larger theory of the aesthetic experience itself as a product of the capacity for response to the pain/subjectivity of the unknown other (or the unknown otherness in the I) and for a co-affectivity that does not 'cure' but processes the irreducible pain in such a way that there can be some movement forward across a gap of real time that aesthetic experience can collapse while generating a future possibility.

Not only seeking through painting a gazing-touching that might meet the incoming appeal of the feminine Eurydician spectres found in historical photographs, Bracha Ettinger identifies with the position of Eurydice as a figure for her own generation as an artist. As a child of survivors of the attempted destruction of a section of modern Europe by fascist nationalism, she becomes the bearer of transmitted trauma that spreads between generations, making her the keeper of an archive of a history she did not live. She cannot escape another history which she carries in her own unconscious that itself is an opened portal between two moments, two deaths. Yet she is distanced by time from events that, none the less, line her own interior, psychic space. This alien but intimate past is externally held before her through an image-archive to which she is called back again and again by the embedded appeal of those figured within it, suspended in its time-freezing capture as an image, at the edge of the abyss she knows before they do. Just as Raphael planted a figure of such 'appeal' into his *Fire in the Borgo*, so the artist responds repeatedly to an appeal emerging from the time-space of the archived image of a perpetrator photograph documenting a massacre in the Ukraine in 1941 by means of the lens-based gaze that makes us forever Orphic in our looking.

As a series of meditative encounters with the ready-mades of history, the found photographic and textual images freighted with the extremity of their conditions of existence, Ettinger's paintings disavow the creative, expressive, gestural, representative qualities that distinguish the Western tradition of painting epitomised by Raphael and Titian. None the less, they learn from the power of touch and colour to be found at this initiating moment of painting's material affectivity that transcends its immediate figurative purposes. Ettinger's paintings do not, however, succumb entirely to the sublime alternatives of non-figurative abstraction provided by modernist painting (Fautrier's *hostage* paintings come to mind) which took that material affectivity as its exclusive preoccupation. Thus the potential of the modernist affirmation of the formal possibilities of materiality, colour, process and medium to produce affect beyond significance are not disdained. Reclaimed and reconnected by Ettinger to the contemporary history they seemingly disavowed, the touch and pure colour associated with artists such as Rothko are redeployed, however, on an intimate scale of daily encounter and repetition, as indeed are the lessons of Titian and Raphael which underlie them, as we can see from close examination of the background surfaces and colour of paintings by Raphael such as *The Three Graces*, where the layering of delicate glazes of haunting violets laid on in delicate strokes we also find in Ettinger are already at work. Working at the intersection of old and new technologies of a painting practice in daily dialogue with both the artistic past and the photographic images that carry histories of the catastrophe of modernity, Ettinger's *Eurydice* plots its unique place in late twentieth-century belated attempts to come to terms with that history. To do this, her practice effects and causes to be theorised elsewhere a turn to the feminine that the artist names the matrixial dimension of subjectivity arising at the unique historical conjuncture of psychoanalysis, Jewish legacies of the Shoah, feminism and modernist/postmodernist aesthetics.

Encountering history *c.* 1996

A compendious exhibition took place in 1996 to 1997 at the Centre Pompidou in Paris, titled *Face à l'Histoire 1933–1996*.[13] Invoking art's necessary encounter with a history of the twentieth century, title and dates declared the organisers' defiance of modernism's ideal of aesthetic autonomy that isolated art from the messy business of historical conflicts and ideological interests.[14] Modernism promoted autonomous art as transcendent hope in the face of a distressing and conflicted social reality. An exhibition that reconnected modern art and the historical disasters of the twentieth century offered a serious move towards a critical postmodern revisionism that might reconjugate the dissonant terms *aesthetics* and *politics*.[15]

It shared with two other major exhibitions of that period an intense preoccupation with looking back over the twentieth century as it moved towards its close and, as a result, produced a different kind of diagrammatic mapping of artistic events in that historical century from the confident and forward-moving project of Alfred H. Barr's chronological chart for the exhibition *Cubism and Abstract Art* at the Museum of Modern Art in 1936. The two other exhibitions were *Documenta X Politics/Poetics*, curated by Cathérine David, and *Inside the Visible: An elliptical traverse of twentieth century art in, of and from the feminine* curated by Cathérine de Zegher.

David's exhibition took seriously its role as the last *Documenta* of the twentieth century, and its look back to a post-war European history was charted by four dates: 1945 was the foundation of post-war European democracies; 1967 marked a radical crisis of this post-war settlement; 1978 registered the already considerable advance of globalising capitalism and the repression of oppositional thought; and 1989 marked both German reunification with the collapse of the Soviet Union and the triumphal celebration of a postmodern aesthetic. All of the processes thus dated leave a legacy of increasing uncertainty. De Zegher's exhibition declared itself an 'elliptical traverse' and cut through the dates of linear, masculine, national time by identifying moments of significant concentration of aesthetic interventions 'in, of and from the feminine'. She plotted out a women's temporality for a feminist history of the twentieth century focusing on the 1920s/1930s, the 1960s and the 1990s. Breaching museum and exhibition convention which usually allows us to encounter artworks only according to date, artist and medium, de Zegher did not exhibit the selected works of these three moments of modern women's time in chronological segments. Instead she played across the threefold archive four themes around which she grouped works made during the 1920/1930s, 1960s and 1990s that revealed unexpected continuities, recurrences, shared pre-occupations she considered 'in, of and from the feminine'. Like an analyst listening for the insistence of unconscious pressures, she discerned the inscription of the feminine in twentieth-century art heightened at four points: concerning the corporeal and fragmentation, the blank in the page and text/image plays, the metaphors and processes of weaving, and movement or transformation associated with embodiment and liveliness.

Grand-scale retrospective review exhibitions such as are offered by these major but diverse examples allow us to take the temperature of the museal as the instrument of reframing historical understanding and forming our historical consciousness through their representations. In this chapter I want to explore the issues thus raised for the virtual feminist museum by tracking the work and related thought of one artist whose work was exhibited in *Face à l'histoire*, *Documenta X* and *Inside the Visible*, as a practice of the 1990s.

Bracha Ettinger confronts a history of traumatic rupture through a ruptured aesthetic practice – painting – which was still possible in its fullest narrative, figurative and even

expressionist resources for an artist like Charlotte Salomon, who hovered on the other shore of the cataclysm incised into world history by 'Auschwitz' where that artist was murdered. How much of the unexpected shifts in Western art after 1945 are responsive to or determined by coming 'after Auschwitz' is only slowly being investigated by a traumatised culture that did not recognise as its determinant that which it had neither forgotten nor remembered. The virtual feminist museum must confront this rupture – by exploring at least one practice of one artist whose entire project places before us, as it unfolds, the deepest questioning of the intimacy between the aesthetic, the ethical and the historical by dedicating a lifetime of reflection and creativity to a sense of space, what she will name *matrixial borderspace*, as a supplementary structural element in subjectivity that can become a passageway through time in relation to a traumatising archive – both social and representational and both subjectivising and co-affecting.

Face-off: painting and photography between modernism and the postmodern

Taking the year 1933 as its starting point, the exhibition *Face à L'histoire* showed paintings that directly engaged with the rising terror of Nazism through the innovative forms of modernist art.[16] Thus the exhibition obliquely inscribed the horrifying affinity identified by Zygmunt Bauman in *Modernity and the Holocaust*, the challenging text that first, but only in 1989, dared to reveal the intimacy between modernity and one of the defining catastrophes of modern history.[17] Down the central hallway off which the chronologically arranged rooms of individual artists' paintings in *Face à L'histoire* branched was an inner lining of photo-journalist 'documents'. Photographs from newspapers and illustrated journals such as *Life*, *Picture Post*, *Der Spiegel*, tracked Western history from the victory of fascism in Germany in 1933 through to wars in Spain, Algeria, Vietnam, Biafra, Bosnia. A spinal column of photography's defaulted promise to deliver history 'in the raw', this display provided a deceptively simple but damningly distressing pictorial story in black and white of a relentless series of conflicts and atrocious human tragedies that defined the twentieth century world-wide. Against this ever-expanding 'documentary' core that brought 'the war back home' as it were, the colourful trajectory of modernist painters' diversely personalised encounters with, or evasions of, public history were then traced in side rooms, each metaphoric of the private studio and hence the individual artist (almost all men). Paintings thus exhibited could only constitute *aesthetic* variations: artists' refractions of history through their individual stylistic affiliations (Cubism, Surrealism, Abstract Expressionism, Pop Art and so forth).

On a massive scale, the exhibition's layout pitted modernist painting, representing the aesthetic and the artistically ambitious individual statement, *against* photography, which was set up – falsely, of course – to offer a direct record of *history*. But where did they face/ encounter each other? The exhibition spatially opposed painting to photography in their competing claims to encode the character of our own times via the antimonies of individual allusion (art) and (not always) anonymous document (photography).[18] This juxtaposition, however, broke down as the exhibition approached the later 1950s, the 1960s, and moved downstairs to the large and separate exhibition space devoted to the exhibition's theme in art post-1980.

With one exception, this section devoted to art since 1980 suggested that the favoured *artistic* medium of postmodern artistic engagement with issues in contemporary social and political worlds was almost exclusively lens-based. The earlier structural opposition of

painting (reflection) versus photography (document), of art versus history became redundant, confirming, as the art historian Leo Steinberg had pointed out, that since the 1950s the flat-bed plane of the modernist pure painting had been increasingly invaded, becoming a billboard or a projection screen open to all the ready-mades of the world.[19] Photography and journalism henceforward transgress the forced antimonies of the main exhibition that celebrated modernist idealism, and interpenetrate in a world of postmodern art without paint, the gesture, the touch, the bodily referent, and without effect. This photographic hegemony in contemporary art I name *the triumph of the gaze*.

Face à l'histoire promised a review of the ways in which twentieth-century culture has, or has not, *faced* up to the dire record of a modernity that has so systematically defaulted on the promises of Enlightenment and rational progress towards social justice. Thus a revised cultural review of twentieth-century history would inevitably have to address the scar of fascism and 'the event' – Auschwitz – that Adorno claimed made [bourgeois] art impossible thereafter, and that Saul Friedlander and others have argued ruptured history itself and stressed inherited modes and systems representation to their very limits.[20] Between the changing modalities of art between modernism and postmodernism and the historical field, 'after Auschwitz' upon which this shift has played itself out, we must enquire into the nature of the connection.

The Holocaust: from trauma and testimony to cultural memory

Beyond the domain of historical knowledge, in the realm of cultural representation, the Holocaust is being thought of as an 'effect' still carried by those few who survived the attempted destruction of the Jewish people. More than half a century later, Western culture is belatedly recognising that it is also an event that not only has implications for, but continues to effect, if not define, the entire civilisation/culture in which it occurred as a history-defying and humanity-destroying rupture. Thus we must encompass and theorise both the individual trauma of those who *suffer* the event and the socio-cultural trauma of the societies in which it happened that cannot be displaced on to a single nation of either perpetrators or victims. The Holocaust cannot and should not be wrapped inside a historical narrative that, drawing upon existing logics of historical causality and teleology, suggests a legibility, a place in known human processes, a containment in a masterable past. The Holocaust is, I suggest, to be grasped as trauma. Thus it persists, unfinished business, a traumatic *survivance* Warburg never contemplated needing its *pathos formulae*.

Trauma is a psychic wounding, a shock or threat so great that it bypasses all our defences to lodge itself as a continuous wound within the psychic apparatus. As a foreign, invading force, trauma inhabits its subjects. Yet its paradox is that despite its settlement within, in its full extent, it remains unknown to its occupied subjects, determining their subjectivity as a defining void. Its full impact and meaning may remain inaccessible to the subject, none the less possessed by it. Theorists of trauma argue that its relief takes the form of a passage from it, a journey through to what I have named 'the relief of signification' and its re-invention as memory. Cathy Caruth argues that this moment of survival may itself be equally traumatic; the pain may become even more intense at the point of its attempted communication to another.[21] Trauma's passage to cultural memory may also traumatise its necessary witness. Thus the traumatic functions doubly as a recurring present breaching the categories of agent, sufferer and witness. It is trans-subjective.

Trauma defeats any sense of history, making senseless the boundaries between past and present. Ungrasped at its point of impact, it remains in a continuous present. Some release may be triggered at any time by a trivial event within the daily time-scale that pierces the thin membrane to a non-past that erupts within this moment. Delay and belatedness define trauma in the individual and in the culture. Thus although the Holocaust is dated 1933 to 1945 or, more precisely, 1941 to 1945, the time of its traumatic imprint has been continuous for its apparent 'surviving' bearers and we, the gleaners of that horror who come after and behind, perhaps now have only just begun to register the process of that journey from trauma to cultural memory in which artistic practices, literature, film and academic studies play significant roles.[22]

Following Freud's thinking about trauma, Dori Laub, a survivor psychoanalyst who works with survivors receiving their testimony, outlines a role for the present-day listener or receiver of another's testimony. Part of the destructiveness of that suffering was the enclosure of the victims within a world whose very traces were destined to be erased while the suffering subject could appeal to no other outside 'the concentrationary universe' to reaffirm her/his humanity at the point of a genocidal assault upon it.

> On the basis of the many Holocaust testimonies I have listened to, I would like to suggest a certain way of looking at the Holocaust that would reside in the following theoretical perspective: that what precisely made the Holocaust out of the event is the unique way in which, during its historical occurrence, *the event produced no witnesses*. Not only, in effect, did the Nazis try to exterminate the physical witnesses of their crime; but the inherently incomprehensible *and* deceptive psychological structure of the event precluded its own witnessing, even by its very victims.[23]

In the specific context of counselling and recording testimony, the listener belatedly restores a witness to the survivor's unwitnessed and thus ungraspable experience. Painting, as an invocation to its spectators to become partners in a testimonial exploration of the sharing of trauma transported into the present, might also take its place in this expanding understanding of the crisis of truth and history created by the Holocaust as still unresolved trauma. It can do so only because of a changed relation to representation in which the voyeur-spectator of classic representation is replaced by a co-emergent *witness* – what the theorist and painter Bracha Ettinger renames as the 'wit(h)ness'.[24] This has to be both enacted through a shifting in painting – *metramorphosis* as Ettinger will name it – of the conditions of gazing, touching and encountering that reconfigure the experience of the viewer of the event of both the work and that to which it gestures.

Painting after painting, or after the murderous modern

The 1980s to 1990s section of *Face à l'histoire* contained a single site of errant painting, a series of tiny paintings hung in formation under the collective title *Eurydice* by Bracha Lichtenberg Ettinger (6.13). This zone could either have looked art historically aberrant, simply out of place and time, a mislaid fragment from the main galleries upstairs, or it marked an intervention in which that 'out of timeness' acquired a renewed potential for producing, affectively, a knowledge of our current predicament vis-à-vis time, space and the archive, *after Auschwitz*.

Thus, the strategic dissonance initiated in the postmodern moment through photographic

and conceptual practices may now be being enacted through a practice I name 'painting after painting'.[25] Painting, so displaced and rejected in the postmodern turn to the photo-mechanical and digital, re-engages not merely with the postmodern in general defined as a hybridity of signs, but with its defining philosophical and ethical condition: the moment 'after Auschwitz'. Precisely because of a different relation to the gaze that photographically now pervades our cultural imaginary, 'painting after painting' can re-investigate who we are now, when we look back to 'the event' that is so often still held before our vision only through the treachery of what was once a necessary *photographic* record. As Barbie Zelizer has shown, it was only through the shock of encounter offered by photographic and film documentary in the immediate moment of the liberation of the camps in Europe in 1945 by Margaret Bourke White, Lee Miller, and many others that the horrifying possibility of genocide could be grasped at all – the journalists' words registering the limitations of language to encompass the unimaginable.[26] That very photographic archive, however, repeatedly risks condemning the victims, whose unimaginable suffering photo-journalists once so shockingly 'shot' at their first exposure, to a perpetual and atrocious death in/by the image. How can we, though we must, look back?

Ettinger's long-term *Eurydice* series could be regarded, therefore, as a symptom of the potentialities for painting that are being created self-consciously as 'painting after painting' in '*after history*': my code words for a feminist rethinking of Adorno's definition of our world and representation not as postmodern but as definitively 'after Auschwitz'.[27] 'Painting after painting' refers to a contemporary practice of painting that knowingly re-engages with issues of painting in the light of – after – feminist and other critical challenges to the modernist idealisation and isolation of painting represented by high modernist formalism in the 1950s. Thus 'painting after painting' signals an epistemic rift that marks not just the modernist/postmodernist rupture as painting versus photomechanical and cybernetic media that I discussed above in the exhibition. It suggests a further level of critical dissidence from the very *media-lisation* of postmodernist art practices, a re-evocation of the corporeal of the drives and of affectivity that can only resonate through a sexuated, embodied subjectivity evoked by a material work(ing). 'Painting after painting' seeks renewed ways through psychoanalytically inflected theories of subjectivity, sexuality and the aesthetic to reconsider the potentialities of painting as practice, mark, gesture, space and visual screen for what Bracha Ettinger has theorised as *trans-subjective co-affection*.[28] Painting addresses its viewer in affecting ways and evokes dimensions of experience different from those posed by dominant forms of spectatorship typical of the photograph or film. Thus the very achievements of modernist painting which, in Greenberg's words, hunted painting back to its defining medium – colour applied to a flat surface to create an optical field – in order to liberate the independently expressive potentialities of these essential elements, can be reclaimed from the modernist discourse which, however, increasingly reduced painting to an inward-looking, problem-solving marketable commodity. In 'painting after painting', the still unrealised potential of the modernist discoveries of painting that were so abruptly foreclosed in the early 1960s can be harnessed to the engagement with trauma, transmitted memory and profound questions about trans-subjectivity in the era 'after Auschwitz'.

I shall argue that this reconnection allows painting to address, in a necessarily affective and charged way, our status as belated wit(h)nesses to the catastrophe with which *Face à l'histoire* commenced, but with the benefit of the political reorientation typical of postmodernist, non-painterly strategies. After – and beyond – its high moments of modernist self-consciousness as a procedure based in colour, gesture and affect, painting can return to

the cultural stage as an ethical necessity to counter a potential fascism in mass, mechanised media culture that effaces the singularity of each historical subject in the desire to bind us into the cycles of consumerism.[29]

It may indeed sound strange to suggest that *feminist* thought can redefine what Theodor Adorno, writing of the Holocaust in Europe, labelled as our epoch: *after Auschwitz*.[30] I am, however, interested in what makes possible a non-fascist aesthetics, or an anti-fascist aesthetic in the wake of a century in which fascism penetrated so many nations and cultures, leaving populations traumatised by genocidal, racist, rightist and sexist state terror. I do not use the term *aesthetic* to refer to matters of taste or disinterested judgement in the old Kantian sense. The aesthetic, understood psychoanalytically, concerns *encounter* and *affectivity* in the presence of extreme suffering and even death, absence and loss.[31] Lacan's idea of beauty concerns a missed encounter with the Real, with death, with a zone that also, for him at least, holds a trio of that which is unthinkable yet structural to human subjectivity's formations: woman, other and thing.[32] Art is not merely documentary or expressive. Since the developments in conceptualism in the later twentieth century, art is more and more recognised as propositional as a way of thinking, often in advance of our more formal modes of philosophy and beyond the limits imposed by focus on conscious reflection and cognition alone.[33] But, by increasingly addressing the wounding of our societies in political and personal traumas that mark the history of modernity from slavery, to genocides and state terrorism, art has also become a way of experiencing-thinking that is linked with psychology and social phenomenology.

Ettinger frames her own work through the figure of Eurydice, the woman, other, thing of the Orpheus myth, which we shall need first to interrogate for its cultural unconscious in order to return to Ettinger's key question: 'What would Eurydice say?' – What would the feminine between two deaths ask were it to address us, via painting, from that impossible space?

Some classical reflections: Ovid to H.D.

What would she say, Eurydice, who has looked on the inhuman space of death and is forced to suffer a second, mortal blow from a human gaze in whose homicidal compass she becomes a frozen image around which his beautiful music will swell? That is to say, what could the victim of catastrophe *say* to us from that space on the threshold of hell between dying and death? Eurydice is not the survivor witness. She is the victim, suspended, however, like the women in the photograph, between the almost and already dead. So how uncanny is it to ask us to imagine what she might say to us from that place?

In painting, Eurydice cannot speak audibly. She is, none the less, made to utter visually through pose and expression. Or is she? In fact, Eurydice as image – what Orpheus desired to see again – serves only to make visible what I name *the Orphic Gaze* and the deadliness of the backward glance that kills again. After her second death, Orpheus will place his musical instrument, his art, in her place and fill it with *his* voice, *his* grief, *his* longing. The obliteration of Eurydice's voice while she remains the apparent cause and support of masculine creativity, the Orphic, hence the masculine poetic voice and gaze, makes this myth central to Western, gendered ideas of creativity. A feminist shift within its imaginary may promise another future.

Let me remind you of Ovid's *Metamorphoses* where the tragic story of this young couple, Orpheus and Eurydice, is movingly narrated. A sombre wedding is followed by sudden loss

when the bride is bitten on her ankle by a serpent and she dies. The desolated bridegroom determines to seek her again in the underworld:

> After the bard of Rhodope had mourned, and filled the highs of heaven with the moans of his lament, determined also the dark underworld should recognize the misery of death, he dared to descend by the Taenarian gate down to the gloomy Styx.

The unique power of Orpheus' music halts momentarily the business of Hades, suspending the perpetual torments, softening the harsh Eumenides and melting the hearts of Pluto and Proserpine, who summon the halting because still wounded Eurydice (the connection with the lame Oedipus and the mythic significance of lame gait in relation to chthonic origins is discussed elsewhere):

> And Pluto told him he might now ascend these Avernian vales up to the light, with his Eurydice; but, if he turned his eyes to look at her, the gift of her delivery would be lost.

Ovid evokes the chilling atmosphere of the 'steep and gloomy path of darkness' which itself suggests an image of a second birth. But, 'in fear he might again lose her, and anxious for another look at her, he turned his eyes so that he could gaze on her.' In the doubled space of fear *and* anxiety, the iteration of eyes, look and gaze emphasises the scopic force of Orpheus' subjectivity which, when turned back upon the following Eurydice, causes her to evaporate before his eyes:

> Instantly she slipped away.
> He stretched out to her his despairing arms, eager to rescue her, or feel her form, but could hold nothing save the yielding air.

At last the feminine subject is allowed her own moment and she speaks:

> Dying a second time, she could not say a word of censure of her husband's fault; what had she to complain of – his great love? Her last word spoken was 'farewell!' which he could barely hear, and with no further sound she fell from him again to Hades.

So what did Eurydice say, according to the poets of old? For Ovid, no word of censure or rebuke but merely a whispered farewell as life, form, sound and substance faded from her to leave a haunting, spectral ghost that was then to become the inspiration for the music of her surviving but murderous spouse. His look, his gaze, his fear, his anxiety, his desire, his need, killed her a second time, betraying the second chance he had been given to bring her back to life. A certain kind of masculine love, too embroiled in its own conditions, can prove fatal to its feminine other.

In the twentieth century, English women poets have reclaimed that almost silent voice of Eurydice, giving her words to speak in defiant rebuke of her fate in patriarchal culture. In her lament *Eurydice*, H.D. (Hilda Doolittle), who worked with Freud, imagines Eurydice as scornful and defiant:

So you have swept me back,
I who could have walked the earth with live souls
Above the earth
I who would have slept among live flowers at last;

So for your arrogance
And your ruthlessness
I am swept back
Where the dead lichens drip
Dead cinders upon moss of ash;

So for your arrogance
I am broken at last,
I who had lived unconscious
who was almost forgot;

If you had let me wait
I had grown from listlessness
Into peace,
If you had let me rest with the dead, I had forgot you
And the past.

What was it that crossed my face
With the light from yours
And your glance?
What was it you saw in my face?
The light of your own face,
The fire of your own presence
What had my face to offer
But the reflex of earth?

Finally Eurydice asserts her own subjectivity against this erasure of her in his image which
he projected back on to her. It was the glance of the poet who never saw her, the woman,
at all:

At least, I have the flowers of myself
And my thoughts, no god can take that;
I have the fervour of myself for a presence
And my own spirit for light;

And my spirit with its loss
Knows this;
And though small against the black,
Small against the formless rocks
Hell must break before I am lost;

Before I am lost,
Hell must open like a red rose
For the dead to pass.[34]

The open, fissured and interrogative syntactical structure of H.D.'s poetry allows Eurydice a voice that refuses the binary opposites of life/death, light/darkness, fire/earth that implicitly align the positive terms of each pairing with masculinity and femininity with the inert, passive, dangerous and mere matter. Instead, Eurydice finds meaning in her new location, a place of dreaming and survival, where mastery is not needed to be a presence, where light comes from her own spirit and the darkness of a womblike hell is described in an erotic and creative metaphor of the blooming of a red rose. Death is a place of cold terror, the inverse of the horror of the originary home of life, the womb. But it is also the site of her singularity: her thoughts and her poetics. In this counter-image, H.D. does more than reverse phallocentric terms. She challenges the deeply installed imaginative foundations of this arch-myth of masculine creativity erected at the expense of the dead beauty of woman. In doing so, she takes her place in twentieth-century women's attempts to create through their poetic rereading of ancient myths an expanded imaginary in which the meanings of the feminine might escape the phallic binary encoded in this myth.

The Orphic Myth at the foundation of modern bourgeois culture

I want to use these feminine engagements with Eurydice's anger at her fate at the hands of Orpheus to emphasise the deadly influence of the Orphic myth in *modern* Western culture. This myth shapes the modern structures of both gendered subjectivity and aesthetics in ways we hardly recognise. For instance, the art form we know as opera, emerging in Italy at the turn of the seventeenth century, is founded on the Orpheus myth which thus places the relations of creativity and sexual difference at the heart of modern and later bourgeois culture. At least, according to cultural mythologist Klaus Theweleit. He asks what happened to Eurydice.[35]

Klaus Theweleit reminds us that one of the new constellations with which 'Europe's head honchos celebrated the exit of the darkened middle ages with a festival of light, noise and colours' took place at the Gonzaga Court of the Princes of Mantua on 22 February 1607. A week later, on 1 March, a second, public performance of a musical play took place. Its title *Eurydice* was an echo of a performance on 6 October 1600 of Peri's musical play written to celebrate the marriage of Maria de Medici to Henry IV of France in the private villa of the bride's father in Florence. A new star was born from these events: Orfeo. He was a product, like all stars, of a new medium, and in this case it was the *favola in musica*, the courtly festival play with music that Mantuan court composer Claudio Monteverdi would transform into what, with his *L'Orfeo* of 1607, would be hailed as the first real opera whose fourth centenary is marked in the year of this book's publication.

Theweleit's interesting question is: 'Why and to what end does the new medium Opera emerge around 1600 in Italy and why is this constellation ignited by Eurydice?' In a careful reading of the score and libretto of Monteverdi's seminal work, Theweleit makes three significant points: Eurydice becomes the beloved of Orpheus through her response to, and thus mirroring of the power of *his* music. Again the image of woman as mere reflector comes into play. In the scene of the abortive return, Theweleit reminds his readers of the Neoplatonic discussions about love. Traditionally, Amor's highest and most sacred form is blind; not visually cued or conditioned. In the opera, Orpheus leads his silent, ghostly wife towards the light. In the absence of his ability to sense and feel her presence – his hands are full of his own music-making instrument – he calls upon the imperative of the god of love,

Amor, to overcome the prohibition on looking enjoined upon him by the dark god of the underworld, Pluto. 'He is ruled by a fury of *wanting to see*.' Something important is happening here as the more abstract, spiritualised courtly modes of love are dislodged by a modern tendency, to see and select a loved one by love at first sight rather than relying on the unpredictable arrow of Amor. To be loved, however, is to look good; for the woman to attract love she must look good and beauty is precisely a kind of self-erasure the better to serve as a mirror of the masculine desire. But embedded in this drama are two more important moves.

One is, of course, that Eurydice is finally allowed to speak but what she is given to say, as with so many dying women in opera, merely serves to make her complicit in her own murder which she accepts as the gift of heterosexual love.[36] Theweleit pushes us to realise what happens as a result. The artist-poet of a new European order is being born before our eyes. He is a rationalising man, a survivor of this great loss that is, in fact, the founding condition of his art raised to a new profundity. His necessary other is no longer the woman, but the instrument through which his music and voice will be produced. Displaced into his medium, the feminine makes one last appearance in Monteverdi: as Echo who repeats Orfeo's last syllables. In a leap that you will see helps to situate my topic, Theweleit starts by quoting the libretto and then comments on it.

> Orfeo says to Echo:
> 'Yet while I lament – why do you answer me only with the last syllables? Give me back my entire laments.'
> You may laugh, (says Theweleit,) but here in 1607 as he seeks to install music upon the throne of enlivening media, Orpheus is asking for Edison. He is calling (into the woods and chasms and down the stairs) for something that will record his song and return it to him *wholly*.
> He is serious, he isn't joking with Ms. Echo, and he is not simply mourning for his various loves: he himself *creates* this recording medium and he creates it out of his dead lover, *Eurydice*. . . . The ear/soul of the dead woman on the banks of the Styx become the tape onto which Orpheus' sounds engrave themselves.[37]

Perhaps this remarkable claim that woman is made into the recording machine by which masculine identity is mirrored back to him will seem less difficult to accommodate through the analogy Theweleit proposes:

> Just as Renaissance painters encode the gaze upon the countrysides that are intended to be seen as beautiful or harmonic with a calculated female body, the musicians here encode the site of appropriate hearing/precise reproduction of their music with the ear/soul of the most beautiful woman.[38]

As part of a major shift in European painting that will install a new order of visual pleasure, we can separate the isolation of iconography – what is being painted or sung about – from the total apparatus of producing, viewing and experiencing. In holding both the what and the how as intertwined facets of a cultural apparatus, we then understand the modern structure: the visual emergence of the painterly ideal female body (the female body as the idealisation of beauty and otherness – desired and necessarily lost or absented in order to be desired) installs the gaze of the artist – or rather his master – in the invisible but decisive

centre of experience and subjectivity for which this new visual object is fashioned. Works such as the *Sleeping Woman in a Landscape* (*c.* 1508, Alte Meister Galerie, Dresden, Germany) attributed to the Venetian painter Giorgione or Raphael's tiny panel of *The Three Graces* exemplify this structure and establish the erotic and political power of the eroticised but essentially narcissistic masculinised gaze that requires the erasure or murder of the subjectivity of the feminine.

So let us review what the operatic writing is doing in its reworking of the mythic material of Orpheus and Eurydice as the representational device through which to produce a modern conception of art and artist in a profoundly masculine psychic structure. Theweleit argues:

> They manufacture (in the work of art) the dead woman that they need for this, simultaneously lamenting her irreplaceable loss (a social tribute) and resorting to inherited mythological recording and representational apparatuses. In the course of its performance, the expiring artwork draws its notoriety for a certain sacredness not least, (indeed perhaps first) of all from its ritual sacrifice of the most beautiful woman before the eyes (and in the ears) of all. But amid sacrifice it is primarily the *reconstruction* of recording devices and perceptual occurrences that is staged with the help of the dead body. . . . They take a 'woman in Hades' as 'membrane,' as 'needle' they take an echo in the instruments according to the notation. '*Echo-Eurydice*' vanquishes the Styx.[39]

The recycling of the Orphic legend as the creative resource for a modern, masculine conception of art and the artist installs a dialectic of sexual difference in the centre of the modern European musical and visual imaginary. Feminism did not create the issue of sexual difference in this central place in culture. Feminist analysis of the structure is, however, necessary for its naturalness to be deconstructed. Why would we want to denaturalise the trope of masculine narcissism achieving its poetic realisation through the echoing membrane of the body of dead, silent or spectral femininity? Perhaps we seek to do it in the hope that through introducing into culture other paradigms for human relations and human creativity we might renounce this intimacy between love, art and feminine death and thus relieve our culture of the love affair with *Thanatos* in the name of a feminine directed *Eros*: a love and respect for life.

Eurydice, like Lacan's Antigone, stands between two deaths. Uncanny and consoling, she has seen the inhuman and is cast back into its annihilation by a second, backward and unconsciously murderous glance. The Orphic look is deadly. Does that mean that any backward glance – into the modern history of atrocity, for instance – kills rather than reanimates? What would we hear if we listened to her feminine voice, suspended at the threshold between one death and that which with our retrospect we may again inflict? This opens on to the question of the relation between the aesthetic, art, music, film and the atrocities or catastrophes of our many histories. How do we look back, remember trauma, and how do we respond to the victims, and to ourselves as their witnesses?

A matrixial gaze: the Eurydicean paintings of Bracha Ettinger

As a counter force to a deadly culture of modernity, of which, as Zygmunt Bauman has argued, the Holocaust was one of its many horrifying possibilities, we can explore Ettinger's

Eurydicean Painting as a *matrixial gaze that does not kill.* Ettinger has introduced into the psycho-analytical vocabulary a new concept – the *Matrix* or *matrixial* which supplements and shifts rather than replaces the phallus and phallic as the presently sovereign signifiers of the phallocentric Symbolic (theorised by Lacan). The Matrix introduces the feminine to the heart of human subjectivity. Matrix refers to a radical theorisation of dimensions of human subjectivity which, from the beginning, including the latest periods of pre-natal/pre-maternal co-existence, are *several*, shared and based on *encounter* rather than on the separations and cuts that define Freudian and Lacanian ideas of an exclusively postnatal subjectivity.[40] Ettinger's radical innovation is to allow us to imagine that all of us, men as well as women, straight as well as homosexual, psychically glean grains of sensation and intensities from the later stages of our intra-uterine sojourn and that this delivers into human possibility a specifically feminine dimension of subjectivity whose phantasmatic and later symbolic structure is premised on *encounter*, on threshold and transmission, rather than on the phallic logic of presence/absence and the cut of subject from object that lies at the basis of the paradigm of castration. Foreclosed from all theory (this means made unthinkable for lack of a signifier to bring it into fantasy and thought), the sexual specificity of the female body that is thinkable as *co-affecting and co-emerging encounters between unknown partial subjectivities*, is reconceptualised by Ettinger as a logic of trans-subjectivity that is not, however, psychotic. As a signifier expanding the Symbolic with elements gleaned from our formative encounter with the sexual specificity of the feminine as *a severality from the beginning*, the signifier, the Matrix enables us to think about co-affectivity as a virtuality in subjectivity. It, therefore, concerns precisely raising the historically conditioned experience of transmitted trauma to the level of a theorisation of a potentiality in all our subjectivities that opens the 'I' to the ever co-affecting and co-emerging 'non-I' – an unknown partner who is not simply the other of phallic discourse.

This radically shifts our current, Freudian and Lacanian conceptions of subjectivity which are premised on the cutting out of the subject from the symbiotic cloth of undifferentiation. Birth, weaning, castration and the acquisition of language all imply separation, a cut, that sets up subject-object relations premised on a closed border and a defined limit between I and other. The Matrix focuses on the borderspace that is shared between several (partial) subjects based on the hitherto unacknowledged subjectivising dimensions of the shared spaces of later pregnancy where two unknown partial subjectivities mutually co-affect and co-emerge. This has nothing to do with maternity as we currently think of it, in which mother and baby are already phallic objects for each other caught up in a logic of loss, substitution and desire. The Matrix draws into culture, that is into fantasy and thought, from this space of the formerly foreclosed feminine as originary severality, a radically different way of thinking about the shared borderspaces between subjects that can become thresholds of transmission and affectivity particularly animated in key processes such as transference in analytical situations or in the aesthetic encounter.

As a result of rethinking key, late Lacanian researches about the space stretched psychically between trauma and fantasy (the Real and the Imaginary), Ettinger shifts Lacanian concepts of the gaze and/as *objet a* which mark a crucial stage in Lacan's rethinking of the Imaginary and the visual field of subjectivity. In 1963 Lacan proposed his theory of the gaze as what he called an *objet a*, a psychic residue of a corporeal, sensory zone such as the mother's gaze, touch, voice, breast, which is registered in the psyche only as lost, hence becoming an obscure object of desire. This gaze as *objet a* is not the Oedipal gaze of mastery associated with voyeurism or in a different register, with Foucault's eye of power. The

Lacanian gaze as *objet a* is like the verso of a piece of paper; it is the scarred pit on the surface of the psyche which has been cut away from the cloth of a primary, undifferentiated sea of sensations to create the subject thus defined, negatively, by its missing objects. The logic here is that of presence/absence. Lacan's gaze as *objet a* is therefore a phallic *objet a*: phallic being that logic of presence/absence. A matrixial *objet a*, based on a different logic, means that whatever we invest with desire or rather yearning was neither completely lost nor even completely (in retrospective imagination) possessed. Rather it works like a tuning-in and fading-out of waves or pressures, tactile connectivity that always also sensed a distance-in-proximity, registered by 'the erotic aerials of the psyche'. Neither fused nor separated – as the phallic image suggests – the matrixial marks the shared spaces of transmission within shared borderspaces and borderlinking where there is always already a minimal difference/distance. Although not visual in the way that phallic logic defines the visual field as one of longing for lost or mastered objects, the matrixial dimension can be intuited through the visual in art, but in a different way, facilitated by the very complexity of painting as at once visual, tactile, material and resonant.

The work of Bracha Ettinger stands out amongst the profound artists who feel obliged to remain with the archive of European genocide to return a compassionate, sharing matrixial gaze on to the screen of this, her own, and our, history. It does not seek to restore the missing by means of fetishism, nor to memorialise them in their absence, to provide what Eric Santner calls 'narrative fetishism' that allows us to escape the ever-present question of their dying by depositing our anxiety in image or monument.[41] Her work also goes beyond the classic Freudian idea of *Durcharbeit* – working through. She undertakes in painting a perpetual but not melancholic offering of hospitality that seeks a means, a technology and a process, to re-encounter the dying at that threshold where a backward glance does not re-inflict a murderous second death, but opens the threshold of transmission of affect and human sharing in which we are touched, a little, in a co-affectivity with the unknown other at the moment of her loss of humanity in an inhuman murder that has an affect of subjectivising, humanising we who look with this painting at that virtual space, in time, in space, in the archive. Through the specific materiality and the duration of painting practice that touches the membrane between now and then created by the shimmering ash-deposited spectre on the paper upon which the artist builds her veils of eye-alluring and gaze-dispersing colour, the spectral victims are protected from being visually abjected as icons of an unbearable, dehumanising fate on which we the latecomers look as voyeurs, as occurs when we confront the documentary or perpetrator photographs in museum or book. Avoiding both Orphic voyeurism and the abjecting recoil from the sight of the humiliated other, Ettinger's multi-layered paintings slide us from one to the other down the opened pathways of matrixial connectivity between the remains of the human at the moment of an extreme suffering and our capacity to respond to and share with the unknown other, unknown because past, lost and also experiencing a fate beyond our comprehension. Yet their fate was the beginning of what is now our possibility.

In the mid-1980s Bracha Ettinger had turned back to painting after her training as an analyst in London. She first began to produce large-scale, expressive paintings in which a bleached and desolated landscape was populated by the skeletal forms of tortured, emaciated bodies burned on to our consciousnesses by the first films and photographs of the liberated concentration and death camps. Certain forms emerged almost too potently, like a death's head. This kind of painting was abandoned, as the means – landscape and figure – seemed inadequate to the extremity of this historical subject that lived within her. Allowing

recurring automatic forms such as the death's head the autonomy of an automatic image-making, the artist then formed such fragments into a new alphabet of what she named *hand-thoughts* that were exhibited in black-framed boxes in shapes that offered their own additional image of nomad words in the modern desert. She then began to work with an archive of image fragments: family photos, parts of atlases, Hebrew lexicons, diagrams from Freudian manuscripts, typescripts of the seminars of Jacques Lacan she was translating into Hebrew and the one 'tiny document of the Shoah' from which the frieze of women – a woman with a child, a woman appealing to the photographer, and one with no face – looking into the inhuman abyss – were gleaned (6.4). Combining her own drawing with this photographic archive that was both a family album and the stuff of every Holocaust memorial museum, she created works via a new process. Images were put through a photocopier whose operation was interrupted before it had completed the replication of the image. Thus a scattering of black dust had begun to trace the historical image on the paper and this trace was both appearing and disappearing in the same suspended moment. On to these phantasmal traces, the artist worked with grieving colour and wounding line, allowing both abstract inscription and the lexicon of image-thoughts to conjugate at the thin membrane of her contact with historical catastrophe.

These fragments of paper were then combined into new composites that, in their upright, often three-tiered groupings almost suggested ghostly personages that clustered into varied constellations in shows in Villeurbanne, Oxford, Leningrad, Kortrijk and Brussels. At the same time some of these paint-bearing papers began to call for more attention. Ettinger attached them to small canvases that took their own place once again as paintings, but always in series, since no one could comprehend the space of trauma she was contacting. Paintings 'after painting' break from the premise that informed historical painting, namely that its single surface could encompass a world. These paintings were fragments, but they came in series, holding the artist again and again at the portal of certain deeply freighted images whose human apparitions called to her not to abandon them but to return daily to the threshold of an encounter which is then inscribed into each painting at the level of its layered and intensified surface. Colour and touch attract our eye, lure us to it to slither over its constantly out-of-focus meeting between the image and our seeking to see. In her work there is no centre, no fixed point at which the whole becomes intelligible to a mastering eye. The matrixial gaze is like a pulse, a constant fading in and out of potential focus generated not in the desire for knowledge and mastery but the yearning to share contact with what remains beyond knowing, yet, none the less, resonates within the gazing subject as a trans-subjective other in a sharing beyond knowledge. Each painting opens on to another in the series, allowing the ceaseless movement and connectivity of the matrixial gaze.

Bracha Ettinger's journey to the works of the early 1990s *Autistworks* and then *Eurydice* is a result of a painful engagement with the fracture and the disassembly of the catastrophe that is her life as child of these events. Yet the result of that travail has been a major retheorisation of the aesthetic and ethic of the painter–painting encounter and of visuality that is not premised on the binary of the whole and the fragment, the visible and the invisible, but on what she named *Metramorphosis*. Like metaphor and metonym, the key figures of rhetorical language, *Metramorphosis* describes a mode of creating meaning, but non-linguistically, sub-symbolically, aesthetically. It is not based on substitution (metaphor) or contiguity (metonymy). Instead, *Metramorphosis* describes a sliding in and out of vision, what Bracha Ettinger in discussion with Levinas called *matrixial painting* 'as withdrawal and contracting before consciousness that leads to meeting with an unknown other'.[42] Fleeing the light that

claims the other's alterity for mastered knowledge, painting moves neither in to see nor out to master from a distance. Her painting lures one to its surfaces with affect-laden colour but dissipates the mastering gaze into a diffusion of the visual into a psychic transmission in which our unsighted eyes become what she calls 'erotic aerials of the psyche'.

It was in this revelation that the relations between the found photographic archive image, already dense with historical trauma, suspended by its processing through the graininess of incomplete dusting in the machinery of failed photocopic reproduction, is gleaned by the aching intensities of colour. It is not a matter of seeking to see and understand each image or its meaning as a delineated singularity. Rather we are invited to participate at this aesthetically opened borderspace that the painting is creating between the memory-bearing image from a historical catastrophe from which Eurydice makes an appeal for *wit(h)ness* rather than *witness* to a Eurydice, ourselves as the survivors of traumatic history, prepared to be co-affected by this other. The titles of Ettinger's work pass from the desolate *After the Reapers* through a series of works on language: *Mamalangue*, on *Family Album and Transport, Woman-Other-Thing* to *Autistworks* – a moment of extreme dissociation and pain to *Eurydice* (6.14), which progressively bathes the artworks in richer tapestries of what I call *the colour of grief* that none the less have the power to solace in the intensity of sensation before a human other.[43]

The suffering of others and the question of looking back

This problem has been with us from the moment that photographs were made to register the unthinkable discovered by the liberators as they entered Germany's and Poland's death camps.

Margaret Bourke-White photographed scenes at Buchenwald for *Life* Magazine in April 1945. This staged photograph (6.15) stands apart from the many that form the horrific archive, for all its figures are blessedly clothed and still, just, alive. Bourke-White has composed her image across the horizontal axis with no relief of background as a potentially limitless frieze of faces who stare out at the viewer from another world. Yet those spectres who look at us, the spectators, are divided from us by a fence that cuts horizontally across their prisoners' vertically striped garb as a barely visible barrier. What these men have seen, and what they will never cease to carry as images burned into hunger and pain-dulled minds, our sight of them from this side of that frontier cannot imagine. The photograph makes them the metonyms of their own unimaginable trauma that is not shown but is encrypted in their deadened faces. Beyond the limits of all representation, before all that they experienced there, representation fails. Yet the structure of the photograph indexes something significant: a gap and their suspension as survivors between two worlds, two deaths: the death their humanity suffered in that place and the relief of a death their bodies will later deliver – or they will, like Primo Levi, Paul Célan, Jean Amery and others, actively seek by their own hands. Yet, for us, not to look back, not to consider again and again this horizon of our present that is cut into history at that razored wire, is to obliterate all that which these men look for in meeting whoever is there, on the other side.

Hardly equivalent in horror and abjection to the myriad images that were rushed down the wires to the European and American press following the liberations in 1945 which of course included no images of Auschwitz itself, Bourke-White's photograph once shared with those I choose not to show the power of a terrible novelty.[44] As Susan Sontag, the cultural critic who mused so instructively on photography long before it had attracted much serious theorisation, wrote of a moment in her life in July 1945:

One's first encounter with the photographic inventory of ultimate horror is a kind of revelation, the prototypically modern revelation; a negative epiphany. For me, it was the photographs of Bergen-Belsen and Dachau which I came across by chance in a bookstore in Santa Monica in July 1945. Nothing I have ever seen – in photographs or in real life – ever cut me as sharply, deeply, instantaneously. Indeed it seems plausible to me to divide my life into two parts, before I saw those photographs (I was twelve) and after, though it was many years before I understood fully what they were about.[45]

Susan Sontag bears witness to a sight that forever changed her life. But she asks:

What good was served by seeing them? They were only photographs – of an event I had scarcely heard of and could do nothing to affect, of suffering I could hardly imagine and could do nothing to relieve. When I looked at those photographs something broke. . . . Some limit had been reached, and not only that of horror; I felt irrevocably grieved, wounded but part of my feelings started to tighten; something went dead; something is still crying.[46]

Typical as a defence against the threat of the traumatic image, a certain withdrawal or an over-affectivity floods the image. Individuals as well as cultures defend themselves against these terrible wounds and what was once the overpowering impact of a real transmitted by the photograph becomes de-realised by the very existence of the image and repeated exposure.

To suffer is one thing; another thing is living with the photographed images of suffering, which does not necessarily strengthen conscience and the ability to be compassionate. It can also corrupt them. Once one has seen such images, one has started down the road of seeing more and more. Images transfix and images anaesthetise. An event becomes more real than it would have been if one had never seen a photograph. But after repeated exposure to images it also becomes less real.[47]

Susan Sontag suggests, therefore, that images happen to us. The subject is not merely a viewer; she or he is affected by the encounter with *an image* of the pain of others – the title of Sontag's more recent and much less compelling return to her first reflections on photography and culture in 1977.[48] Images wound us, transfix us, Medusa-like in the confrontation with horror that breaches the outer ramparts of our discrete subjectivities to lodge their woundings in our memories. Images can be traumatic, drawing from the Greek root of this word the idea of the wound that pierces.

Yet Susan Sontag suggests that even the most shocking of images of atrocity towards the fellow human cannot retain its initial power. In her study of *Holocaust Memory through the Camera's Eye*, Barbie Zelizer reveals how the first journalists to report the concentrationary horror struggled with the inadequacies of language to describe what they were seeing as they followed the armies into concentration camps on German soil. Words fail me, was their repeated refrain, and the readers back home could not understand or appreciate the nature of the terror these men and women were witnessing. Once the stream of highly charged and selected photographic images began to pour into the daily newspapers and illustrated weeklies, the reality of what had actually happened had a huge impact in the emerging

rhetoric of documentary witness to atrocity. This shock of the first time may happen for individuals as they too come across this archive. But as a culture it cannot hold this terrible rupture before us any more. It has become part of the possible.

Although no repetition dulls that moment of first encounter that seemed to mark a burning line in time – before and after the knowledge the image traumatically projected into her being – Susan Sontag must admit that repetition does inure us. The photographs of Holocaust atrocity and suffering – and these are differently adjusted possibilities of what we are shown – guarantee the evidence of firsthand witnesses that defies the deniers. As Roland Barthes has argued, truly traumatic photographs are rare and their traumatic impact hangs upon the fact that the photographer had to be there for this image to have been captured. Now, of course, in the age of digital fabrication, that last tenuous and indexical link has been severed and all reality is *in potentia* virtual. So we swing back from the initial function of this photographic archive of atrocity as proof, primary witness in the first person, in which the image alone is able to register in its poverty something of the horror that the rhetoric of language could not encompass without returning it to known tropes, to think about other modes of encounter via an image archive that become a transport to and from that suspended historical moment.

In our current imperative to remember and memorialise distant as well as all-too-recent atrocities and traumatic events that have befallen many peoples in Latin America, Africa and elsewhere, we face the most challenging of ethical questions about what we do when we look back, when we look again and again upon the very images that first arrest our gaze and bring us into encounter and confrontation with the suffering of the other. I am of the opinion that the archive of the photographic inventory of Nazi atrocities cannot and should not be publicly exhibited. Each image contains known or knowable individuals, not merely anonymous corpses or walking skeletons whose horrifying neglect and reduction to anonymous numbers is part of the profound horror of this event. If we wish to resist participating in fascism's rupture of the most ancient marker of humanity's self-consciousness, namely the consideration for the human dead, we must return to each body its status as a potentially known, beloved, valued, possibly brilliant, certainly mourned human being whose degradation and torture has served its first and immediate purpose as evidence and must now be sheltered in the decent obscurity of archival entombment not allowed to those who in being 'disappeared' remain unburied and worse.

Yet such a proper *Bilderverbot* – prohibition on the visual image – precisely denies to us the summons from the other side of the fence that we meet in Margaret Bourke-White's photograph, to lend our humanity and its witness to those who, as Dori Laub has argued, suffered precisely the torture of the absence of witnesses to their dehumanisation within the absolute power of the totalitarian concentrationary universe. Dori Laub introduces the idea of horror as *an event without a witness:* for it was intended by the Nazis that the annihilation itself would leave no trace and, in the absence of a human other to whom appeal could be made by the victims, their own humanity was being suspended as its physical support was being tortured beyond death.[49] Bracha Ettinger's work as a painter which indeed raises painting to a place beside philosophy and ethics revises Dori Laub's formulation in two ways. Those of us who come after, anything, these events, or any painting and meet it later, somewhere else, are in effect *witnesses without an event.* It is not our experience that we encounter, for we were not there when the painting was made or the event took place. Yet we are witness to a trace, a register, a deposit that has called for us, wanting to be met, seen, discussed, interpreted, responded to. To view is to come after and behind the originary moment. To be a witness is

a call upon a subject-to-subject response mediated via a material object, a technological production, an image in paint or silver nitrates or pixilated digitisation.

Wit(h)ness: a feminist move in post-Holocaust psychoanalysis and aesthetics

Bracha Ettinger, however, proposes a further turn that is beyond the Sontag testimony to the impact of the image. She introduces into the word witness an additional 'h' rendering it *wit(h)ness*. This introduces a dimension of inter- and trans-subjectivity that is an ethical move that allows us never to look back and kill a second time either by inured indifference, or by defensive substitution of our own defensive emotions.

> The artist in the matrixial dimension is a wit(h)ness without an event in compassionate wit(h)nessing. The viewer, and this particularly includes the artist in her/his unconscious viewer position, is the wit(h)ness without an event par excellence. The viewer will embrace while transforming traces of the event and will continue to weave metramorphic borderlinks to others, present and archaic, cognized and uncognized, future and past. The viewer is challenged by the art work to join a specific matrixial borderspace, an alliance, an anonymous intimacy. Beyond representation, s/he is carried by an event s/he did not experience, and through the matrixial web an unexpected transformation and reaction to that event arises. That's why, I believe, an ethical aspect is already carried inside aesthetic production, without the artist's consideration or will.[50]

The practice of painting in which wit(h)nessing evolves and is performed, inviting its belated wit(h)ness-viewers to participate, is presented under the classical title *Eurydice*. Conversing with philosopher Emanuel Levinas, Bracha Ettinger proposed, as we have already read:

> The fragility of Eurydice between two deaths, before, but also after the disappearance . . . the figure of Eurydice seems to me to be emblematic of my generation and seems to offer a possibility for thinking about art. Eurydice awakens a space of re-diffusion for the traumas which are not reabsorbed. The gaze of Eurydice starting from the trauma and within the trauma opens up differently to the gaze of Orpheus a place for art and it incarnates a figure of the artist in the feminine. You wrote that woman is at the origin of the concept of alterity and that 'the Other, the feminine, withdraws into its mystery.' Starting with Eurydice and with the aid of your concept of the feminine, linked to the future and to this flight before the light, I can see a certain interpretation of the poetic or *paintorial* act, of painting at work. Writing as following on the ever fleeing centre, paintings as withdrawal and contracting before consciousness.[51]

Eurydice is imagined here as a figure for the artist in the matrixial feminine, because she represents a subjective moment or space between two deaths, at the heart of the relationship between disappearance and the difference of the feminine. The matrixial feminine is the set of psychic strings by which any of us remain open to the other, unable *not* to share the trauma of the other, for we are not bachelor machines, autistically isolated, but in our originating humanising in relation to a shared borderspace with the m/Other a capacity for

co-affectivity and co-emergence was laid down. Fascist culture is an extreme statement of the potential murderousness of the phallic system that disowns the co-humanity of those it designated 'other'. It could suspend the commonality of all that wear a human face. The matrixial model activates a counter force within our psychic, imaginative and intellectual potential that can resist, founding its ethics and its politics in the opening of the borderspaces between subjectivities so that, in processing the pain of others, we also realise our implication in any other's pain.

This statement also introduces a specific place for painting, which was historically displaced in the 1960s to the 1990s by the triumph of the gaze, the mainstream artistic investment in mediatic, lens-based and later digitised image-making that is so much at risk of mere compliance with the inhuman purposes of global capitalism's profit motive and commodification. After perhaps the most intensive century of thinking through painting from Courbet and Manet to Rothko and Krasner, painting ceased abruptly to be the centre of artistic practice and thought around the middle of the twentieth century. But Bracha Ettinger, working through this double heritage of modernist painting and its postmodern engagement with art in the age of mechanical reproduction, suggests a special potential for painting to work as a Eurydician process: a meeting between appearance and disappearance – the counter structure to voyeurism, fetishism and sadistic mastery. We can call it a feminine disposition embedded in this historically conditioned potentiality of a certain painting practice that addresses the world after Auschwitz.

To even raise this term, the feminine, is to court disaster in our profoundly misogynist culture that infects even its most thoughtful feminist thinkers. To speak of Eurydice as a figure of the feminine is not to say this mythical figure was an image of a woman, gendered according to some either physiological or even socio-psychological formation that is then different from those gendered as men. It is not to claim that women are nicer, better, more generous than men. In the work and thought of Bracha Ettinger, I understand the feminine as that common dimension and possibility of human subjectivity concerning severality and encounter that may be distinguished not from the masculine (i.e. attributes of men), but from the *phallic*, a universally applied logic that constitutes the universe of meaning and structures subjectivity on the basis of a binary: plus/minus; on/off; presence/absence. Within this phallic model, the feminine is aligned with the minus, the off, the absence, the dead. It is a deficiency vis-à-vis the other term, the masculine that is positivised in this relational difference.

In Bracha Ettinger's revolutionary concept of the Matrix as a supplementary signifier in an expanded Symbolic, the feminine refers to a logic that can introduce a dimension of meaning and articulate subjective possibilities for all subjects *between* appearance/disappearance, *between* presence/absence, *between* living/dead which has enormous resonance for cultures condemned to incomplete mourning through state terror, civil war and terrorism. It suggests a dimension of trans- and partial subjectivity; it speaks to elements or grains of our subjectivities that are still marked by a minimal difference and yet share a borderspace that can become a threshold for mutual transformations between unknown partners. This is the vitally important aspect of this theory: the partners in difference who co-affect and co-emerge in this borderspace are radically unknown, unknowable to each other, yet co-affecting none the less. Thus, this theory is not about fusion, sympathy, empathy; it theorises about ways in which, within a situation of radical alterity in human subjectivity, processes of co-affection and transformation rather than phobic hostility can be at work.

Thus the trauma of others concerns precisely the nature of the ethical and human

response to that other who retains difference and is not assimilated through identification or recognition, through becoming familiar. If the historical frame of the Holocaust is part of the long and painful history of the modern nation, and nationalisms, with all its ambivalences about identity and difference, any future we may conceive after the repeated acting out of a deadly hostility to those designated the enemy of the narrowly and exclusively 'true nation' (be that racially or religiously defined) must be premised upon a radically different ethos, politics and hence Imaginary.

Bracha Ettinger is aesthetically proposing *Eurydice* (6.16) as a figure by means of which we can imagine a non-phallic, non-fascist condition which has considerable implications for this fundamental issue of our relation to our own histories, histories of how we shall live with, beside, after and behind the pain of others. It would be my contention that unless we really know the pain of others rather than turning away in tired indifference through over-exposure, we have little chance of human survival. We, as humans, were irrevocably damaged by what happened over and over again during the various fascisms of the twentieth century and we are acting out that ignorance daily. The repressed – fascism and its demonising ethnic and political racisms – are indeed returning. We feel powerless, or worse, witless, before them. Feminist psychoanalytical and aesthetic theory seems an unlikely place to find hope. But, as this encounter with Bracha Ettinger's art and theory shows, hope is offered there. This is my plea for the value of studies in art and culture as analyses of the imaginaries, the fantasies and images that underpin our formal political institutions and practices, our social conventions and procedures. It is my plea for allowing art – the imaginative invitation to virtual encounters – a serious place in our thinking not merely as art world entertainment and sound financial investment, but as a way of addressing the major ethico-political questions of our moment as we deal with legacies of trauma in cultural memory by means of that still potent aesthetic legacy of painting after painting in a feminist, matrixial turn.

Part IV

TIME AND THE MARK

The complexity of contemporary artistic responses to the traumas of more recent history from Vietnam to Kosovo traverses an expanding range of media and forms of visuality, sound and installation. In Part IV I focus on artistic practices in which materiality and virtuality become core topics. Materiality is foremost in terms of the continuing theme of making, processes and properties of medium that underlie and underline the modernist project and remain significant for any critical artistic practice, even more so when it is preoccupied with questions of trauma. In the postmodern return to representation, or rather the return of representation through engagement with the image, the cinematic, the mediatic, the spectacular, what is the status of artistic practices that maintain a different involvement with modernist legacies of critical practice through materiality as a means of critical intervention in this moment?

Delay and time are part of Christine Taylor Patten's practice as an artist involved with drawing. Drawing is not a supplementary habit, a preparatory exercise. It is the core of a thirty-year project stretching across the minimalist movement and the interruptions of early feminist calls for new forms and new visions to the moment of liquid modernity. Series and variable scales from micro to macro lead towards a monumental series of drawing time across 2001 drawings each numbered for a year of the double common millennia. Still in the making, *micro–macro* takes us back to the questions of the body, embodied subjectivity and the mark. Marking time, making space, inscribing memory in the archive of recent history through practices that assert their own materiality, all the better to inscribe the virtuality of what they wish to evoke, the artist does not produce representation but *poïesis*. Installation implies and plans for the living body and attentive mind of the viewer, calling her into co-emergence with the work as an event whose threads, dispersed in space and across the serial image in time calls for the moving body and remembering subject to engage across several registers of subjective time and space.

Exhibited items in Room 7

7.1 Christine Taylor Patten, *micros*, 1998– , crow quill pen and ink on paper, 2.5 × 2.5cm. Selection from the first millennium.

7.2 Christine Taylor Patten, *imagine² (preliminary for macro)*, 2004, crow quill on paper, 52.5 × 258.7cm. New York, private collection.

7.3 Installations of selections from *micro/macro* at the Drawing Gallery, London, May–June 2006, and at the University of Leeds Gallery, September–October, 2006.

7.4 Christine Taylor Patten, *12E Line 55* (no. 1 in the *Vietnam* series), 1984, crow quill and ink on paper, 55 × 75cm. New York, Karen Schlesinger.

7.5 Christine Taylor Patten, drawing, 2005.

7.6 Maya Lin, *The Vietnam Veterans' Memorial*, Washington, DC, detail, artist's photograph. Courtesy Maya Lin Studio.

7.7 Maya Lin, sketch for *The Vietnam Veterans' Memorial*, Washington, DC, 1980. Courtesy of the Maya Lin Studio.

7.8 Christine Taylor Patten, *Unity is a Minimum of Two* (from the *Vietnam Afterimage* series), installed at the Addison/Ripley Gallery, 1994, crow quill pen and ink on paper, 2.10 × 6.30 metres (7′ × 21′). Courtesy of the Artist.

7.9 Christine Taylor Patten, *Free Radical (Simple)*, crow quill pen and ink on paper, 57.5 × 63.5cm, private collection.

7.10a Christine Taylor Patten,

> *No Poem*
> *Doesn't Make Sense*

 (no.1 in *Life as We Know It* series), 1984–5, 55 × 75cm. Collection Michael Powell.

7.10b Christine Taylor Patten, *There's No Such Thing as a Little Plutonium,* (no.2 in *Life as We Know It* series), crow quill pen and ink on paper, 55 × 75cm. Courtesy of the Artist.

7.11 Christine Taylor Patten, installation shot of *What is the Sound of the Speed of Light?*, 1989, alongside *And How Will the Music Help Now?*, 1989 (no. 13 and no. 7 in the *QED* series), crow quill pen and ink on paper, 101.25 × 180cm and 105 × 180cm.

7.12 Christine Taylor Patten, installation shot of drawings from the *Peace Series*, 1995, crow quill pen and ink on paper, 65 × 100cm.

7.13 Christine Taylor Patten, *micros*, 1998– , crow quill pen and ink on paper, 2.5 × 2.5cm. Courtesy of the Artist.

7.14 Christine Taylor Patten, detail of polyfoam sculpture – interior view, 1983, 360 × 270cm, installed in Armory for the Arts, Santa Fe.

7.15 Christine Taylor Patten, *Free Radical (Complex): Worm with Horns*, 1976, crow quill pen and ink on paper, 75 × 100cm. Collection Robert and Monica Powell.

7.16 Christine Taylor Patten, *Free Radical: Magnolia*, 1977, crow quill pen and ink on paper, 120 × 180cm. Courtesy of the Artist.

7.1

7.2

7.3

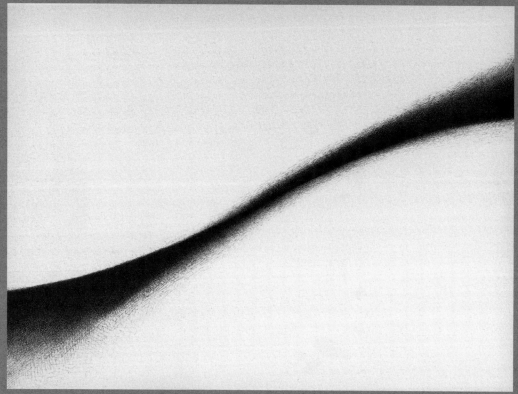

7.4

7.5

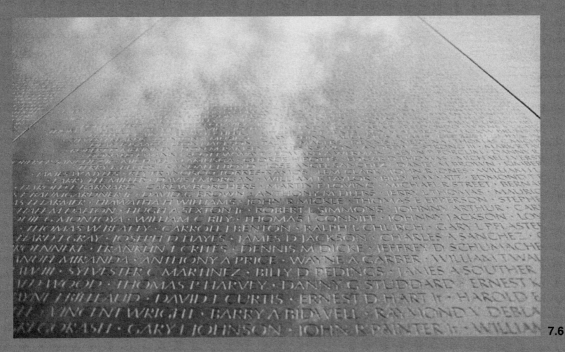

7.6

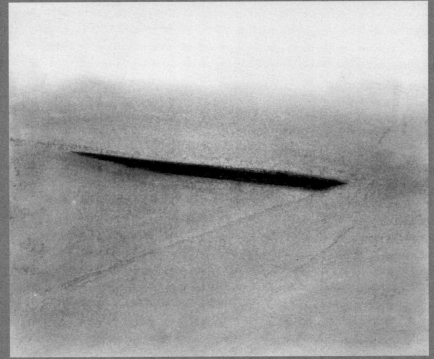

7.7

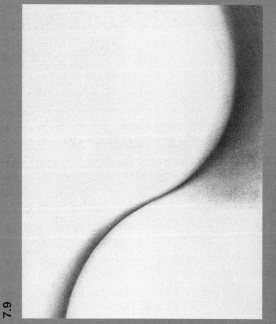

7.9

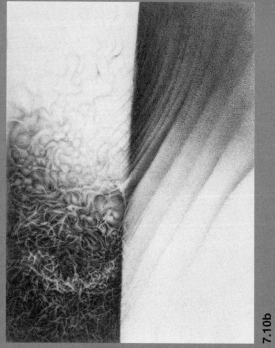

7.10b

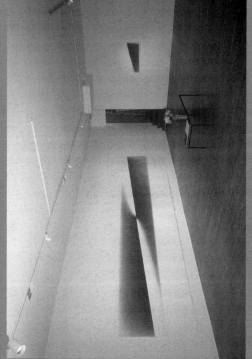

7.8

7.10a

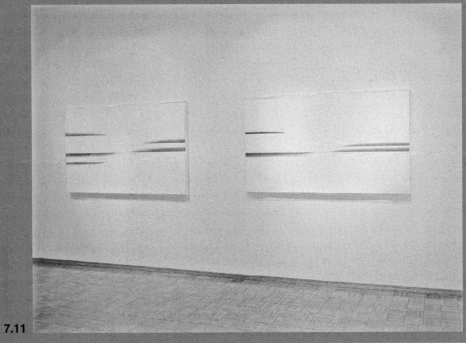

7.11

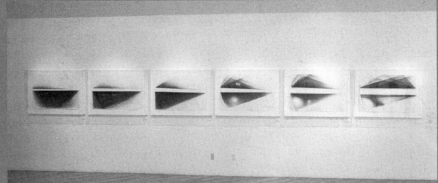

7.12

7.14

7.13

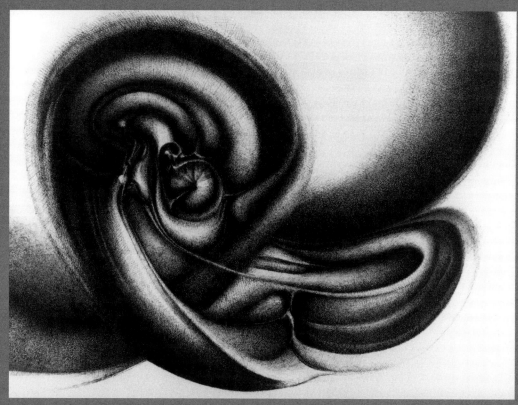

7.15

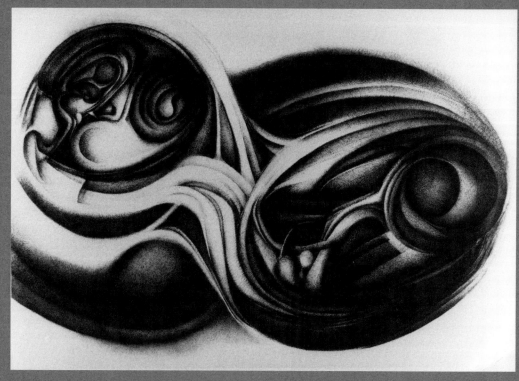

7.16

7

THE TIME OF DRAWING: DRAWING TIME

micro/macro (1998–) by Christine Taylor Patten

For me real drawing speaks of consciousness.

Christine Taylor Patten[1]

And here, too, is the artist's great strength. The series is stunning for its visual and tactile effects, yet the core of this encounter with intangible space is the discovery of linear time: the viewer's slow, or sudden awareness of the artist's own hand in the infinite application of discrete strokes that by themselves compose, shape and animate those effects. With the elemental scale of *Unity is a Minimum of Two*, Patten conveys an elemental link between material process and private myth on an epic level.

MaLin Wilson[2]

Drawing allows one to go back and reflect. The gestural record on the page stages a moment of existence that is no other moment. It measures and binds and establishes perimeters. It allows one imaginatively to rethink that moment of action even though it is past, and in that sense it marks its time.

Avis Newman[3]

Drawing is thus not to do with perceptual illusionism, but with infinite space as mental possibility. Is the drawing itself, the ground, the space of transience?

Cathérine de Zegher[4]

In 1998, American artist Christine Taylor Patten (b. 1940), who has worked on ten major series of drawing projects over thirty years that ultimately produced drawings more than twenty feet long (just under seven metres), conceived a monumental new series that would enable her to 'see more of what drawing could do'. She undertook to draw 2000 drawings, each one inch by one inch (2.5 × 2.5cm). These *micros* would be complemented by one twenty-four-foot (7.3 metres) drawing.[5] The series is called *micro/macro* (7.1). So far three studies for the macro titled *imagine* have been completed (7.2). The *micros* are titled with numbers and letters running from 1 AD to 2000 AD. These link the drawings to the years of the double millennia *Anno Domini*, sometimes also known through its global use as the *Common Era*. Ideally exhibited in a single line of *micros* ultimately meeting the monumentality of the vast *macro*, Patten's 'millennia' of drawing have at times been exhibited in gridded squares as well as running lines around the gallery spaces (7.3). Until a truly magnanimous

museum undertakes to show the project in its monumental entirety, we only get to see a few 'centuries' at a time, to experience a tiny dimension – yet even this makes evident the grandeur of its conception and realisation.[6] Time, invoked by the millennial titling and by the literal time of seeing the whole work, plays across this project at three levels.

First, there is the time dedicated by the artist to creating this epic journey of drawing so many drawings in a continuous, unfolding experimental series in which each drawing 'takes off' from some event or potentiality in the preceding one. This introduces into the drawing the living time of the artist, the events, inside her world and in the world at large that intersect with the moments of formal preoccupation with making the works. Drawing, furthermore, has an intimacy with the body, sensorial, erotic, time-bound through age, and as a trace of a sentient consciousness registered in the vitality and drama of the works at the level of mark and decision in its space.

Second, there is the meditation on time in creating a drawing for each year of 2000 years of the Common Era that literally makes such vast expanses of linear time – history – graspable as a flow of differences through the marker of each year monumentalised as an individual drawing with all its own internal complexity even as a tiny unit of a vast, unfolding stream of drawing. Yet the only way to encompass the project is for the viewer to move along the line of time, in the real time it takes to see 2001 drawings.

Third, the events that occur in the drawings, as the fundamental battle of light and dark pursued by the marks of the crow quill pen with a thin arc of black ink against the textured surface of the paper placed following the logic of the initiating dot in space that splits in the second drawing, open up even on their tiny scale to a cosmic sense of time as an endless virtuality, of worlds coming into being, evolving and transforming. Without any intention to create references or images, the drawing produces spaces, forms, cavities, and above all light. Invisible when you look at the burning white sheet of untouched paper, light has to be produced by the counter force of created darkness that blocks out that limitless white. This negative creativity is the drawing's work – itself an accumulation of tiny marks that bring us to see the light it – drawing as darkness – creates in this generative opposition–difference.

This project forms the conclusion to these encounters into the virtual feminist museum – not because I do not hope that ultimately a major museum will embrace the project and finally allow the world to experience Patten's vision of time in its complete form. Such experience demands the phenomenological encounter with its material presence by the embodied, moving spectator experiencing its movement of line as time. Rather, it is because it is itself a museum of aesthetic virtualities, an artwork dealing *poïetically* with time and space, by means of a singular and often undervalued, even feminised practice: drawing. (Despite its Albertian origins in *disegno* as a masculine value of creative, even intellectual conception, drawing has a feminine value as supplement, sketch, notation in contrast to the tableau or sculpture.) Patten's drawing signally returns us to the themes underpinning this book: time and space, the woman's creative body/mind and the inscription through the novelties of modern artistic processes – including abstraction – of sexual difference, and the play of history at the intersection of aesthetics and ethics across the long twentieth century, the century of women that was also a century of catastrophic challenges to modernity.

From Free Radical to Vietnam

12E Line 55 is the later given title of a drawing in crow quill pen and black ink on paper measuring 55 × 75cm by American artist Christine Taylor Patten (7.4). It originated in

a series called *Free Radicals* made during the 1970s (7.9) and marks the transition into a series of very large drawings titled *Vietnam* (1982–6) that it initiates, one of which is called *In Memory of Someone who was Killed in Vietnam*. Swooping in a falling diagonal from upper right to lower left across the large, otherwise unmarked expanse of paper, or alternatively rising slowly from lower left to upper right, curving, bowing and opening as it traverses the white fields it creates in its bisection, a dense network of hatched black lines condenses and massifies to create both a dark crevice across the image and its twin fields of contrasting white volumes which were, in effect, the drawing's main object of enquiry. Sharply defined at its upper edge on the lower left as the darkness begins its journey, the blacknesses splinter into less concentrated masses so that individual strokes of the crow quill pen become visible as they wander into the blankness of the paper they trellis with their tracery.

The drawings are made by a single movement of the hand holding a mounted crow quill pen which draws a delicate line, only thousands of which added together by repeated action bring out the deep darknesses (7.5). Density is thus created over time with a multitude of tiny strokes cross-hatching each other, building out the light and always leaving their own trace embedded, a palimpsest of making. At the edges of these created darknesses, stray pen strokes leave an uncertain border between drawing and support, between darkness and light. Close up, they yield an uncanny sensation of hairs escaping a cap. This always sets up, for me at least, another invocation of the body, in ways that remind me of Eva Hesse's equally subtle, controlled yet almost erotic minimalism that creates only to break through its formal bounds to allow us feelings associated with the strange things like body hair and body spaces that are ours but not quite us. The play of a created darkness with a light that can only become light by virtue of the effects of the lever of drawn marks accumulating to create an impenetrable black neither references, nor shows anything but its own process. Yet there is much to see. The hungry eye is fed and nourished with the visual event at the micro level of the multiplying strokes from which the drawing is made and at the macro level of the resulting experience of ' "Things" passing each other, touching, twisting, meeting', that is neither a straight nor a curving line, neither a volume nor a space but an event-encounter (Ettinger's terms) on paper that draws the viewer into its interior depths and sweeps the gaze restlessly across the areas the pen has worked. A reviewer in the *Washington Post* wrote:

> Patten's surfaces initially suggest minimalist simplicity . . . they are in fact grounded visual structures, built from thousands of precisely incised hatch marks – artistic obsession made manifest, creating sublimely abstract invocations of light. . . . The myriad ink strokes seem like a sear mark, the afterburn of a magnifying glass. Patten's adroit handling of the masses of marks achieves vibrant, seamless shifts from black to gray to white and back again . . . suggestive of everywhere and nowhere. With only a chiaroscuro spectrum, she conjures extremes which . . . co-exist in impeccable equilibrium.[7]

Christine Taylor Patten starts a drawing with an establishing pencil stroke. Then she begins to work with ink, to set up the lower level darks and to begin to seek out the density, and imagine the weight of the overall distribution of marks. Working along the initiating line in space, the ur-mark of drawing that creates event and ground, to build up the overall under-drawing, an event with its accidents and unexpected becomings finds its basic form.

Here begins the push and pull of artist and drawing, her decision-making responding to

chance effects that are accumulating as a result of the inherent potential of a dark force against its emerging opposite, light, of the tension between a line and its ground which is ceasing to be ground and becoming a partner in the dialectic of the straight mark and the curved form it can produce, the contrary quality of a fabricated depth of darkness of the accumulated lines and the fragility of the single, visible stroke of a hand-held pen (7.5).

Patten draws with the back of a crow quill pen which produces long, vertical strokes. These can be left as a casual scatter of criss-crossing gestures or they can build up an area by her going into it to work at it, that is, to suppress some of the forms that spontaneously appear or have emerged such as hollows, curves, bulges and swells as the inevitable and always fascinating effects of chance angles and distribution. In each completed drawing, the artist sees the layers of its own history, the archaeology of its becoming. Time is thus inscribed into the resolved balance of density and surface that the viewer finally encounters, pondering only the final resolution of these struggles over the time of making. For Patten, therefore, drawing is a process of emergence at the intersection of work and the virtualities of the effects of line (darkness and distinction) and ground (support and light). The line is not inscription but sculpture: it sculpts the negative space from the blank paper so as to find and explore an 'image' which is what happens in the areas that become light, the image being produced by the work of drawing that blocks some of that light out. The nature of the pen mark for chance event and final control alone produces the invisible moments of passage, transition, modulation. Dark and light are not tones used to shape an image from the world; they become the event of drawing. Before the final work, the viewer cannot see all the moments of shift or becoming. But through the final 'image' the viewer experiences change visually. Time is translated into a spatialised movement. Thus three propositions may be offered:

- Christine Taylor Patten creates light. Her instrument in drawing.
- Christine Taylor Patten makes time visible. Her method is drawing.
- Christine Taylor Patten materialises thinking. Her process is drawing.

Patten was born in California but spent much of her young life in Europe. There she was able to visit the great museums, in Amsterdam and Rome, and, even as a tiny child who drew incessantly, she discovered for herself a world of art. Losing her parents one day in the Borghese, one of the great sculpture galleries of Rome, she wandered alone amongst the objects, the guard indulgently allowing her to run her childish hands over the surfaces and to feel the forms of the sculptures in her arms. Working initially in sculptural installations, Patten eventually decided to follow the line, felt in the movements of her tiny hands over those energised forms of Baroque and classical sculptures. For over thirty years she has made drawing the central process, practice and investigation of her work to explore the line. Utterly abstract and non-representational, these drawings are, none the less, deeply inscribed with both historical time – American and world historical events since the 1970s – and women's time – the time of this one woman's living, sexual time, subjective time, gendered time. Drawing time suggests time set aside for drawing as well as drawing as a means of thinking, feeling and seeing time. Could such drawing tell us something different about the time and sexual difference?

History drawing

'12 E Line 55' is also a location on *The Vietnam Veterans' Memorial* (1982) by Maya Lin (b. 1959) in Washington, DC (7.6 and 7.7).

Maya Lin's dramatic abstract monument (7.6), chosen out of over 1000 submissions when she was still a student of architecture at Yale, inscribes the names of the 47,424 American service personnel killed in the Vietnam War 1961 to 1975 on a black granite wall, shaped in a V that cuts into the earth at the heart of the nation's capital under the brooding presence of the Capitol (7.7). Maya Lin disowned the expressive rhetorics of traditional war memorials that, by figuration of the dead soldiers, fetishistically disavow loss, violence and endless absence of the men and women killed in war. With black granite, Maya Lin cut a physical scar descending into the earth. Like a wound, its length, calculated by the space needed to record in columns each name, would mark in the time taken to traverse it, the accumulation of losses, one by one, making a place for each and every death. As visitors pass along its polished granite length and find the place of the one for whom they have come, they are themselves reflected in its shining surface. The living bodies are confronted with and written over by all that remains: a stony signature on a mass grave.

What is the relation between the location on the Vietnam Memorial, known now as 'The Wall', and the title of Patten's large drawing?

At the moment that the curving bows of the *Free Radicals* began to straighten out, Patten attended a reunion in Washington, DC of the American High School in Frankfurt she had attended. She looked forward to meeting up once again with John Joseph Livingston whom she believed had long since realised his ambition to become a paediatrician. He was not there. His absence led his former classmates to the dreaded realisation that he had been killed in Vietnam. They went to Maya Lin's Vietnam Memorial and found his name at *12E Line 55*. Recognising a deep aesthetic affinity with Lin's monument – 'the utter severity of the gashes in the land that the sculpture makes as the two planes meet at its apex like two broad, angry strokes of a pen' – Christine Taylor Patten titled her current series of drawings to reference to 'issues of war, sons, lovers, mothers'. In the *Vietnam* series, she matched the millions of tiny strokes like gashes in space to the millions of tiny acts that made the war. *Vietnam Afterimages*, begun five years later, registered the process of living with the knowledge of John Joseph Livingston's death. Death is a slow realisation of an endless absence. It takes time to know it; the bearer of the knowledge of an other's death must live beside that knowledge to grasp its active effects on the living who are its survivors. Yet, in these drawings, one twenty feet long, light seems to press through the dark masses shifting the drawings from being, in the words of Patten, a 'refuge from chaos' to 'being a fascination with the serenity of resolution itself' (7.8). This comes about through a formal exploration of what Patten calls *the turning plane*, the moment and the place where change occurs, a shift, an alternation, that marks the otherwise slow and invisible point of radical difference.

The pattern of her work, the artist tells us, has a constant rhythm from simple to complex and back. Thus the later *Free Radicals (Simple)* (7.9) set in motion a single diagonal trajectory across the page, leaving large areas of untouched rag paper. Across the papers of the *Life as we Know it* series (1984–5) a diagonal or a horizon appears as the intersection of densities of massed hatchings that configure intricate networks of cavities and flows taking us closer to contemporary theories of chaos and turbulence (7.10a and b). The drawings in *QED* radically shift us to the horizontal plane, a vast white expanse created by the subtle interventions of spears of dense hatching. 'Sometimes I feel as if am sculpting paper as I draw' (7.11).

213

The exploration of line – horizon lines – produced two other series that involve not so much a study of wave forms as the stages of change and alteration that would lead to the image turning over on itself, turning planes. The *Peace Series* comprising twenty-seven drawings (7.12) bisects the paper with a thick horizontal band of unmarked paper that is created by two opposing partial triangles of differing densities of pen markings. As the greater density of marks in the lower segment yield and those in the upper segment increase, an effect of a time-delayed camera marking the movement of the triangles over the median line is staged over twenty-seven (3 × 3 × 3) 'frames' while additional drawing events occur to animate the areas of most intense working with unexpected areas of light, like discovered stars. Only when the drawing has opened and journeyed through the complete arc over the gaping but still line of emptiness at its core will the series be finished. Each single drawing bears the word 'peace' in one of twenty-seven languages. Difference and iteration mark peace as a process that must be wanted and made, not as the blank state interrupted periodically by war. One of Patten's other drawings is titled *First we must want peace before we can have it*. Peace is a virtuality to which we aspire. The *Vietnam* and *Vietnam Afterimage* (7.8) series offer a dramatic example of this by an inversion. Diagonally bisecting the paper the great fields of darkness pivot around a single central point of contact. What is significant here is the scale of the work. The drawings are twenty feet long.

Even the selective installations of 250 or 261 micros and the macro studies, *imagine* (7.2, the first of which was part of the series *Vietnam Afterimage*, 7.8) stage a juxtaposition between many and one, between small and large, between series and singularity, between moving along a line and standing back before an expanded space, between seemingly infinite, surprising or open evolution and the serenity of the resolved, between intimacy and grandeur, between scale and size. Yet both micro and macro are created by the same process and speak to a shared project hinged across these differences. Patten states:

> All attention seems to be on the micros, perhaps because there are so many of them, but the core of the work is the difference between the two [micro/macro], and its meaning. Why is that difference what it is? Is it only perception? . . . The tensions and contradictions between the [micro/macro] is important to me, some life in between the two that is not represented visually, only sensorially, on some other level.

What is the difference the slash between micro and macro is making visible for us to experience by means of drawing?

Cosmogenesis: artistic registers of the virtual

The *micro* drawings 403–978 AD that I have before me, mounted temporarily as a square 24 × 24cm as demonstration and overview, starts from a white void/dot in the centre of its own galaxy of speckled darkness and ends 575 drawings later with a flattening disc forming a horizon line on a similar background. History has, however, happened visually in that the inner logic of taking off from one of many elements or potentialities of any of even the tiniest of drawings to follow. Thus swirls of cloud, clusters of planets, energy fields of vibrating neutrons, wave patterns, burning suns, all spring to mind as a cosmic vocabulary of forms emerges. Yet these drawings in turn lead to geometric as well as organic abstractions as tessellations, spears, platelets, sections, dance and play.

I am wrong to impose my personal associations on these drawings. The metaphorics I invoke run against the absolutely non-representational structure of this practice. These are not copies of already existing forms. We are watching advanced aesthetic intimations of what postmodern architect and theorist Charles Jencks argues scientists now understand about the universe's own processes: cosmogenesis.

The relations of art to science have been both intimate and problematic. Nothing is flakier than to attempt to suggest relays between contemporary physics and abstract art – or biology and art which was a vogue in the 1960s and 1970s. These studies suggested a kind of autonomy of the natural world which was unconsciously inscribed into abstract art as if the highly complex artefact, aesthetic abstraction, spontaneously registered forms and processes of the physical or biological world. We have been more hospitable recently to relations between abstract, formalist art and the workings of psychic drives and energies that can at least be theorised through a singular psychic apparatus. But the nebulousness of the connections between life forms and art forms bypasses everything to which art historians and critics think we must attend.

Yet, as architect Charles Jencks has pointed out, at the level of the relays between different spheres of the production of knowledge about the world and the kind of imaginary art or science fosters in relation to the conditions in which we are living, it is important to analyse whether our images of the world engage or distort our knowledge of it. Thus if the current modes of scientific theorisation about the physical universe or biological life world – post-relativity and post-quantum mechanics, chaos, turbulence and so forth – is *thinking* the world through non-similar processes of dynamic genesis rather than the logical forms of repetition, regularity, pattern and so forth (such as are architecturally expressed in the gridded forms of international modern architecture and serial minimalism), it might be argued that it behoves artists to think new forms that enable a radical reorientation of human understanding of the world of which they are embodied moments. Thus at the level of coincidence, the aesthetic processes of Christine Taylor Patten, setting herself in good minimalist fashion a project based on a defined set of formal parameters, perform and discover forms for effects that current chaos and turbulence theorists in the physical sciences propose as the state of the generative cosmos. The aesthetic then becomes a means of visually confronting the invisible forces of chaos, turbulence and non-regular genesis – which, in a sense, is precisely the creative principle that her practice discovers, independent of the scientific theory that later resonates with it.

Thus the picture I have been creating of a faithful modernist unravels before the recognition that the work itself advances through its formal conceptualisation into the territory of postmodern science offering, across this false frontier between art and science, an instance of unpredictability, creativity. As Michel Foucault, the regular attendee at lectures on the history and philosophy of science demonstrated, the humanities often need to look beyond their own inherited conventions to find ways to think that are more attuned to the social as well as subjective worlds. Charles Jencks, the first to point to the development of the paradigm shift in architecture that we name postmodern, and now to yet another, poses architectural form as a cultural index of responsiveness to the dissemination of ideas about the cosmos and life processes.[8] If these are not static, orderly, uniform, regular and repetitious, the classic modes of international architecture and even minimalist art are not merely anachronistic but ignorant. The architecture of Frank Gehry and others based on computer-generated engineering of wave forms and other new physical dimensions attendant on post-quantum mechanics and turbulence will ensure that the embarrassment about art/science

interfaces is displaced by generous and genuine interest in the simultaneous occurrence of new paradigms and hence new imaginaries grasped through new forms and images.

When Christine Taylor Patten says her eyes are drawing eyes, which means she sees things as drawings others might not see as drawings, she points to the wonder, in effect, of discovering that what has been made in the private space of a studio in New Mexico as the continuing project of a refined and profound artistic commitment to drawing as a practice despite its long absence from the forefront of cultural attention and indeed curatorial fashion, belongs in and resonates with the major currents of scientific and social thought. Not inspired by, derived from or illustration to, but rather a co-*poïesis* that allows the framing of this work, so insightfully about a liquid concept of time, to bring its mode: drawing into visibility and pertinence.

The vast undertaking to create 2001 drawings across the micro/macro difference begins with a dot in space, a circle of darkness on a tiny piece of paper from which evolve 1999 micro drawings, each of which departs from only one of the many possibilities present in the preceding drawing. A parallel series of *Tangents*, moving off in other directions over a sequence of twenty drawings, initiates other possible series adding a third dimension to the linear movement of the main series. Moving through the 2000 micro drawings evolving from each other without any predicted or anticipated outcome, we become witnesses to what Patten is doing: 'drawing *drawing*.' The drawing process is determined by the consistent parameters of Christine Taylor Patten's 'rules': a crow quill pen, black ink and white paper and the gesture of the hand holding the pen in making a single mark used repetitiously to hatch and cross-hatch. By hatching out the blinding light of the white paper, forms are discovered where light is not, or fields emerge to give this otherwise invisible environment, light, a shape. The process reveals both the infinite possibilities of such limited but fundamental procedures: drawing in its essence perhaps as a signifier of life, and a history of the cosmos and of time. On the tiny scale of one inch by one inch drawings, whole planetary systems, stellar worlds and cosmic events tumble and evolve, shifting from spheres whirling through infinite dark space to jagged zags of lightning, flows of turbulence, falling comets, burgeoning seeds, fractal geometries, dancing lines. Organic and geometric forms morph seamlessly over sequences taking hundreds of drawings to return to something similar. The linear hang of the drawings means that the viewer follows, with the movement of her/his body in space, 'a line' created by the sequence of drawings, a physical arrow of time. Yet to get it all, the viewer needs to backtrack and recapitulate, to trace the movements and processes through which the end-point emerged from its predecessors. Time as a flow, time as an event, the two major philosophies of time intersect. Since the Greeks, the question of time and hence of how we understand historical time, the time of consciousness and of human intervention, has challenged philosophers. For Heraclitus, time is envisaged as a flowing river, a continuous movement halted momentarily by our stepping into it to grasp from that flow a single moment. This image of time produces history as a continuous narrative with its own inner logic of progression: destiny. Democritus, on the other hand, suggested a 'world occurring in bursts and explosions, as the rainfall of reality'. This privileges 'the event, the unfolding, particularity rather than generality'.[9]

The series also captures that aspect of time we call life, the humanised aspect of our experience of time, in the sense that we only understand what it was, a life, our life, *after* it has unfolded, flowing forward, unpredictably. We catch up its process only in retrospect as an event. History can only tell us of time's movement backward, from the point at which we arbitrarily look back to make sense of the process by which we arrived here.

These series bear witness to Patten's work, therefore, as a kind of 'history drawing' or a drawing practice that engages ethically with historical experience, her own time, what we call history, the history of the later twentieth century that stretches between the anguish of the Vietnam War and current world conflicts so scarred by escalating violent slaughter, suffering and wasteful loss of lives. Patten is an artist whose career has spanned peace movements of the 1960s to 1970s that were a new generation's reaction against the horror of the two industrial world wars and the prospect of an endless Cold War with its far-flung regional hot points to meet the present torment of our newly traumatised twenty-first century. Her titles suggest that her drawings in their series, often months or years in the making, are themselves prolonged meditations on contemporary history mediated through its deeply personal resonances, pained, joyful, erotic and mournful, the meeting of the personal and the epic, the private and the mythic.

Change, transformation, process, emerge then as the substance of this lively investigation and as the experience gained in the encounter with their installation. Tensed between what I can only call the cosmic – referring to the physical universe, the world, time-space, in which we are a tiny dot of consciousness, and the historical – the act of consciously reflecting upon our actions in the fabric of human time, the meaning of human social existence, and hence an ethico-political consciousness, Christine Taylor Patten's drawing practice can only be glimpsed here in a tantalising fragment. This becomes an invitation to a discerning world to enable the realisation of the complete project as one of the most ambitious and serious in contemporary art that bridges its roots in the still vibrant aesthetic of the late modernist–minimalist intersection and our current hunger for that experience of art as profound thought undertaken through the human manipulation of materials to create, to make visible, to offer something via perception to reflection, so often betrayed by what is now packaged and sold as art but which offers only its glamour and spectacle and a quick-fix, a one-off hit.

What is drawing?

Conceivably, drawing may be the most haunting obsession the mind can experience. . . . But is it, after all, a question of mind? . . .

The soul of the mind requires marvellously little stimulus to make it produce all that it envisages, and to employ all its reserve forces in order to be itself, which clearly it is not until it is very different from its ordinary condition. It does not want to submit to being what it most frequently is.

A few drops of ink, a sheet of paper as material for the accumulation and co-ordination of moments and acts, are all that is required.

Paul Valéry[10]

It is one of the unexplained paradoxes of twentieth-century art that the 'highest' and most sustained moment of painterly, sculptural and graphic modernist abstraction – reaching an apogee in the 1950s in New York with the concentration of modernist artists in the United States resulting from their flight from Nazism in Europe – was not sustained beyond that decade. Instead, within a few years, the cutting edge of artistic practice swerved away not merely to different media but to a radical challenge to that modernist conception of art

itself. In 2007, the curatorial team of *Documenta XII* could pose the question: Is modernism now our antiquity?

Passing through a series of equally profound and important paradigms, of which minimalism and conceptualism remain the most fertile as the lingua franca of so much contemporary practice, we witnessed, under the added impact of a specifically feminist intervention in art practice, the return to narrative, to the investigation of the body, and the arrival of new media as the means of such post-painterly, post-abstract projects.[11] Representation as both practice and critique re-emerged. What I call the 'triumph of the gaze' and the predominance of lens-based artistic, if not representational, practices in photography, video and latterly digital media coupled with the widespread expansion of sculpture into performance and installation left what had been, on the cusp of the 1960s, the most serious, ambitious and still unexhausted practices based on traditional artistic protocols looking old-fashioned and frankly historical.[12] Curatorially and critically smoothed over by the nebulous concept of postmodernism, this short-circuiting of high modernism so embedded in painting and abstraction remains a theoretical and art historical puzzle. The implications for our contemporary acknowledgement of artists whose practice continues something of this imaginative and aesthetic territory that rendered modernist art so complex as artwork has, however, been adverse to say the least.

A review of exhibitions from the later 1990s and a prospect of those forthcoming reveal an interesting sea change in which 'painting' and 'drawing' are re-emerging as sites of both serious curatorial revision and current creative activity.[13] This re-vision and re-engagement in discourse, curation and theory with the potentialities of painting and drawing provides a new frame to make visible and legible artists, such as Christine Taylor Patten, faithful to a creatively modernist conception of art as a form of visual thought, as an ethical laboratory in which, by pursuing with rigour and attention the interface of the affective and semiotic properties of material, media and process with the moment of human subjectivity, existence, being and action (in the Rosenbergian sense), a lifelong practice is sustained.

Of all these 'returns', the recognition of *drawing* as one of the great modernist practices rather than a mere preparatory process is the most significant. Drawing has so often been placed in a kind of supplementary relation to the big aristocrats (John Golding's term), painting and sculpture. Prized for informality and spontaneity, for the insight into the imaginative and creative process, drawing has been treated as preliminary or exploratory and rarely is it pursued for itself. Few artists have understood and created so faithfully within the parameters Paul Valéry recognised in the work of his contemporaries: Manet, Degas and Morisot, when he wrote: 'A few drops of ink, a sheet of paper as material for the accumulation and co-ordination of moments and acts, are all that is required.' Christine Taylor Patten's thirty-year career is one profound and current example of an artistic practice committed to drawing for itself.

Valéry's comments serve me here for a paradox. He insists on the traditional relation of drawing to the mind, to thought, to *hand-thoughts* (as Bracha Ettinger has named her process in her notebooks) in the classic battle between line and colour, between classicism and romanticism, between a self-denying ordinance of reduced resources: ink and paper, black and white, and the sensuous indulgence of colour.[14] But then he wonders if it is *only* a question of the mind. There follows his wonderful phrase: the soul of the mind, that opens human thought to its ethics and to its affects – refusing Cartesian dualism of mind and body while interlacing feeling, reflecting, thinking, knowing and sensing as the supreme human activity. Such interplay is not normally allowed as these elements are divided up into work

and play, sex and labour, thought and feeling. The aesthetic of the great projects of modernist practice summonsed us precisely into that kind of human *being* – the legacy of Heidegger's profoundly important phenomenology that resonates through art history via the readings of Cézanne, the ur-modernist, by Maurice Merleau-Ponty. The current and long overdue interest in art and art history in the aesthetics of Merleau-Ponty provides us with a tough and rigorous if ever beautiful vocabulary for speaking of the curious processes at the heart of art-making that recall Patten's identification of drawing and consciousness. Merleau-Ponty too cites Valéry:

> The painter 'takes his body with him' says Valéry. Indeed we cannot imagine how a *mind* could paint. It is by lending his body to the world that the artist changes the world into paintings. To understand these transubstantiations we must go back to the working, actual body – not the body as chunk of space or a bundle of functions – but that body which is the intertwining of vision and movement.[15]

For Merleau-Ponty, it was Cézanne and Matisse as painters who enabled him, a philosopher, to see what their transformation of painting into modern painting enabled us to think/ understand as the intertwining of vision – so often suspended as a kind of autonomous ocular observation or perception of the world – and movement, the living body embedded in the surrounding world which is not only seen (as if from the distance of the mind) but is itself seeing the enworlded human subject who is part of the 'things of the world' and yet has a consciousness with which to see him/herself both seeing and seen. Much of what Merleau-Ponty writes about painting can be addressed to what Christine Taylor Patten explores through drawing and finds out about drawing as a means of seeing seeing and being being by means of marks and spaces. The question of seeing: visibility as well as the unseen: invisibility, were emerging for Merleau-Ponty as key questions premised on the duality that forms the human experiencing subject as both seeing and seen.

> But humanity is not produced as the effect of our articulations of by the way our eyes are implanted in us (still less by the existence of mirrors, though they alone can make our entire bodies visible to us). These contingencies and others like them, without which mankind would not exist, do not by simple summation bring it about that there *is* a single man. The body's animation is not the assemblage or juxtaposition of its parts, nor is it a question of mind or spirit coming down from somewhere else into an automaton – which would imply that the body itself is without an inside and without a 'self'. A human body is present when, between se-er and the visible, between touching and touched, between one eye and the other, between hand and hand a kind of crossover occurs, when the spark of the sensing/sensible is lit, when the fire starts to burn that will not cease until some accident befalls the body, undoing what no accident could have sufficed to do. . . . Once this strange system of exchanges is given, we find before us all the problems of painting.[16]

Merleau-Ponty argues that 'things and my body are made of the same stuff'. Quoting Cézanne: 'Nature is on the inside,' he argues: 'Quality, light, colour, depth which are there before us, are there only because they *awaken an echo in our bodies* and because the body welcomes them' (emphasis added).[17] In discussing the paintings of animals on the limestone walls of the caves of Lascaux, the philosopher defines the 'image' as the visible to second

power, a carnal essence rather than a faded copy, and thus what 'it' is, is neither one with the walls nor elsewhere so that it is hard to say 'where' the painting/drawing is.

> For I do not look at it as one looks at a thing, fixing it in its place. My gaze wanders within it as in the halos of Being. Rather than seeing it, I see according to, or with it.[18]

Of painting and drawing, therefore, Merleau-Ponty can conclude: 'They are the inside of the outside and the outside of the inside which the duplicity of feeling (*le sentir*) makes possible and without which we would never understand the quasi-presence and imminent visibility which make up the whole problem of the imaginary.'[19]

The phenomenological reading of certain aspects of modernism's duality – the attention to 'the world', sensation, perception, life on the one hand, and, on the other, the preoccupation with art – with making, gesture, mark, action – brings into view the practice pursued with a dignity of self-defining authority and integrity by Christine Taylor Patten over the last decades of the twentieth century and in the present one. The question then arises around what Merleau-Ponty did not address: How does sexual difference at the level of our embodied consciousness and desire inflect that seeing/seen, the feelings and thoughts about space and time that awaken echoes in. . . . what . . . gendered? . . . body, the world and things experienced in the mediation of our specific living and historically shaped mind/bodies find themselves inscribed in/through/with the aesthetic activities of seeing/making/seeing/being seen?

In her subtle and critical reading of the repressions in Merleau-Ponty's text, 'The Invisible of the Flesh', Luce Irigaray starts from her agreement with the philosopher that 'we must go back to a moment of pre-discursive experience, recommence everything, all the categories by which we understand things, the world, subject-object divisions'.[20] But in doing so, Irigaray argues, we will 'bring the maternal-feminine into language'. Thus she intimates what he disavows: a relation between our consciousness of things and being in the world and the specific forms of human becoming in intimacy with a generative bodily other: the maternal feminine. Commenting on a passage in Merleau-Ponty: 'It is as if our vision were formed in the heart of the visible, or as though there were between it and us an intimacy as close as between the sea and the strand', Irigaray picks up on the deeper and unsaid intra-uterine associations of immersion and emergence in Merleau-Ponty's metaphors. It is this possibility – not as an organic, anatomical space, but as a cradle of subjective possibility and sensitisation – that Irigaray pursues to expose the repression of the play of sexual difference in Merleau-Ponty's thought.

Visible/invisible and se-er/seen seem to offer a reversibility, and yet Merleau-Ponty senses something about these pairings that exceeds them. Irigaray bluntly dares to suggest that the paradoxes can be thought better through acknowledgement of a tangle of beings that precede the subject–object relations after birth:

> Which corresponds doubly to a reality in intra-uterine nesting: one who is still in this night does not see and remains without a visible (as far as we know); but the other cannot see him. The other does not see him, he is not visible for the other, who nevertheless sees the world, but without him.[21]

What she calls 'the invisible of prenatal life', none the less, leaves its traces:

A carnal look which becomes that which gives perspective to 'things': shelters them, gives birth to them, wraps them in the touch of a visibility that is one with them, keeps them from ever being naked, envelops them in a conjunctive tissue of visibility, an exterior-interior horizon in which, henceforth, they appear without being able to be distinguished, separated, or torn away from it.[22]

This will lead Irigaray to puzzle if there is

a foreseeing where the maternal is concerned? Something that would make the child believe it is seen before it sees. That the invisible looks at it. And if the mother foresees her child, imagines it, she foresees it also in this sense that the feeling of it within herself is sometimes transformed into a vision, a clairvoyance of, and within the flesh. Could it be that he uses this clairvoyance to surround things?[23]

Irigaray suggests a refused nostalgia to explain the unspoken immemorial maternal locus of his becoming that haunts Merleau-Ponty's masculinist text. More creatively, she is proposing that our acts of art-making, place-making and space-making that offer something to vision rather than merely visually representing the things of the world, as well as our acts of pleasured looking, may be seeking, *down the path of vision*, a way to catch up once again the psychic traces of this formative embrasure that we could not then know, but which impressed itself upon the proto-being as the existing, already-awaiting outside-other, impressing what will later become a memory on to the still formless being-to-come that could carry forward and seek again at some deep level the impression of this dark, sightless yet beheld being that was none the less 'seen', imagined, held in another's fantasy. Thus non-figurative, non-abstract process art, made by a living, thinking and feeling artist's body, searching through gesture, the blank light of the page to carve out some place of such invisible night, might bring us to an encounter with a memory of becoming in the invisible presence of another that we never had, but which, once structured through an artistic form as an 'image', we belatedly recognise with unexpected joy and visual delight. Such insights bring us back once again to Bracha Ettinger's more exhaustive propositions about matrixial dimensions of subjectivity as the register of this co-emergence at a shared borderspace that may not be only, but certainly can be intensely re-experienced through the metramorphoses of aesthetic practices. For Ettinger, it is painting's dissolution of the fixed gaze and delivery of a non-centred field that allures the eye into this dimension of relations-without-relating. In her own analysis of how Lacan drew for his later theory of the gaze as '*objet a*' on Merleau-Ponty's concept of *voyance*, this awareness of the other who sees me from where I cannot know, Ettinger derives her shift in the double field where phenomenology encounters psychoanalysis, consciousness encounters the unconscious, to propose a matrixial gaze. Far from suggesting a legacy of the physical environment of uterine space (even as a basis for a psychic memory), Ettinger is working in strictly psychoanalytical terms when she writes:

The Matrix identifies a passage for sensations and affections, desires, phantasies, traumas, feelings and ideas that do not cohere in the process of castration. I use the term 'metramorphosis' to remap specific routes of passability and transmissibility, transitivity, conductibility, and transference between various psychic strata, between subject and several other subjects, and between them and assembled objects. In these routes, 'woman', for both men and women, weaves a sub-symbolic web,

knitted just into the edges of the phallic Symbolic universe but which, nevertheless, cannot be appropriated by it.[24]

Although, as a result of this specific psychoanalytical terminology, some phrasing is both unfamiliar and difficult to grasp immediately, Ettinger's argument enables us to grasp how a 'memory of oblivion (the never-yet-remembered but still affecting – hence a trauma, an unprocessed psychic impact) may be the origin of the impulse to make art as a means to find, again and for the first time, traces of the other in me, the non-I and I.

> Metramorphosis is the originary human potentiality for reciprocal yet asymmetrical crossing of borderlines between phantasy and trauma of I and Non-I. It induces instances of co-emergence and co-fading as meanings of trans-subjectivity and sub-subjectivity, and transmission and transcription of unforgettable memory of oblivion, a treasuring of events one cannot recollect because they have been treated by one's own originary repression and also transcribed in the m/Other. The idea of transcription . . . and cross-scription is a means for thinking the enigma of the imprints of the world on the artist, of the artist's potentiality to transform the world's hieroglyphs, and of the viewer's capacity to join in this process. . . . A matrixial screen unfolds through a dispersal and sharing of the already joint gaze which is also always-already partial and severalised.[25]

In the kind of visual field created by Patten in her drawings, we may also find this matrixial dimension supplementing with its other, unconscious, uncognised *jouissance* the exploration of consciousness and being that joins her work with Merleau-Ponty's phenomenological speculations on painting, Irigaray's feminist intervention, and Ettinger's propositions about a matrixial gaze and the aesthetic process of metramorphosis.

Thus I want to propose a double, at least, axis for the encounter with these drawings. Drawing is a way of thinking in and about the lived world of time, history and pain. Drawing is also a journey that may, on its way through time, catch up and offer to us, through the pathway of vision, unremembered but formative conditions of subjectivisation that are deeply charged with the effects and affects of our encounter as humans-in-the-making with the invisible specificity of the feminine sexual body. This living being, both organic and subjective, embraced us in its invisible gazing upon a not-yet-formed becoming but also initiated all human beings into a primary experience of co-emergence, and shared borderspace. Thus virtuality becomes a condition of the feminine as hospitality to future life and a foundation for each subject-in-the future thus emerging into life in this sharing encounter to which certain kinds of art processes, historically conditioned in the researches we call modernism, inflected by embodied women subjects, may once again allure us as we gaze upon the screens their art have created in their own encounter-events of the making.

Genealogies of the feminine in aesthetic practice

Within each tiny square of the *micros*, one could teach a whole history of drawing (7.13). The mediatic revolution and the digital virtualisation which beam a million shifting images at us to saturate us with the only identity capitalism wants: ever-desiring consumers, ironically render the archaic technologies of pre-modern/modern art production politically and culturally significant as a mode of resistance to the erosion of what is serious and ethical in

culture. As Julia Kristeva argued in 1979, in an age of information and the mass production of fake individualities, aesthetic practices which foster and depend upon the value of the singular, both the creative singularity of a subject and a practice and on what is called forth in contemplation of that instance in the viewing partner, acquire, unexpectedly, a renewed cultural significance.[26]

What does viewing art do to and for us, now, in this our moment of historical time? What might encountering and engaging with Christine Taylor Patten's work do to and for us insofar as it embodies the resistant, defiant even, pursuit of an *aesthetic practice* as Julia Kristeva might understand it: working, as her beloved literary avant-garde had done, on the frontiers between the semiotic and symbolic, seeking not merely to renew it but to transform the subjectivities of an over-ordered and potentially totalitarian society? Kristeva called her privileged moment of revolutionary avant-garde negativity 'feminine', but, being part of the French intellectual tradition, it is not meant in a reductive, essentialist or biological way. The 'feminine', for Kristeva, is a non-anthropomorphic possibility, a principle of creative transformation, renewal and openness. Many people remain resistant to any mention of the feminine, including even Kristeva's highly cerebral allowing of the feminine as a cultural or psychic principle of non-violent revolution. In a new confident post/anti-feminist era, brushing all these tedious questions of gender and sexual difference under the carpet of has-been political moments, it would be rash, in analysing any artist, to invoke now disdained feminism. But we do history and women in art a terrible injustice if we allow ourselves to police out of view the huge significance of the feminist theoretical revolution in our thinking. Far from reducing the artist to being a mere woman, hence local, particular and of little narcissistic value to the hero-worshipping critic, art historian or curator, feminist analysis of artists enriches and expands our sense of the human and its several modes of being, as indeed does reference to the singularities of every artist who is shaped according to culture, class, sexuality, location, generation and geography. What might resonate with significance for all of us (have general meaning) can indeed be articulated from a place specific to any one of us (a particular location). Our particularity does not diminish but enlarges all of our diversified but ultimately linked and co-emerging humanity. Thus I want to conjoin some feminist analysis to the ethics of Christine Taylor Patten's aesthetic practice.[27]

I have mentioned Merleau-Ponty's conjoining of 'Eye and Mind' as the definition of the human's being, and Valéry's invocation of the soul of the mind. I can now invoke Avis Newman's phrase: 'I am not speaking of the language of depiction and representation, but of what constitutes the mental energy of engagement that is so evident in drawing; how the makers of an action translate the murmurings of the mind.'[28] Minds and bodies are not given but formed, yet they offer their own potentialities in interplay to produce singular experiences of the world. My mind is not confined by my body *pace* the old lie about hysteria that women's wombs determined their psychic health or the medical myth that active female brains would wither female wombs. Yet my embodied experience and thinking about the world is mediated by the only, sexed, gendered, classed and ageing body I have in which to live my subjectivity, itself the composite of corporeal affect, fantasy, identifications and thought. When feminists look at the work that has been made by women, we do not ask, as the nineteenth-century critics did, where are the signs of a universal and defining femininity? They sought as feminine weakness, passivity, imitativeness, decorousness, gentleness, sentiment. We ask: How has this particular woman found within the resources of her cultural moment and place, her generation and geography, her singular means to translate the

murmurings of the mind embodied in that specific historical, sexual and different subject, in which her femininity will provide unpredictable but possibly interesting determinations?

When, in 1996, Cathérine de Zegher mounted her landmark exhibition of three generations of marginalised twentieth-century artists from four continents, all of whom were women, she detected certain possible groupings for the myriad works she collected.[29] They clustered around themes such as the fragmentation of the body, movement, weaving, and sound/silence, said/unsaid, inscription and erasure, and the blank in the page. Her exhibition mapped concentrations of aesthetic investment that enabled us to see patterns of attention amidst radical diversity of means and procedures. By placing artists in an exhibitionary relation to each other across three periods, the 1930s, 1960s and 1990s, *Inside the Visible* defied the standard curatorial categories of period, style, national school and date. The show proposed a feminist reading of the 'women's time' of twentieth-century art revealing a genealogy rather than history of art rich in echoes, resonances, unexpectedly shared concerns distanced by time and space. A genealogy of artistic concerns derived from a close reading of artworks was plotted out across the century, offering a model for feminist studies of the visual arts which I regularly adopt: an actual feminist exhibition that feeds into this virtual feminist museum.

What genealogical grouping would provide the larger frame for Patten's drawings? With what works might they be creatively in conversation?

Christine Taylor Patten's drawings emerged from a very different place, from her work with foam built into vast sculptures which the viewer was invited to penetrate (7.14). The fleshly colour and pliable material was further transformed by the running of cords and string across its surfaces to produce a physical environment that evokes a kind of bodily interiority that no one has ever seen or experienced and yet we seem to recognise it. Viewed from the outside, the structures resemble trussed internal organs, stitched up after some botched operation. But inside, flowing movements of forms that are the effect of the exterior stitching undulate and bubble. These installations invoke a powerful sensation of the body – but compared, for instance, with Mona Hatoum's *Corps Etrange*, we realise that what is missing entirely is any trace of the abject: the truth of our moist, mucousy or bloody inner spaces from which we sometimes recoil with anxiety or disgust has not been forced before our eyes through the managed distancing of optical fibre photography.

In Patten's work line has drawn a world out of foam, a world to which we attach the adjective interior, without reference to anything specific. So where is the bodiliness of this body-ness? The pink of the foam and its texture threaten to render the drawing invisible because of overwhelming associations. Even though they are experienced by the viewer's participating body, such associations risk a collapse of the work's own identity into reference. It was from referentiality in drawing that the earlier discovery that what was important was *the drawing line* – the moving worm that made time and space – had released Patten. Real space, real scale and real 'swimming' in the lines would be sacrificed to the infinitely expanded possibilities of the virtuality of drawing (see pp. 227–8).

Drawings which preceded these sculptures, early *Free Radicals* (7.15 and 7.16), create an extraordinary experience of interior spaces that might generate powerful visual evocations of what we imagine as bodily space. But we must ask what these are and why such effects, affects, occur in us on viewing. The artist writes that *Magnolia* (7.16) was often referred to as the 'womb' by others. 'It was drawn in response to a rather liquid movement I made on paper with pencil, and there was never any intention to draw particular forms.' She dismissed the over-quick adult readings of the image as 'womb' but says she was humbled

when a 3-year-old saw the work on exhibition and declared emphatically that it was just like the inside of his mother's tummy. I might well steer clear of such discussions – and the artist has made clear what the nature of her own, formal investigations were. Feminist criticism has already found itself in trouble for suggesting analogies between abstract forms and bodily sensations.[30] I am not about reinstating the 'central-core imagery' debate here. Rather I want to recall an earlier famous debate in psychoanalysis: the Freud-Jones debate about the specificity of female sexuality based on whether little girls have archaic intimations of interiority (Jones, Horney) and Freud's adamant assertion that there is only one libido, active, hence 'masculine' because the tiny girl child can have no sense of her sexual interiority.[31]

I must take full responsibility for raising this here; it is not part of Patten's concerns. Rather my interest and angle of interpretation relates to my interest in Ettinger's Lacanian-inflected matrixial theory which contests Freudian denial of the potential psychic resources deposited in *all human subjects* from their archaic, pre-natal *encounter* with a feminine sexual specificity – a specificity which lies not in organs (penis, vagina, clitoris, umbilicus, placenta, as in the Freudian scenario) but with a fundamental *severality* arising from a long period of mutually affecting encounter between at least two partial human subjectivities co-emerging during the period of pre-natality for the becoming infant and pre-maternity for the remembering adult. Severality as a psychic event-encounter induces a resonance, a deeply engraved sense of moving/being moved, touching/being touched, sharing, being co-affected and co-transformed. What the little child spontaneously 'saw' in Patten's volumetric drawings that are, as I have established about movement, transition, touching, transformation at the point of encounter with formal, graphic difference, has to be understood at the level, never of anatomy books, but of the way inchoate and pre-verbal sensations are belatedly recognised in what aesthetic forms offer to our vision. The image creates a visual structure for a non-visual, hitherto unremembered and therefore unforgotten, traumatic, psychic trace of the archaic matrixial severality and sharing of borderspaces and encounter-events which is the psychic and aesthetic legacy of feminine sexual difference. Let me first lay this out more starkly.

Anatomically, the uterus is a small pear-shaped organ formed of muscle that, expanded in pregnancy, stretches as a tight skin around a growing child living in the variegated darkness and eventual immobility of its cramped, watery ur-dwelling. Who has ever *seen* its inside? So we must dismiss any sense of the uterus as organ, and replace it with the idea of a *spatial subjectivising condition enduring over time premised on encounter with an unknown, sensed otherness.* The inter-uterine can therefore only refer to a psychically engraved sensate human memory of being in space with and feeling affected by an unknown other, a living human subjectivising co-presence in the shared borderspace that may always become a threshold for encounter and hence effects deposited differentially in either partner-in-difference.

When non-pregnant, the womb is tiny and closed up. When pregnant it is full of child, its walls becoming a shared membrane at once at the inner and the outer limit of the co-emerging pair. So where does our idea of the inside of 'Mummy's tummy' come from? Anatomy books, initiated by Scottish surgeon William Hunter's section dissections of gravid wombs, especially those now written for expectant mothers, now offer a medicalised, and often violently cut open, visual image of the invisible and sensuous event taking place within this uncharted and never-seen territory of encounter between several partners-in-difference, that may later resurface against the force of primary repression that befalls all such archaic events in the real of the body, as displaced fantasies associated with a luxurance of movement in space and a feeling of homeliness of place.

225

In his essay on the uncanny, *Das Unheimliche*, literally the unhomely, the familiar-turned-strange by a return of its repressedness, Freud acknowledged the aesthetic as sharing the traces of two fantasy structures; one is castration (mutilation by the father) and the other are *Muttersleibfantasien*, inter-uterine fantasies, memories of the co-emergence with the m/Other.[32] The latter reveal themselves in feelings of familiarity in a space, return to somewhere already known, and in fantasies of being buried alive. The definition of 'the uncanny is whatever that ought to have remained secret and hidden but which has come to light'.[33] Its sources lie in infantile complexes: castration complex and womb fantasies.[34] Freud further argues that whenever a man dreams of a place or a country and says that he has been there before, 'we may interpret the place as being his mother's genitals or body'.[35] Psychologically, because we were all, men and women alike, once nurtured within the body of a feminine other, we carry, unknown to our conscious selves, deep, physical, tactile sensation memories of interiority and connectivity that must by definition be shapeless and formless. Any breach of primal repression, however, behind which castration and intra-uterine life shelter any return to our original 'home', transgresses the frontiers of the subject formed by the effect of repression of these primal fantasies. The return of the repressed, the uncanny, generates a profound anxiety that threatens the very integrity of the subject. These events occur at the level, stresses Freud, of psychical reality and draw their power from their repeating of an original situation that could not have been apprehended at the originating moment, but which acquires its shock and power by the 'return' occasioned by an image or a representation or an encounter which, in fact, provides the structuring form or representation for the inchoate infantile complex of affects and sensations: Ettinger's *memory of oblivion*. But the child who looked at Christine Taylor Patten's drawing as the inside of his mother's tummy without uncanny anxiety anticipated by Freud, or the adult who names a certain formal configuration a womb, is responding, by retrospective naming, to the *pleasurable* uncanniness evoked by the drawing's creation of a visual form that prompts unremembered archaic sensations into an imagined memory moved through aesthetic encounter. In its own exploration of a liquid line, of touching and mutually affecting volumes and voids, Patten's drawing has traced into culture a virtual space that, at the level of psychical reality, may evoke, for some viewers, a sensational memory of 'home' that has nothing to do with anatomy, organs or knowledge.

I suggest the luxuriant but also alarming feelings of eroticism, or the sexual, that are evoked in looking at some of these flowing drawings, and which might mistakenly lead to projecting associations with the imagistic and metaphoric use of the specificities of female sexuality in feminist work of the 1970s, arise in a way closer to the troubling power of other women modernists' early explorations of graphic abstraction that also inspired a psychoanalytical vocabulary to catch their unique charge. If we propose some relation between abstraction in art and what I might call the associational memory of the psyche, we might then ask how much the emergence of these created spaces/places, environments that register the artist's own desire may be creating, *for the first time in culture*, a formal event to tip into visibility the distinctively non-visible quality of the effect of feminine sexual specificity upon human subjectivity – its sensate invisibility and qualities of constantly readjusting co-transformation. Women do not make this kind of work because they have wombs they have never seen. Some artists may, however, allow, or rather not block, when they arise, the visually discovered aesthetic effects that, for the viewer, evoke a solacing and even delicious feeling of 'being with another' through that memory-shared borderspacing of which Ettinger has written so provocatively and called the matrixial. The 3-year-old boy 'knew', on

feeling the sensations he linked with the drawing, this home as the uncanniest of beginnings in that fantasmatic sharedness of what Bracha Ettinger raises to theoretical recognition as the matrixial borderspace.

The drawings we are discussing are, moreover, notable for their invocation of movement, flow, and thus they consistently displace any centre, refuse fixity and closure. What they image is not an interior topography (cut, dissected and drawn in medical illustration). They find visual forms that suggest becoming events that happen in the becoming of the drawing, as the artist follows the possible hints and accidents to elaborate darkness that excludes light by the intensive hatching and scratching of lines until a velvety depth appears that is never entirely freed from its laboured making, or produces a luminous counterpoint that inverts the illusion of depth to produce a bulging form precisely by withholding the marks, peppering them with stray strands of hairy pen strokes and letting the paper come toward us. Such forms swoop and dive, turning back on themselves like a Moebius strip, without edges, and never becoming units. They are already liquid and witness to the artist's fidelity to their singular becoming in living.

A living line: the story of the worm

Patten tells a story of her student days at Otis Art Institute in Los Angeles in the early 1970s:

> One of my teachers . . . told us to bring a drawing to class the next day, to bring a line. Yes, a single line. One of the students concocted a great apparatus that resembled a Rube Goldberg contraption that had all sorts of moving parts and managed to make a path across a piece of paper that he placed on the floor, and it drew a pencil line as it crossed in front of us, right before our eyes. I brought a live worm on a pile of sand. I liked the multi-levelled aspect of that – the worm was a line in itself, and as it moved in the sand it drew all through class time. Its aliveness brought time into the equation, as did the man-made Rube Goldberg drawing machine. We got to see lines being made, some locked into time, some not.

This story of the worm and its earth drawing in and beyond time catches up as allegory the quality that marks the mind and art of Christine Taylor Patten. She writes:

> I thought a lot about those lines over the years, because as I passed through painting and clay and then large foam sculptures that one could get into, I kept scratching little lines all over the place, looking for what happened when I did that, where the abstract qualities of space and time took me when I was playing so. I kept wanting to go swimming in those lines, into the crevices and pockets, into the vastness of the empty spaces. I loved seeing the light that got trapped and the idea that my little scratches seemed to me more a way of manipulating the light, blocking it out to see what was there hidden in the paper, covered up by all that light, all that white space.

In her interview with Cathérine de Zegher for a major exhibition of drawings from the Tate Collection, drawing artist Avis Newman stated:

> I would definitely identify drawing with the infinite space of sensation: both the sensations of the body and the sensations of the mind. The consciousness of that

limitless space is embodied in the reality of the white page, which I would say is a space of fragmentation that has, since modernism, been an interminable potentiality, symbolically the dreadful place of boundlessness.[36]

While Newman's ideas about the space of sensation both corporeal and physical accords with Christine Taylor Patten's avowal of a desire for immersion but also investigation, Newman's dread image – itself freighted with already gendered anxieties – of the uncharted space and fear of fragmentation and boundlessness is radically at odds with Patten's openness to, joyousness in, discovery and curiosity. Her practice, in its scale and sustaining philosophy, certainly takes its place within the grand canons of modernist ambition and self-reflexivity. What sets it on its own singular pathway is the depth of curiosity that allows the drawing process – ink, crow quill pen, carefully selected paper – to be the means of movement, swimming perhaps, travel in and beyond the space-time continuum by means of this fascination with what we might see if drawing 'opened' up the vast expanse to the tiny worlds from which we are blinded by too much light, by too much knowledge and preconception. What is found by her drawing is both an event at the level of Merleau-Ponty's 'things' of the world and what this artistic practice as intervention alone can deliver into the world – for seeing, knowing, sensing due to the singularity of the mind, the person, the body, the moment that is making it.

The story of the drawing worm holds something more. Art-making is a necessary yet impossible form of attention to the life of the world which modern art concluded it could not represent without inflicting a reifying mortality. Yet the foundation act of art, drawing, can bear perpetual and creative *witness* to the life of the world because, like the worm, it is not merely boundary, delineation, edge, but movement that itself, in its own and other world, makes space and time visible. Like music, there is no verisimilitude in this attentive witnessing because there has to be an equally profound commitment to watching the autonomous liveliness of the process itself. Thus, in encountering the drawings of Christine Taylor Patten, we find ourselves in a deeply formal territory where we must attend to process, material and effect created by both the discipline of a reduced resource (ink, pen, paper) and by a gesture based on the stroke made by the movement of the hand – the ur-mark of human inscription. At the same time, notably visible in the *micro/macro* series, this formal process and its gestures set in motion a phenomenally limitless but directed process of other marks, all bonded in an unpredictable creative relativity that brings forth an event which we are invited to witness on paper, and imaginatively/projectively enter by means of the movement of our eyes in it and bodies beside it, in the way we process what is happening in the drawing not as a drawing *of* something but as some 'thing' *become* drawing.

A serious and profound artist makes a world by seeing with/in/through her work as both an autonomous event and a trace in the world of the intertwining of vision and movement as the living, embodied person made the work over time. Such art is neither a representation of the world nor an abstraction from it. It is a world. It is also, in its physical reality and engagement with living, the world. It comes forth from the world, and returns it to itself, *differenced*, through the astounding particularity of a singular art-making that seamlessly joins consciousness and thought, materiality and creativity, sensation and affect, aesthetics and embodiment.

Passionate minimalism

Christine Taylor Patten takes her place within the great traditions of twentieth-century and contemporary drawing through her lifelong fidelity to its core: a gesture that is a mark that, therefore, produces not merely a drawing or drawings (which are, none the less, always works of extraordinary formal beauty and affective intensity). She performs the very conditions of drawing as a process of doing and making in every work. Christine Taylor Patten takes drawing to an exploration of the possibilities of its fundamental co-ordinates – 'a few drops of ink, a sheet or paper' that become an 'accumulation of moments and acts'. She also makes it a restless investigation of the mind in an engagement of enquiry into being in the world which returns us to the question of time and the body. In doing both thus, she achieves a *passionate minimalism.* Her work undoubtedly shares in the great adventure of the minimalist project that is one of the most important, complex and sustained achievements of the modernist century. It emerged in the 1960s to salvage modernism's commitment to material and process from the threat of romanticism and gestural individualism. Yet, in the hands of so many women, it became a more vital, erotic, affecting modality. Patten's projects are defined by a typically minimalist set of formal parameters. They never, however, simply become the proposition as in so much work by minimalism's canonical masters. Like Eva Hesse and so many other women artists, both liberated and supported by minimalism's discipline, Patten finds through it a means to explore living, love, death, mourning, anger and curiosity.

Her work distinctively differences minimalism's potentially desiccated formalism to assert the ethics of an impassioned citizen speaking to her world of peace and loss, energy and change, and the deep pathos and joy of life. In addition, her work speaks of and from our real modes of being in the world as the resource for a singularity and a history that links the kind of foundational research into materiality and making with the challenge of engagement with real time, with history.

Relations

I first encountered the works of Christine Taylor Patten on a visit to Santa Fe, New Mexico, in 1994. From the very first, I knew I was in the presence of a major intellectual and artistic personality, one creating a sustained project that was deep and subtle, profound both ethically and aesthetically. It was evident to me that she was producing works that could solicit and hold prolonged attention and reflection – works that were humorous, erotic, pathos-laden and visually astonishing – fully belonging to a genealogy that extends from the great modernists of the twentieth century. I detect in her work elements in elective affinity with Käthe Kollwitz's graphic and intellectual strength, Agnes Martin's sustained exploration of line and its other – thought – through the grid in pencil and paint, Eva Hesse's playful and prescient engagement with chaos and complexity through forms both mechanical and visceral, Nancy Spero's maternal rage at war and its wastage of life, Mark Rothko's ethereality and stillness in layered effects of veiled paint, and Avis Newman's sustained exploration of drawing and the body as trace in space. The intellectual company Patten might keep also includes the artists she herself most reveres: Johann Sebastian Bach and Johannes Vermeer.

Particularly in his work on the fugue form, Bach represents an exemplary commitment to combining purely abstract research into a chosen artistic language/medium with a perplexingly moving and spiritually serious kind of mathematical playfulness in sound. 'Bach's counterpoint seems to me to be (in its infinite forms, responsive to each moment) an

expansion of time in the guise of sequence.' Thus we might find in Patten both a trace of a musicality lived through the body's music-activated movements as she draws on the vast scales she sometimes works on. The painter Vermeer, whom Patten imagines as the quiet, studious, persistent student of the conditions of visibility, raised to inimitable serenity the simplest and yet most challenging of artistic encounters – that between a gaze, an other, and space, studied over time, in a way that made slowly emerging painting an encoding of desire in time and held forever in a suspended moment. Patten writes:

> Drawing is the closest thing to love, for me, apart from another person.

> It is the inner search for stillness and silence, a quiet, contemplative state in which I listen for sounds I have never heard and look for sights I have never seen. Drawings are places, new places in the universe that seem to be powerful and powerless, tranquil and full of life, and for me, questioning and not questioning.

Bach, Vermeer, Patten: a musician, a painter, and an artist who draws – the last category being one for which, significantly, we have no proper name. 'Draughtsman' indicates our exploitation of drawing for purposes other than itself. Somewhere along the line of art history, drawing – so often presented as supplementary, transient, shorthand (though also studious), preparatory, delineating, translating, projecting – lost its profound position as *disegno*, or 'conception' in Latin. I use the word 'conception' because 'design', *disegno*'s literal translation, no longer holds the elevated status attributed to the term by the great Renaissance sculptor and architect Leone Battista Alberti, who wanted to register a new concept of the artist as akin to the intellectual, as a *creator* rather than a mere servant of other branches of intellectual and spiritual life. Today, though we have the words 'painter', 'sculptor', 'etcher' and 'print-maker', we have no word to define those artists who have made drawing their life's work. 'Drawing', however, as a present participle or gerund, holds a fundamental truth before us, which is that of the medium's unusual relation to time: when we think of *a* drawing, the '-ing' of the word reminds us that it is still at work while we are looking at it, *drawing*. The artist states:

> Drawing is the examination of movement and feeling, made material, the materializing of the evanescent and ephemeral, locked into a part of its being. What is seen on paper is a moment of the drawing's being, an illusory state, its other processes buried beneath the surface, hidden now, forming its substance.

Supporting engagements

Two further supporting engagements with related processes opened up during these intervening thirty years between the worm's living movement and the project for drawing *drawing* that is the *mirco/macro* series: geometry and holography. Her understanding of geometry links Patten with another significant contemporary, Louise Bourgeois. For the study of geometry, Patten's motivation was:

> to understand structure and movement better, and how we perceive it. And how it has some connection to human beings. I started folding paper to find out about movement, the movement of light mostly, how it crossed paths with the various

planes of the paper . . . I'd been fascinated with the simplest of relationships, the subtleties and hidden activities of points of intersections. Change. That's what all of this is about. Observing change and trying to understand it. Trying to see what it reveals to us in new languages.

The other experimental field Patten explored side by side with a continuing drawing practice was holography. Holography was a temporary means of getting inside the ever-enlarging drawings she found herself making. Patten reports having had the curious experience of encountering a large drawing she had been working on. In early morning light, it appeared to move off the wall and come forward to meet her: 'The accumulation of all those hundreds of thousands of pen marks on that paper had been memorized somewhere in my brain, memorizing space, creating the drawing in time.' The time involved in making the drawing – the building up of layer by layer, version replacing version, the continuous working process that results in strata that are no longer visible but are remembered by the artist who accompanied each level of emergence and change – this 'time element' virtually materialised before her, returning the drawing to the artist in an almost three-dimensional form. 'I wanted to stay there and move forever in between those strokes and inside the dynamic spaces that were spinning and throbbing and changing shape as I watched.' Thus, in 1982, the artist decided to establish a holography laboratory to explore the several dimensions of her drawing by means of this luminous technology that turned line into intense light and opened up the dimensionality of drawing in space.

I miss that light, but I know about it, remember it, I learned it. Once you have seen something has meaning to you, it isn't forgotten, like the strokes of that drawing that came out from my wall and let me dance within it, the laser light is still inside my brain and lights my drawings on paper, where I need to be.

These experiments with virtual drawings using industrial lasers to draw space with light as well as early work with large-scale sculptures (1973–85), in which she would truss up and sew vast constructions of foam to create interior spaces, took the artist to places and possibilities that helped her distil the deeper project: 'ink drawings as a solitary direction.' Patten writes that this simplicity of process 'allows me unlimited expansion, unlimited scope, beyond the confines of my own imagination'. This statement allies the artist with a significant aesthetic position in the later twentieth century, hanging as it does on the cusp between two crucial concepts: on the one hand, the high modernist idea that the artwork can approach its ethical essence only through total fidelity to the uncharted capacities of its medium; on the other, the minimalist revolt against the supplementary baggage of spirituality and personality that attended high modernist painting and sculpture. Minimalism – and its successors, process art and systems art – made of modernism an *economy*, producing extraordinary artworks that achieved almost philosophical status as propositions. By 'economy', I mean setting oneself a project defined by the limits of chosen materials and processes that themselves exert the pressure of what I dare to think of as a structural unconscious inviting in addition, precisely due to the logic of the parameters set for the work, the free play of the subject's unconscious.[37] Patten's drawings, be they on a scale of one by one inch or seven by twenty-four feet, are all made with exactly the same movement and materials. Yet neither predict the extraordinary range of formal and suggestive possibilities that can result. Thus economy does not imply economical in the sense of frugal or limited; in artistic

parlance, it captures the dialectic of structural parameters that are infinitely generative and genuinely poeitic: creative, willed into existence, but not intentionally known in advance.

Art as economy can therefore result in a work of magnificent scale or import – but that effect cannot, as with a motivated representation, be predicted. At the same time the outcome is not merely automatist surprise. Economy denotes research by aesthetic process – premised on the understanding that the simplest of materials, gestures and processes, put into action by a thinking, sentient, sensuous and reflecting human being, can only reveal more than could ever be anticipated before the drawing which becomes for itself an event in the world. Parameters in art are like hypotheses in scientific research, undertaken in the knowledge that one is both part of the world one is exploring and impinging on and, therefore, changing what is being explored. Divisions between the two attitudes, aesthetic and scientific, in terms of twentieth-century physics and aesthetics, have shrunk significantly, allowing some sense of parallel if irreducibly different paths of investigation, mutual insight into related post-classical ways of understanding the interrelations of knowing and knowledge, of the world and us its human investigators.

Modernism, a core art consciousness of the twentieth century, now so remote as to be interesting in archaeological retrospect, was marked by a strange contradiction between, on the one hand, an immersion in material and medium, and, on the other, a spiritual aspiration that sometimes took traditional religious forms and at other times wandered through all kinds of alternatives, from quantum physics and genetics, to occultism and cosmology. Anxious before the fruitful and often chaotic confusion of boundaries between models and modes of knowledge that pervade twentieth-century art and artists' writings, writers of art history have tended to stress only 'proper' formalist aspects, edging towards other qualities with a belated willingness to consider the psychological through a turn to psychoanalysis as a resource for analysing the charge of otherwise non-referential exercises in materiality and process. Patten accepts and enjoys the affinities between the research process of her drawing practice and the other worlds and knowledge systems around her. Like Eva Hesse or Agnes Martin before her, Patten tracks down complexity through procedural simplicity and the unexpected events that occur across her interacting and co-generating series.

> In the illusion of complexity, in the illusion of repetition of little movements, the universe is what it is, changing forms, changing illusions, changing metaphors, changing change; and by using such a simple tool, a tiny pen tip, a tiny bit of ink at a time, a tiny space on any size paper, I get to see more than when I try to look at it all at the same time. Its contradictions and baffling processes lead me to discovering the kind of things that physicists discover when they watch electrons, atoms, and quarks, and the kind of things that surgeons discover when they open human beings' bodies up, and the kind of things astronomers see when they take pictures of places millions of miles away and moving out. Because when a human being moves a hand, and leaves a trace of that movement, part of the universe is being exposed; the second generation movement, the ink on the paper, mimics all other movement in the universe, irregular, baffling, metaphysical, abstract as well as concrete movement. I feel like I get an inside view of it all, trapped there for a while on that paper, trapped in time in my brain, ready to lend perspective to the next movement, changing the context of the next movement, the next stroke, the next day of this life that is such a mystery.

Patten is fundamentally interested in the work of juxtaposition. This may be the juxtaposition of the apparent ephemerality of a passing thought in the artist's mind and the way it can be trapped on paper by drawing for another mind, the viewer's, to look at and make sense of at another moment in time or place. She also works with the juxtaposition of the vast amount of time it takes to draw these drawings, and the all-of-one-timeness – the seen in a moment – that happens when [a finished drawing] can be seen at once in that single space, in a single moment, on that simple piece of paper.

> So drawing isn't cool. I cannot use it to show that I am disattached from life, from others, from ideas, from mind or purpose. I am guilty of being utterly consumed by the process of observation in relationship to all of the past and all of the future, all of now. My detachment is not disattachment – these are different parts of the act of living. I prefer to let attachment and detachment co-exist in this process of my life and acknowledge that what I discover has been discovered before, but not by me. So I must do this, so that I can see and take my next step in this larger context, and then the next step. . . . Drawing is still a vital force, taking on new ideas and new ways of using it to discover what this grand experiment is all about. The fact that sometimes a drawing can be beautiful should not deter us from recognizing that its beauty is secondary to its process, not unrelated, but just another part of the gift that all forms of life are to us.

Christine Taylor Patten's majestic drawings are beautiful in their complexly achieved simplicity and their serenely resolved transitions, whether they are worked out on a micro or macro scale, whether we have to move in close to see a world or move back to experience a shift in space as a plane turns over or two intersect. The timeliness of her *micro/macro* project seems at once out of our current, postmodern time due to its intelligence, ethical self-consciousness and passionate commitment to seeing as a form of thinking. Such an attitude places the work both at the centre of seriously considered art and at odds with so much of what is passed off as contemporary art's fundamental inability to take time (to make), to demand time (to be seen), to be the product of a practice over time, a lifetime of thinking and making. In a statement, echoing Maurice Merleau-Ponty's phenomenological response to Cézanne's exemplary dedication to the passionate making of an art of seeing a world of which he claimed to be the eyes, Christine Taylor Patten says:

> For fifty years I have drawn because I am compelled to. Images come from deep within, from where my spirit begins and reaches out to the visible world, searching for resonance and meaning. As I draw, I examine qualities in human nature that are like the wind, or waves of water, of the invisible power of time and repetition. I find all of life in a single stroke of a pen, in the accumulation of the tracks of my being, there on paper for all to see. Millions of strokes become a whole, exposing what was never seen before. My drawings are the by-products of my examination of life, not unlike a membrane which catches and makes visible the movement which passes through it.

NOTES

1 WHAT THE GRACES MADE ME DO. . . . TIME, SPACE AND THE ARCHIVE: QUESTIONS OF FEMINIST METHOD

1 Nancy Miller, 'Reading as Woman: The Body in Practice' in *The Female Body in Western Culture: Contemporary Perspective*, ed. Susan R. Suleiman, Cambridge, MA: Harvard University Press, 1987, 355.

2 Adrienne Rich, 'When We Dead Awaken: Writing as Re-vision' in *Lies, Secrets and Silence*, New York: Norton, 1979, 35.

3 Malcolm Baker, 'Canova's *Three Graces* and Changing Attitudes to Sculpture' in *Figured in Marble; the Making and Viewing of Eighteenth Century Sculpture*, London: V&A Books, 2000. Alex Potts, *The Sculptural Imagination: Figurative, Modernist, Minimalist*, London: Yale University Press, 2000. Alison Yarrington, 'The Three Graces and the Temple of Feminine Virtue', *Sculpture Journal* (2002) vii, 30–43.

4 Luce Irigaray, 'Women on the Market' and 'Commodities Among Themselves' in *This Sex which is Not One*, trans. Catherine Porter, Ithaca: Cornell University Press, 1985, 170–97.

5 This will be discussed in greater detail in Room 2.

6 Mieke Bal, *Louise Bourgeois'* Spider: *The Architecture of Art-writing*, Chicago: Chicago University Press, 2001.

7 Bracha Ettinger, 'Matrix and Metramorphosis', *Differences* (1992), 4:3, 196.

8 Mieke Bal, *Reading Rembrandt: Beyond the Word/Image Opposition*, Cambridge: Cambridge University Press, 1990; reprinted by University of Amsterdam Press, 2006.

9 Roland Barthes, 'Rhetoric of the Image' in *Image, Music, Text*, ed. Stephen Heath, London: Fontana, 1977, 32–51.

10 Bracha Ettinger, *The Matrixial Borderspace*, prefaced by Judith Butler, introduced by Griselda Pollock, edited by Brian Massumi, Minneapolis: University of Minnesota Press, 2006.

11 Griselda Pollock, 'The Image in Psychoanalysis and the Archaeological Metaphor: Thinking Art with a Feminist Gait' in *Psychoanalysis and the Image*, ed. Griselda Pollock, Boston and Oxford: Blackwell, 2006, 1–29.

12 Generations and Geographies is a conceptual pair I proposed to situate each artist and artistic practice on the double axis of geo-political positionality and historico-familial lineage. Griselda Pollock (ed.), *Generations and Geographies in the Visual Arts: Feminist Readings*, London: Routledge, 1996.

13 'Negation: Procedure whereby the subject, while formulating one of his wishes, thoughts or feelings which has been repressed hitherto, contrives by disowning it, to continue to defend himself against it' in J.B. Laplanche and J. Pontalis, *The Language of Psychoanalysis*, London: Karnac Books, 1988, 261, referencing Sigmund Freud, 'Negation' [1929], *Standard Edition*, XIX.

14 Linda Nochlin, 'Eroticism and Female Imagery in Nineteenth Century Art' in *Woman as Sex Object Studies in Erotic Art*, ed. Thomas B. Hess and Linda Nochlin, New York: Newsweek, 1972, 8–15; Griselda Pollock, 'Inscriptions in the Feminine' in *Inside the Visible: An Elliptical Traverse of Twentieth Century Art in, of and from the Feminine*, ed. Cathérine de Zegher, Cambridge, MA: MIT Press, 1996, 67–88.

15 Griselda Pollock, *Differencing the Canon: Feminist Desire and the Writing of Art's Histories*, London: Routledge, 1999.

16 See H.E. Roberts, *Art History Through the Camera Lens*, Amsterdam: Gordon & Breach, 1995.

17 Ulrich Keller, 'Visual Difference: Picture Atlases from Winckelmann to Warburg and the Rise of Art History', *Visual Resources* (2001), XVII, 179–99: 197.

18 André Malraux, *Le musée imaginaire*, Paris: Gallimard, 1965; Rosalind Krauss, 'Postmodernism's Museum without Walls' in *Thinking about Exhibitions*, ed. Reesa Greenberg, Bruce Ferguson and Sandy Nairne, London and New York: Routledge, 1996, 340–8.

19 For a fuller discussion of this point see Griselda Pollock, 'Un-framing the Modern: Critical Space/ Public Possibility' in *Museums after Modernism: Strategies of Engagement*, ed. Griselda Pollock and Joyce Zemans, Boston and Oxford: Blackwell, 2007, 1–39.

20 W.H. Fox Talbot, *Pencil of Nature*, London, 1844–6, pl.V.

21 Mary Bergstein, 'Lonely Aphrodites: On the Documentary Photography of Sculpture', *Art Bulletin* (1992), LXXIV: 3, 475.

22 Griselda Pollock, 'Inscriptions in the Feminine' in *Inside the Visible: An Elliptical Traverse of Twentieth Century Art, in, of and from the Feminine*, ed. Cathérine de Zegher, Cambridge, MA: MIT Press, 1996), 67–88.

23 Griselda Pollock, *Differencing the Canon: Feminist Desire and the Writing of Art's Histories*, London: Routledge, 1999.

24 Gayatri Spivak, 'The Rani of Sirmur: An Essay in Reading the Archives', *History and Theory* (1985), 24:3, 247–272, reprinted in revised form in *A Critique of Postcolonial Reason*, Boston: Harvard University Press, 1999, 198–312.

25 A similar point has been made by the Guerilla Girls who asked if a woman has to be naked to get into the Metropolitan Museum of Art, playing off the numerous nudes in the collection and the paucity of work by women artists.

26 Tony Bennett, *The Birth of the Museum: History, Politics, Theory*, London: Routledge, 1995, 59–86.

27 For one recent discussion, see Georges Didi-Huberman, *Devant le Temps*, Paris: Les Editions de Minuit, 2000. Didi-Huberman advances the notion of anachronism with considerable persuasiveness.

28 Giorgio Agamben, 'Warburg and the Nameless Science' in *Potentialities*, trans. Daniel Heller-Roazen, Stanford: Stanford University Press, 1999, 90.

29 Ibid.

30 Ernst Gombrich, *Aby Warburg: An Intellectual Biography*, Oxford: Phaidon Press, 1970, 223.

31 Agamben, *op. cit.*, 101. He is referring to Erwin Panofsky, *Meaning in the Visual Arts*, Chicago: Chicago University Press, 1955, and to *Studies in Iconology: Humanistic Themes in the Art of the Renaissance*, Oxford: Oxford University Press, 1939.

32 The two key figures here are Sigrid Schade whose doctoral thesis on sixteenth century witch-hunts was indebted to Warburg's methods, *Schadenzauber und die Magie des Körpers: Hexendarstellungen in der frühen Neuzeit*, Worms, 1983, and Margaret Iverson, 'Retrieving Warburg's Tradition', *Art History*, 1993, 16:3, 541–54. See also Sigrid Schade, 'Charcot and the Spectacle of the Hysterical Body: The "pathos formula" as an aesthetic staging of psychiatric discourse – a blind spot in the reception of Warburg'. *Art History*, 1995, 18:4, 499–517.

33 I invoke feminist *thought* in honour of the work of Julia Kristeva who has argued that thought as opposed to the compromised term Reason offers some space for serious dissidence that tries to avoid self-deception, I invoke cultural analysis to indicate a practice between history and theory that works with and against the settlements into old disciplinary or new interdisciplinary formations. It is a work on and with cultural practices, seeking how to invent new ways to read art and the extended practices with which it procedes and interacts.

34 Kenneth Clark, *Civilisation*, 13 Episodes, first screened on BBC2 in 1969; John Berger, *Ways of Seeing*, BBC, 1972.

35 Matthew Rampley, *The Remembrance of Things Past: On Aby Warburg and Walter Benjamin*, Wiesbaden: Harrassowitz Verlag, 2000.

36 John Berger, *Ways of Seeing*, London: Penguin Books, 1972, 45 and 47.

37 'The other episode in Rome that changed my life was a lecture by Aby Warburg . . . Warburg was without doubt the most original thinker on art history of our time, and entirely changed the direction of art-historical studies . . . The parts of my writing that have given me the most satisfaction, for example, the chapter in *The Nude* called "pathos", are entirely Warburgian.' Kenneth Clark, *Another Part of the Wood: A Self Portrait*, London: John Murray, 1974, 189–90.

38 Kenneth Clark, *The Nude: A Study of Ideal Art*, Harmondsworth: Penguin Books, 2nd edition, 1964, 64.

39 For a detailed study of such readings, see Christine Mitchell Havelock, *The Aphrodite and Her Successors: A Historical Review of the Female Nude in Greek Art*, Ann Arbor: University of Michigan Press, 1995.

40 I am grateful to Molara Ogundipe for informing me of this sacredness of the feminine body and its political use in Nigeria. Penny Siopis also drew my attention to a case in Apartheid South Africa where a group of women unrobed before the bulldozers coming to destroy their shanty-town. See *The Sacred and the Feminine: Image, Music, Text, Space*, ed. Griselda Pollock and Victoria Turvey Sauron, London: I.B. Tauris, 2007.

41 Zainab Bahrani, 'The Hellenization of Ishtar: Nudity, Fetishism and the Production of Cultural Differentiation in Ancient Art', *Oxford Art Journal*, 1996, 19: 2, 3–16.

42 Nanette Salomon, 'The Art Historical Canon; Sins of Omission', in Donald Preziosi, *The Art of Art History: A Critical Anthology*, Oxford: Oxford University Press, 1998, 344–55; and 'The *Venus Pudica*: Uncovering Art History's Hidden Agendas and Pernicious Pedigrees', in Griselda Pollock (ed.), *Generations and Geographies in the Visual Arts: Feminist Readings*, London: Routledge, 1996, 69–87.

43 Lynda Nead, *The Female Nude: Art, Obscenity and the Sexuality*, London: Routledge 1992; Elisabeth Bronfen, *Over Her Dead Body: Death, Femininity and the Aesthetic*, Manchester: Manchester University Press, 1992.

44 Aby Warburg, 'Sandro Botticelli's *Birth of Venus* and *Spring*: An Examination of Concepts of Antiquity in the Italian Renaissance' [1893], *The Renewal of Pagan Antiquity*, trans. David Britt, introduced by Kurt Forster, Los Angeles: The Getty Research Institute for the History of Art and the Humanities, 1999, 139.

2 THE GRACE OF TIME: NARRATIVITY, SEXUALITY AND THE VISUAL ENCOUNTER

1 The classic tales of the viewing of Praxiteles' *Cnidian Venus* are preserved in Pliny and Lucian, and are discussed by Nanette Salomon, 'The *Venus Pudica*: uncovering art history's hidden agendas and pernicious pedigrees' in *Generations and Geographies in the Visual Arts: Feminist Readings*, ed. Griselda Pollock, London: Routledge, 1996, 69–87.

2 That phrase, 'Women's Time', is from Julia Kristeva, 'Le temps des femmes' first published in *33/ 44 Cahiers de recherche de sciences des textes et des documents* (1979) 5, 5–19, and translated for *Signs* (1981) 7:1, 13–35, reprinted in *The Kristeva Reader*, ed. Toril Moi, Oxford: Blackwell, 1986, 187–213, trans. Alice Jardine and Harry Blake. Distinguishing linear time (project, teleology, progress, nation-state) from cyclical (repetition) and monumental (eternity) time, Julia Kristeva analysed the complex relations of femininity historically to the political time and psychologically to the other temporalities of the symbolic order. This tension plays itself out in generations of feminism which in differing ways seek access to the political time of the nation-state in the name of modernisation and emancipation, while also, through literature and art, exploring the longer *durée* of sexual difference, the body, sexuality and reproduction which exhibits both cyclicality and monumentality. Identifying the delusions of both positions of egalitarianism and difference, she argues for a Hegelian resolution of their contradiction in a suspension of all anthropomorphism (the symbolic represented by masculine and feminine) and the realisation via the impact of symbolic castration by language itself of the singularity of each subject. This is a theme recently returned to in her work on women and genius.

3 Kristeva in Moi, 193.

4 It might be pointed out that most survey texts place the beginning of art history either in some ancient texts such as Pliny's or more often with Vasari's *Vite*. Rather than work with this great-man theory of the origins of our discipline, I am using a Foucauldian discourse analysis that would look to the institutionalisation of the practice through university curricula and pedagogy, publication and a corresponding development of the museum. I locate these features in the nineteenth century and refer the reader to an excellent examination of the racialising nationalisms of the foundations of modern art history by Margaret Olin, 'From Bezal'el to Max Lieberman: Jewish art in nineteenth century art-historical texts' in *Jewish Identity in Modern Art History*, ed. Catherine Soussloff, Berkeley: University of California Press, 1999, 19–40.

5 The phrase, initiated by me and used by Cathérine de Zegher in her catalogue *Inside the Visible: An Elliptical Traverse of Twentieth Century Art in, of and from the Feminine*, Cambridge, MA: MIT Press, 1996

(see my essay 'Inscriptions in the Feminine' in that volume, 67–88) indicates a sphere of potential sub-symbolic subjectivising meanings not yet available to either feminine or masculine subjects in a phallocentric symbolic, but not utterly foreclosed precisely due to the psychic proximity of the formations of sexuality, sexual difference and the aesthetic. The proposition is in dialogue with Bracha Ettinger, 'The With-In-Visible Screen', *Inside the Visible*, 89–113.

6 John Kenworthy-Brown, 'The Sculpture Gallery at Woburn Abbey and the Architecture of the Temple of the Graces' in *The Three Graces by Antonio Canova* by Timothy Clifford, John Kenworthy-Brown and Hugh Honour, London: Victoria and Albert Museum, 1995, 61–71.

7 When its fate was settled a major conference was held and the resulting publication documents this history and many others of the sculpture. Timothy Clifford, John Kenworthy-Brown and Hugh Honour, *op. cit.* I am indebted to this volume.

8 Roland Barthes, 'The Photographic Message', *Image–Music–Text*, translated and edited by Stephen Heath, London: Fontana,1977, 15–31. For more recent discussions of sculpture, reproduction and photography see Anthony Hugues and Erich Ranfft (eds), *Sculpture and its Reproductions*, London: Reaktion Books, 1997, and Geraldine A. Johnson (ed.), *Sculpture and Photographs: Envisioning the Third Dimension*, Cambridge; Cambridge University Press, 1998.

9 Heinrich Wölfflin, 'Comment Photographier les Sculptures' in *Pygmalion Photographe: La sculpture devant la caméra, 1844–1936*, Geneva: Cabinet des Estampes, Musée de'Art det d'Histoire, 1985, 127–31, 132–6.

10 The bibliography on this topic is too vast and too generally known to list. Perhaps I should merely cite the recent work of Jonathan Crary and the long feminist tradition acknowledging a psycho-analytical reading of the scopic field initiated by the work of Laura Mulvey and explored in film theory by Mary Anne Doane and Kaja Silverman. On the fantasmatic aspects of photography, the work of David Phillips stands out especially.

11 For a discussion of what sculpture in its installation form demands of the viewer, see Mieke Bal, *Louise Bourgeois' Spider: The Architecture of Art-writing*, Chicago and London: University of Chicago Press, 2001.

12 It should be noted perhaps that the infusing of marble with a flesh-like glow was one of the touchstones of Canova's finishing of his sculptures. See Potts, *op. cit.*, 43.

13 Kenneth Clark, *The Nude: A Study of Ideal Art*, Harmondsworth: Penguin Books, 1956. Chapter I is titled 'The Naked and the Nude'. This book was the object of one of the earliest feminist critiques by Rozsika Parker and a developed analysis occurs in Lynda Nead, *The Female Nude: Art, Obscenity and Sexuality*, London: Routledge, 1992.

14 Jacqueline Rose, *Sexuality in the Field of Vision*, London: Verso Books 1986, 224–33 and the section 'Postmodern Oppositions' in *Imaging Desire* by Mary Kelly, Cambridge, MA: MIT Press, 1996, especially 'Desiring Images/Imaging Desire', 122–9.

15 I am drawing here on the work of John Ellis and of Annette Kuhn who both attempt to distinguish the modern, industrial and commodity structure of pornography, giving rise to particularities of staging a visual encounter through representational and circulation strategies. John Ellis, 'On Pornography' *Screen* (1980), 21:1, 81–108; Annette Kuhn, *Women's Pictures: Feminism and Cinema*, London: Routledge & Kegan Paul, 1982, especially the chapter 'The Body in the Machine'.

16 Hubertus van Amelunxen, 'Skiagraphia: "L'expositions du sculpté" ' in *Sculpter-Photographier: Photographie-Sculpture* by Dominique Païni and Michel Frizot (eds), Paris: Marval, 1993. This reversal from positive to negative recolours the sculpture, rendering their marmorean whiteness ebony black. The profound significance of the politics of pigmentation, of colour – what Frantz Fanon would call the racial-epidermal schema – cannot be underestimated in the aesthetics of neoclassical sculpture which, inheriting sun-bleached marbles without their original painted coloration, shared in the whitening of the Western canon. Photography's complex relationship with the representation of a racialising discourse and its difficulty in creating a semiotic adequate to the appearances of peoples other than the pale-skinned, demelatonined Northern European stock is discussed in my 'Territories of Desire' in *Travellers' Tales*, ed. George Robertson *et al.*, London: Routledge, 1994, 63–92. See also David Bindman, *Ape to Apollo: Aesthetics and the Idea of Race in the Eighteenth Century*, Ithaca: Cornell University Press, 2002; Jennifer Devere Body, *Impossible Purities: Blackness, Femininity and Victorian Culture*, Durham; Duke University Press, 1998.

17 The definitive study of this arcane tradition is to be found in Edgar Wind, 'Seneca's Three Graces' in *Pagan Mysteries in the Renaissance* Harmondsworth: Penguin Books, 1958, 26–35, and his further

chapter on Botticelli's *Primavera*, 113–27. See also David Rostand, 'Ekphrasis and the Renaissance Painting: Observations on Alberti's Third Book in Florilegium Columbianum' in *Essays in Honor of Paul Kristeller*, ed. K-L. Selig and R. Somerville, Ithaca: New York University Press, 1987: 'The ancients represented them [The Three Graces] dressed in loose transparent robes, with smiling faces and hands intertwined; they thereby wished to signify liberality, for one of the sisters gives, another receives, and the third returns the favour, all of which degrees should be present in the act of liberality' (156).

18 Ibid.

19 For a relatively recent review of feminist issues in classical archaeology, see Shelby Brown, ' "Ways of Seeing" Women in Antiquity: An Introduction to Feminism in Classical Archaeology and Ancient Art History' in *Naked Truths: Women, Sexuality and Gender in Classical Art and Archaeology*, ed. Ann Olga Koloski-Ostrow and Claire L. Lyons, London and New York: Routledge, 1997, 12–42.

20 'Charis' in *Lexicon Iconologicum Classicae Mythologiae*, Zürich and Munich, 1986, 192.

21 Robert Graves, *The Greek Myths*, Harmondsworth: Penguin Books, 1960, and Jane Ellen Harrison, *Ancient Art and Ritual*, New York, 1913, reprinted Montana: Kessinger Publishing, n.d.

22 For a discussion of the evolution of Warburg's distinctive thesis of the *pathosformel* or pathos formula see Ernst Gombrich, *Aby Warburg: An Intellectual Biography*, London: Phaidon, 1970. For an interesting analysis of its more contemporary sources in nineteenth-century psychology see Sigrid Schade, 'Charcot and the Spectacle of the Hysterical Body: The "pathos formula" as an aesthetic staging of psychiatric discourse – a blind spot in the reception of Warburg', *Art History* (1995), 18:4, 499–517.

23 I am thinking here of the Derridian trajectory and its use in a critique of art history and anterior narrative offered by Mieke Bal in *Quoting Caravaggio: Contemporary Art – Preposterous History*, Chicago and London, 1999; Mieke Bal, *Louise Bourgeois' Spider: The Architecture of Art-writing*, Chicago and London: University of Chicago Press, 2001, and *Looking In: The Art of Viewing*, London: Routledge, 2001. Her major revision to iconography is developed in *Reading Rembrandt: Beyond the Word–Image Opposition*, Cambridge: Cambridge University Press, 1992.

24 Julia Kristeva, 'Experiencing the Phallus as Extraneous, or Women's Twofold Oedipus Complex' in *Julia Kristeva 1966–1996: Aesthetics, Politics, Ethics, parallax* (1998), no. 8, 41; for a discussion of Levinas and the feminine see Bracha Ettinger, *What Would Eurydice Say?*, Paris: BLE Atelier, 1997, and Griselda Pollock, 'The Presence of the Future: Feminine and Jewish Difference', *Issues in Architecture, Art and Design* (1997), 5:1, 37–63.

25 Edgar Wind, *op. cit.*, 28.

26 Ibid, 30.

27 Cited in Graham McCann, *Marilyn Monroe*, Cambridge: Polity Press, 1988, 80.

28 Mary Kelly, *Interim*, New York: New Museum of Contemporary Art, 1990 which includes Griselda Pollock, 'Feminist Interventions in History: On the Historical, the Subjective, and the Textual', 39–51, reprinted in Griselda Pollock, *Looking Back to the Future: Essays on Art, Life and Death*, London: Routledge, 2000, 52–73.

29 The phrase *gylandric* was formulated by prehistorian Marija Gimbutas, *The Language of the Goddess*, London: Thames and Hudson, 2000.

30 Kathleen Woodward, *Ageing and its Discontents: Freud and Other Fictions*, Bloomington: Indiana University Press, 1991.

31 The photograph by Mark Richards of the *Daily Mail* appeared in *The Observer* 26 January 1997. Jo Spence, *The Family Album 1939–1979* is reproduced in Jo Spence, *Putting Myself in the Picture: A Personal Political and Photographic Autobiography*, London: Camden Press, 1986.

32 Claudine Mitchell, 'Intellectuality and Sexuality: Camille Claudel, the Fin de Siècle Sculptress', *Art History* (1989), 12:4, 419–47, p. 431.

33 Ibid., 430.

34 Melanie Manchot, *Look at You Loving Me: Bilder Meiner Mutter von 1995–1998*, Basel, 1998, London, 1999.

35 See Mary Ann Doane, 'Woman's Stake: Filming the Female Body' in *October* (1981), 17, 22–36.

36 'Mona Hatoum: Interview with Claudia Spinelli', *Kunst Bulletin* [Zürich], September 1996, 23, translated in Michael Archer, Guy Brett and Cathérine de Zegher (eds), *Mona Hatoum*, London: Phaidon Press, 1997, 141.

37 Jacqueline Rose, 'Sexuality in the Field of Difference' in *Sexuality in the Field of Vision*, London:

Verso, 1986: 'A feminism concerned with the questions of looking can therefore turn this theory around, stressing that particular and limiting opposition of male and female which any image seen to be flawless serves to hold in place. More simply we know that women are meant to look perfect, presenting a seamless image to the world so that the man, in that confrontation with difference can avoid any apprehension of lack. The position of woman in fantasy thus depends on a particular economy of vision. Perhaps this is also why only a project which comes via feminism can demand so unequivocally of the image that it renounce all pretension to a narcissistic pefection of form. At this point we might argue that fantasy of absolute sexual difference could be upheld only from the point when painting reduced the human body to the eye' (232).

38 'Inscriptions in, of and from the feminine' is from Griselda Pollock, 'Inscriptions in the Feminine', in Cathérine de Zegher (ed.), *Inside the Visible: An Elliptical Traverse of Twentieth Century Art, in, of and from the Feminine, op. cit.* I use the term in order to contest the idea that art is the direct expression of its author and that we can know what the feminine is or means under a patriarchal system.

39 I want to thank Felicia Huppert of Cambridge University for bringing this work to my attention. Ella Dreyfus, *Age and Consent*, Sydney, 1999, first shown at Stills Gallery, Sydney, 17 March to 17 April 1999. See also *Art, Age and Gender: Women Explore the Issues*, London: Orleans House Gallery, 2002.

40 See Aileen Ajootaian, ' "The Only Happy Couple": Hermaphrodites and Gender' in *Naked Truths: Women, Sexuality and Gender in Classical Art and Archaeology, op. cit.*, 220–42.

41 We are reminded here of Freud's paper on the sexual fantasies of children who frequently assume that babies are born from the anus. On the other hand, the archaeological record and the architectural as well as sculptural forms from Old Europe's Neolithic cultures indicate that the opened female body and the passageway between the legs was frequently symbolised. Sigmund Freud, 'On the Sexual Theories of Children' [1908] in *On Sexuality Penguin Freud Library Vol. 7*, London: Penguin Books, 1977, 183–204.

42 Alison Rowley, 'On Viewing Three Paintings by Jenny Saville: Rethinking a Feminist Practice of Painting' in Griselda Pollock (ed.), *Generations and Geographies in the Visual Arts: Feminist Readings*, London: Routledge 1996, 86–109.

43 Linda Nochlin, 'Floating in Gender Nirvana', *Art in America* (March 2000), 83:3, 95–7.

44 Nanette Salomon, 'Contrapposto: Inscribing (Homo)Erotic Time in the Body', unpublished paper, CIHA, London, 2000.

45 Mark Cousins, 'The Insistence of the Image: Hitchcock's *Vertigo*' in *Art: Sublimation or Symptom*, ed. Parveen Adams, New York: The Other Press, 2003.

46 Edmond Engelman, *Berggasse 19: Sigmund Freud's Home and Offices, Vienna 1938*, New York: Basic Book Publishers, 1976.

47 See Griselda Pollock (ed.), *Psychoanalysis and The Image*, Boston and Oxford: Blackwell, 2006, and the extended preface for this book available as CATH Documents No. 2, 2006, which may be ordered from CentreCATH and online at www.leeds.ac.uk/cath/publications/.

48 George Dimock, 'The Pictures over Freud's Couch' in *The Point of Theory: Practices of Cultural Analysis*, ed. Mieke Bal and Inge Boer, Amsterdam: University of Amsterdam Press, 1994, 239–250.

49 Sigmund Freud, 'Delusions and Dreams and Jensen's *Gradiva*' [1907], *Art and Literature Penguin Freud Library Vol. 14*, London: Penguin Books, 1985, 27–118. Sarah Kofman, *The Childhood of Art: An Interpretation of Freud's Aesthetics*, trans. Winifred Woodhull, New York: Columbia University Press, 1988.

50 Kofman, *op. cit.*, 178.

51 In my 'The Image in Psychoanalysis and the Archaeological Metaphor' in *Psychoanalysis and the Image, op. cit.*, I explore the differences between Freud's three different models for the archaeological metaphor: Pompeii, Troy and Knossos.

52 Kofman, *op. cit.*, 187.

53 Hélène Cixous, 'The Laugh of the Medusa', trans. Keith and Paula Cohen, ed. Elaine Marks and Isabelle de Courtivron, *New French Feminisms*, Brighton: Harvester Press, 1981, 245–264.

3 THE OBJECT'S GAZE IN THE FREUDIAN MUSEUM

1 Sigmund Freud, Letter to Stefan Zweig, 7 February 1931, Sigmund Freud, *Briefe 1873–1939*, ed. Ernst and Lucie Freud, Frankfurt am Main: S. Fischer, 1960, 420–1.

2 Pierre Nora, 'Between Memory and History: Lieux de Mémoire', *Representations* (1989), 26, 7–25.

3 Jacques Derrida, *Archive Fever: A Freudian Impression*, trans. Eric Prenowitz, Chicago: University of Chicago Press, 1995. The original title is *Mal d'Archive: une impression freudienne*, Paris: Editions Galilée, 1995.

4 The specific significance and repression of Egyptian mythology and its material remnants in the formulation of psychoanalysis despite its omnipresence within the analytical theatre is brilliantly analysed by Joan Raphael-Leff in 'If Oedipus was an Egyptian: Freud and Egyptology', *International Review of Psychoanalysis* (1990), 17, 309–35. See also Joan Raphael-Leff, 'Freud's Dark Continent', *parallax* (2007), no. 43, 13:2, 41–55.

5 For my discussion of the varied models of archaeology used by Freud as metaphors of the mind see Griselda Pollock, 'The Image in Psychoanalysis and the Archaeological Metaphor' in *Psychoanalysis and the Image*, Boston and Oxford: Blackwell, 2006, 1–29.

6 *Berggasse 19: Sigmund Freud's Home and Offices, Vienna 1938 – The Photographs of Edmund Engelman*, introduction by Peter Gay, captions by Rita Ranshoff, New York: Basic Books, 1976, 60. The Freud quotation is from *The Interpretation of Dreams, Penguin Freud Library, Vol.4*, London: Pelican Books, 1976, 740, and the final quotation is from 'An Autobiographical Study', *Standard Edition*, 1925, vol. 20, 8. See also Eva M. Rosenfeld, 'Dream and Vision: Some Remarks on Freud's Egyptian Bird Dream', *The International Journal of Psychoanalysis* (1956), 38, 97–105.

7 Joan Raphael-Leff, *op. cit.*

8 See Page Dubois, *Sowing Bodies: Psychoanalysis and Ancient Representations of Women*, Chicago: Chicago University Press, 1988.

9 Maurice Halbwachs, *On Collective Memory*, ed. and trans. Lewis A. Coser, Chicago: University of Chicago Press, 1992.

10 'It may happen that someone gets away, apparently unharmed, from the spot where he has suffered a shocking accident, for instance a train collision. In the course of the following weeks, however, he develops a series of grave psychical and motor symptoms, which can only be ascribed to his shock or whatever else happened at the time of the accident. He has developed a "traumatic neurosis". This appears quite incomprehensible and is therefore a novel fact. The time that elapsed between the accident and the first appearance of the symptoms is called the "incubation period", a transparent allusion to the pathology of infectious disease. As an afterthought we observe, that in spite of the fundamental difference between the two cases – the problem of traumatic neurosis and that of Jewish monotheism – there is a correspondence in one point. It is the feature we might term *latency*.' Sigmund Freud, 'Moses and Monotheism' [1939] in *The Origins of Religion. Penguin Freud Library, Vol. 13*, London: Penguin Books, 1985, 309.

11 Jan Assmann, *Moses the Egyptian: The Memory of Egypt in Western Monotheism*, Cambridge, MA; Harvard University Press, 1997, 215.

12 Ilse Grubrich-Simitis, *Early Freud and Late Freud: Reading Anew Studies on Hysteria and Moses and Monotheism*, London: Routledge, 1997, 10.

13 Ibid., 63.

14 In passing, I should mention that this political, leftist reading is otherwise supported by a direct aesthetic translation of Freud's text by a Mexican Marxist-feminist artist Frida Kahlo, who painted her metaphoric vision of new life inspired by reading Freud's 'Moses and Monotheism' in 1945 in a truly transcultural modernist political archive *Moses*, 1945 (Private Collection).

15 Theodor Adorno, 'Freudian Theory and the Pattern of Fascist Propaganda' [1951] in *The Esssential Frankfurt School Reader*, ed. Andrew Arato and Eike Gebbhardt, New York: Urizen Books, 1978, 118–137.

16 Peter Gay, *A Godless Jew: Freud, Atheism and the Making of Psychoanalysis*, New Haven: Yale University Press, 1987, and Isaac Deutscher, *The Non-Jewish Jew and Other Essays*, Oxford: Oxford University Press, 1968.

17 My reading of Freud's purposes in this book has been inspired by Richard J. Bernstein's brilliant analysis, *Freud and the Legacy of Moses*, Cambridge and New York; Cambridge University Press, 1998. He makes the strongest case against the accusation of Lamarkianism in Freud's notion of culture and tradition: 46ff.

18 Derrida, *op. cit.*, 65.

19 Cathérine Clément and Julia Kristeva, *The Feminine and the Sacred* [1996], trans. Jane Marie Todd, New York: Columbia University Press, 2001, 57.

20 Having tracked these movements myself, I was delighted to find Louis Rose's *The Survival of Images: Art Historians, Psychoanalysts, and the Ancients*, Detroit: Wayne State University Press, 2001.

21 Sigrid Schade's suggestion that Charcot's charts of the hysterical phases is an overlooked source for Warburg's concept of the *pathos formula* brings hysteria back into view as the 'body that speaks' what the mind will not admit. Sigrid Schade, 'Charcot and the Spectacle of the Hysterical Body. The "pathos formula" as an aesthetic staging of psychiatric discourse – a blind spot in the reception of Warburg', *Art History*, (1995), 18:4, 499–517.

22 See Griselda Pollock, 'The Visual Poetics of Shame: A Feminist reading of Freud's *Three Essays on the Theory of Sexuality* (1905)' in *Shame and Sexuality*, ed. Claire Pajaczkowska and Ivan Ward, London: Routledge, 2007.

23 For a discussion of this dimension in masculinity see Griselda Pollock, 'To Inscribe in the Feminine: A Kristevan Impossibility', *parallax* (1998), 8, 84.

24 Sandor Ferenczi, 'On the Symbolism of the Head of Medusa' [1923] in *The Medusa Reader*, ed. Marjorie Garber and Nancy J. Vickers, London: Routledge, 2003, 87.

25 Sigmund Freud, 'Medusa's Head' from 'Infantile Genital Organisation' [1922–3], in *The Medusa Reader, op. cit.*, 84.

26 Sigmund Freud, 'A Mythological Parallel to a Visual Obsession' [1916] in *Collected Papers*, Vol. IV, The International Psychoanalytical Library No. 10, London: The Hogarth Press, 1949, 345–6.

27 See Marina Abramovic, *Balkan Erotic Epic* (2005) for a contemporary artist's exploration of comparable myths about the power of visual exposure of women's sex in relation to causing excessive rain to cease.

28 Ellen Handler Spitz, 'Psychoanalysis and the Legacies of Antiquity' in *Sigmund Freud and Art: His Personal Collection of Antiquities*, ed. Lynn Gamwell and Richard Wells, New York: Harry N. Abrams, 1989, 165.

29 Caroll Smith-Rosenberg, 'The Female World of Love and Ritual: Relations between Women in Nineteenth Century America' in *Disorderly Conduct: Visions of Gender in Victorian America*, Oxford: Oxford University Press, 1985, 53–76.

30 Handler Spitz, *op. cit.*, 166.

31 Sigmund Freud, 'On Female Sexuality' in *On Sexuality, Penguin Freud Library Vol. 7*, London: Penguin Books, 1977, 372–3.

32 Ibid., 383.

33 Bracha Ettinger, 'Fascinance and Girl to m/Other Matrixial Difference' in *Psychoanalysis and the Image*, ed. Griselda Pollock, Boston and Oxford: Blackwell, 2006, 60–93. The implications of this will be explored in Chapter 6.

34 Sigmund Freud, 'The Theme of the Three Caskets', *Art and Literature, Penguin Freud Library Vol. 14*, London: Penguin Books, 1985, 242.

35 Peter Gay, 'Freud's Antiquities Collection' in Gamwell and Wells, *op. cit.*, 29.

4 VISIONS OF SEX *c.* 1920

1 I owe this concept to the thinking of Bracha Ettinger, which will be analysed more fully in Chapter 6.

2 Nancy Miller in the epigraph to Chapter 1 in this book, p. 9; Jacques Lacan, *Encore Seminar XX – On Feminine Sexuality: The Limits of Love and Knowledge 1972–73* [1975], ed. Jacques-Alain Miller, trans. Bruce Fink, New York: W.W. Norton & Co, 1998, 61–77.

3 For a fuller survey of the Calla Lily's place in American modernism see Barbara Buhler Lynes, *Georgia O'Keeffe and the Calla Lily in American Art, 1860–1940*, New Haven and London: Yale University Press, 2003.

4 It was often thought that these were paintings of another woman, Leah Harris, a food demonstrator, with whom O'Keeffe was friendly during the period in which she was teaching in Texas in 1917 and after she left the post and stayed at the Harris family farm. There is one 1918 watercolour that is untitled but identified as a painting of Leah Harris (no. 242 in the catalogue *raisonné* below). In *Georgia O'Keeffe Catalogue Raisonné* (New Haven and London: Yale University Press, 1999, 106), Barbara Buhner Lynes confirms the arguments of Sarah Whitaker Peters in *Becoming O'Keeffe* (London: Abbeville Press, 1991, 109–12) that these are indeed self-portraits and by Barbara Rose, 'O'Keeffe's Originality' in *The Georgia O'Keeffe Museum* (1997) that they are 'probably self-portraits

in a mirror', 102. This might account for the specific positioning of the hands, the drawing hand being on the left as a result of the mirror image. Nude Series VIII cat no. 182 alone does not conform to this but may be a reworking of cat. no. 181.

5 Sharyn R. Udall, *O'Keeffe and Texas* (New York: Harry Abrams, 1998) deals only with landscapes and abstracts.

6 Linda Nochlin, 'Eroticism and Female Imagery in Nineteenth Century Art', in *Woman as Sex Object*, ed. Thomas B. Hess and Linda Nochlin, *Art News Annual*, xxxviii, 1972, 11.

7 In her important book *Three Artists (Three Women): Modernism and the Art of Hesse, Krasner and O'Keeffe* (Los Angeles: University of California Press, 1996) Ann Wagner takes me to task for an over-monolithic critique of the possibilities for women to negotiate modernism. She shows convincingly how profoundly all three artists she studies grappled with and transformed its potentialities over the century. The significance of their work as not merely a contribution to, but an intervention in, a differencing of the canon of modernism increases the more we appreciate the contradictions held within modernism in the dialectic between its formal challenge and the mythic return of the repressed: the feminine other. This chapter forms part of a continuing dialogue with other feminist art historians precisely by returning to this debate about modernism and the feminine. I have tried to plot out the unexpected ways in which what might appear to be deeply sexist incidences in modernist practice can be read otherwise, revealing what women artists took back from these ambiguous encounters with modernism and its sexual politics to forge their own interventions and practices.

8 Sigmund Freud, 'On Female Sexuality' [1931], in *On Sexuality, Penguin Freud Library Vol. 7*, London: Penguin Books, 1977, 372.

9 Bracha Ettinger, *The Matrixial Gaze* (1993), now reprinted in *The Matrixial Borderspace*, ed. Brian Massumi, Minneapolis: University of Minnesota Press, 2006, 41–92.

10 For a fuller discussion of this point see Griselda Pollock, 'Painting, Feminism and History', in *Looking Back to the Future: Essays on Art; Life and Death*, London: Routledge, 2001, 73–112.

11 It was Carol Duncan who first brilliantly developed this argument in 'Virility and Domination in Early Twentieth Century Vanguard Art', *Art Forum*, 1973, 30–9, reprinted in her *The Aesthetics of Power: Essays in Critical Art History*, Cambridge: Cambridge University Press, 1993, 81–108. I remain eternally indebted to Duncan's work to which this chapter is, with other essays of mine, a supplementary commentary.

12 A chapter removed from this text discussed this in more detail. See Griselda Pollock, 'Femininity, Modernity and Representation: The Maternal Image, Sexual Difference and the Disjunctive Temporality of the Avant-Garde', in *Jahrhundert der Avant-garden*, ed. Cornelia Klinger and Wolfgang Müller-Funk, Munich: Wilhelm Fink Verlag, 2004, 97–120.

13 Rosemary Betterton, 'The Maternal Nude', in *Generations and Geographies in the Visual Arts: Feminist Readings*, ed. Griselda Pollock, London: Routledge, 1996, 159–79.

14 In fact, Georgia O'Keeffe has been very well served by many serious scholars, led by Barbara Buhler Lynes and many others. In her *Becoming Georgia O'Keeffe: The Early Years* (New York: Abbeville, 1991), Sarah Whitaker Peters tracks the tendencies in reviews of posthumous exhibitions to denigrate and devalue O'Keeffe's work in seemingly direct response to the increasing feminist interest in her work (18).

15 Marsden Hartley talked of her 'utterly embedded femininity': '291– and the Brass Bowl', in *America and Alfred Stieglitz: A Collective Portrait*, ed. Waldo Frank *et al.*, New York: Literary Guild, 1934, 240.

16 Paul Rosenfeld, *Port of New York: Essays on Fourteen American Moderns*, New York: Harcourt, Brace, 1924, 207; cited in Anne Wagner, *Three Artists (Three Women): Modernism and the Art of Hesse, Krasner and O'Keeffe*, Berkeley: University of California Press, 1996, 38.

17 Paul Rosenfeld, 'The Paintings of Georgia O'Keeffe . . .', *Vanity Fair*, 19, October 1922, 112; cited in Wagner, *op. cit.*, 38.

18 Wagner, *op. cit.*, 100.

19 Maurice Merleau-Ponty, cited in Wagner, *op. cit.*, 100.

20 As Sanford Gifford has written, Freud's lectures at Clark University, Worcester, Massachussetts in 1909 'were the equivalent of the Armory Show for the history of painting in the United States': Sanford Gifford, 'The American Reception of Psychoanalysis 1908–1922', in Adele Heller and Lois Rudnick (eds), *1915, The Cultural Moment: The New Politics, the New Woman, the New Psychology, the New Art and the New Theatre in America*, New Brunswick, NJ: Rutgers University Press, 1991, 128.

21 Lincoln Steffens, cited in Sanford Gifford, *op. cit.*, 134.

22 Luce Irigaray, *This Sex which is Not One* [1977], trans. Catherine Porter, Ithaca: Cornell University Press, 1985.

23 Margaret Hooks, *Tina Modotti: Photographer and Revolutionary*, London: Pandora Books, 1993.

24 Margaret Hooks, *op. cit.*

25 Bracha Ettinger, 'Trauma and Beauty: Transubjectivity in Art', *n.paradoxa*, 1999, no. 3, 15–23.

26 Bracha Ettinger, *The Matrixial Gaze, op. cit.*

27 Richard Lorenz, *Imogen Cunningham: Flora*, Boston: Bullfinch Press, 1996.

28 For the concept of reference, deference and difference in avant-garde strategy see Griselda Pollock, *Avant-Garde Gambits: Gender and the Colour of Art History*, London: Thames and Hudson, 1992.

29 Elisabeth Bronfen, *Over her Dead Body: Death Femininity and the Aesthetic*, Manchester: Manchester University Press, 1992.

30 O'Keeffe's involvement in photography is discussed by Sarah Whitaker Peters, *op. cit.*, 14–15.

31 Michèle Montrelay, 'L'enquête de la Féminité', in *L'Ombre et le Nom*, Paris: Les Editions de Minuit, 1977; 'Inquiry into Femininity', *m/f*, 1978, no. 1, 83–101.

32 Virginia Woolf, 'Professions for Women' [1931], in *Virginia Woolf: Women and Writing*, ed. Michelle Barrett, London: The Women's Press, 1979, 59.

33 Ibid., 61.

34 Griselda Pollock, 'Painting, Feminism and History', *op. cit.*

35 Carol Duncan, 'Virility and Male Domination in Early Twentieth Century Vanguard Art', *op. cit.*

36 Griselda Pollock, *Avant-garde Gambits: Gender and the Colour of Art History, op. cit.*

37 Claudine Mitchell, 'Intellectuality and Sexuality: Camille Claudel, the Fin de Siècle Sculptress', *Art History*, 1989, 12: 4, 419–47.

38 Michel Foucault, *The History of Sexuality, Volume I: An Introduction*, London, Harmondsworth: Penguin, 1978.

39 Susan Fillin-Yeh, 'Dandies, Marginality and Modernism: Georgia O'Keeffe, Marcel Duchamp and other Cross-dressers', *Oxford Art Journal*, 1995, 18: 2, 33–44. Anna Chave, 'Georgia O'Keeffe and the Masculine Gaze', *Art in America*, 1990, 78, 115–25, 177, 179.

40 Joan Riviere, 'Womanliness as Masquerade,' *International Journal of Psychoanalysis*, 1929, 10, reprinted in *Formations of Fantasy*, ed. Victor Burgin, James Donald and Cora Kaplan, London: Methuen, 1986, 35–44.

41 See Sheri Benstock, *Women of the Left Bank 1900–1940*, London: Virago Books, 1987, and Andrea Weiss, *Paris was a Woman*, London: Pandora Books, 1995. On Gluck see Diane Souhami, *Gluck*, London: Pandora Books, 1988.

42 Sheri Benstock, *Women of the Left Bank*, London: Virago Books, x.

43 Judith Halberstam, *Female Masculinity*, Durham, NC: Duke University Press, 1998.

44 J.C. Flügel, *The Psychology of Clothes*, London: Hogarth Press, 1930. See also Kaja Silverman, 'The Fragments of a Fashionable Discourse', in *Studies in Entertainment: Critical Approaches to Mass Culture*, ed. Tania Modleski, Bloomington: Indiana University Press, 1986, 139–52.

45 Charles Baudelaire, 'The Salon of 1846', in *Art In Paris 1845–1862*, ed. Jonathan Mayne, Oxford: Phaidon Books, 1965, 118.

46 Monique Wittig, 'One is not Born a Woman', in *The Straight Mind*, Boston: Beacon Press 1981.

47 The complex meanings of fashion, sexuality and a lesbian culture in Britain have been explored by Laura Doan, *Fashioning Sapphism: The Origins of Modern English Lesbian Culture*, New York: Columbia University Press, 2001. Her extensive research reminds us that the correlation between choosing the 'severe masculine' style of dress and sexual orientation was not fixed during the 1920s; that the style existing as a fashion statement indicating modernity allowed for ambiguity or rather fluidity. Only after the trial of Radclyffe Hall's book *The Well of Loneliness* for obscenity in 1928 did the widespread circulation of Hall's personal appearance make the linkage between a certain widely used style of tailored clothes, short crops, cigarette smoking and sexuality more likely in the public realm. Gluck was from the early 1920s more radical in her sartorial rebellion by wearing trousers and men's clothes rather than a masculinised female suit. Her youth, slightness and chosen style made reporters uncertain about gender but not necessarily sure about the nature of her desire. Doan's work returns us to the fluidity or flexibility of fashion, re- and trans-coded bodies within the emerging cultures of modernisation.

48 Janet Flanner cited in Phyllis Rose, *Jazz Cleopatra: Josephine Baker in her Time*, New York: Doubleday, 1989, 31.

49 Karen C.C. Dalton and Henry Louis Gates, Jnr., 'Josephine Baker and Paul Colin: African American Dance Seen Through Parisian Eyes', *Critical Enquiry*, 1998, 24, 915–16.

50 Hortense J. Spillers, 'Interstices: A Small Drama of Words', in *Pleasure and Danger: Exploring Female Sexuality*, ed. Carol S. Vance, London: Pandora Press, 1989, 74.

51 Ibid., 76.

52 Tyler Stovall, *Paris Noir: African Americans in the City of Light*, Boston: Houghton Mifflin, 1996. See also Benetta Jules-Rosette, *Black Paris: The African Writers' Landscape*, Champaign: University of Illinois Press, 2000.

53 Benetta Jules-Rosette, 'Josephine Baker: Inventing the Image and Preserving the Icon', in *Josephine Baker: Image & Icon*, ed. Olivia Lahs-Gonzales, St Louis: Reedy Press, 2006, 4.

54 Janet Lyon, 'Josephine Baker's Hothouse', in *Modernism, Inc.: Body, Memory, Capital*, ed. Jani Scandura and Michael Thurston, New York: New York University Press, 2001, 29–47.

55 Karen C.C. Dalton and Henry Louis Gates, Jnr., Introduction to *Josephine Baker and La Revue Nègre: Paul Colin's Lithographs of* Le Tumulte Noir *in Paris, 1927*, New York: Harry Abrams, 1998.

56 Phyllis Rose, *Jazz Cleopatra: Josephine Baker in her Time*, New York: Doubleday, 1989, 6–7.

57 Mary Anne Doane, 'Film and the Masquerade: Theorising the Female Spectator', *Screen*, 1982, 23: 3/4, 74–88.

58 Petrine Archer-Shaw, *Negrophilia: Avant-garde Paris and Black Culture in the 1920s*, London: Thames and Hudson, 2000.

59 On urbanism and jazz see Toni Morrison, *Jazz*, New York; Plume, 1993.

60 Cited in Benita Eisler, *O'Keeffe and Stieglitz: An American Romance*, New York: Penguin Books, 1991, 7, referencing Clive Giboire, *Lovingly Georgia*, New York: Simon & Schuster, 1990, 115.

61 Laura Mulvey, 'Pandora's Box: Topographies of Curiosity', in *Fetishism and Curiosity*, London: British Film Institute, 1996, 59.

62 Ibid., 61.

5 JEWISH SPACE/WOMEN'S TIME: ENCOUNTERS WITH HISTORY IN THE ARTWORKING OF CHARLOTTE SALOMON 1941 TO 1942

1 Walter Benjamin, 'On the Image of Proust' [1929], in *Selected Writings: Volume 2 1927–1933*, trans. Rodney Livingstone and others, ed. Michael W. Jennings, Howard Eiland and Gary Smith, Cambridge, MA: The Bellknap Press of Harvard University Press, 1999, 237.

2 It is interesting to relate this representation of working/living space to the photographic record by Edmund Engelman of Prof. Dr Freud at Berggasse 19, studied in Chapter 3 of this volume.

3 I first used this concept in my 'Theater of Memory: Trauma and Cure in Charlotte Salomon's Modernist Fairy-tale', in *Reading Charlotte Salomon*, ed. Michael P. Steinberg and Monica Boh-Duchen, Ithaca: Cornell University Press, 2006, 34–72. It is also the title of my forthcoming monograph, *Theatre of Memory: Allothanatography in Leben? oder Theater? by Charlotte Salomon 1941–42*, New Haven: Yale University Press, 2008.

4 I cannot illustrate all the paintings by the artist Charlotte Salomon that visually represent this theatre of memory. I shall therefore refer the reader to the catalogue *Charlotte Salomon Life? Or Theatre?* introduced by Judith Belifante, trans. Leila Vennewitz (Zwolle: Waanders Publishers and London: Royal Academy of Arts, 1998) which illustrates the entire work with accession numbers from the Jewish Historical Museum (JHM). The paintings of Paulinka Bimbam singing Bach are JHM 260–61.

5 The radio occurs several times in *Leben? oder Theater?*, particularly associated with Marianne Knarre, the grandmother, who listens anxiously for news about conditions in Germany. See JHM 4841.

6 Jeffrey Mehlman, *Walter Benjamin for Children: An Essay on His Radio Days*, Chicago: University of Chicago Press, 1993; Sabine Schiller-Lerg, *Walter Benjamin und der Rundfunk: Programmearbeit zwischen Theorie und Praxis*, Munich: K.G. Saur, 1984; Walter Benjamin, *Aufklärung für Kinder*, ed. Rolf Tiedermann, Frankfurt: Suhrkampf, 1985.

7 See the clarification of these necessarily distinct identities, CS, Charlotte Salomon and *Charlotte Kann* in Mary Lowenthal Felstiner, *To Paint her Life: Charlotte Salomon in the Nazi Era*, New York: HarperCollins, 1994, xii. Felstiner rightly points out why we must distinguish between the use

of characters in the work and the author herself. Charlotte Salomon wrote: 'I was all the characters in my play and thus I became myself' (cited on p. xii, JHM 4931). In addition, I want to thank Marcia Pointon for raising the issue of the monogram as a visual sign actively resisting but referencing the swastika. We could also reference the disguising of gender by initials to other artists such as Lee Krasner. See Anne Wagner, 'Lee Krasner as L.K.', *Representations*, 25 (winter 1989), 42–57.

8 A collection of hitherto lost paintings has been donated to the Holocaust Museum at Yad Vashem and the curators will publish them in due course after restoration work and full documentation can be established.

9 The full history is documented in Felstiner (223 30). A first exhibition took place at the Fodor Museum, an extension of Stedelijk Museum in Amsterdam in 1961. It was soon followed by a selected and modified choice of pictures and texts, introduced by theologian Paul Tillich, and titled *Charlotte: A Diary in Pictures* (1963). The work was donated to the Jewish Historical Museum in 1971 where 250 works were shown in 1981 and a major facsimile edition of the paintings was produced and edited by Judith Herzberg. Critics were still uncertain as to the artistic, documentary, autobiographical or therapeutic status of these images. The works were first exhibited in Berlin in 1986. Claire Stoullig first presented selected works of *Life or Theater* in Paris at the Centre Pompidou in 1992 as a modernist work of twentieth-century visual art in 1992, and it was further revealed and re-evaluated in terms of feminist studies of the ignored margins of modernism by Cathérine de Zegher's monumentally important exhibition *Inside the Visible: An Elliptical Traverse of Twentieth Century Art, in, of and from the Feminine* (Cambridge, MA: MIT Press, 1996). Only in 1998 did the work receive an unequivocally major representative art historical exhibition at the Royal Academy of Arts in London, curated by Monica Bohm-Duchen. From London, this exhibition travelled to the Art Gallery of Ontario in Canada (April to July 2000) and to the Jewish Museum in New York (December to March 2001). In 2005 to 2006 it was shown in Paris at the Musée de l'histoire et de l'art de judaisme, the Jewish Museum in Frankfurt and finally at the Holocaust Museum of Yad Vashem. It is interesting to note the effects of the difference between these sites, art museum and marked Jewish cultural venue that revealed a further difficulty in identifying how this work should be located on our current cultural maps. There was considerable debate in New York in 2001 about the effect of such a specifically Jewish framing of the work at the Jewish Museum and how else the work would have been received and reviewed had it been at MOMA. The frame seemed both accurate and yet was perceived as too narrow to ensure that the work entered in the purview of, for instance, major students and scholars of twentieth-century modern art.

10 *Charlotte: A Diary in Pictures by Charlotte Salomon*, Comment by Paul Tillich, Biographical Note by Emil Strauss, New York: Harcourt, Brace & World, 1963; *Charlotte: Life or Theater? An Autobiographical Play by Charlotte Salomon*, introduced by Judith Herzberg, trans. Leila Vennewitz, London: Allen Lane in association with Gary Schwartz, 1981. For a fuller discussion of the case of Anna Frank see Griselda Pollock, 'Stilled Life: Traumatic Knowing, Political Violence and the Dying of Anna Frank', *Mortality* (2007), 12: 2, 124–41.

11 On artworking, a concept inspired by Bracha Ettinger, in relation to Charlotte Salomon, see my 'What does a Woman Want? Art Investigating Death in Charlotte Salomon's *Leben? oder Theater?* 1941–2', *Art History* (2007), 30: 2, 383–405.

12 Julia Kristeva, 'Women's Time', in *The Kristeva Reader*, ed. Toril Moi, Oxford: Blackwell, 1986, 187–213.

13 For a most complex and disturbing analysis of the psycho-sexual fantasy structures underlying German fascism see Klaus Theweleit, *Male Fantasies* [1977], trans. Stephen Conway with Erica Carter and Chris Turner, Cambridge: Polity Press, 1987.

14 Mary Felstiner, *To Paint a Life, op. cit.*, 208.

15 Nanette Salomon, 'On the Impossibility of Charlotte Salomon in the Classroom', in *Reading Charlotte Salomon*, ed. Michael P. Steinberg and Monica Bohm-Duchen, Ithaca: Cornell University Press, 2006, 212–22.

16 Stephanie Barron, *Degenerate Art: The Fate of the Avant-garde in Nazi Germany*, Los Angeles: County Museum of Art, 1991.

17 The phrase comes from 'The Prayer for the Six Million', in the Reform Synagogues of Great Britain's *Machzor* for the *Days of Awe*, 1985, 618. I am indebted for the deepened concept of the

half-empty bookcase resulting from the loss to Cynthia Ozick's section 'On the Depth of Loss and the Absence of Grief' in her 'Notes Towards Finding the Right Question', in *On Being a Jewish Feminist: A Reader*, ed. Susannah Heschel, New York: Schocken Books, 1983, 133–8. Ozick points out that the general sense of the missing histories of women resulting from patriarchal exclusions and repressions was magnified by the vastness of the Jewish losses during the genocide which not only 'excised' a people in its prime but destroyed the treasure of a people in its potential. Ozick notes too that while there is some grief expressed for the losses occasioned by the Holocaust, patriarchal culture sheds not one tear for the vast historical loss to human culture of the exclusion of women from culture, thought and creativity through active repression of their opportunities to write, think, create or by consistent negation of what women, none the less, did write, think and create.

18 See Mark Roseman, *The Villa, The Lake, The Meeting: Wannsee and the Final Solution*, London: Penguin Books, 2002.

19 For a translation and analysis of this postscript see Julia Watson, 'Charlotte Salomon's Memory Work and Postscript to *Life? or Theater?*, *Signs: Gender and Cultural Memory* (2002), 28: 1, 409–30. Julia Watson provides both a translation of this unpublished element of the total archive and a reading.

20 Walter Benjamin, 'Berlin Chronicle', in *One-way Street*, trans. Edmond Jephcott and Kingsley Shorter, London: Verso Books, 1979, 316.

21 Walter Benjamin, 'Berlin Chronicle', 295. I have developed a fuller line of analysis of this material in my 'Life-maps or Charlotte Salomon and Walter Benjamin Never Met', in *Conceptual Odysseys: Passages in Cultural Analysis*, London: I.B.Tauris, 2007, 63–88.

22 See Walter Benjamin, 'On the Image of Proust', *op. cit.*, 238.

23 The work is divided into three parts: a prologue which covers events from 1913 to 1936 with 211 paintings, a main part which has 469 paintings and deals with a major encounter with Amadeus Wolfsohn (1936–9), and an epilogue of 103 paintings dealing with the period between 1939 and the summer of 1940.

24 Walter Benjamin, 'Berlin Chronicle', *op. cit.*, 295.

25 Griselda Pollock, 'Modernity and the Spaces of Femininity', in *Vision and Difference: Feminism, Femininity and the Histories of Art*, London: Routledge, 1988; new classic edition, 2002, 50–90.

26 On the linguistic dimension of fascism see Victor Klemperer, *The Language of the Third Reich* [1975], London: Continuum, 2006.

27 Griselda Pollock, 'Modernity', *op. cit.* See also Janet Wolff, 'The Invisible Flâneuse: Women and the Literature of Modernity', *Theory, Culture and Society* (1985), 2: 3, 37–46 and a riposte by Elizabeth Wilson, 'The Invisible Flâneur' in *The Contradictions of Culture: Cities, Culture, Women*, London: Sage, 2001, 72–89, and a new collection, Aruna da Souza and Tom McDonough (eds), *The Invisible Flâneuse: Gender, Public Space and Visual Culture in Nineteenth Century Paris*, Manchester: Manchester University Press, 2006, in which Janet Wolff replies to the critics of her (and my own) position, 'Gender and the Haunting of Cities', 18–31.

28 The motif of the woman at the window is iconically associated with Caspar David Friedrich's painting of this subject, *Woman at the Window* (1822), which was in the Berlin National Gallery and would have been known to Charlotte Salomon.

29 On film and architecture in the Weimar period see Dietrich Neumann, *Film Architecture: Set Designs from Metropolis to Blade Runner*, Munich and New York: Prestel, 1966.

30 See Jill Lloyd and Magdalena Muller (eds), *Ernst Ludwig Kirchner: The Dresden and Berlin Years*, London: Royal Academy of Arts, 2003; Janet Ward, *Weimar Surfaces: Urban Visual Culture in 1920s Germany*, Berkeley: University of California Press, 2002; Dorothy Rowe, *Representing Berlin: Sexuality and the City in Imperial and Weimar Germany*, London: Ashgate 2003.

31 Maria Tatar, *Lustmord: Sexual Murder in Weimar Germany*, Princeton: Princeton University Press, 1995.

32 Elisabeth Bronfen, *Over her Dead Body: Death, the Aesthetic and the Feminine*, Manchester: Manchester University Press, 1992.

33 See Rudy Koshar, *German Travel Cultures*, Oxford: Berg, 2000.

34 Ken McMullen, *Pioneers in Art and Science: Gustav Metzger*, London: University of the Arts, 2003.

35 For an analysis of that painting and the visual semiotics of departure and independence it produces see Griselda Pollock, 'Mapping the "Bios" in Two Graphic Systems with Gender in Mind: Van Gogh and Charlotte Salomon', in *Biographies and Space*, ed. Dana Arnold and Mark Westgarth, London: Routledge, 2007.

36 When Frida Kahlo had her first one-person exhibition in New York at Julien Levy's gallery opening on 1 November 1938, the *Time* magazine critic wrote of 'the famed muralist Diego Rivera's German-Mexican wife, Frida Kahlo', quoted in Hayden Herrera, *Frida: A Biography of Frida Kahlo*, New York: Harper Colphon Books, 1983, p. 231.

37 *Charlotte Salomon*, Museum Fodor, Amsterdam, 2 February to 5 March 1961.

38 The still most significant reading of Kahlo's complex project as an artist, that itself challenges the biographical reductionism evident in the majority of the literature, is in Laura Mulvey and Peter Wollen, *Frida Kahlo and Tina Modotti*, London: Whitechapel Art Gallery, 1982.

39 Laura Mulvey and Peter Wollen, *Frida Kahlo and Tina Modotti*, op. cit.

40 Margaret A. Lindauer, *Devouring Frida: The Art History and Popular Celebrity of Frida Kahlo*, Hanover and London: Wesleyan University Press, 1999.

41 Gannit Ankori, *Imagining her Selves: Frida Kahlo's Poetics of Identity and Fragmentation*, Westport and London: Greenwood Press, 2002; Gannit Ankori, 'The Hidden Frida: Covert Jewish Elements in the Art of Frida Kahlo', *Jewish Art* (1993/94), 19/20, 224–47. I am deeply indebted to Dr Ankori for this important revelation.

42 Gannit Ankori, op. cit., 230.

43 Darcy Buerkle, 'Historical Effacements', in *Reading Charlotte Salomon*, op. cit., 73–87, Footnote 15.

44 Sarah H. Lowe (ed.), *The Diary of Frida Kahlo: An Intimate Self-portrait*, introduced by Carlos Fuentes, London: Bloomsbury, 1995.

45 Anna Frank, *The Diary of Anne Frank*, edited by Otto Frank and Mirjam Pressler, London: Puffin Books, 1997, entries for 5 and 6 April and 8 May 1944.

46 Griselda Pollock, 'Stilled Life: Traumatic Knowing, Political Violence and the Dying of Anna Frank', op. cit., Footnote 10.

6 THE GRACES OF CATASTROPHE: MATRIXIAL TIME AND AESTHETIC SPACE CONFRONT THE ARCHIVE OF DISASTER

1 Maurice Blanchot, *The Writing of the Disaster* [1980], trans. Ann Smock, Lincoln and London: University of Nebraska Press, 1995, 51.

2 In an unpublished paper for a conference on *Picturing Atrocity* (New York University, December 2005), I explored what makes certain photographs of atrocity and suffering bearable for us to look at. Considering two of the most recurrent images in Holocaust museum displays, both showing the death of women, I suggested deeper psychic predeterminations at work linking femininity and death.

3 Charlotte Delbo, *None of us Will Return* in *Auschwitz and After*, trans. Rosette Lamonte, New Haven: Yale University Press, 1995.

4 Hannah Arendt, *The Origins of Totalitarianism*, New York: Harcourt, Brace, Jovanovich, 1951, 433.

5 Bracha Ettinger, *Que Dirait Eurydice? What would Eurydice Say? Conversation avec/with Emanuel Levinas*, Paris: BLE Atelier, 1997, 30.

6 The year of publication marks the 400th anniversary of the first public opera, Monteverdi's *L'Orfeo*, of which more anon.

7 Bracha Ettinger, *Matrix Halal(a) Lapsus: Notes on Painting*, Oxford: Museum of Modern Art, 1993, 85.

8 In her notebooks, *Matrix Halal(a) Lapsus: Notes on Painting*, 84, the artist records that her mother's brother was kidnapped by the Nazis from the ghetto for experiments, being blond, blue-eyed and beautiful. 'It's when the traces of her beloved brother had disappeared into total anonymity that something was shattered in my mother for good. Nothing that I could say or do could evoke this tragedy. Yet, at the same time, all that concerned me evoked it.'

9 Bracha Ettinger, 'Art as the Transport-station of Trauma', in *Bracha Ettinger: Art Working 1985–1999*, Brussels and Gent: Ludion, 2000, 91.

10 Judith Kestenberg, 'Psychoanalytic Contributions to the Problem of Children Survivors of Nazi Persecution', *Israeli Annals of Psychiatry and Related Disciplines* (1972), 10, 249–65.

11 Dina Wardi, *Memorial Candles: Children of the Holocaust*, London: Routledge, 1992.

12 Bracha Ettinger, *'Matrix Halal(a) Lapsus: Notes on Painting*, op. cit.

13 See Griselda Pollock, 'Feminism, Painting and History', in *Looking Back to the Future: Essays from the 1990s*, London: Routledge, 2001; 'Killing Men and Dying Women; A Woman's Touch in the Cold

Zone of 1950s American Painting', in *Avant-gardes and Partisans Reviewed* by Fred Orton and Griselda Pollock, Manchester: Manchester University Press, 1996.

14 The classic statement of the necessary distance between the avant-garde and the conflicts of society is Clement Greenberg, 'Avant-garde and Kitsch' [1939], in *Art & Culture*, Boston: Beacon Press, 1961, 3–21.

15 *Aesthetics and Politics: Debates between Bloch, Lukacs, Brecht, Benjamin and Adorno*, ed. Frederic Jameson, London: Verso, 1977.

16 Post-Cubism – Marc Chagall's *White Crucifixion* (1938, Art Institute of Chicago) and Picasso's *The Charnel House* (1945, New York Museum of Modern Art); Surrealism – Salvador Dali's *Le Visage de la Guerre* (1940, Rotterdam, Museum Boymans van Beuningen) and *L'Enigme de Hitler* (1938, Madrid, Museo Reina Sofia); Expressionism – Felix Nussbaum's *Self Portrait with Key in the Camp of St. Cyprien* (1941, Tel Aviv Museum); Art Brut – the *Otages* series of 1945 by Jean Fautrier.

17 Zygmunt Bauman, *Modernity and the Holocaust*, Cambridge: Polity Press, 1989.

18 All photography is authored, by photographer or publication. Yet the distinction between news photography and a 'named' photographer's work was not maintained by this display.

19 Leo Steinberg, 'Other Criteria', in *Other Criteria: Confrontations with Twentieth Century Art*, New York: Oxford University Press, 1972, 55–92.

20 Theodor Adorno, 'After Auschwitz', in 'Meditations on Aesthetics', in *Negative Dialectics*, trans. E.B. Ashton, New York: Continuum, 1973, 362; Saul Friedlander (ed.), *Probing the Limits of Representation: Nazism and the 'Final Solution'*, Cambridge, MA, and London: Harvard University Press, 1992, 3.

21 Cathy Caruth, 'Introduction', in *Trauma: Explorations in Memory*, Baltimore and London: Johns Hopkins University Press, 1995, 3–12.

22 Griselda Pollock, 'Gleaning in History or Coming After/Behind the Reapers: The Feminine, the Stranger and the Matrix in the work and theory of Bracha Lichtenberg Ettinger', in *Generations and Geographies: Feminist Readings in the Visual Arts*, ed. Griselda Pollock, London: Routledge, 1996, 266–88.

23 Dori Laub, 'An Event without a Witness', in *Testimony: Crises of Witnessing in Literature, Psychoanalysis and History*, ed. Dori Laub and Shoshana Felman, London and New York: Routledge, 1992, 75–92 (80).

24 Bracha Ettinger, 'Wit(h)nessing Trauma and the Gaze', in *The Fascinating Face of Flanders*, ed. Paul Vandebroek *et.al.*, Antwerp: Stad, 1998.

25 Griselda Pollock, 'After the Reapers: Gleaning the Past, the Feminine and Another Future from the Work of Bracha Lichtenberg Ettinger', in Bracha Ettinger, *Halala-Austistwork*, Jerusalem: The Israel Museum, 1995, and in a shortened version in *Third Text* (1994) 28/29, 61–70.

26 Barbie Zelizer, *Remembering to Forget: Holocaust Memory through the Camera's Eye*, Chicago: University of Chicago Press, 1998.

27 See Griselda Pollock, *Generations and Geographies*, op. cit.

28 Bracha Ettinger, 'Traumatic Wit(h)ness – Thing and Matrixial Co/inhabit(u)ating', *parallax: practices of procrastination* (1999), 10, January–March, 89–98.

29 See Julia Kristeva, 'Women's Time', in *The Kristeva Reader*, ed. Toril Moi, Oxford: Blackwell, 1986, 187–214 (210).

30 Theodor Adorno, 'Cultural Criticism and Society,' in *Prisms*, trans. Samuel and Sherry Weber, Cambridge, MA: MIT Press, 1983, 34, is the first use of this phrase first published in 1949. It then becomes the topic of repeated reflections culminating in *Negative Dialectics*, trans. E.B. Ashton, New York: Continuum Books, 1973. For a full discussion of the 'chronotope' *nach Auschwitz*, see Michael Rothberg, *Traumatic Realism: The Demands of Holocaust Representation*, Minneapolis: University of Minnesota Press, 2000, 25–58.

31 For a fuller discussion of the relation of the aesthetic to death see Bracha Ettinger, 'Transgressing Wth-in-to the Feminine', in *Differential Aesthetics*, ed. Penny Florence and Nicola Foster, Burlington: Ashgate, 2000, 185–210, and Griselda Pollock, 'The Aesthetics of Difference', in *Art History, Aesthetics, Visual Studies* ed. Michael Ann Holly and Keith Moxey, New Haven: Yale University Press, 2002, 147–74. On the aesthetic as transformation of the inner world of the subject by affect, see Christopher Bollas, *The Shadow of the Object: Psychoanalysis of the Unthought Known*, New York: Columbia University Press, 1987.

32 Lacan's theory is advanced in *Le Séminaire, Livre VII: L'ethique de la psychoanalyse 1959–1960*, Paris: Editions de Seuil, 1986.

33 See Griselda Pollock, 'Does Art Think?', in *Art and Thought*, ed. Dana Arnold and Margaret Iverson, Boston and Oxford: Blackwell's, 2003, 129–55.

34 H.D. (Hilda Doolittle), *Collected Poems 1912–1944*, ed. Louis L. Martz, Manchester: Carcanet Press, 1984, 51–4. Reprinted with kind permission of the Carcanet Press. See also Elaine Feinstein, *The Feast of Eurydice*, London: Faber & Faber, 1980.

35 Klaus Theweleit, 'Monteverdi's *L'Orfeo*: The Technology of Reconstruction', in *Opera Through Other Eyes*, ed. David Levin Stanford: Stanford University Press, 1994, 147–76.

36 See Cathérine Clément, *Opera or the Undoing of Women*, trans. Betsy Wing, London: Virago Press, 1989.

37 Theweleit, *op. cit.*, 169.

38 Ibid., 172.

39 Ibid., 172.

40 Bracha Ettinger, 'Matrix and Metramorphosis', *Differences: A Journal of Feminist Cultural Studies* (1992), 4: 3, 176–208, and *The Matrixial Gaze*, University of Leeds Feminist Arts and Histories Press, 1995. Bracha L. Ettinger, *The Matrixial Borderspace* with Judith Butler, Griselda Pollock, Brian Massumi, Minneapolis: University of Minnesota Press, 2006. A full bibliography may be found at www.metramorphosis.org.uk. For an extended introduction to this theory see Griselda Pollock, 'Thinking the Feminine: Aesthetic Practice as Introduction to Bracha Ettinger and the Concepts of Matrix and Metramorphosis', *Theory, Culture and Society* (2004), 21: 1, 5–65.

41 Eric Santner, 'History beyond the Pleasure Principle: Some Thoughts on the Representation of Trauma', in *Probing the Limits of Representation: Nazism and the Final Solution*, ed. Saul Friedlander, Cambridge, MA: Harvard University Press, 1992, 143–54.

42 Bracha Ettinger, *Que Dirait Eurydice? What Would Eurydice Say? Conversation avec/with Emanuel Levinas*, Paris: BLE Atelier, 1997, 26 and 30.

43 On the autistic self-portrait in Ettinger see Griselda Pollock, 'Rethinking the Artist in the Woman, the Woman in the Artist, and that Old Chesnut, the Gaze', in *Women Artists at the Millennium*, ed. Carol Armstrong and Cathérine de Zegher, Cambridge, MA: MIT Press, 2006, 35–84.

44 See Barbie Zelizer, *Remembering to Forget: Holocaust Memory through the Camera's Eye*, *op. cit.* Verbal reports expressed their own inadequacy before atrocities never before encountered that photographic images alone could confirm and convey.

45 Susan Sontag, *On Photography*, London: Penguin Books, 1977, 19–20.

46 Ibid., 20.

47 Ibid.

48 Susan Sontag, *Regarding the Pain of Others*, New York; Farrar, Strauss & Giroux, 2003.

49 Dori Laub, 'An Event without a Witness: Truth, Testimony and Survival', *op. cit.*

50 Bracha Ettinger, 'Wit(h)nessing Trauma and the Gaze', *op. cit.*

51 Bracha Ettinger, *Que Dirait Eurydice? What would Eurydice Say?*, *op. cit.*, 30.

7 THE TIME OF DRAWING: DRAWING TIME. MICRO/MACRO (1998–) BY CHRISTINE TAYLOR PATTEN

1 All quotations are from the unpublished notes by the artist that Christine Taylor Patten has kindly made available to me for my research.

2 MaLin Wilson, *Artlines Magazine*, 1992. Artist's archives.

3 Avis Newman, 'Conversation', in *The Stage of Drawing: Gesture and Act* by Cathérine de Zegher and Avis Newman, London: Tate Gallery, and New York: Drawing Centre, 2003, 78.

4 Cathérine de Zegher, 'Conversation', in Cathérine de Zegher and Avis Newman, *op. cit.*, 167.

5 Patten's twelve series are: *Free Radicals* (consisting of eleven works, 1970–8); *Vietnam* (five works, 1983–6), one of which is titled *In Memory of Someone who was Killed in Vietnam*; *Life As We Know It* (nineteen works, 1985–90), including *There's No Such Thing as a Little Plutonium*; *Vietnam Afterimages* (nineteen works, 1990–4), including *Imagine, Unity is Minimum of Two, What If War Were Not An Option?*; *QED* (sixteen works, 1989–90), including *What is the Sound of the Speed of Light?* and *Ode to Pollock and Krasner*; *Bears* (ten works, 1987–8), *Gracetime* (six works, 1993–8); *Peace* (twelve works ongoing, 1993–); *Peace Preliminaries* (eighteen works, 1993–5); and *New Light* (four works, 1995–), *micro* (1998–) and *macro/imagine* (1998–).

6 So far extracts have been shown at Knoedler Gallery, New York, 1999, James Kelly, 2000, New Mexico Governor's Gallery, 2001, Harwood Museum of the University of New Mexico, Taos, 2005, The Drawing Gallery, London, the University Art Gallery of the University of Leeds, 2006, the Drawing Center, New York, 2006–7. See *Christine Taylor Patten: micro/macro 261 drawings*, New York: The Drawing Center, *Drawing Papers 66*, 2006.

7 From the artist's archives.

8 Charles Jencks, *The New Paradigm in Architecture: The Language of Postmodernism*, New Haven and London: Yale University Press, 2002. See also *The Architecture of the Jumping Universe: A Polemic: How Complexity Science is Changing Architecture and Culture*, Toronto: John Wiley & Sons, 1997; *The Garden of Cosmic Speculation*, London: Frances Lincoln, 2003.

9 Ulrich Baer, *Spectral Evidence: The Photography of Trauma*, Cambridge, MA: MIT Press, 1992, 5.

10 Paul Valéry, *Degas, Dance, Dessin*, Paris: Gallimard [1938], 117–18.

11 Two recent exhibitions are bringing the significant impact of feminism in the redirection of art into view. Barbro Werkmaester and Nicolas Ostlind, *Konstfeminism*, Lilljevalchs Konsthall, Stockholm, 2006, and Connie Butler, *WACK! Art and the Feminist Revolution*, Los Angeles Museum of Contemporary Art, 2007.

12 Griselda Pollock, 'Rencontre avec L'histoire: Stratégies de dissonance', in *Face à L'Histoire 1933–1996*, ed. Jean-Paul Ameline, Paris: Centre Pompidou et Flammarion, 1996, 535–40.

13 Alison Rowley and Griselda Pollock, 'Painting in a "Hybrid Moment" ', in *Critical Perspectives on Contemporary Painting: Hybridity, Hegemony and Historicism*, ed. Jonathan Harris, Liverpool: Liverpool University Press, 2003, 37–80; Philip Armstrong and Stephen Melville, *As Painting: Division and Displacement*, Columbia, OH: Cambridge, MA: Wexner Center and MIT Press, 2001. *Eight Propositions*, New York: Museum of Modern Art, 2002, and Cathérine de Zegher and Avis Newman, *The Stage of Drawing: Gesture and Act*, London: Tate Gallery, and New York: Drawing Centre, 2003.

14 Bracha Ettinger, *Matrix Halal(a)-Lapsus: Notes on Painting*, Oxford: Museum of Modern Art, 1992, reprinted in Bracha Ettinger, *Artworking 1985–1999*, Gent: Ludion, and Brussels: Palais des Beaux Arts, 2000.

15 Maurice Merleau-Ponty, 'Eye and Mind' [1961], in *The Merleau-Ponty Aesthetics Reader: Philosophy and Painting*, ed. Galen A. Johnson, trans. Michael B Smith, Evanston: Northwestern University Press, 1993, 123–4.

16 Ibid., 124.

17 Ibid., 124.

18 Ibid., 126.

19 Ibid., 126.

20 Luce Irigaray, 'The Invisible of the Flesh: A Reading of Merleau-Ponty, *The Visible and the Invisible*, "The Intertwining–The Chiasm" ', in *An Ethics of Sexual Difference*, trans. Carolyn Burke and Gillian C. Gill, Ithaca: Cornell University Press, 1993, 151–84. The quotations are taken from 152–5.

21 Irigaray, *op. cit.*, 152.

22 Ibid., 153.

23 Ibid., 154–5.

24 Bracha Ettinger, 'Matrixial Gaze and Screen: Other than Phallic, Merleau-Ponty and the Late Lacan', *ps*, (1999) 2: 1, 7.

25 Ibid., 7.

26 Julia Kristeva, 'Women's Time' [1979], in *The Kristeva Reader*, ed. Toril Moi, Oxford: Blackwell, 1986, 210.

27 Kristeva's term does not imply Kantian hierarchies of value, beauty and genius but rather making art that synthesises meaning and affect, that draws on archaic drives and finds ways to filter these intensities into semiotic systems by which we make sense of the world and share those meanings intersubjectively: aesthetic practices are music, dancing and painting and, since drawing is effectively all three, it might be *the* aesthetic practice.

28 Avis Newman, *op. cit.*, 231.

29 Cathérine de Zegher, *Inside the Visible: An Elliptical Traverse of Twentieth Century Art, in, of and from the Feminine*, Cambridge, MA: MIT Press, 1996.

30 I need to signal the infamous and contested arguments in feminist criticism of the 1970s about women's artwork exhibiting a tendency to 'central core imagery'. This initial observation has not

withstood the test of time. Yet it paid attention to how we might begin to discuss what abstract practice allowed to emerge into visual forms that intimated fantasies of interiority and memories of relational space which can best be explored through psychoanalytical theorisations of fantasmatic corporeality in order to avoid any suggestion of direct relations between forms and human anatomies. This also avoids the tired and useless rhetoric of essentialist versus constructionist theories of gender.

31 For discussion of the debate and feminist rereading see Michèle Montrelay, 'Inquiry into Femininity', *m/f* (1978), 1, 83–102.
32 Sigmund Freud, 'The Uncanny' [1919], in *Art and Literature, Penguin Freud Library Vol. 14*, Harmondsworth: Penguin Books, 1990, 335–76.
33 Ibid., 345.
34 Ibid., 371.
35 Ibid., 368.
36 Avis Newman and Cathérine de Zegher, 'Conversation', *op. cit.*, p 233.
37 This insight resonates with Rosalind Krauss, *The Optical Unconscious*, Cambridge, MA: MIT Press, 1993, and with Ettinger's extensions to Krauss' formalist insights in *The Matrixial Gaze*, in *The Matrixial Borderspace*, ed. Brian Massumi, Minneapolis: University of Minnesota Press, 2006, 41–92.

INDEX